All the Art That's Fit to Print
(And Some That Wasn't)

Milton Glaser

All the Art That's Fit to Print (And Some That Wasn't)

Inside 𝕿𝖍𝖊 𝕹𝖊𝖜 𝖄𝖔𝖗𝖐 𝕿𝖎𝖒𝖊𝖘 Op-Ed Page

JERELLE KRAUS

Columbia University Press New York

Columbia University Press
Publishers Since 1893
New York Chichester, West Sussex

Copyright © 2009 Jerelle Kraus
All rights reserved

Library of Congress Cataloging-in-Publication Data
Kraus, Jerelle.
 All the art that's fit to print (and some that wasn't):
inside the New York Times op-ed page / Jerelle Kraus.
 p. cm.
 Includes bibliographical references and index.
 ISBN 978-0-231-13824-6 (cloth: alk. paper)
 ISBN 978-0-231-51090-5 (e-book)
 1. Editorial cartoons—New York (State)—New York.
 2. American wit and humor, Pictorial. 3. New York times.
 I. Title
 NC1428.N377K73 2009
 071' .471—dc22 2008023525

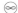

Columbia University Press books are printed on permanent
and durable acid-free paper.
Printed in the United States of America
c 10 9 8 7 6 5 4 3 2

Designed by Jena Sher
Typefaces: Cheltenham BT, ITC Franklin Gothic

Permissions
© 1994 Art Spiegelman, permission of The Wylie Agency
© Charles Addams. With permission Tee and Charles
 Addams Foundation.
© 1994 The Estate of Keith Haring
© Jules Feiffer
© 1997 Paul Davis. Courtesy of the artist
© Paula Scher/Pentagram
© Sue Coe, Courtesy Galerie St. Etienne, New York

For Arthur

Tulio Pericoli

Thought is impossible without an image.
ARISTOTLE

Contents

Frances Jetter

Illustrations

THE EIGHTIES

THE NINETIES

THE AUGHTS

Ralph Steadman

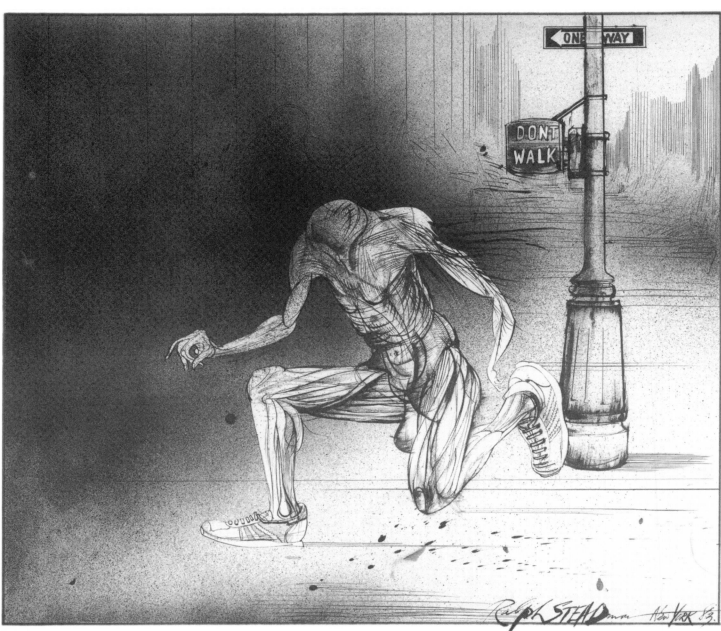

Ralph Steadman

Foreword

The world is lousy with wisdom. It was ever thus. Most of us complain, and the optimists make a line of ink.

Jerelle Kraus must have interacted with just about every major artist, writer, and philosopher for more than thirty years. At a time when so many came and went, and so quickly, in the quicklime of progress, she always was there, clucking away, as Mother Hens do, keeping everyone in line and safe from foxes.

She has the eye of a hawk and the heart of a revolutionary who cares deeply about what happens tomorrow. I have always known that she is on our side, the good side of every soul striving to express the inexpressible. We—the artists—chose to go that way, sink or swim, and sometimes life belts were offered because few of us are channel swimmers.

An artist sifts through a piece of writing like a frogman checking for buried treasure in a sunken wreck. Something special in the text may need a picture to signal its presence across the columned landscape of words. That special something cannot be spoken but takes flight to demonstrate Wittgenstein's claim that the only thing of value is that which you cannot say. I think I know what he meant. Locked inside all writers are other souls that got suffocated in the telling. An artist can often exactly express what cannot be spoken and release it to shine like the reflection of a harvest moon in a subterranean sky.

Skies and landscapes are the common tools of our trade that breathe life across the pages of a daily newspaper. After all, it is only as an aesthetic phenomenon that existence and the world are permanently justified. The Op-Ed page has been striving to unite words and pictures and give us a multiple moment—that green flash across a sunset in the split second before the sun drops out of sight. I like to think that still happens and that pictures go with words like blood brothers and wild sisters.

Fashionable statements are not Op-Ed's territory, but universal qualities are—those timeless nuances and idiosyncratic earthquakes that make art what it is and always will be, as long as sentient beings think and feel the way they do. Artists do think, but that has never been their primary role in the order of things, and so we artists take second place. That is the unspoken injustice that Jerelle, J. C. Suarès, and others strove to reveal in their struggle to give art its true voice on the page.

The faceless stars delineate not only the likenesses but the crimes of others. They are outraged by their own kind's inhumanity and never stop struggling to keep alive the world's conscience. Such artists have cried out for thousands of years, ever since they could lay their hands on a burned stick that would make a mark. They are stopped only by persecution or death.

It doesn't take much to encourage them. Given the right conditions—greed, oppression, stupidity, pomp, arrogance, and the Op-Ed page of the *New York Times*—they thrive like Triffids. In a mere four decades, they have explained the meaning of life in pictures and, what's more, have taken on a hideous life of their own. They are insatiable! And they are coming YOUR way!!!

All the Art expresses the imaginations of 142 international picture makers, dream spinners, and visual philosophers who have taken the printed word by the scruff of the neck—gently mind!—and enabled the writers and their readers to see for themselves just what it was that they were really trying to say.

Ralph Steadman 2008

Michael Matthias Prechtl

Acknowledgments

While working at Op-Ed, I considered my bosses to be the readers. Yet I owe everything to the *New York Times* and its tolerance of my outspoken obstinacy. Any faults in this volume are mine. The *Times* did not participate beyond permitting the inclusion of headlines, blurbs, and text when they were integral to the art. The art is copyrighted by the artists who created it and to whom it belongs.

I thank all my editors, especially (alphabetically) Steven Crist, for his composure and humor; Charlotte Curtis, for persisting in convincing me to join Op-Ed; Max Frankel, for his warm approval and artistic sophistication; Howard Goldberg, for his editorial creativity and valuable memories; Mike Levitas, for his adventurousness and request that I rejoin Op-Ed; Jack Rosenthal, for his generosity and support; and suave Bob Semple, for always publishing my pages—despite his qualms.

Talented design director and assistant managing editor Lou Silverstein hired me and never interfered with my Op-Ed decisions; nor did his gifted successor, Tom Bodkin, who magnanimously tolerated my quirks. I'm immensely grateful to them both, as I am to two gentlemen publishers, Arthur Ochs Sulzberger and Arthur Ochs Sulzberger Jr., for their enlightened management. I'm forever in the debt of *Times*men Herb Mitgang, John Oakes, Harrison Salisbury, and David Schneiderman, who informed me about Op-Ed's crucial early days, and I thank colleagues Katherine Darrow, Truman W. Eustis III, Steven Heller, David Shipley, Nicholas Wade, and Alex Ward for their kind assistance.

To the 142 artists who permitted the publication of their imagery in this volume, I offer my deepest appreciation. Those 10 who generously agreed to extended, filmed interviews have my great gratitude: Marshall Arisman, R. O. Blechman, Andrzej Dudzinski, Brad Holland, Mirko Ilić, Frances Jetter, Mark Podwal, Ralph Steadman, Jean-Claude Suarès, and David Suter. Warmest thanks to you, Ralph, for also writing this volume's inspired foreword.

For granting further interviews, I thank many good souls, including Nicholas Blechman, Barry Blitt, Horacio Cardo, Seymour Chwast, Brian Cronin, Etienne Delessert, Douglas Florian, Bob Gale, Milton Glaser, Bob Grossman, Steven Guarnaccia, Cathy Hull, Viktor Koen, Martin Kozlowski, Luba Lukova, Christoph Niemann, Rafal Olbinski, Larry Rivers, Edel Rodriguez, Ronald Searle, Nancy Stahl, Roland Topor, Garry Trudeau, Pamela Vassil, Edith Vonnegut, Henning Wagenbreth, and Cynthia Wick.

I am indebted to my first-class literary agent, Robin Straus, for her stylish expertise and to my splendid acquiring editor, Columbia University Press associate director and editorial director Jennifer Crewe, for exquisitely guiding this entire project. Special thanks go to the two Columbia staffers directly responsible for this book: expert, classy editor Irene Pavitt and talented, sensitive art director Lisa Hamm. I'm also delighted to acknowledge the top-notch Columbia professionals who have brought this volume to life: Afua Adusei, Elizabeth Ahlering, Peter Barrett, Brad Hebel, Meredith Howard, Todd Lazarus, Philip Leventhal, Patricia O'Connell, Marisa Pagano, Dominic Scarpelli, Jena Sher, and Clare Wellnitz.

For rescuing *All the Art* at critical moments, I extend fond appreciation to Igor Alexander, for his valuable editing; Joan Chiverton, for shepherding a mountain of artwork; Janet Davidson, for impromptu assistance; Arthur Dworin, for skillfully finessing myriad electronic and strategic issues; Marc Eliot, for sharing his sage counsel; and Annette Grant and Jonathan Baumbach, for conferring on the title.

I'm exceedingly grateful to talented designer Irv Grunbaum, for building the Web site jerellekraus.com; Bruce Jaffe, for his lesson on Internet history; Nurit Karlin, for her unselfish inspiration in the early going; Lisa Krohn, for sparking valuable ideas and contacts; Pia Le Moal, for the generous gift of her time; Amy Nowacki, for her unparalleled dedication to an earlier version of this volume; and Irina Posner, for reading that volume. My warmest gratitude goes to Victoria Lang, Meredith Rich, Jason Dukes, and Andrew Moser for expertly alerting the world to *All the Art*.

I'm also indebted to Samanta Cardo and David Ceng, for their commitment; Andrea Charles, for being the ideal assistant; Coca Rotaru, for her generosity; Gabi Rotaru, for her scans; Anna Steadman, for salvaging a critical interview; Cathy Suter, for her index and encouragement; Valerie Suter, for liberating the first draft; Beata Szpura, for her books and support; Fred Taylor, for directing and filming the interviews; and Lena Williams, for her wisdom.

For their patience with my ranting and for their priceless friendship and inspiration, my loving appreciation goes to Sylvia Brown, Margaret Croyden, Adina Dabija, Christine De Lailhacar, Keith Edwards, Evette Joseph, Suzanna Klintcharova, Carolyn Wells Kraus, David Lang, Barbara and Jeffery Leimsieder, Hanna and Benjamin Levy, Richard Louis, Dennis Monthei, Doru Paul, Monica Rotaru, Michel Rywkin, Mariarosa Sclauzero, Nick Stine, Zan Stine, Jon Terrell, Gideon Vaisman, Frank Veteran, Brian Wall, Ruth Wolman, and so many of the people acknowledged earlier.

Finally, for our shared eccentricity, which caused me to rebel and embrace the *Times* establishment, I thank my free-spirited mother—Joyce Robinson Kraus—for passing on her Dionysian passion and artistic gifts. And I acknowledge an Apollonian, otherworldly hermit—the absent Dr. Otto Kraus—for handing down a genetic love of language and languages.

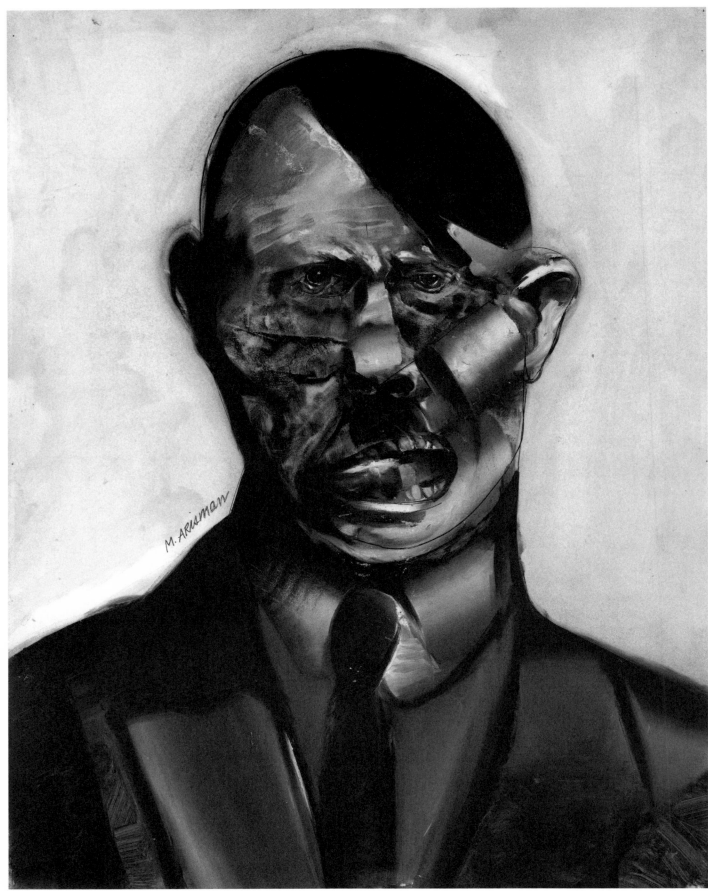

Marshall Arisman

All the Art That's Fit to Print
(And Some That Wasn't)

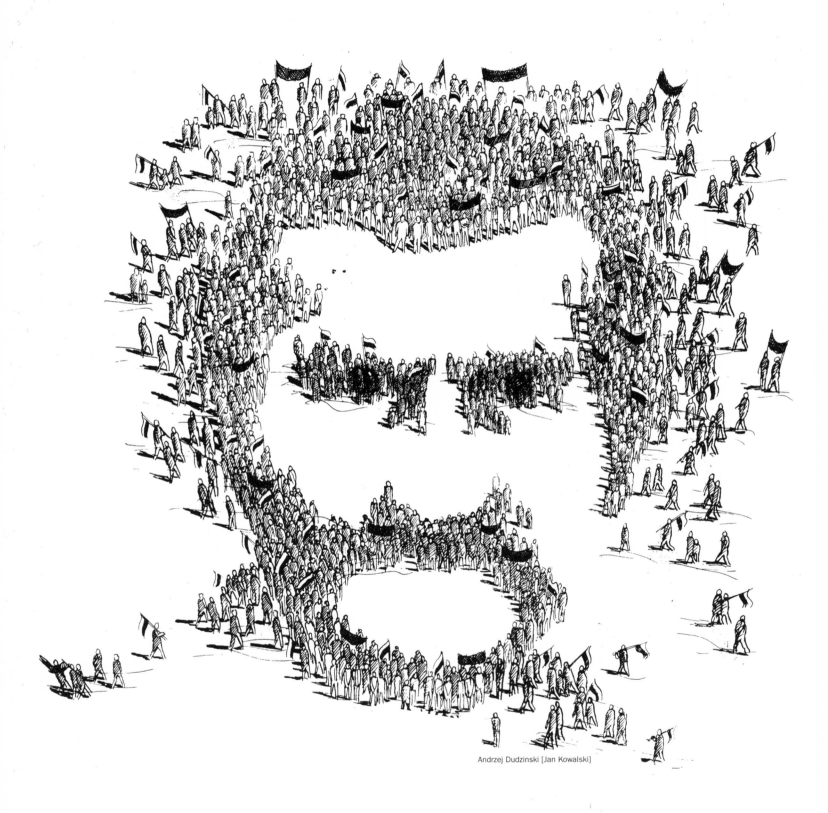

Andrzej Dudzinski [Jan Kowalski]

Prologue

In 1970, the *New York Times* launched the world's first Op-Ed page, a groundbreaking phenomenon that transformed journalism and—by providing a platform for anyone with an opinion—prefigured, by decades, the Internet's blogosphere. Not only did the new page's nonstaff bylines shatter tradition, but its pictures were revolutionary. Unlike anything ever seen in a newspaper, Op-Ed art became a fertile, globally influential idiom that reached beyond narrative for metaphor and changed the very purpose and potential of illustration.

Once I began this book, I approached a literary agent. "It's about *Times* Op-Ed," I told him. "Great," he said. "I've been reading it for twenty years." The book gives the story of the page, I explained, from the vantage point of its art. "Are you telling me," he responded, "there are cartoons on the Op-Ed page?" Beyond the fact that these drawings aren't cartoons, his reaction spotlighted the need to document Op-Ed's history to underscore that while the texts reach the brain's logical left lobe, the art links directly to the cerebrum's right hemisphere, which processes intuitively, visually, and subliminally.

We refer to the holistic right lobe when we say, "Do you get the picture?" So powerful are graphics that even if we say only "That's cute; there's a picture on the page," the image registers in our brains. The impact of visuals isn't lost on *Times* editors, who are the trustees of the paper's standards. The vigilance of the editors, ever alert to infelicitous notions the art might implant in readers' minds, is the source of the parenthetical phrase in this volume's title.

For every true artistic blasphemy, however, three imaginary offenses surface. And sometimes—following last-minute interpretations of *Times* standards—illustrations are stripped of their wit. With no time to redraw, a once savvy depiction can become, in print, pointless and hollow. A rich trove of censored graphic treasures appears in this book for the first time.

Only after thirteen years as Op-Ed's art director did I relinquish the role—when über editor Howell Raines had had enough of my obstinacy. (Then chief of the editorial "church" he later headed the newsroom "state.") In those thirteen years, I worked with five top Op-Ed editors and three editorial page editors at a demanding, volatile, thrilling job that's seen twenty-four art directors in thirty-eight years. *All the Art* is thus inevitably personal, as well as historical.

The never-before-told adventure of Op-Ed is rife with duels between headstrong art directors and implacable editors, with risky deadline decisions, and with battles begun by smart readers who rant. None of this is unique to the *Times*, but since this newspaper is the Olympus of American journalism, every controversy radiates ripples whose ultimate compass is vast.

Research for this project has centered on interviews with editors, writers, artists, art directors, and readers. Ten conversations were filmed, and the rest recorded on tape. I also closely tracked Op-Ed while art directing other *Times* sections, so *All the Art* chronicles the page from its conception in 1958 to its birth in 1970, and through the decades to the present day.

The *Times* Letters column and its Op-Ed page have generated thirty thousand pictures, a vast corpus that's marked the movement of the zeitgeist across the shifting terrain of history. Far more artists have contributed than can be represented in this book. And because our focus is the formative 1970s and 1980s—those rule-dissolving decades when Op-Ed came into its own—omissions are especially pronounced among the great profusion of current contributors.

I've had the good fortune to work with superb editors in vibrant Culture and Style sections. Yet the pulsing heart of my thirty-year tenure at the *New York Times* is the incomparable Op-Ed page—with the world as its subject and the world's finest graphic artists as collaborators. These artist colleagues aren't on staff, and they're often on other continents. They hail from Kansas City and Copenhagen, Buenos Aires and Bucharest, Havana and Helsinki. What they share is a hunger to communicate their visions and a longing to stir our cultural-political pot.

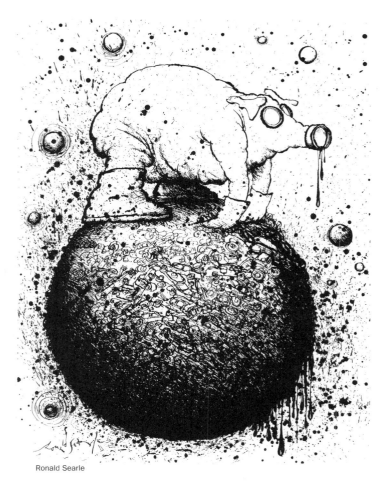

Ronald Searle

ORIGINS

Kiss-Off

Art is dangerous. It is one of the attractions.
When it ceases to be dangerous, you don't want it.

ANTHONY BURGESS

I'd scarcely embarked on the task of Op-Ed art direction when I set off an unseemly spectacle. The year was 1979, and Sunday's lead piece was to be an essay accusing Henry Kissinger of catastrophic war crimes. Written by influential foreign policy author William Pfaff, its authoritative tone called for bold art. Although new to New York and the *Times*, I was sufficiently conversant with the superb oeuvre of shrewd *New York Review of Books* caricaturist David Levine to think he'd be ideal to illustrate Pfaff's stinging prose. Eager to ensure that he'd take the job, I gave the artist carte blanche. After all, I reasoned, no illustration could skewer the controversial statesman as harshly as our text's blistering attack.

Levine jumped at the chance and delivered a satiric tour de force [figure 1]. Tattooed on the diplomat's back are hallmarks of his career. Shoulder hairs become Arabic script, bombs fall on Cambodia, and Vietnam darkens; "Richard" shares forearm billing with "Mother"; and the shah of Iran and a Chinese dragon adorn the cheeks. Glowing with pride, I showed the sublime spoof to Op-Ed editor Charlotte Curtis. She turned up her nose.

"That's awful!" she sneered. "It's kinder to Kissinger than the Pfaff text," I ventured. Curtis fixed me in an arctic stare, her normally fluttering eyelids immobile. Then she squeezed her lids tight as I struggled to salvage the drawing: "I'll try to negotiate a middragon crop." "That's not it," she snapped before pronouncing, bafflingly: "It's the excessive midsection flesh." "But publishing this drawing will be a real coup," I argued. "It's a cheap shot," she decreed with withering finality. Curtis then spun around in her chair. Her turned back closed the matter. Still clutching the condemned picture, I felt like it and I were insects caught in flight, only to be pinned to a wall of slain specimens.

Levine's satire was so clever that even the man portrayed might have been amused. "The only thing worse than being in it," Kissinger once said of Garry Trudeau's syndicated comic

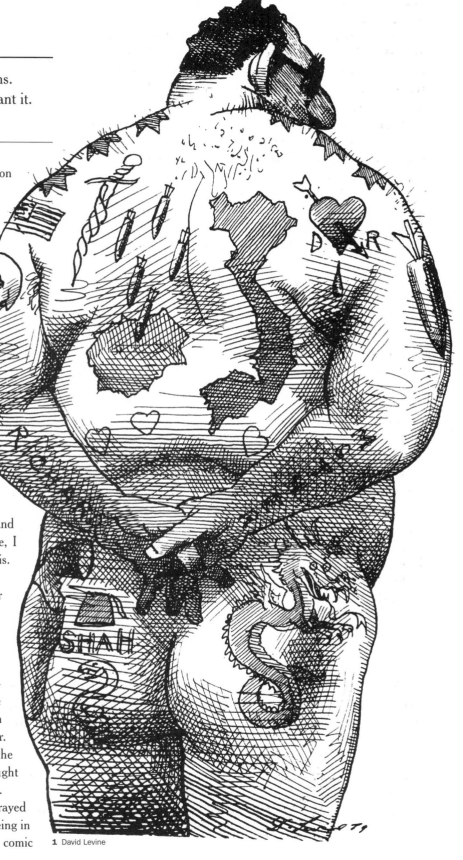

1 David Levine

strip, *Doonesbury*, "would be not to be in it."[1] And this was just after Trudeau had called Kissinger a war criminal.

Having failed to meet *Times* standards, all I could do was apologize profusely to the artist. "Send it back" came his icy reply. I returned Levine's original and told the bookkeeper to send him a check for full publication rather than the half-price "kill" fee. That wasn't the end of the story, however.

The cover of the *Village Voice* soon featured a detail of the drawing above the headline "Too Cheeky for the 'Times.'"[2] The article, according to its author ID, was written by "Matthew Levine, who works at *Time* [and] is David Levine's son." Matthew's account, alongside an enlarged reproduction of the full image of Kissinger, quoted his father: "I told her to tell her editors never, ever, ever, ever to contact me again." (That the elder Levine recanted this dire threat is clear; you'll soon see his later caricature of Saddam Hussein, which was published to even greater controversy.)

"The 'Times' knew what they were getting into," the article continued, "when they hired Levine," since two of his "caricatures, of [Richard] Nixon and [former New York mayor] Koch, were rejected due to the strength of statement in each."[3] This assertion paints the paper as a monolithic body whose actions arise from a single, omniscient brain. Yet I knew nothing about the earlier rejections, which had occurred before I arrived at the *Times*. That said, as a representative of the paper, albeit a recent hire, I was responsible for the Kissinger debacle.

The chief editors of *Times* sections, however, cannot make mistakes. As guardians of the *Times* brand, they're expected to uphold the paper's ideals. Editors are justified in scrutinizing the art for anything that could offend, since it's they who'll get called on the carpet. Seasoned artists are savvy about such matters. The veteran Levine, having experienced two rebuffs, was on intimate terms with *Times* policies. He later wrote to me, "I expected exactly what transpired by the *New York Times*."[4] Artists, we should note, are tremendously invested in their works and hate to see a strong example languish; drawings rejected by one client thus may be offered later to another.

This incident pointed up the disparate standards for word and image. No matter how savage or defamatory the text, the art—with its greater power to provoke right-brain reactions—must hold back. The episode also sounded an alert regarding the downside of working in the belly of the media beast. Prominent figures cannot be satirized in the *Times* any more than grenades can be joked about at an airport baggage check.

Levine's spurned masterpiece highlighted my ignorance about the caution that must be exercised when representing America's newspaper of record—especially when treating a figure like Kissinger, with his inevitable connections to *Times* brass. I vowed to learn the ropes. In the process, I discovered the intriguing tale of how the Op-Ed page and its groundbreaking art came about.

Upheaval

It's well known that the artist is a magician. Then why is he set free to express himself with impunity in the *New York Times*?

ROLAND TOPOR

Why, indeed, did the staid, canonical *Times* suddenly offer both writers and artists unprecedented freedom? This gift of sovereignty was tendered on September 21, 1970, when the paper unveiled an exhilarating vista. The obituaries vanished from the penultimate page of section A. In their place, a novel organism appeared, sprouting plums by three nonstaffers: a foreign affairs adviser to President Johnson, a contributing editor to the *New Republic*, and a Chinese novelist. The seed for this novel crop had been sown twelve years earlier. Alternately nurtured and neglected by the *Times*, uprooted, and cut back, it was finally planted in the terra firma of hot type.

This autumn day was the inauguration of "Op-Ed," the world's first newspaper page written—except for two staff columns—by readers. By creating Op-Ed, the *Times* anticipated the structural media change expressed in the explosive blogosphere of today's Internet: the shift of content from top-down to consumer-supplied. What's more, the new concept embraced a newspaper secret: many people turn first to letters to the editor. Now everyone was welcome to climb on a much larger soapbox to offer perspectives on the day's hottest topics, perspectives that would often be, as an opening-day editorial expected, "completely divergent" from those of the *Times*.[5]

Not only did Op-Ed's nonstaff bylines shatter tradition, but its pictures were revolutionary. Unlike anything ever seen in a newspaper, their backstory is compelling. Before exploring their origins, here's a sample of the pictures that would earn the epithet "Op-Ed art."

In 1972, Murray Tinkelman's ironic fantasy mocked the decision by the United States to bomb Indochina, thereby creating the world's mightiest air war to date [figure 2]. And in 1975, James Grashow's woodcut depicted the penitentiary system as analyzed by French philosopher Michel Foucault [figure 3]. Prisons succeed, claimed Foucault, at exactly what we expect of them: they recruit and train a lawbreaking group that the ruling class controls.

These pictures reveal that illustrations can do more than break up gray text or decorate it narratively. They can be vessels of meaning that enhance right-brain experience by altering mood, jump-starting imagination, or swaying interpretation. This is what Op-Ed art did, and it was startling.

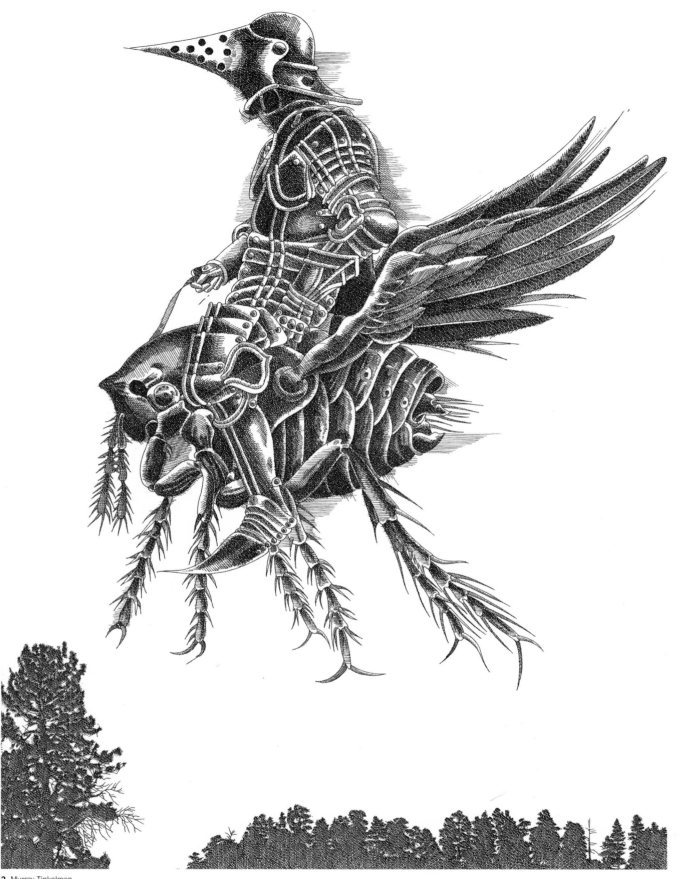

2 Murray Tinkelman

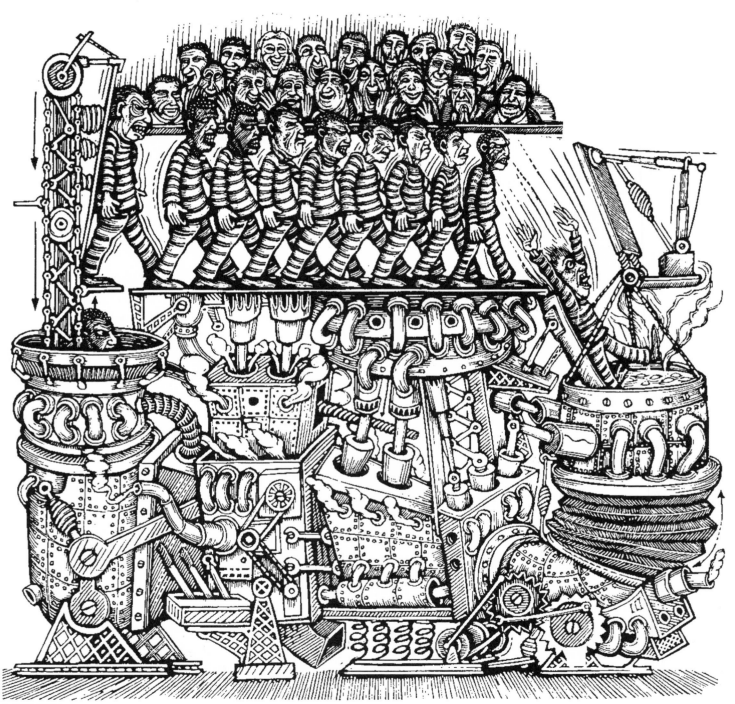

3 James Grashow

Unfit to Print

A corollary to the power of visual imagery is the editor's perceived need to curb that power, to predict and avoid the reverberations of any open-ended implications. Scores of commissioned pictures, having thus failed to meet *Times* standards, have suffered death on arrival. Many of these aborted images are published here for the first time, including this foretaste.

In 1983, a manuscript on the neglect of black Korean War veterans recounted the courage of one heroic African American corporal who stood alone on a hill after his entire company had fallen. Ammunition exhausted, he bravely flung rocks at the enemy, who, in awe, captured rather than killed him. Yet his own country's army denied him the Congressional Medal of Honor. Horacio Cardo, who created the perfect embodiment of the army's flagrant racism [figure 4], remembers how the editor assessed his drawing before killing it: "We can't picture the army as racist!"

In 1996, Cathy Hull illustrated a letter to the editor on historical meteorology [figure 5]. The letter writer pointed out that the mildest winter in sixteen years had preceded the fierce blizzard of 1888. Hull cleverly drew a thermometer that, despite reading 70 degrees Fahrenheit, was covered with ice and surrounded by falling snow. Her little scene was realistic, with the thermometer and its calibrations faithfully reproduced, and the Letters editor easily approved it. Why, then—in the last seconds before the page closed—was this innocuous, two-inch-square drawing summarily killed? The verdict from editorial page editor Howell Raines was "It's an ejaculation."

This little picture proved evocative for Raines, propelling him to create imagery of his own and triggering his fear that readers would construct the same image. Ironically, the picture treated the safest possible topic—the weather. Its presence—a type blurb replaced it—would have added to the letter's message the subtle emotional sensations that we get from climate changes.

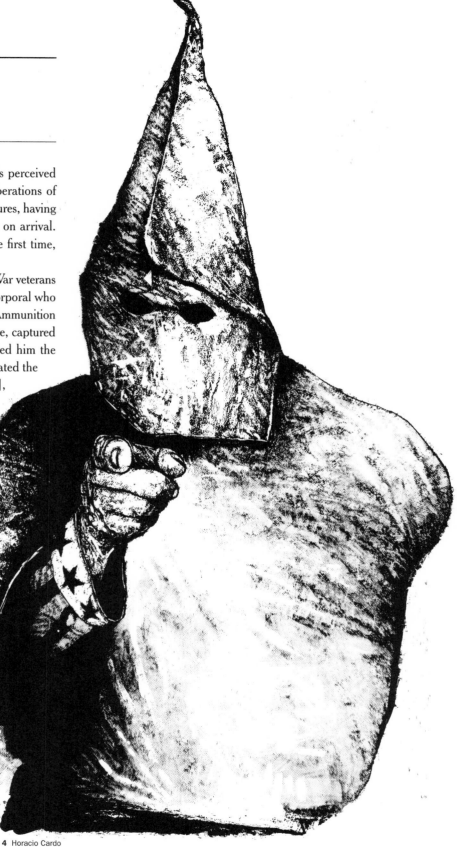

4 Horacio Cardo

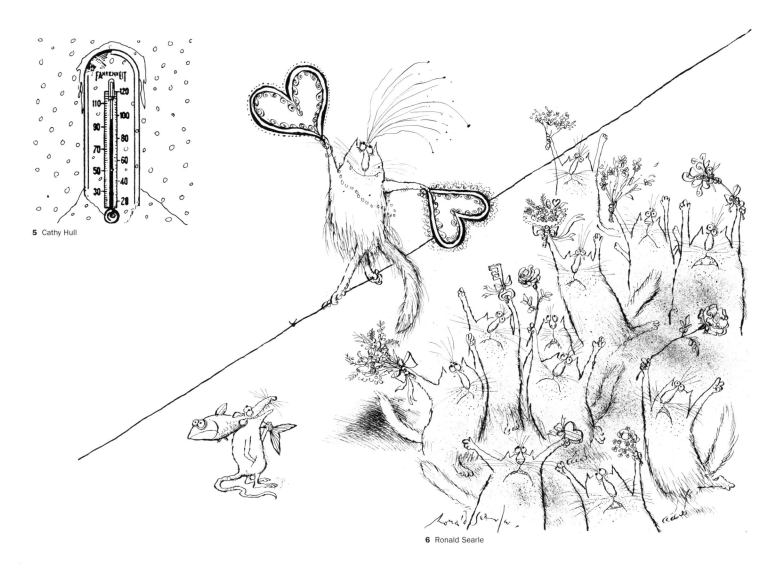

5 Cathy Hull

6 Ronald Searle

7 Nancy Stahl

Another category consists of pictures that faced serious editorial challenges yet managed to squeak into print by a whisker. Ronald Searle's ingenious drawing in which a finicky feline passes up suitors of her own sort bearing proper bouquets in favor of a raggedy, fish-proffering rat was pronounced politically incorrect [figure 6]. "It implies," said an editor, "that ladies love outlaws." Only after extended deliberation was Searle's confection cleared to run on Valentine's Day 1989.

In 1996, Nancy Stahl's digital wit interpreted a text that proposed that all Internet content be free [figure 7]. Every intellectual property claim, went the argument, is a chunk taken out of the public domain. The image of a copyrighted idea glowing on a locked computer window seemed perfect, and the Op-Ed editor endorsed it. It was thus astonishing to hear the editorial page editor say, "We can't publish a bare breast and a nipple!" This picture would, eventually, narrowly prevail, but the editor's interpretation provided grounds for celebration. When images are disputed, the improper "parts," as editors term them, are generally male. Now a whole new area of controversy was opening up!

Combustion

Gentlemen! You can't fight in here!
This is the war room!

STANLEY KUBRICK

To find out how the Op-Ed phenomenon was born, we have to peek behind the closed door of editorial writer John Oakes's office on the *Times*'s ecclesiastical tenth floor. There, on a Monday morning in 1958, Oakes leaned back in his plush leather chair to read the "urgent" manuscript he'd received in that morning's mail, a text so compelling that the black coffee in his cafeteria paper cup grew cold. The essay's discussion of the Suez Canal was incisive. Oakes ached to publish it, yet returned it with this note: "I regret that your excellent piece is too long for a Letter to the editor and too short for a magazine article." That Friday, Oakes opened the *New York Herald Tribune*, which ran occasional outside contributions, and saw the very Suez text he'd been offered on Monday. He concluded that the *Times* should dedicate a full page to nonstaff essays!

Nearly two years elapse between the conception and the birth of an African elephant. The gestation of the Op-Ed page exceeded the emergence of six such beasts. Its story, related in his Manhattan home by the late John Oakes, was also taped for Columbia University's Oral History Project. Oakes, a nephew of *New York Times* founder Adolph Ochs, was the family's black sheep. His personality was too obstinate and his politics too leftist for his centrist clan. Moreover, unlike the rest of his tribe, who managed *Times* business or served on its board, Oakes—a Rhodes Scholar—wrote editorials. Besides, Oakes's father—angry with Germans after World War I—had alienated the family by anglicizing his surname. (Adolph Ochs's father had earlier shortened the family name from Ochsenhorn.)

When Oakes became editor of the editorial page, he wrote fierce editorials against the Vietnam War long before such pieces appeared in other publications. Yet, as a decorated counterintelligence officer in World War II, he was "strongly patriotic," recalled Op-Ed's first editor, Harrison Salisbury, and "did not come easily to his antiwar position."[6] Oakes also advocated—in the 1950s and 1960s—the rights of minorities, women, and gays, as well as gun control, arts financing, and choice about abortion. He was at his most prescient, however, on the environment.

"John Oakes invented the American environment," says former editorial writer Herb Mitgang. "For many years, when such a beat didn't yet exist, he wrote a monthly column on it. *Times* editors doubted readers would be interested, so he offered to write it for free." The *Times* itself has reported that before Oakes took over the editorial page, *Times* editorials sounded "more like the advice of the family doctor than the boom of civic conscience."[7]

Now retired and sitting in his own living room, Oakes wore a starched shirt, serious suit, and solemn demeanor. "By 1960," he explained, "I was convinced the *Times* needed an independent forum for the rational exchange of views. But each time I contemplated the idea, the sticking point was the same. The editorial columns could yield no space, and we were already unable to give Letters the real estate its swollen mailbags deserved."

Arthur Hays Sulzberger—Adolph Ochs's son-in-law and the paper's second publisher—had retired in favor of his own son-in-law, Orvil Dryfoos. Yet A. H. S. still exerted tremendous influence over the *Times*, and he'd personally anchored the obits next to the editorials.

In 1961, Dryfoos appointed Oakes as editor of the editorial page. Oakes began to publish occasional nonstaff opinion pieces atop the Letters columns. "I especially wanted writers who disagreed with our editorials," said Oakes. "I felt that was a function of a free press. I ran a piece by Ambassador Henry Cabot Lodge and another by someone I hated—Nixon's vice president, the dreadful Spiro Agnew. We also got pieces from Arthur Miller, E. B. White, Arthur Schlesinger, and Philip Roth. It was a way of getting the germ of my idea into the paper."

Oakes and Dryfoos walked to work together from Manhattan's Upper East Side. One morning, Oakes spelled out his Op-Ed proposal to the new publisher. "It's a good idea," Dryfoos observed, "but the logical spot for opinion is next to edit, and A. H. S. will never move the obits from that facing page." (So the space now allotted for freewheeling opinion and art was originally reserved for the solemnities of death. The worldview of an old order would be replaced by something growing, vivid, and iconoclastic.)

When Dryfoos died in 1963, A. H. S.'s sole son, Arthur "Punch" Sulzberger, was appointed publisher. Sulzberger had the vision to see that the problems with Oakes's idea were surmountable. "I always referred to my idea as an 'Op-Ed' page," said Oakes, "because that was the handle for the famous sheet facing Joseph Pulitzer's *New York World* editorials of the 1920s and '30s. It was nothing like my notion, but I wanted our page positioned similarly. Many people don't realize the page's name simply abbreviates its geographical position Opposite the Editorials and that the term 'Op-Ed' was not a *Times* invention." Once the sheet began, Irving Sarnoff, the grumbling gremlin of a printer who assembled the page in the composing room, gave it his own name—"page Op."

In 1966, the publisher wrote to Oakes: "I would appreciate your chairing a group studying the pros and cons of an Op-Ed page." Sulzberger chose as the group's members managing editor Clifton Daniel, Sunday editor Dan Schwartz, and the *Times*'s eminence grise, James "Scotty" Reston. Daniel was out of town for the first meeting; his deputy, Harrison Salisbury, attended instead. Reston and Schwartz favored Op-Ed, and Salisbury grasped Oakes's vision immediately.

"Salisbury's support was daring," Oakes remarked, "since he represented Daniel, the debonair son-in-law of Harry Truman, who was vehemently against the idea." Daniel passionately opposed both moving the obits and allowing outsiders into the *Times*. He also ignited a bitter turf battle by resisting the editorial department's control of Op-Ed. "In the third meeting," said Oakes, "we decided the page should have two staff columns and commissioned, nonstaff essays. I didn't think unsolicited texts could fill the space and had no idea they'd come in such volume."

The meetings in 1966 were inconclusive. Then nothing happened until 1969, when, continued Oakes, "I received this note from Punch: 'I will go to work on an Op-Ed page.'" Now things got hot. "I didn't want ads on the page," said Oakes. "But Punch said, 'No ads, no Op-Ed.'" It was also in 1969 that Sulzberger replaced managing editor Daniel with A. M. "Abe" Rosenthal, who guarded newsroom territory even more aggressively than had his predecessor.

To recall ensuing events, let's shift our perspective from that of a player—Oakes—to that of Susan Tifft and Alex Jones, chroniclers of the *Times*: "After endless internal wrangling, the Op-Ed battle turned into an ugly, head-bashing exercise between John Oakes and Abe Rosenthal... about who would control the space—a commodity *Times* editors battled over like feudal lords. Neither man would budge. In the end... [Sulzberger's] ruling—that the editorial department would run... Op-Ed... was a victory for John."[8] Now, twelve years after Oakes conceived it, the *Times* was finally ready to deliver the world's first Op-Ed page.

With expanded space, the number and importance of staff columnists increased. In 1972, Sulzberger surprised his staff and readers by hiring the conservative speechwriter William Safire, who'd written for Nixon's vice president Agnew an oft-quoted dismissal of the press as "nattering nabobs of negativism." Oakes passionately protested the hire, yet Safire was a resounding success in his thirty-two-year run on Op-Ed.

Op-Ed columnists have nearly total independence. "The cool thing about it," says columnist Nicholas Kristof, "is that there's no adult supervision. And a column can put things on the agenda." Kristof knows whence he speaks; he won a Pulitzer Prize in 2006 for single-handedly having brought Darfur's plight to world attention.

In 2008, *Times* publisher Arthur Sulzberger Jr. appointed neo-conservative strategist William Kristol an Op-Ed columnist. The page already had the conservative David Brooks. "But," one journalist complained, "Brooks is a pussycat compared to Kristol. It's a sell-out for the *Times* to hire the guy who appears on Murdoch's Fox and runs Murdoch's mouthpiece, the *Weekly Standard*. Now Murdoch can't accuse the *Times* of being too liberal, since it's taken on one of his own captains."

"Today people ask," says Herb Mitgang, "'Did you read Maureen Dowd this morning?' 'Did you read Frank Rich?' They used to ask," recalls Mitgang, "'What does the *Times* editorial say?'"

Oakes's deputy was Abe Raskin, America's leading labor writer. The board also included the country's foremost education expert, Fred Hechinger. Ada Louise Huxtable covered architecture and received the nation's first Pulitzer for criticism. Leonard Silk was the economics expert, and Ernest Hemingway's friend Herbert Matthews had reported on the Loyalists during the Spanish Civil War. Matthews himself became news when Fidel Castro invited the journalist to interview him in his hideout before he ousted Fulgencio Batista from Cuba. Che Guevara later declared that an American journalist's interview with Castro was "worth more than a military victory."[9] Although Matthews was attacked for having failed to reveal Castro's political sympathies, Oakes put him on the editorial board.

THE SEVENTIES

Ur-Editor Meets
Ur-Art Director

The artists are leading the editors
forward, showing them how images can stimulate
readers and establish a mood so that the
writers' ideas can penetrate more deeply.

HARRISON SALISBURY

In an inspired move, Punch Sulzberger appointed Harrison Salisbury Op-Ed editor. The dapper, enterprising Salisbury was a handsome figure of patrician bearing, with a shock of white hair. He'd been the first to report that American warplanes were bombing Vietnamese civilian targets. A long-tenured *Times*man and a Pulitzer Prize winner, Salisbury had been bureau chief in Moscow, top national correspondent, national editor, and deputy to the managing editor. Now his talent and vision secured him the Op-Ed plum. Another factor was at play, too: Rosenthal had inherited Salisbury as his deputy, yet the two men didn't get along. "The fact that one was a Jew," says Herb Mitgang, "and the other a WASP didn't help." Moving Salisbury from state to church solved a personnel problem.

Op-Ed kicked off at an auspicious moment. The Vietnam War raged, American and South Vietnamese forces had just invaded eastern Cambodia, members of the Ohio National Guard had fatally shot four antiwar demonstrators at Kent State University, and the imminent release of the Pentagon Papers would soon reveal the Defense Department's devastating lies. The black power movement was transforming the civil rights struggle; the baby boom had doubled the number of eighteen- to twenty-four-year-olds; and new social forces had led to environmentalism, feminism, and a sizable counterculture. Psychedelics had been classified as drugs of abuse with no medical value, and Jimi Hendrix had just given his final concert.

The turbulence of the era whetted America's appetite for debate and accelerated the widespread hunger for a sounding board. Unsolicited offerings deluged Op-Ed editors—passion from politicians and outrage from prisoners, fury from mothers against drugs and indignation from students hoping to legalize them. No topic was off-limits; submissions were welcomed from monks and atheists, from guerrillas and generals, and from what Montaigne called "the common herd."

A full page of text—its grayness broken only about half the time by a quarter-page ad—needed relief. How would the new forum be spruced up? This question the editors left unanswered. They did specify, however, what they didn't want. They didn't want the only non-

photographic visuals that newspapers then used: comics and cartoons.

Following the founding of England's *Punch* in 1841, readers in Great Britain and the United States demanded cartoons. The *New York Daily Times* initiated political cartoons in 1861, and Adolph Ochs—the debt-ridden son of German Jewish immigrants—borrowed money to buy the once-powerful paper in 1896. The bankrupt *Times* had nine thousand readers and sold for three cents. Ochs shortened its name, lowered the price to one cent, and soon dropped the hyphen, but he continued some of the comics.

The *Roosevelt Bears* strip ran from January to July 1906 but was stopped because its partisan stance undermined the *Times's* desired neutrality. Editorial prose could be opinionated, but pictures with an explicit, captioned point of view? Heretical. So in 1970, cartoons and comics were out of the question.

"It was important for us to develop an arresting visual world of our own," says Op-Ed's first art director, Lou Silverstein. Searching for ideas, "I grabbed two editors," he recalls, "and we spent a couple hours looking at illustrations in the public library." Then Silverstein sent seven top designers a list of the day's main issues, requesting that they make drawings. "These guys didn't need the extra money," Silverstein comments, "yet they could express themselves publicly on their burning issues. I spent a lot of time working with them, but it was a dead end. I got enough banal responses to realize designers weren't the key. You have to have a direction, a focus. Not everybody has something important to say."

The Op-Ed page began publishing before establishing a fresh visual identity. The first page carried a photo of China and borrowed theater caricaturist Al Hirschfeld to draw a spoof of Spiro Agnew. Before long, though, Op-Ed showcased a potent drawing by Ralph Steadman that Silverstein had seen in the artist's London apartment. Steadman would be good, Silverstein thought, because "he's an angry artist who focuses his anger." In 1973, an example of Steadman's focused anger accompanied one of Op-Ed's countless articles on Watergate [figure 1].

Silverstein also found Manhattan's highbrow collage artist Anita Siegel, whose work exhibited exacting skill in the use of cutting tools, tonal transitions, and retouching. Like the Dadaist collagists after World War I, Siegel was militant. She didn't know, however, when illustrating Senator Edward Kennedy's plea to stop the bombing of Vietnam in 1971 [figure 2], that Saigon's most popular seasonal toy was Santa Claus aiming a gun.

On Christmas Eve 1971, when Americans were demanding peace, the horror of continuing war also elicited an image from *New Yorker* humorist Ed Koren [figure 3]. He would fulfill occasional Op-Ed commissions for two decades, while Siegel was an Op-Ed mainstay throughout the 1970s and 1980s, and Steadman's frenzy persisted into Op-Ed's 1990s.

After Silverstein got things going, he put staff art director Bob Melson in charge. During Op-Ed's first year, however, strong illustra-

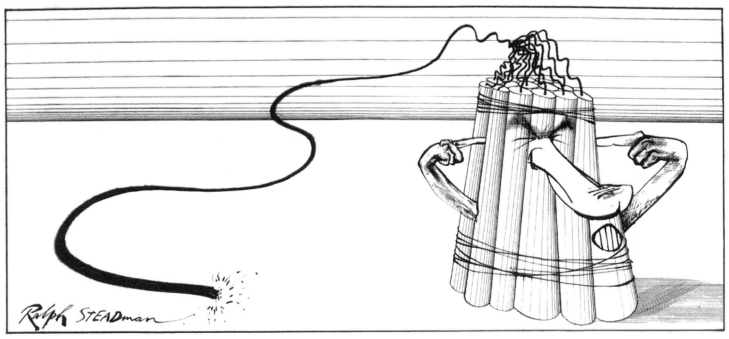

1 Ralph Steadman

tions only occasionally showed up among lackluster spots and shots from the "morgue," the *Times's* photograph archive. Melson held the helm until Memorial Day 1971.

Enter alpha male Jean-Claude Suarès, a wheeler-dealer who answers to "J. C." "Wearing a suit and hair down to my shoulders," he says, "I went for an interview at the *Times*. They were looking for somebody to find art for Op-Ed." The paper eventually hired him as a freelance art editor. "But when I showed them images," Suarès recalls, "they'd say, 'That's great, but it's too crazy. We can't run it.'" Op-Ed didn't print a thing he showed them for seven months.

"I realized it was a joke," says Suarès. Then, one day in 1971, an article compared living in New York to living on the moon. It made Suarès think of "a perfect Topor drawing of a guy hanging from the moon" [figure 4]. "I had it made into a cut [lead engraving] and sent to the composing room. Then the mucky-mucks came down and said exactly what drove me nuts: 'I'm worried.' Whenever they said that, I saw red."

The editors replaced Topor's drawing with a photo of New York. Suarès thought that he was finished at the *Times* and had nothing to lose. "So I left," he recounts, "and took the Topor cut with me. I returned to the composing room just before closing. The mucky-mucks were gone. I told a printer, 'They changed their minds.' 'You sure?' 'Yes.' So the printer put the photo on the floor and Topor's drawing in the page." Suarès smashed the lead engraving of the photo with his boot heel to ensure that it couldn't be used and then got a proof of the finished page.

"I knew my *Times* career was over," says Suarès. "I returned to my office and cleaned out my desk. I planned to see a movie the next day, but I got an early call to come in." He went to see Silverstein, who told him, "I can't believe how stupid you are! What made you think we'd ever run a drawing like this?"

"I thought that was what I was hired for," replied Suarès. Then Silverstein's phone rang. Editor Harrison Salisbury wanted to see Suarès. "So," Suarès relates, "I go up to Harrison, who's talking to the publisher. The publisher's telling him it's a great page. I don't speak. I never spoke to Silverstein again. I took over. And the page became what it was supposed to be—a place for the most committed political artists to show their work and feel in good company."

Suarès thrived with the unflagging support of Salisbury, who stated, "Art Director Jean-Claude Suarès, more than any other individual, gave life to the Op-Ed symbiosis."[1] Born in Alexandria, Egypt, to a German mother and an Italian father who communicated in French, Suarès's ease in six languages facilitated his work with international artists. Sturdily built, Suarès has a star quality that stems from supreme confidence, shrewd intelligence, artistic talent, and an ingenious instinct for directing others. He dazzled Silverstein. "J. C.'s contribution was enormous," says Silverstein. "I knew those European artists were there and wanted them, but he got them. His talent and persona enchanted me. I sensed he'd be the perfect guy to art direct our new page."

John Oakes recalled, "J. C. wanted striking art. The graphics related to the articles impressionistically rather than literally, and they were crucial to Op-Ed's sensational success." In an explosive year and a half, Suarès forged a visual face for Op-Ed that stimulated, delighted, and disturbed readers—and changed editorial art forever.

Editor Salisbury's open mind enabled the art's daring course. As his deputy, he chose David Schneiderman, a precocious news clerk who'd gone straight from Johns Hopkins to the *Times*. Both these men understood that art could bring to the Op-Ed matrix something altogether different from what the articles brought. Even when they didn't "get" an illustration, they'd often publish it unchallenged, giving the artist the benefit of the doubt.

For the page to come into its own, to create a style, it would have to break a lot of rules. "I didn't want the illustrators to illustrate," says Suarès. "I didn't want clean, inoffensive drawings. I wanted personal expression, experimentation with symbols, and no words. So I spent a lot of time developing ideas with artists," Suarès notes. "Some came with ideas, but their styles needed encouragement. Others came with great styles but no ideas. Some didn't need any help at all, like Steadman. I stayed away from most people. But if I could develop one or two artists a year, I thought, that would be great.

"One of the most frequent artists," Suarès continues, "was Eugene Mihaesco, who later did a hundred *New Yorker* covers. When he arrived in New York, he had a lot of cross-hatching but no real style. And he used words. It worked for him in Romania and Switzerland but not at Op-Ed. Yet I saw his potential, and we shared passions: Max Ernst, De Chirico, Duchamp. I added a horizon line to his work. Nearly every drawing he did from then on had a horizon line."

In the early days, Op-Ed art's pay scale also had a horizon line: one-column Letters art was $50; two- to three-column Op-Ed, $150; and four to six columns, $250. "Mihaesco needed money," Suarès remarks, "so every fucking drawing he did stretched across five columns." These unwieldy rates soon gave way to standardized fees until the mid-1980s, when the art director gained some latitude to determine payments. But the Letters fee remained stagnant. After months of crusading in 1983, Letters artists were granted a 20 percent raise—to $60. Another three-year campaign got them $75.

In 1994, when editorial page editor Howell Raines was in charge, I again sought relief for underpaid Letters artists. Raines said, "Get somebody who'll do it for $75!" He later insisted that I write a list of economic and journalistic justifications for the raise. I dutifully complied, but it was years before the fee grew to $100. Letters artists now receive $175.

In 2005, Op-Ed editor David Shipley addressed potential writers of Op-Ed essays on matters procedural: "At the end of the day, you'll receive $450."[2] That's a big leap from the $150 "honorarium" for writers that held steady seemingly forever and helped mollify artists dissatisfied with their own low rates. Now there's wiggle room in the Op-Ed art budget; rates range from $300 to $450.

"I encouraged Mihaesco to try something new with every drawing," says Suarès, "not to sit on his laurels. And I expected the same of myself." Suarès's own Op-Ed illustrations of the 1970s are unquestionably the most varied of his career. In 1973 one of his drawings surreally juxtaposed incongruous objects as though in a dream

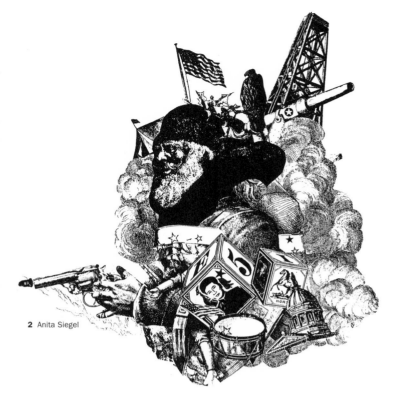

2 Anita Siegel

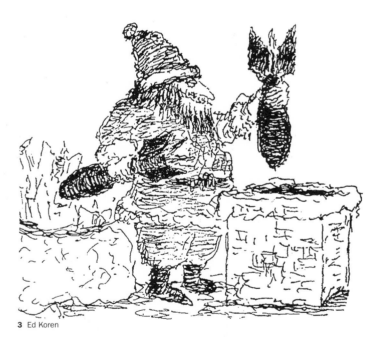

3 Ed Koren

[figure 5]. Another of his images from that year interpreted an article that claimed certain songs meant to bring happiness are actually offensive. "I sent Mihaesco to buy cheap music paper," notes Suarès, "and we started putting nails through it. When Mihaesco got tired and said that's enough nails, we shot it. That's Dada" [figure 6]. This striking image bears a remarkable resemblance to Man Ray's *Cadeau* (*Gift*), a clothes iron studded with spikes.

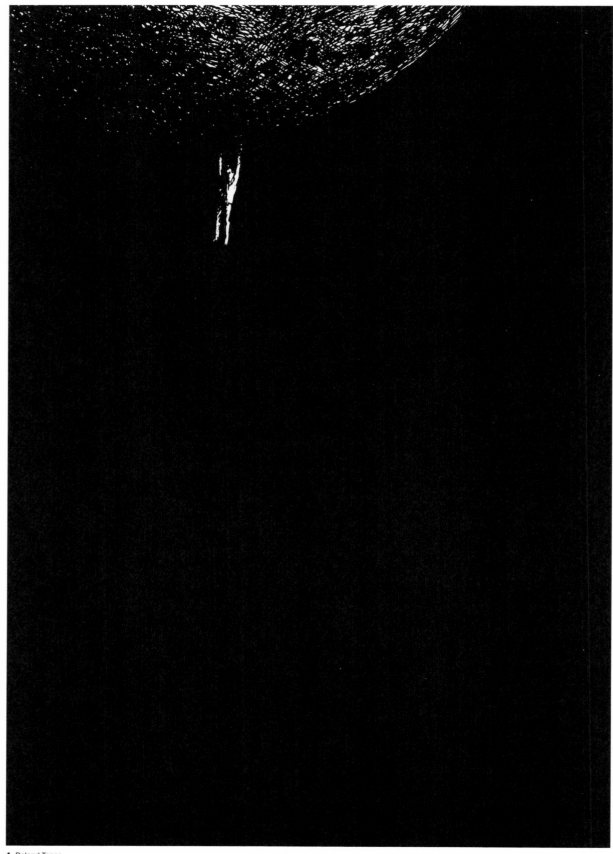

4 Roland Topor

5 Jean-Claude Suarès

6 Jean-Claude Suarès

Is not the typewriter mightier than the gun? This was the premise that elicited a witty image by Suarès in 1973 [figure 7]. "I cut the background out of an old engraving, stuck it in my manual typewriter, and typed on it," he explains. "This drawing's been reprinted more than anything I've done." That's unsurprising, since editors love words, even gibberish. "Gibberish is Dada," says Suarès. "That's what I learned from Duchamp."

In 1974, Suarès illustrated Russell Baker's parody of the fat cat has-been politician who is pretending to be poor [figure 8]. "Whenever there was a cat drawing," Suarès continues, "someone wanted to buy the original. In 1976, I did a book with Seymour Chwast called *The Illustrated Cat*. Then every couple years someone asks me to do a cat book. I've done twenty so far—and ten on dogs. Cats sell better than dogs because people think in terms of dog breeds. They want their Labrador book. But cats are cats. Except for my friend Martha Stewart. The only cats she likes are fancy."

"I was once at the Society of Illustrators bar speaking with a member," Suarès remembers. "I asked him, 'What do you do?' 'I draw airplanes,' he said. His stuff was very clean, very professional. He then asked what I do. 'I work for *Times* Op-Ed,' I said. 'It's about issues. You know, ideas.' He asked, 'Have you got anything I can see?' When I showed him the Op-Ed page, he said, 'Oh, line art.'"

A good idea, along with a touch of the ineffable, distinguishes the finest Op-Ed art. Superior craft always appeals, but, without a core concept, it's meaningless. "Only that form is correct," wrote the painter Kandinsky, that "materializes its corresponding content. All other considerations . . . are inessential and damaging, in that they detract from the sole purpose of form—the embodiment of its content."[3]

8 Jean-Claude Suarès

7 Jean-Claude Suarès

Local Lights

New York, the nation's thyroid gland.

CHRISTOPHER MORLEY

Creating an Op-Ed aesthetic required a tone, a mood, and a style commensurate with the strong personality desired by the architects; like a person, the page was to have quirks, passions, and an irascible yet sympathetic soul, all of which were lurking in nearby neighborhoods.

Many of the artists in New York were not native New Yorkers. Strasbourg-born satirist Tomi Ungerer had survived the German occupation of Alsace, when the Nazis requisitioned his family's home. In 1956, he moved to New York, where he created antiwar posters, children's books, and volumes on erotica, especially sado-masochism. Ungerer illustrated numerous Op-Ed pieces before settling in County Cork, Ireland. In 1973, he portrayed the story of Tony, who had returned from Vietnam to become "your friendly neighborhood blue-collar pusher" [figure 9].[4] "We gave the illustrators lists of topics," says Suarès. "Tomi did a drawing for each topic on the list without benefit of a single text."

An early expert draftsman was the Honolulu-born, Japanese American Mel Furukawa. "Furukawa had a wonderful style,"says

10 Mel Furukawa

9 Tomi Ungerer

Suarès, "but few concepts. So I tried to steer him to develop a latent area of his brain." That Furukawa succeeded in stretching his mind is demonstrated in a drawing from 1974, which underscored the notion that the success of those who rise at 5:00 A.M. and strive compulsively all day isn't worth the sacrifice in quality of life [figure 10].

In 1973, Edward Gorey interpreted the contention that humankind violates the natural law that dictates the self-regulation of animal numbers with a drawing dipped as much in Surrealism as in his signature Victoriana [figure 11]. Reclusive and probably asexual, Gorey was a self-taught artist who'd studied French literature at Harvard. He wrote and/or illustrated hundreds of books—some under pseudonymous anagrams of his first and last names, such as Ogdred Weary. He also published movie reviews under the pen name Wardore Edgy (another anagram), wrote novels and poetry, and was passionate about cats, soap operas, television commercials, and ballet. "I couldn't crack Gorey as a person," Suarès admits. "He never acknowledged my presence. But he did terrific drawings."

11 Edward Gorey

12 Douglas Florian

New York painter Douglas Florian began illustrating Op-Ed articles at age twenty-one. In 1974, he created an image whose origin he describes: "The article said the world was coming to the end of a five-hundred-year era. As the author spoke in abstractions like 'harsh edges of expanding nationalism' and 'minimum underlay of feudal inheritance,' my ideas grew complex and contrived. Finally I retreated to the sanctuary of my stamp collection and encountered a Spanish stamp depicting a Renaissance sailing ship. The solution became clear—a literal turning of the world. Here was the simplicity I'd been seeking" [figure 12]. As a horizontal, it also yielded Florian the maximum fee. "I was prone to prone," the artist recalls. "I always did Lincoln lying down." In 1974, another of his images accompanied a text by novelist Lawrence Durrell, who wrote about "the hedgehog of a problem" that is Cyprus [figure 13].

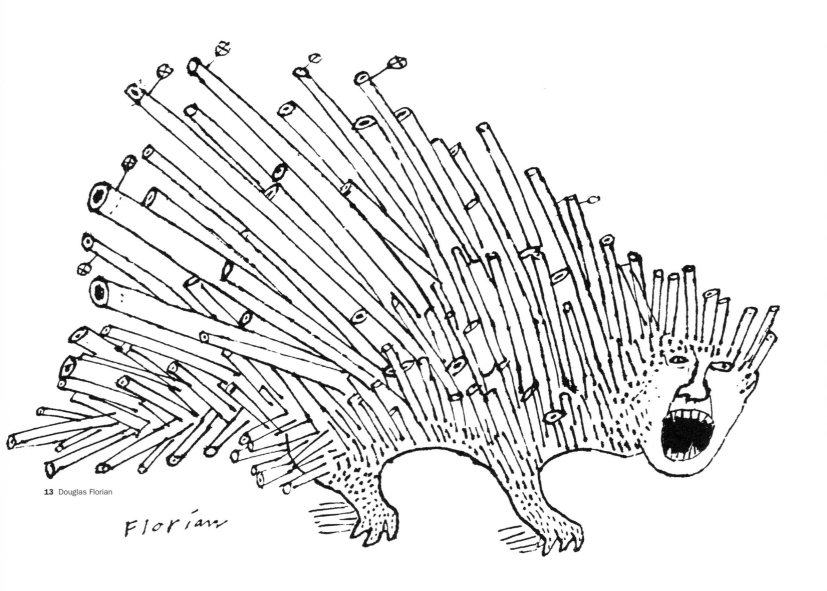

13 Douglas Florian

Wunderkind

I never liked illustrations. They were ghosts
of ideas, transparent, vaporous. I wanted my drawings
to engage. When I tackled the Watergate hearings
or the formation of OPEC, I internalized the public
issues. Then I rooted through the junkyard of pre-
consciousness. The pictures that came out were inkblots.
See in them what you want.

BRAD HOLLAND

14 Brad Holland

The Op-Ed page attracted artists whose personalities and concep-
tual styles were distinct yet complementary. They thus paralleled the
Op-Ed columnists, each of whom had a specific turf. These twin
cadres dominated the page, exuding a group personality like an or-
chestra in which instruments vary in range and texture but play to-
gether seamlessly. Op-Ed's visual–verbal ensemble became a spunky
counterpoint to its facing page's consensus view.

While working in the gritty underground press, Suarès encoun-
tered an artist who became Op-Ed's signature voice: the aw-shucks
handsome, Ohio-bred Brad Holland. An autodidact of considerable
creative and intellectual gifts, Holland left home at seventeen for the
big city—Chicago. Deemed too young to draw on skin, he swept up
in a tattoo parlor before securing a drawing gig at Hallmark Cards
in Kansas City. When he'd saved $1,000, he left for New York and
went straight to renowned designer Herb Lubalin. "How long have
you been in this city?" Lubalin inquired. "What time is it?" Holland
asked. He'd been there five hours. Lubalin hired him on the spot to
draw a double spread for the magazine he designed, *Avant Garde.*

Holland was soon contributing to the *New York Review of Sex
and Politics, East Village Other, Screw, New York Ace, Rat, Mobster
Times, Berkeley Barb,* and *L.A. Free Press.* "My first connection
with J. C.," says Holland, "was illustrating the *Free Press,* which he
art directed." It wasn't long before Suarès called him to ask: "How
would you like to do the same thing for the *Times* that you're doing
for the hippie papers?"

When Holland brought his drawings to Op-Ed, J. C. asked him
how he viewed them as illustrations. "I saw them married to pre-
existing texts," says Holland. "I'd work all night, drag my drawings
in about noon, and pile them up on a little table in the editor's office.
I had attitude: Here's a picture. Write something to go with it." David
Schneiderman did most of the pairing, and the editors let Holland
roam the offices, especially during Watergate. One day while Harrison
Salisbury was at lunch, Holland fell asleep on his sofa. "I awoke,"
says the artist, "to Harrison working at his desk, blissfully ignoring
the boots of a long-haired hippie splayed on his couch."

Holland's first Op-Ed drawing, in 1971, depicted welfare as a
body covered with bleeding mouths. "I based it on one of my junkie
neighbors on the Lower East Side," he comments. "It took them a
month to find a text to go with it. In the meantime, they gave me an
article by Sam Ervin." Senator Ervin begged the government to stop
intimidating the media. "I drew a press guy with his mouth gagged,"
says Holland. "That's why open mouths appear elsewhere on his
body" [figure 14]. The drawing was printed with a bare chest,
however, to save the mouths for a welfare picture.

15 Brad Holland

Ink, with its precise line, is unforgiving. "So I try to muss it up," Holland remarks. Flowing tailcoats and blowing hair have helped him counteract ink's precision. "I hate backgrounds in line drawings," he says. "So I just crosshatch them or leave them blank." Holland cites as his strongest influences two masters of the ink line: German satirist Heinrich Kley and Austrian Expressionist Alfred Kubin.

"Los Tres Grandes" of Mexico—Orozco, Siqueiros, and Rivera—have also informed Holland's work. "When art sophisticates were drawn to Cubism," he notes, "those Social Realists were painting happy farmers shouldering scythes." Holland says he learned to make bulky, generic figures by studying Rivera's sombreros and serapes. Italy's outdoor frescos so seduced Rivera that he returned home from a trip and launched a new public art. "In the States at that time," says Holland, "we artists used magazines the way those muralists used walls."

Prisoners at the Attica Correctional Facility revolted in 1971, taking guards hostage. The uprising ended when 211 police stormed the facility, killing ten hostages and twenty-nine inmates. Editors rejected Holland's illustration of the uprising because of its pro-prisoner stance [figure 15]. (Never mind that the text was a Black Panther's pro-prisoner polemic.) So Holland contributed his image to the Attica Defense Fund. One year later, Suarès asked him to bring it in again. On the revolt's first anniversary, this Op-Ed reject now could be published as a cultural artifact! The credit read, "A poster from the Attica Defense Fund."

Today, Holland's passion is copyright legislation. With knowledge of intellectual property law that's deeper than that of most lawyers, he writes extensively on the subject, appears before Congress, and is a founder of the Illustrators Partnership, which advocates the continuation of existing copyright protection for freelance writers, artists, and photographers in this tricky Internet age.

Holland takes aim at those who have set themselves "the goal of rolling back or abolishing copyright protections. Their stated mission is to serve the public interest by speeding the passage of copyrights from private hands into the public domain." These "attorneys, activists, and legal scholars, known loosely as the 'Copy Left,'" continues Holland, "portray themselves as visionaries trying to restore the 'Jeffersonian' ideal of a 'free society' by making all culture accessible to consumers for 'fair use.'" Holland sees them as "trying to make the public a generous gift of other peoples'work."[5]

Cows, Guns, Auras

It's hard to explain the excitement of that time.
It was a thrill to open the page every day.
We all felt that anything was possible.
Op-Ed art was a revolution that changed imagery.

MARSHALL ARISMAN

As Marshall Arisman contemplated how to present his work, Tomi Ungerer told him, "The only place for these drawings of yours is the *Times* Op-Ed page." "When I arrive at Suarès's office," recalls Arisman, "he's sitting behind a huge desk smoking a cigar. He motions me to open my portfolio. I already don't like him. He looks

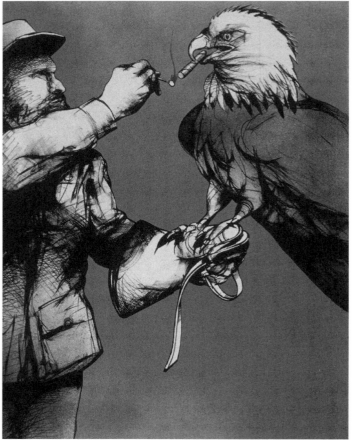

17 Marshall Arisman

16 Marshall Arisman

at my forty-five originals in silence and spills cigar ash all over them. Now I really don't like him." Suarès closed Arisman's portfolio without a word and waved the artist out the door. "But the next day he calls me with a job," Arisman says, smiling. "Now I'm thinking, he's not such a bad guy. And I begin making Op-Ed art that I would have done for myself. They gave me complete freedom."

In 1971, a drawing by Arisman accompanied a discussion of a politician who had begun on a ladder's first rung because a patron one rung up had put him there [figure 16]. "I grew up in a generation of illustrators who were basically decorators," Arisman continues. "By expecting commentary, Op-Ed changed illustration. We could bring in anything we did on our own, and the editors would really try to find a story for it. Once Schneiderman gave me five articles and said, 'None of these may run, but pick one, and we'll pay you.'" As Op-Ed's impact spread, Arisman got calls from major magazines. "I did a *Time* cover on violent crime," he recounts, "that never could have happened if Op-Ed hadn't paved the way for this kind of imagery."

Arisman is exceedingly humble and gentle but also ambitious. "I have a huge ego," he says. "I'm competing with Goya." Arisman's influences, besides Goya ("You feel he was at the scene he painted, but of course he wasn't"), include Edward Hopper ("his isolation of

emotional moments"), Lucian Freud ("He so intensely sees what's there"), and Francis Bacon ("I look at Bacon through my nerve endings; I once met the man, and we got drunk together"). In 1977, Arisman created a freestanding image that ran above Fidel Castro's prediction that the United States and Cuba would regain good relations but that did not illustrate a text [figure 17]. Arisman challenges the conventional division between fine and commercial art, believing that an image's intrinsic value, not its context, is what's important. "But the fine art world stigmatizes people for illustrating," he notes. "Every gallery tells me to quit illustration: 'It will ruin your fine art career.' They'd prefer me to be a plumber." Blue-collar work romanticizes an artist.

Arisman remembers the sculptor David Smith once saying that art that meets the needs of other people is commercial art, and art that meets the needs of the artist is fine art. In those terms, many gallery artists are commercial, while those illustrators who stick to personal themes are fine artists.

"At age thirty I realized I'd been making pictures for other people," says Arisman. "So I listed the things I knew. Thirty years later I'm still working on that list of four." First, "Cows. I grew up on a dairy farm in upstate New York." Second, "Deer. We hunted and ate them. In my painting, the animal component has stretched to monkeys and buffalo." Third, "Guns. My brother had a lot of guns." Finally, "Psychic phenomena. My grandmother lived in a community of psychics."

"I see auras," remarks Arisman. "Around humans—and animals too. The people who did those cave drawings were trying to move from the material to the spiritual world, and they had animal helpers. I did a series of humans transforming into animals. But I knew that if I talked about that series, I'd get a lot of New Age people. And I'm more afraid of them than redneck killers. If I do a prison drawing, I don't mind getting letters saying, 'I'm going to kill your ass.' But I don't want those New Age people on me."

In 1977, "Anonymous," a Ugandan citizen who'd escaped Idi Amin's bloodthirsty dictatorship, sent Op-Ed his story. Amin had ordered him to dig graves. "I had to bury the headless bodies of my friends," the writer stated.[6] Arisman, who illustrated Anonymous's report of terror, says, "I love Goya's picture *The Execution* because the victims have faces and the executioners don't. So I gave a face to the hooded man" [figure 18]. Arisman's show "Sacred Monkeys" was the first exhibition of American paintings to appear in mainland China, and he is the subject of a full-length documentary film, *Marshall Arisman: Facing the Audience.* Storyteller Arisman has also recorded a compact disk of his gripping, original tales: *Cobalt Blue.*

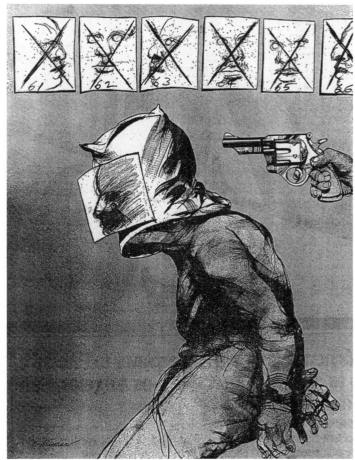

18 Marshall Arisman

The Doctor Draws

It seems to me that your doctor is
more of a philosopher than a physician.

PHILIP STANHOPE

Brooklyn native Mark Podwal has been an Op-Ed fixture since Suarès discovered his book of brilliant anti–Vietnam War drawings, *The Decline and Fall of the American Empire*, which was published in 1971 while the artist was finishing his medical boards. Podwal's earliest Op-Ed picture was an image that ran sans text; it bore witness to the 1972 Olympics in Munich, when the Palestinian group Black September seized eleven Israeli athletes in a terrorist act that caused seventeen deaths, including all the Israelis held captive [figure 19]. Podwal's passion and professionalism have embraced four careers: physician, illustrator, fine artist, and writer.

In 1977, young Dr. Podwal published *Freud's da Vinci*, a hilarious satire of Freud's psychobiography of the Renaissance genius with whom he identified. Podwal's premise? To provide the lost, racy sketchbook that Freud would like to have discovered among Leonardo's chaste manuscripts. The "kissing," "screwing," and "tickling" machines that Podwal fashioned—all rendered in Leonardo's style—finally support the Viennese analyst's resolute research![7]

Podwal has since illustrated scores of books—his own and those of Harold Bloom, Francine Prose, and Elie Wiesel. "I met Elie," the artist says, "through his seeing my Op-Ed work. We became frequent collaborators. The Haggadah we did together is in its tenth printing, I accompanied him to Stockholm when he received the Nobel Peace Prize, and he introduced me when I lectured at Yale."

By the mid-1980s, Podwal chose to focus his art on Jewish themes. "I prefer to specialize in art just as I do in medicine." (He's the rare dermatologist who does no cosmetic procedures.) In 2007, he wrote and coproduced the documentary *House of Life: The Old Jewish Cemetery in Prague*, narrated by Claire Bloom. Podwal's art is represented by the Forum Gallery, which also shows the work of David Levine. Museums that collect his art include the National Museum in Prague and the Victoria and Albert in London.

19 Mark Podwal

Squiggly Wit

Wit ought to be a glorious treat, like caviar.
Never spread it about like marmalade.

NOËL COWARD

Illustrator, author, and filmmaker R. O. Blechman applies his satire with a hummingbird's beak. So nimble is his ink line that it hovers in midair, always moving, never overstaying. Yet the strength of his message is unmistakable. His first and middle names are Oscar Robert. But Blechman, who's perennially restless, liked neither name. He settled on the initials R. O. before becoming a professional artist.

Narrow and edgy as his line, Blechman refined a highly personal style early in his career. In 1972, he illustrated a text that chronicled Nixon's most remarkable moment: meeting Mao. The artist pictured the time when Nixon was reversing two decades of American policy by traveling to the heart of Communist China. He placed Kissinger, who'd paved the Beijing path, second in the saddle [figure 20].

Blechman knows that his talents lie in cinematic visualizing, humor, and conceptualizing. When he was a child, his "theater was a shoe box with a rectangle cut out for the screen" and "two pegs to move the long strips of paper" that were his picture stories.[8] He graduated to picture stories that "encapsulate[d] life in booklets," whose spines he sewed.[9] These led to his first published book, *The Juggler of Our Lady*, which thrust him into a career as a graphic commentator. In 1973, his Op-Ed drawing captured the code of loyalty in Nixon's White House [figure 21].

Blechman has illustrated *New Yorker* covers, created books, and designed Arianna Huffington's Web site, the Huffington Post, as well as operating Ink Tank, a design and animation studio, for twenty-seven years. His animated films have received Emmys and have been shown in a retrospective at the Museum of Modern Art.

21 R. O. Blechman

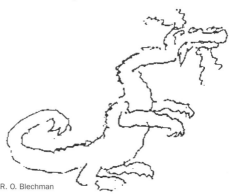

20 R. O. Blechman

Two Titans

Push Pin's principal cofounders...created
a style of their times that helped define the look
of the '60s, but transcended it too.

STEVEN HELLER

Like the office supply whence the name comes, the design firm Push Pin turned out to be a penetrating entity. The powerhouse studio was put together in 1954 by hungry, visionary Cooper Union graduates. *Push Pin Almanack* was a promotional pamphlet created by Seymour Chwast and earlier partners, but the studio was started by Chwast, Milton Glaser, and Edward Sorel (who quit after two years). Chwast and Glaser rejected the prevailing naturalistic style as well as its opposite, the all-Helvetica, all-the-time approach. Instead, they looked to European fine and decorative art and to American comic strips for inspiration. Push Pin (which later became Pushpin) was a vortex of eclecticism and inclusiveness, but its designers created work with a zest all its own. "We were doing illustration," Chwast has stated, "that technically and stylistically wasn't being done."[10]

Each issue of the studio's wildly successful *Push Pin Graphic*, published bimonthly from 1957 through 1980, displayed rich conceptual skills in treating a single theme from multiple literary and artistic angles. The periodical is the subject of Chwast's book *The Push Pin Graphic: A Quarter Century of Innovative Design and Illustration*. Recognition of his talent prompted the Poster Museum in Warsaw, Poland, to hold a one-man show of Chwast's posters, which are collected by the Smithsonian Institution and the Museum of Modern Art.

In 1973, Chwast illustrated an Op-Ed article that described a professor's childhood memory of his first airplane sighting [figure 22]. Imaginatively, the artist focused on a moment the manuscript didn't describe, the moment just before the plane landed on a farmer's field. While the pilot pointed down at Jugendstil curves of roads and houses, the unseen children looked up.

In *The Left-Handed Designer*, Chwast stated, "Some of my most satisfying drawings were . . . [of Nixon, who] was the caricaturist's dream."[11] Of the five Nixons he reproduced in his own volume, three were for Op-Ed. A pointed caricature accompanied a call to make the members of Nixon's staff accountable to the public in 1973 [figure 23]. In this piece, Chwast notes, "all fingers point to the Guilty One."[12]

Although Chwast has stated that his left-handedness "was considered a handicap—and evidence of my being a little odd"[13]—his company includes Crumb, Dürer, Escher, Klee, Leonardo, Munch, Raphael, and Rembrandt, as well as Ronald Searle and many other artists in this book. Michelangelo painted with both hands (note his left-handed Adam on the Sistine ceiling). And Op-Ed artist Horacio Cardo writes with his right hand, draws with his left, and plays soccer with his left foot. The artist Luba Lukova, who illustrated Op-Ed in the 1990s, is also ambidextrous. "I draw with my left hand," she says, "and write with my right. But I can do everything with both hands."

22 Seymour Chwast

23 Seymour Chwast

Chwast has been influenced by Ben Shahn: "The depth of his feeling and his humanity were always there."[14] He's also looked to Rouault's boldness, Steinberg's wit, and Daumier's "bite." Glaser and Chwast each illustrated Op-Ed articles in the 1970s, and both continued to do so for decades after Glaser left Push Pin in 1974 to establish Milton Glaser, Inc.

Glaser's illustrations from the 1970s are stylizations etched with cross-hatched shadows. In an image that complemented a text on the origin of the universe, God's hair curls about him voluptuously [figure 24], while the gown of the "tall woman in gray silk" curves behind her in another portrait [figure 25]. In the latter image, Glaser interpreted an Argentine's memory of Juan Perón's flight from Buenos Aires: "At midnight," a woman "walked the streets holding a mirror tilted menacingly over her head. She meant liberty; she meant death."[15]

"Milton used a fine pen," Chwast has written, "resulting in beautiful, engraving-style drawings," while "I made woodcuts, monoprints and drawings with a Speedball pen, which gave me a bold line."[16] Among Glaser's career splendors are his stunning posters, the codesigning with Chwast of the hardcover magazine *Audience*, the designing and cofounding of *New York* magazine, the designing and redesigning of over fifty publications with Walter Bernard, and the publishing of two luminous tomes of his own work.

Glaser's passion for the precision of Italian art led to his Fulbright study in Bologna with painter and etcher Giorgio Morandi and, in 2007, to his pictures paying homage to Piero della Francesca's painterly geometry that were shown in Piero's birthplace, Sansepolcro. His countless awards include the 1996 Grand Prix Savignac for the World's Most Memorable Poster. Glaser has had one-man shows at the Museum of Modern Art in New York and the Centre Pompidou in Paris, and he continues to design our world—from logos to architectural exteriors.

25 Milton Glaser

24 Milton Glaser

Persian Pluck

> Everyone has a talent; what is rare is the courage
> to follow the talent to the dark place where it leads.
>
> ERICA JONG

In the 1970s, Op-Ed readers were introduced to the dark, wiry wit of Ardeshir Mohassess. This Iranian artist, who studied political science at Teheran University, made intricate and politically powerful images much admired in Iran. But Sarak, the fierce secret police, ordered him to cease his artistic critiques of the shah's rule. This acerbic artist, who's incapable of toning down his satiric imagery, thus was forced into temporary exile in the United States. With the Islamic revolution of 1979, his exile became permanent.

Despite having long lived in New York, Mohassess has not lost his deeply Persian sensibility. His line, now angry and primitive, now delicate and decorative, reveals the grim reality of his world—injustice and oppression, tyranny and cruelty.

Mohassess has often populated his work with dismembered figures, contending that they "represent my personal vision of the world, not Islamic reality." Editors, however, have insisted that they be removed, fearing that they'd brand Muslims as sanctioning barbarism. Despite editorial qualms, a few such figures have made it into the paper. One graced an article pessimistic about the outcome of Middle East talks in 1977 [figure 26].

26 Ardeshir Mohassess

Oceans Away

Great artists have no country.

ALFRED DE MUSSET

In the 1970s and 1980s, nearly as many Op-Ed visuals came from Europe as from America. Artists overseas produced work with perspective and punch. A slew of them settled in Paris: Polish Louis Mittelberg, who worked under the name TIM; Roland Topor, born in Paris of Polish parents; Belgian Jean-Michel Folon; Romanian André François; and two Frenchmen: Senegal-born Philippe Weisbecker and Jean-Jacques Sempé from Bordeaux.

Of these Parisians, only Weisbecker established a New York residence. The golden key to working with these artists was impeccable gentleman agent John Locke, a Vermont farm man of few words who represented first-class international illustrators. Locke was invaluable at finessing connections to the Parisians as well as to the English Ronald Searle, the German Hans-Georg Rauch, and the Americans Edward Gorey and Robert Pryor. He was the only agent with whom I dealt other than Ralph Steadman's literary representative, ferocious negotiator Nat Sobel.

"Since first tottering out of the cot to freelance," says Searle, "I've been blessed with agents. The dream of being free to get on with the anguish of creating something, undisturbed by having to sell oneself, negotiate fees, and handle the billing, is worth every cent of the percentage deducted from rewards collected." Steadman lives in England but is loyal to his New York rep. "I can't be doing with reading contracts and invoice sending," he declares. "Drive me potty, that would! I'm an artist and preoccupied. This is a dangerous world for an honest person!"

In 1973, one of TIM's drawings reflected Golda Meir's memories of anti-Semitism [figure 27]. The artist, a longtime illustrator for the French newspaper *L'Express*, sculpted a moving memorial to Holocaust inmates not far from the tombs of Balzac, Proust, Piaf, and Jim Morrison in the largest cemetery in Paris, Père Lachaise.

In 1971, Folon, a passionate supporter of human rights, addressed the death of a man's beloved wife [figure 28]. This piece is particularly admirable, since it depicts the toughest thing to illustrate: absence. Folon—far better known in Europe than in the United States—had two-man shows with Milton Glaser in cities from Buenos Aires to Liège and a solo show at the Metropolitan Museum of Art.

27 TIM

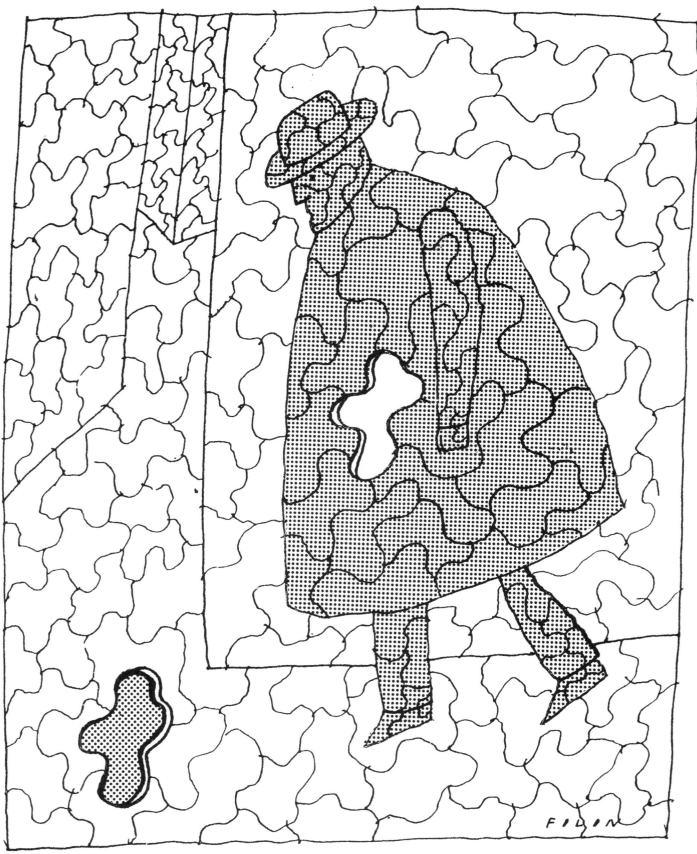

28 Jean-Michel Folon

29 André François

Painter, sculptor, satirical illustrator, and cartoonist André François (né André Farkas) created an apt drawing to illustrate a writer's plea in 1972 against breaking up New York City's government into smaller entities [figure 29]. François was born in what is now Timișoara, Romania, and attended Budapest's Academy of Fine Arts, where he addressed his professors as "Your Excellency." At seventeen, he moved to Paris to study and then worked prodigiously, straddling the worlds of commercial and fine art.

Tall and silver-screen handsome, François settled in the French village of Grisy-les-Plâtres. A garden path led to a huge, soaring studio designed by his architect son. I had the great fortune of visiting François and Margaret, his British-born wife of sixty-six years, three times before a fire tragically gutted his studio and nearly all its contents in 2002. François bravely set out to produce new work. In 2004, an exhibition of his art, assembled after an Internet appeal for contributions, was held at the Centre Pompidou; the show's title was "L'épreuve du feu" (Trial by Fire). François died the following year at eighty-nine.

In 1977, Sempé spoofed fashionably jaded New Yorkers, depicting the fate to befall the city if Sunday became yet another shopping day [figure 30]. Without attending art school—and probably because he didn't—he developed a personal tragicomic style in which tiny humans are overwhelmed by their environment. Sempé's Op-Ed work preceded the start of his long, poignant series of *New Yorker* covers. The artist travels to Bordeaux and New York, but he works in a stunning, glass-walled, sun-soaked Paris studio. Sempé remains the epitome of a stylish, private, and circumspect Frenchman with a huge dose of talent.

Suarès hired two Germans who worked in the intricate style of old masters. The phenomenal draftsman Michael Matthias Prechtl is best known in central Europe, where his drawings often offended conservative authorities. Prechtl, who achieved some of his texture with his own ink-dipped thumb, illustrated German editions of works by Dante, Goethe, Cellini, and Mozart, as well as covers for *Der Spiegel*. In 1972, he drew a President Nixon who viewed the economic proposals of his opponent, George McGovern, as ignorant, inconsistent, and unintelligible [figure 31].

A master of the minuscule, Hans-Georg Rauch loved contributing to Op-Ed. In 1971, he embellished a jaunty prescription by Paul Dudley White, a cardiologist who'd treated President Eisenhower: "The best way to cultivate an optimal flow of blood to the brain is to move your legs vigorously by walking" [figure 32].[17] Rauch was born of a Nazi-arranged match in a "Lebensborn" clinic. (Heinrich Himmler, head of the SS, encouraged his officers to sire children outside marriage to create a German master race.) The poor care granted those "chosen" children is blamed for Rauch's death at fifty-four in 1993.

30 Jean-Jacques Sempé

31 Michael Matthias Prechtl

32 Hans-Georg Rauch

Enfant Terrible

Topor is perhaps the greatest
graphic wit of the twentieth century.

SEYMOUR CHWAST

"Turning down the sheet," reported Roland Topor, "I discover a cadaver in my bed, the husk of a man of small stature, but fat, and of an age equal to mine. My first reflex is to warn the police. But the presence of this rotting carcass in my bed is embarrassing. Explanations will be demanded of me that I'll be incapable of furnishing." This nightmare experienced by short, round-bellied Topor left him ecstatic. "I get more ideas for art," he said, "in eight hours of sleep than I do in sixteen waking hours." He saw this dream as the seed of his first detective novel. "The story fits the genre," he told his son, "because it starts with a corpse."

At age twenty-five, Topor wrote a horror novel, *Le Locataire chimérique*, that was filmed by Roman Polanski as the cult classic *The Tenant*. Polanski, speaking from Spain, told me that he had discovered the novel in the Paramount Studios library. It was only then that the director realized that Topor, whom he knew solely as "the funny and brilliant graphic artist in the Café Flore," could write as wickedly as he could draw. Topor didn't live to write the detective novel he'd hoped to base on his dream, since that eerily prescient nightmare foretold his untimely death at fifty-nine, precisely one week later.

In 1971, an article about the violence we do to ourselves occasioned a potent drawing by Topor [figure 33]. This master of the intimate and the macabre had spent his childhood in the French province of Savoy, where his Jewish family hid from the Nazi peril. He went on to contribute some eighty drawings to the *Times* from 1971 through 1995. Brad Holland cites Topor and Magritte as the two artists who most profoundly influenced Op-Ed visual style. British graphic virtuoso Ronald Searle admits to being "continually startled by the extraordinary acrobatics of Topor's imagination, which contrasts with his deceptively conventional pen."

Coupled with phenomenal work habits, Topor's unrivaled access to the world of his unconscious produced a torrent of images that are the envy of artists the world over. Learning to draw, Topor said, "should take no more than twenty minutes. But your responsibility is to put your deepest soul on paper, to communicate directly from your nakedness. Anything less is unforgivable. You mustn't do lots of roughs or listen to the client. I draw when I have to draw, when the idea is poisoning my brain so much that I must vomit it out."

"Without an outlet," contends Milton Glaser, "Topor would have been an ax murderer." Glaser's word choice is apt. When accused of sadistic imagery, Topor gleefully pointed out that the Polish word for "ax" is *topor*. Exuberant, restless, and extraordinarily generous, he applied his wit to many formats besides illustration and novels—sculpture, ceramics, theater, opera, film, television, songs, and acting. Topor designed sets for Federico Fellini, who once told the artist that living in a Topor drawing was like living in one of his movies.

Topor's own film, *Marquis*, is a bawdy intellectual satire of the Marquis de Sade's life in the Bastille. The actors are human, but Topor masked and costumed them as animals. The film's only human character is Sade's adorable, voluble phallus, which challenges Sade in continual philosophical discourse.

Topor's huge, Peter Lorre eyes and unforgettable, legendary laugh landed him several acting roles. "When Roland laughs," wrote author Wolfram Siebeck, "leaves are stripped from trees."[18] In Werner Herzog's film *Nosferatu the Vampyre*, a remake of the German Expressionist classic, Topor—playing an indelible minor character—lets out a haunting guffaw that resounds for minutes, echoing over a vast landscape of rats.

On Topor's second (and last) trip to the United States—fearing flight, he traveled by boat—Op-Ed artists celebrated him with a big bash in my home. The walls were covered with butcher paper and the floors with cans of paint, crayons, and brushes. During the evening's early hours, the paper contained twenty passages that would, cut out and framed, be smashing. But after the vodka brought by the Polish artists was consumed, the mural's entire length was scatology and sexual perversity that could only be trashed.

I'd copied one of Topor's drawings, *Happy End*, onto a king-size sheet cake in frosting. The image consisted of two lovers' faces, one per cheek, kissing across a female derrière. The guest of honor was presented with a bowl of water and a knife to cut the cake. But Topor waved them away, raised high his drawing arm, and—shouting "Merde!"—bisected the cheeks with one karate chop.

Jerelle Kraus, cake frosted with Topor's *Happy End*

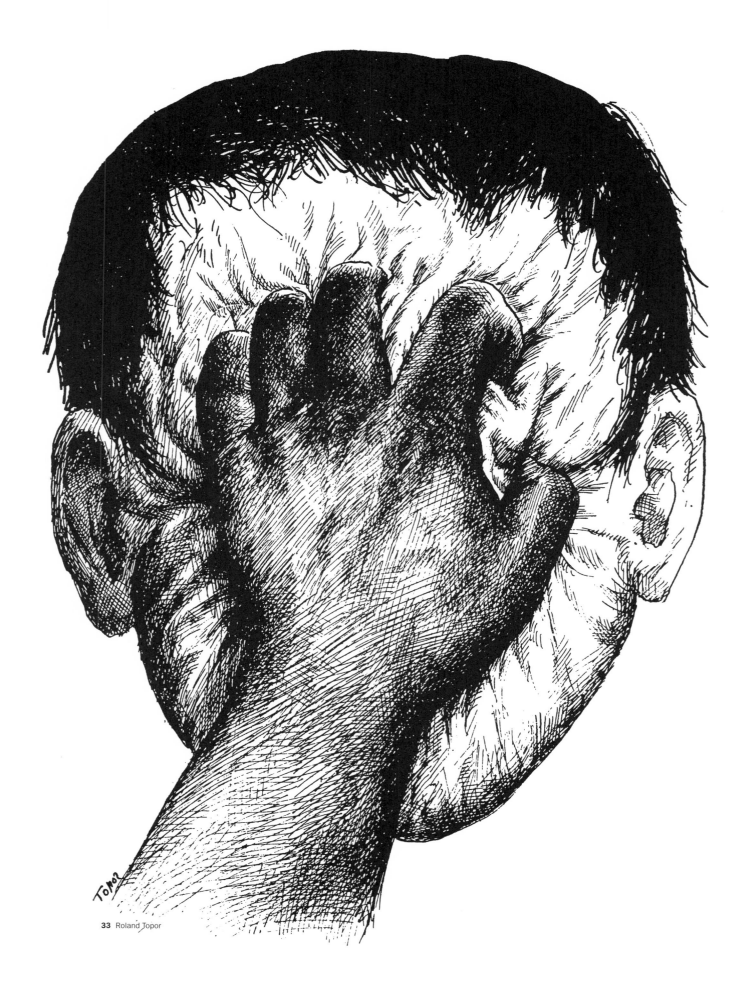

33 Roland Topor

Wild Welshman

A creative work of art is, by its very novelty, aggressive;
it strikes out at the public, against the majority.

EUGÈNE IONESCO

When Ralph Steadman first visited the United States in 1970, he was, in his words, "a poverty-stricken Welshman who hadn't learned to take a bath." A magazine named *Scanlon's*, he recalls, "asked me to go to Kentucky to collaborate with an ex–Hell's Angel named Dr. Hunter S. Thompson. Not a real doctor, mind you, but a doctor of sophistry." (Suarès, at the time *Scanlon's* art director, matched Steadman with Thompson.) "When I arrived, I realized I'd left my art materials in the cab and had nothing to draw with. But the wife of the magazine's editor was a Revlon rep. Her eye shadows and lipsticks became my tools. That was the birth of Gonzo."

Steadman combines extremes—the violence of his radical art and the childlike innocence of his soul. In 1974, one of his illustrations accompanied a text about the intrusion of television into parts of people's lives that were once regarded by the media as private [figure 34]. "This poor guy," Steadman remarks, "who's surrounded by reporters and cameras preceded reality television by thirty years."

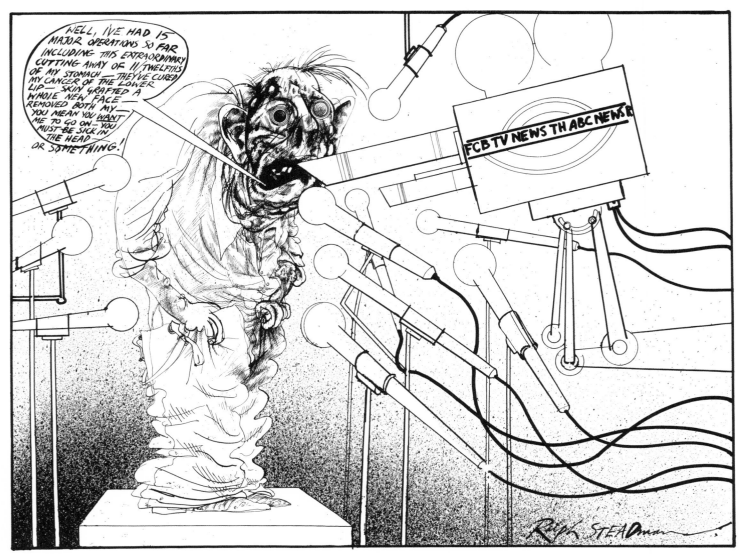

34 Ralph Steadman

Searle's Sustenance

The two people who have had the greatest influence
on my life are Lewis Carroll and Ronald Searle.

JOHN LENNON

Ronald Searle is unmatched in his capacity for giving pleasure to
readers, in his profound humility despite monumental talent, and in
his extraordinary professionalism.

At the start of World War II, young soldier Searle was sent to
Singapore. A month after he arrived, the Japanese captured the
island nation. Searle spent the entire war in Changi, an unspeak-
ably vicious Japanese prison, where he did forced labor. He bartered
with other prisoners to get drawing materials and risked death to
record—in painfully beautiful pictures—the savagery and squalor of
camp life. Despite beatings, malaria, a guard's pickax in his back, a
diet of rats, and the demise of most of his comrades, Searle never
stopped recording what he saw. Although many of his drawings
rotted in the heat, three hundred survived because he hid them
under the beds of prisoners suffering from cholera, where guards
were loathe to go.

Searle's prison drawings are the scratchings of a condemned man
intending to leave witness. "When you're shut up in the jungle," he
says, "your body is so disgusting that you can live only in your head."
Down to eighty-four pounds and on the point of death, emaciated
and clutching his precious drawings, Searle was one of the few to
survive Changi and be liberated. Upon his return to England, he
settled in London, where he became *Punch*'s theater caricaturist and
an internationally successful illustrator.

In 1973, Searle interpreted an Op-Ed manuscript by French
president Georges Pompidou on the state's role in urban architecture
[figure 35]. He created thirty-eight covers for the *New Yorker*, most
of them before 1992, when Tina Brown became editor. Searle's
preference is for sophisticated and elliptical comedy. "Humor today
is infantile," he says. "Stick out your tongue, cross your eyes, fart.
The subtlety has gone."

The French gave Searle a major retrospective at the Bibliothèque
Nationale, and the Wilhelm Busch Museum for Caricature and
Critical Drawing in Hannover, Germany, has dedicated the
Searle Room, where his work will sit alongside his collections
of books and drawings by graphic greats Hogarth, Gillray, and
Rowlandson. Searle celebrated his eighty-eighth birthday in
2008. In 2007, he created forty lavish illustrations for the book
Beastly Feasts! A Mischievous Menagerie in Rhyme, by poet
Robert Forbes.

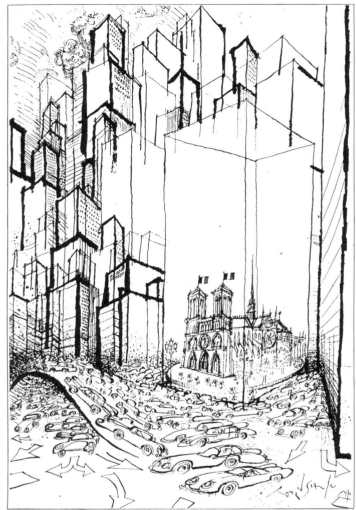

35 Ronald Searle

Searle says that his prisoner-of-war experience colors everything
he's done. "I've never really escaped from that prison. It's so terrible
that anybody who didn't experience it can't comprehend it. I main-
tain contact with a couple former prisoners. I phone one—a simple
farmer—and ask how his cows are. We don't have to talk." Today
Searle and his German wife, Monica, live in a four-story medieval
home in one of Provence's tiny villages, where goats outnumber
humans. He's exceedingly loyal to his fortunate friends, and there
isn't a more enchanting human than Ronald Searle.

Clannish

In the larval stage of Op-Ed, the pictures
were direct, frequently awkward, and
usually personal. But they resulted in a style so
successful that it became commonplace.

BRAD HOLLAND

37 Eugene Mihaesco

Op-Ed texts often treat subjects that are complex, abstract, or both, which makes them tough to illustrate. How does one graphically capture the breakdown of an empire, for example, or the division of our planet, without becoming busy or banal? As visual language emerged to address these questions, a core group of illustrators seized on certain iconographic conventions. One of their answers to the challenge of unwieldy topics was to make an imaginative leap: anthropomorphize! In addition to simplifying and personifying, this ingenious solution created particularly memorable pictures. In 1971, Steadman used this technique to symbolize the decline of England [figure 36]. In 1973, an anthropomorphism by Mihaesco, while alluding to the work of Surrealists Dalí and Ernst, embodied the notion that the earth is divided into parts [figure 37].

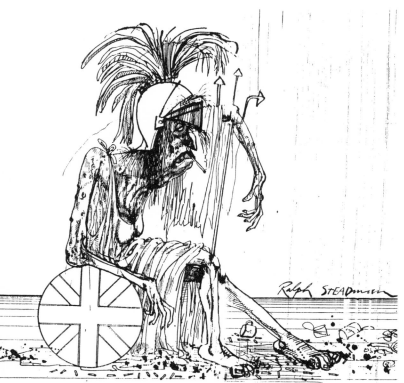

36 Ralph Steadman

Nineteenth-century illustrators used an established artistic idiom to portray the generic big shot as a top-hatted, tailcoat-wearing, tall or corpulent man. Daumier, Grosz, and Nast pictured a typical member of the ruling class wearing "a long black coat which was called a frock coat and a queer, shiny hat shaped like a stovepipe, which was called a top hat. This was the uniform of the capitalist, and no one else was allowed to wear it," wrote George Orwell in *1984*.[19] A drawing by Topor symbolized nations as human power players in 1972 [figure 38]. In 1973, in an image by Mihaesco accompanying a declaration that politics is infiltrating science, the interloper's headgear became a British bowler, the characteristic hat of the London financier [figure 39].

Another graphic convention that artists shared in the 1970s was the depiction of women (in those rare instances when women were depicted) in long black gowns. Two examples show this convention continuing to appear into the next decade. In 1981, Mihaesco illustrated a complaint about body searches [figure 40]. In 1983, an archived image by Holland interpreted the claim that America's Middle East policy was wrong to focus on Lebanon to the exclusion of other states [figure 41].

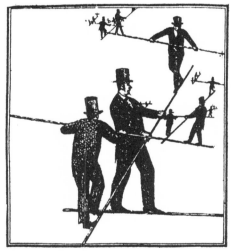

38 Roland Topor

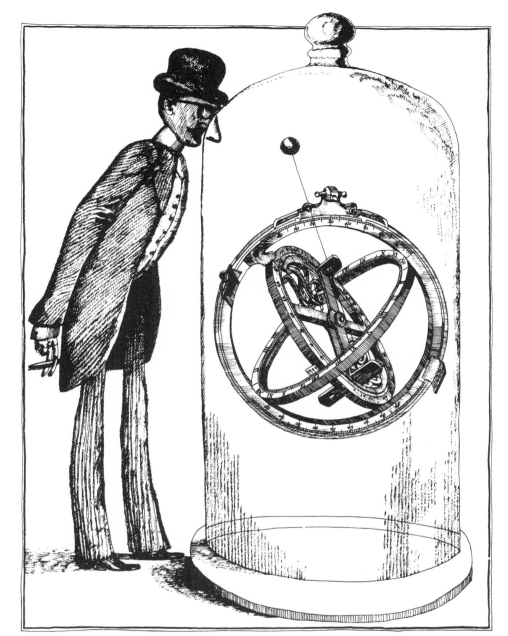

39 Eugene Mihaesco

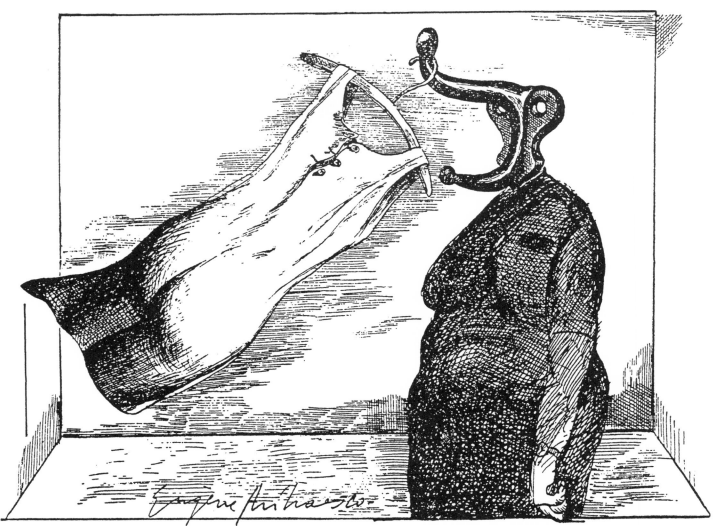

40 Eugene Mihaesco

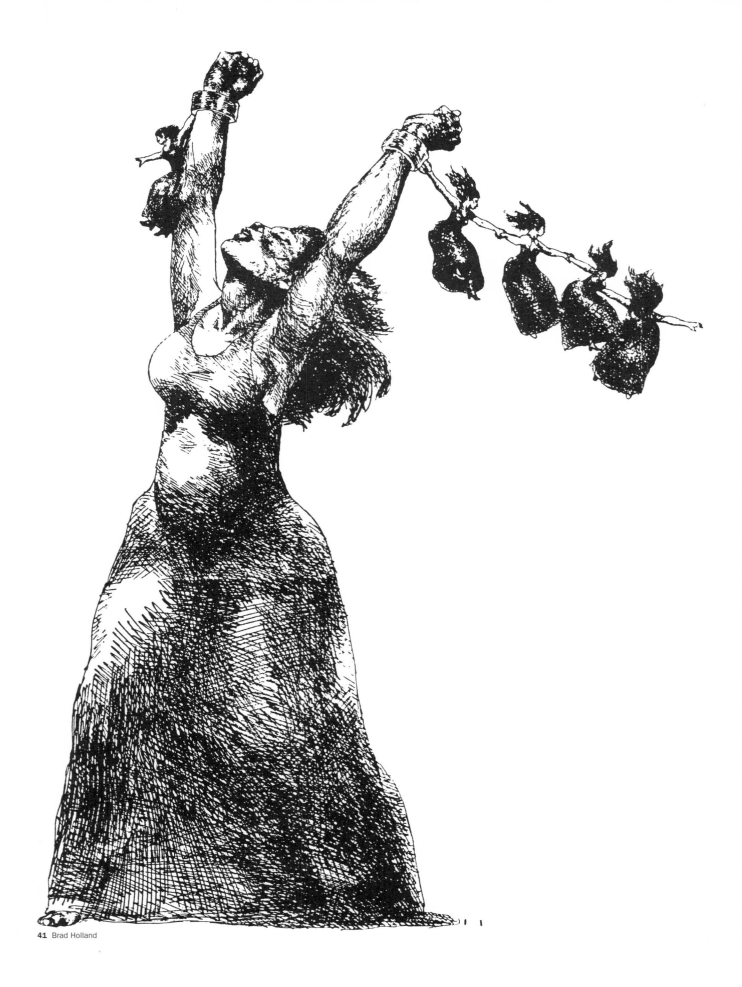

41 Brad Holland

The decapitated figure was a resounding favorite of this decade's artists. French quarrels over the legacy of the guillotine occasioned a drawing by Topor [figure 42], Ardeshir Mohassess interpreted the premise that Islam is a science rather than a religion [figure 43], and Murray Tinkelman's otherwise normal, headless men visualized a text on the sources of presidential power in the United States [figure 44].

Op-Ed artists avoided verbal and temporal devices—captions, labels, speech balloons, and sequential panels—and eschewed such symbolic clichés as skulls and crossbones or donkeys and elephants. Although these restrictions limited the range of illustrators' options, they also liberated artists to devise their own metaphors. In concocting symbols, they turned the intangibles in which Op-Ed texts traffic—directions, trends, patterns, and policies—into familiar, concrete structures.

Stairs, ladders, and cliffs became visual prepositions. The theory that apes descended from man's early ancestors, rather than the other way around, elicited another of Topor's images [figure 45]. Ladders helped Mihaesco convey the pomposity of media wizards who applied the criteria used for toothpaste and women's bras to the selling of politicians [figure 46]. And in 1974, Philippe Weisbecker used prepositional hilltops to synopsize the Middle East conflict [figure 47]. This unpretentious, poignant drawing, which reduces a lone figure to an allegorical stance, makes ingenious use of negative space. It is the fruit of the artist's astonishing ability to condense.

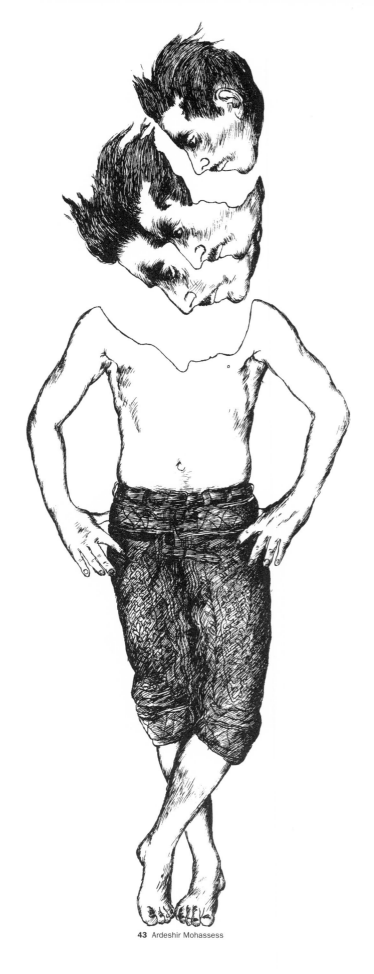

43 Ardeshir Mohassess

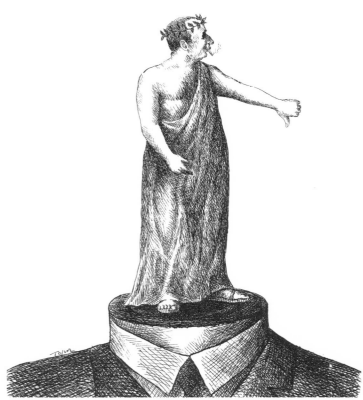

42 Roland Topor

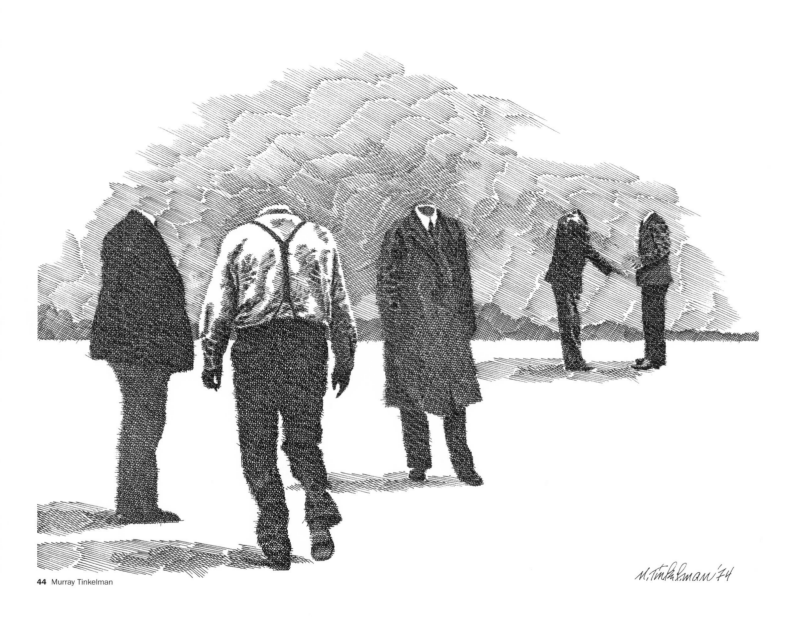

44 Murray Tinkelman

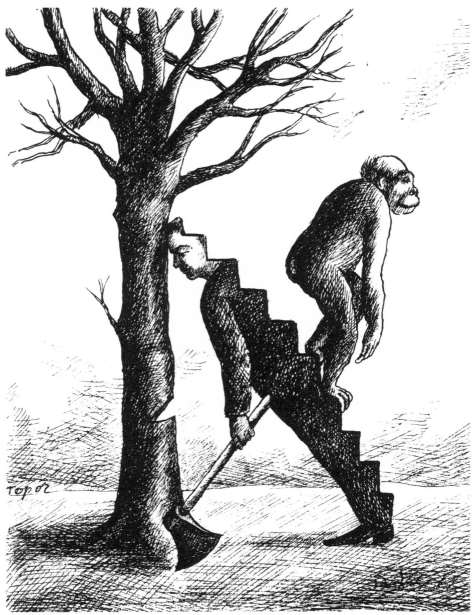

45 Roland Topor

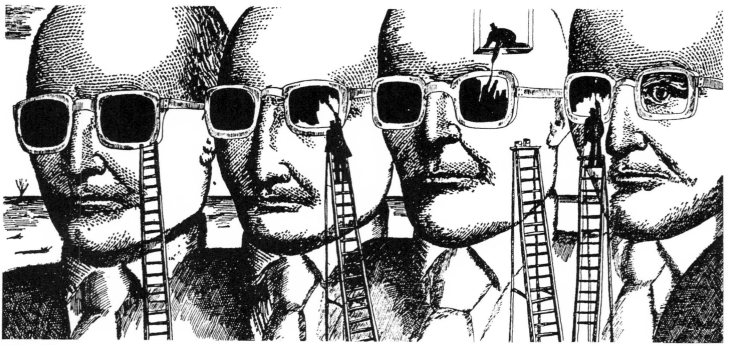

46 Eugene Mihaesco

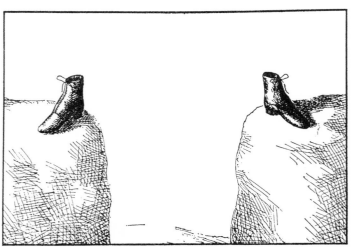

47 Philippe Weisbecker

Up Against the Wall

In 1973, the Musée des Beaux-Arts in Bordeaux offered Roland Topor a one-man show. He generously suggested that it exhibit, instead, the new phenomenon taking root across the Atlantic. So "The *New York Times*: Drawings of the Op-Ed Page" opened in Bordeaux in 1973. An expanded version of the show traveled to Paris the following year—to the Louvre's Musée des Arts Décoratifs. Newspaper drawings in the Louvre!

"Everyone was using the word 'Goya' about my work," says Brad Holland. "I didn't go to Bordeaux, but sent this telegram: 'I heard Goya died in Bordeaux, and I don't want to push my luck.' But I did go to the Paris opening. When I learned the museum didn't serve alcohol, I bought a couple liters of wine, a big bottle of Jack Daniel's, and some plastic cups." Mel Furukawa volunteered as bartender. "But when the guards saw that all the action was in the cloakroom," Holland notes, "they confiscated our booze."

Suarès used the occasion to publish an exhibition catalogue, *Art of The Times*, because "it could be my first book and a way to get credit for my Op-Ed work." The volume, now out of print, contains Suarès's brief statement and the hundred pictures he curated for the exhibit.

"I showed up at the Louvre with my best friend, Charles Mingus," murmurs Suarès. "In New York Charles and I went to dinner every night—sometimes flying to Paris to do so—and we smoked good cigars. We had a special greeting. We both had big stomachs, and we'd rub them. But in France I had the same greeting with Topor."

At the Louvre opening, Topor showed up. "So," Suarès continues, "I go up to him and rub stomachs. A few minutes later, I look for Charles and can't find him. I ask his wife: 'Susan, where's Charles?' She says, 'He saw you rubbing stomachs with that guy and ran back to the hotel.'" Suarès couldn't believe that this major jazz musician was upset because his buddy was bumping someone else's belly. "I had to call Charles and explain that rubbing stomachs was our greeting," he relates. Suarès told Mingus, "I just borrowed it for Topor, and I'll never do it again." The friendship was rescued.

Don't Make Me Think

I cannot give you the formula for success,
but I can give you the formula for failure:
Try to please everybody.

HERBERT B. SWOPE

The warm reception that French critics gave to the new kind of editorial art they saw in the Louvre was not entirely shared by the American media. In 1975, *New York* accused Op-Ed art of perversely befuddling viewers and delighting in pulling everyone's leg. The article singled out Brad Holland as the most perplexing artist and complained that his work never pointed out who's to blame for society's problems.

"There were hostile critics who called the art obtuse and opaque," says former *Times* design director Lou Silverstein. "Sometimes I agreed with them, but never for a minute did I doubt the direction was on target. The best artists went beyond the specific situation and dealt with the subconscious anxiety that existed in the country." Their strength, Silverstein notes, "was that the work was open to interpretation. Op-Ed is a daily. You don't have to tell the whole story in a single illustration. You use those pieces of art to create a mood that gives the page character."

Suarès gave the page character at a cost. "I got to hate the corporate factions within factions," he says. "Every morning I sat on my bed and sobbed. I worked so hard from the heart, and all I am is a cog in the machine." He composed a letter of resignation to Silverstein, who was angry about the shows in France. "The Bordeaux and Louvre exhibits were reported in every newspaper in the world," Suarès recounts, "except the *Times*!" "J. C. liked to confront editors," Holland observes. This maverick art director continued in his stellar, stubborn ways until a final showdown with Silverstein, who claims to have shouted, "You're fired!"

"I quit!" is Suarès's version. A woodcut by German artist Karl Rössing that would accompany an essay on business and labor is also a succinct picture of the relationship between Suarès and the *Times* as they parted ways. But Suarès quickly rebounded.

The article in *New York* "referred to me," says Suarès, "as an Egyptian Jew who shows up in a Rolls-Royce. In fact, it was a Bentley." Suarès soon became, simultaneously, the design director of both *New York* and *L'Express* in Paris. "I couldn't decide which I preferred," he remarks. "For a year, I went to Paris every Sunday night and returned Wednesday afternoon. Then I met my New York wife [painter, marathon runner, and knockout beauty Nina Duran]. She didn't want to move to Paris."

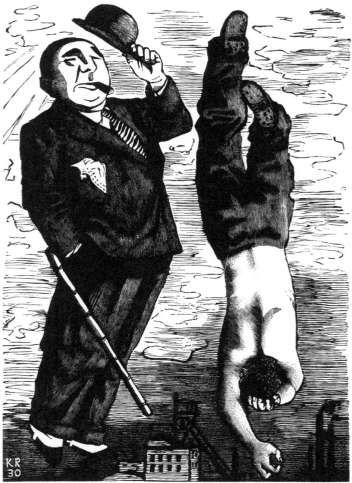

Karl Rössing

When Rupert Murdoch bought *New York*, everyone involved with Clay Felker, its original editor, left, including Milton Glaser, who'd designed both *New York* and *L'Express*. "Milton and I would have lunch," Suarès recalls. "One day he asked, 'What is design?' I said, 'Design is a way to kill time between meals.'" The two men haven't spoken since. "Milton didn't seem to think my answer was reverent enough," says Suarès. "But a friend of mine went to one of his lectures and told me, 'Milton said something brilliant: Design is a way to kill time between meals.'"

Glaser has no memory of either incident, but he chuckled when asked. "It's a clever aphorism, yet cynical and not characteristic of how I speak. And that's the last reason I'd break a friendship."

Protecting Fresh Treasure

Change is inevitable—except from a vending machine.

ROBERT C. GALLAGHER

As national and international newspapers began to adopt the *Times*'s Op-Ed formula, they emulated its distinctive aesthetic as well. The influence of this new visual idiom, moreover, stretched beyond daily journalism to fuel a renaissance in American illustration. Mainstream publications began to hire *Times* artists to do conceptual pieces, and illustrators everywhere tried their hand at idea-based imagery. Many corporations, seeking to enhance the credibility of their products, began to create conceptual, cross-hatched ad campaigns. Op-Ed art became a way of thinking and drawing that altered communication.

Op-Ed art's success concealed contradictions. Like its elite twin, fine art, applied art suffers the antithetical accusations of obscurity and transparency. Early Op-Ed graphic style was often surreal and hard to interpret, giving it a bold, avant-garde aura. But since no one knew for sure what it meant, it couldn't be proved controversial. The advertising business was quick to riff on the technique, noting that— for all its intriguing modernity—it wasn't really political. The same critique had been leveled at Abstract Expressionism in the 1950s. Leftists disliked this revolutionary art form; if a picture represented nothing tangible, it couldn't make a didactic statement à la Social Realism.

Meanwhile, the ever turbulent page we're following hired five art directors in its first decade. Three were appointed in 1973 alone. The first, George Delmerico, strengthened Op-Ed's page design, but soon went on to art direct *New York* and later the *Village Voice*. The *Times* next hired Seymour Chwast, who hoped to art direct Op-Ed while running Push Pin. He managed it for one week before finding it impossible. "That week is the only time I've held a full-time job since 1954," Chwast says now. "Doing a daily was rough."

Steven Heller, Op-Ed's next art director, has an instinctive satiric sensibility that was further honed in the underground press. An autodidact, Heller's breathtaking career began at age seventeen. "Steve used his bar mitzvah money," Holland reports, "to publish a magazine, *Borrowed Time*. I answered his *Voice* ad for artists and became the art director, pasting up each word from individual Letraset letters. We did just one issue."

Heller soon began to assist Suarès at the *Free Press* and became its art director when Suarès went on to design *Screw*. Then Heller succeeded Suarès at that raw, pioneering pornography sheet. Midwife Holland soon arranged a meeting between Heller and the *New York Times Magazine*'s art director, Ruth Ansel. This, Holland says, "got Steve's foot in the *Times* door."

48 Brad Holland

49 Charles Addams

At Op-Ed, Heller told me, "I just continued using Suarès's artists." He enveloped their drawings in more deliberate designs, however. In one striking layout, Holland's poppy illustrated disparate drug themes [figure 48]. Heller was the first to hire Charles "Chill" Addams, Maurice Sendak, and Sue Coe. In 1976, the page ran an Election Day poem by Ogden Nash, and the *New Yorker*'s Addams illustrated the verse [figure 49].

Children's book author Sendak adorned a New Year's Day homage to the joys of drink [figure 50]. In 1975, Coe, a young British dynamo, interpreted a chemist's comparison of snakes and men, which pointed out that snakes can grow only by bursting their skin [figure 51]. In 1976, three years before I called him for an illustration [see "Origins," figure 1], David Levine drew Mao Tse-tung for Heller. Because that likeness, though corpulent, was delightfully innocuous, it was published without controversy.

In 1975, a fat package arrived from Paris with drawings by Jean-François Allaux, a young Frenchman who'd illustrated numerous European publications. Allaux met his first wife, art student Christie Brinkley, at l'École des Beaux-Arts in Paris. "When Christie began to model," says Allaux, "I accompanied her to shoots in LA, where I illustrated for the *Los Angeles Times*. Then back in Paris, I saw the Louvre's Op-Ed show, which inspired me to send drawings to the *Times*. Steve loved one and asked if I'd clothe its full-frontal nude figure. So I put a suit on him."

Heller matched the revised drawing [figure 52] with a text insisting that we take "full slices" out of our defense budget.[20] Another evocative image from that year consisted of surreal vignettes by Walter Gurbo. It illustrated a Nebraskan's letter home describing New York City—a tale of burglaries, muggings, and bomb scares [figure 53].

The Op-Ed editors and Heller parted ways in 1976. Before long, I arrived at the *Times*, where Heller showed me his first publication, *The Book of Waters*. It was slender but not rectangular; its shape was that of a Perrier bottle, and it described various brands of the bottled stuff. It was Heller's first step to becoming a one-man book engine and establishing himself as the foremost American authority on graphic design history.

50 Maurice Sendak

51 Sue Coe

52 Jean-François Allaux

53 Walter Gurbo

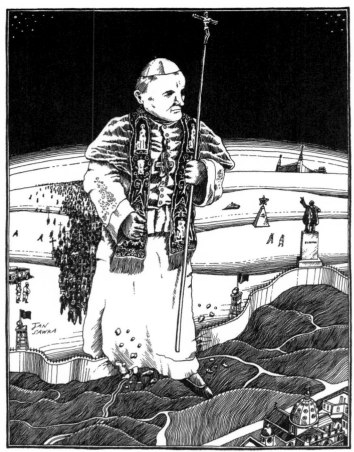

54 Jan Sawka

55 James McMullan

Heller has since created more than a hundred (all rectangular) books, edited the American Institute of Graphic Arts *AIGA Journal of Graphic Design*, written a vast number of articles, won oodles of awards, curated a dozen exhibits, hosted scores of design conferences, and co-chaired the Master of Fine Arts programs at the School of Visual Arts, where his oeuvre was the subject of a large retrospective in 2007. After twenty-nine years of art directing the *New York Times Book Review*, Heller continues his manifold activities, include reviewing visual books for the *Times*, blogging for *Print* magazine, and augmenting his legendary, generous contributions to the graphic design community.

Pamela Vassil, who took charge of Op-Ed visuals in 1976, opened the page to numerous new artists. One of her valuable discoveries was Jan Sawka, who in 1978 illustrated a manuscript predicting that a Polish pope would prefigure Communism's collapse [figure 54]. Sawka, a Polish political refugee, speaks of the drawing's aftermath: editorial page editor Max Frankel "flipped out when he saw my picture. And [executive editor] Abe Rosenthal [a trenchant anti-Communist, having been a *Times* correspondent in Poland] took me to lunch. Then the Soviets said the CIA was responsible for the pope's election, and their ambassador complained that a psychopath made the picture. The original drawing is in the pope's private Vatican collection."

After creating dozens of Op-Ed drawings, Sawka ceased illustrating and began designing monuments. Abu Dhabi's royal family commissioned his Tower of Light, a steel-and-glass structure 515 feet high. He then conceived the Forest of Religious Co-Existence, a grouping of slender white rods almost 100 feet tall in Jerusalem. Each rod bears the symbol of Judaism, Christianity, or Islam.

While previous illustrators worked mostly in ink, art director Vassil added painters to the roster. James McMullan, the painter of lyrical Lincoln Center Theater posters, works in watercolors, a traditionally noncommercial medium. But in 1977, he used mostly ink to visualize a call for tolerating the right of virginity until marriage [figure 55]. Thirty years later, he illustrated a Veterans Day tale of the sole surviving (106-year-old) American veteran of World War I.

Vassil also brought to Op-Ed the art of Paul Davis, painter of New York Shakespeare Festival posters, and the stylized paintings of gallery artist Bascove, both of whose work appears in coming chapters. Savvy enough to avoid controversy, Vassil hired the crème de la crème of local talent and trusted them to do the interpreting. In 1979, she left the *Times* to chair the Department of Continuing Education at the Parsons School of Design.

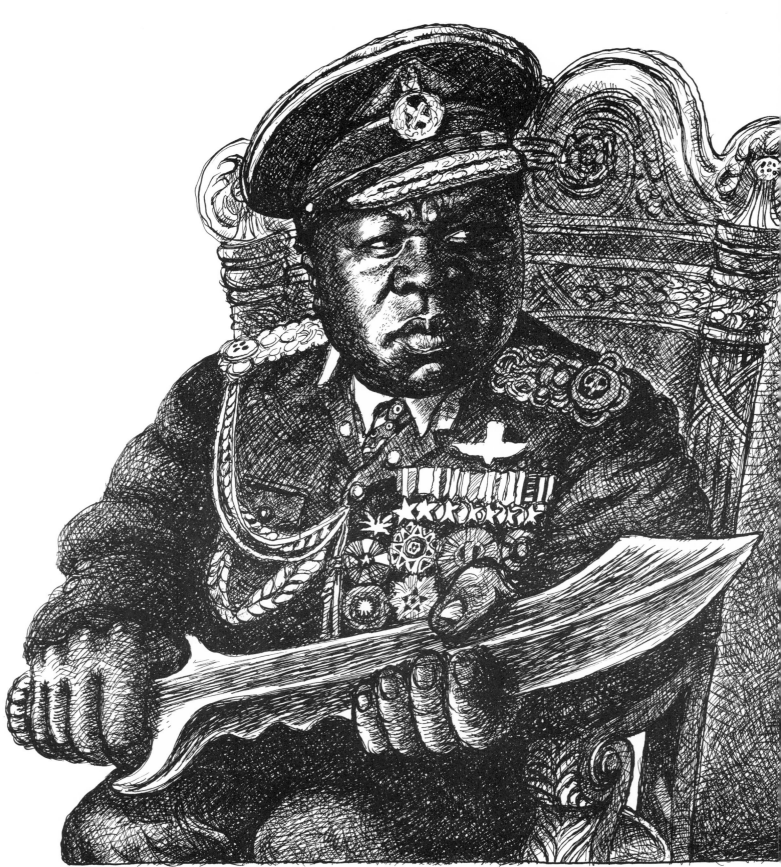

56 Carlos Llerena Aguirre

Thumbs Down

Art made tongue-tied by authority.

WILLIAM SHAKESPEARE

Humans have long been wary of visual imagery. The totemic clout of figurative art is capable, in fact, of subverting logic; aboriginal tribespeople are said to fear that a camera's image could steal their souls. Even the rationalist ancient Greeks chained statues to the ground to prevent them from fleeing. And the Second Commandment cautions: "Thou shalt not make . . . any graven image, or any likeness of any thing." Pictures seem more dangerous than words because our right brains fall more easily under their sway.

In 2006, European cartoons portraying Mohammed that were reprinted from the Danish newspaper *Jyllands-Posten* were declared blasphemous by many Muslim leaders, who issued death threats against the artists. The resulting protests across the Muslim world escalated into violence that led to more than one hundred deaths. In 2008, people are still being charged with plotting to kill the Danish cartoonists.

Here's a sampling of pictures that didn't make the cut in Op-Ed's first decade. A rather mild portrait of Idi Amin Dada by Peruvian artist Carlos Llerena Aguirre was deemed too severe an indictment of the Ugandan tyrant's mass murders of his own people [figure 56]. Brad Holland's image for an article on low-cost housing in Manhattan was rejected for, an editor said, "going too far" [figure 57]. Hans-Georg Rauch's drawing illuminating the Persian Gulf conflict was quashed for its portrayal of the Jewish man [figure 58]. The artist insisted that he'd used the prevalent convention for picturing Jews, but the editor felt that his characterization recalled those of *Der Sturmer*, a Nazi Party newspaper.

During the Italian election in 1976, Communist leader Enrico Berlinguer resented the suffocating domination of the Christian Democrats. Holland's metaphor for that political power struggle failed—with good reason—the *Times*'s taste test [figure 59]. Dr. Mark Podwal's image of American attitudes toward abortion also met with rejection [figure 60]. And Ardeshir Mohassess illustrated a text on fascist tactics, but a (spurious) claim that the spur depicted male genitalia killed it [figure 61]. Another rejected image by Holland was intended for an article about women's intuition [figure 62]. And one of Douglas Florian's images was "too murky," in the opinion of an editor [figure 63]. "That's a fit description for the drawing's subject," says the artist, "which was gun control in America."

57 Brad Holland

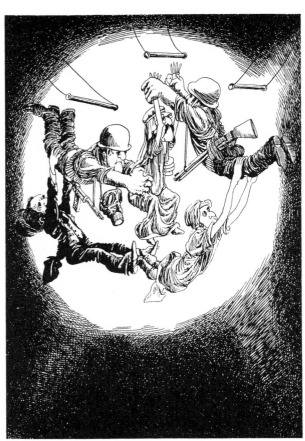

58 Hans-Georg Rauch

59 Brad Holland

60 Mark Podwal

61 Ardeshir Mohassess

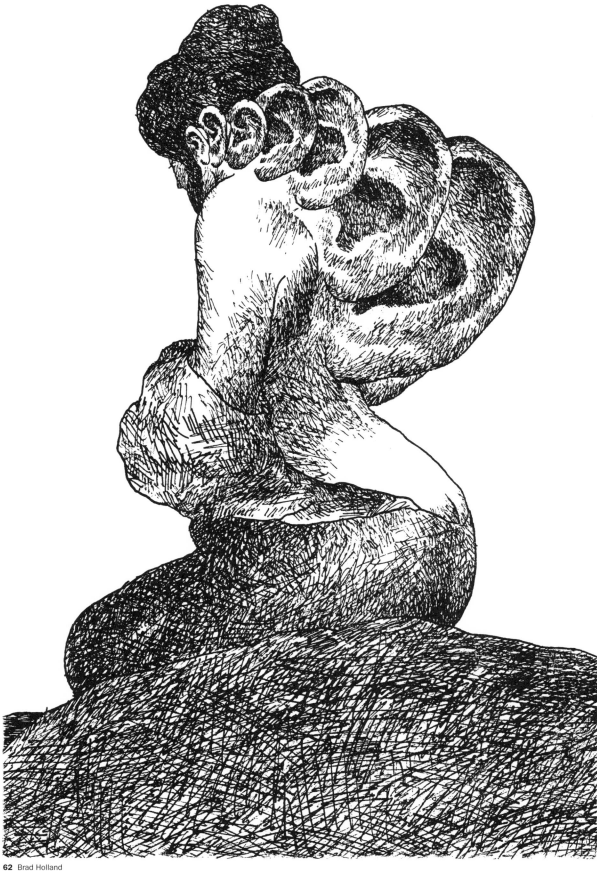

62 Brad Holland

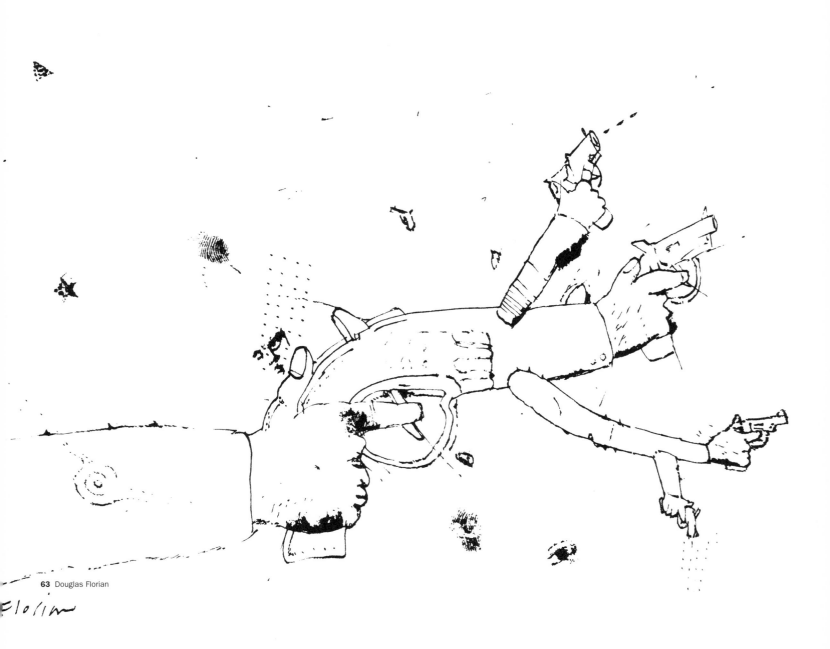

63 Douglas Florian

Changing of the Guard

Charlotte Curtis was the first society reporter
to publish the fact that proper Bostonians sweat.

TIME

In 1974, editor Harrison Salisbury turned sixty-five, mandatory retirement age for *Times* managers. (Salisbury had intended to leave the paper three years earlier, but stayed when offered the irresistible controls of Op-Ed.) When he retired to Connecticut to write the last dozen of his twenty-nine books, Op-Ed editorship passed to tart-tongued *Times*woman Charlotte Curtis, whose perspicacious, iconoclastic reporting had—with deadpan irreverence—mercilessly skewered high society.

Curtis's dry-eyed focus on abortion, rape, and spousal abuse transformed the "Women's Page" she edited from fashion notes to serious journalism. At the height of her career as America's premier newswoman, Curtis was as famous as the people she profiled. *Time* called her "the *Times'* girl on the beat [who] studies her subjects with the detachment of a professional sociologist."[21]

Curtis covered the infamous benefit for the Black Panthers hosted by Leonard and Felicia Bernstein in their Park Avenue penthouse in 1970. She described Bernstein and his millionaire guests "munching Roquefort cheese balls and sipping white wine. In black turtleneck and pants, the conductor laureate of the New York Philharmonic did most of the questioning. Panther field marshal Donald Cox did most of the answering, and there were even moments when both men were not talking at the same time. 'If business won't give us full employment,' Cox said slowly, 'then we must take the means of production and put them in the hands of the people.' 'I dig absolutely,' said Mr. Bernstein."[22]

Tom Wolfe also covered the event for *New York*. His wickedly observant reportage, dubbed "radical chic," became a classic of New Journalism. In 1971, artist Tomi Ungerer, with acid humor, reflected a fashionable Cape Cod event for Hiroshima Day that was tarted up with similar trappings [figure 64].

Curtis complained to art director Steven Heller that the art he used was "lugubrious." She thought that it should be sexier. Her idea was to get Halston to write an article about a new Santa Claus suit and have the fashion illustrator Antonio Lopez draw it. Since she wanted famous artists, Heller showed her a painting by Thomas Hart Benton. "That's lugubrious," Curtis commented. "But he's famous," replied Heller. "Are you sure he's famous?" she asked. "He's in the Museum of Modern Art," he assured. "Well," concluded Curtis, "as long as he's famous."

64 Tomi Ungerer

Despite intense company loyalty, Curtis had her own Op-Ed vision: pepper the think tank treatises with the voices of ordinary people and pieces on society and the arts. In defense of the editors, I agree with former Op-Ed editor Bob Semple that all editors have, like Curtis, made "a conscious effort to relieve the relentless discussion of geopolitics with offbeat and sometimes whimsical essays."[23]

Curtis ran lighter, more personal essays consistently, however, and simply ignored the in-house criticism. She was smart, ambitious, bosomy, slim-waisted, and petite. "This combination," wrote her biographer, Marilyn S. Greenwald, "gave her an almost geisha-like appeal to some powerful male editors, who nurtured her career. . . . At her memorial service, which she planned meticulously, seven of the nine speakers were male."[24]

One of those speakers was David Schneiderman, to whom Curtis had entrusted the day-to-day running of the page. Delighted to be the figurehead while Schneiderman guided the ship, Curtis would put Henry Kissinger on hold to take Nelson Mandela's call—while Versace waited in the lobby to take her to lunch at Le Cirque. "Just as David was Harrison's right arm," says Holland, "he became Charlotte's, and she deferred to him on the art. He'd gone to the Louvre opening. Impressed by our reception there, he knew our accomplishment was appreciated away from the grumbling at the *Times*. David was our ally in those first days when Charlotte must have been tempted to move in a different direction."

Schneiderman quickly learned what he needed to know from art director J. C. Suarès and the illustrators. "I was fascinated with making connections between pictures and stories," he recalls. "It was so exciting that J. C. and I would go out for dinner and then come back to the *Times* to get the first edition." Schneiderman remembers that Suarès disliked words in the art and that editorial page editor Oakes forbade them. "Other than that," he says, "J. C. was let loose."

Schneiderman's love of the drawings never overwhelmed his commitment to the texts. Harrison Salisbury's announcement—on the

Today show—that "we welcome articles from anyone," says Schneiderman, "brought us a deluge of over-the-transom manuscripts." When he wasn't reading the mountain of unsolicited manuscripts, he was soliciting them. "Harrison wanted extreme opinions," Schneiderman recalls. "One of my early jobs was finding right-wing writers. I got conservative ideologue H. L. Hunt, one of the world's richest men, to write for us and also right-wing Montana senator Burton K. Wheeler, who opposed America's entering World War II."

After shining as deputy to Op-Ed's first two editors, Schneiderman left the *Times* in 1978, won two Pulitzers as editor of the *Village Voice*, and became the *Voice*'s publisher. He's since moved to Seattle, where he's writing *The Last Journalist*, a biography of Harrison Salisbury.

The next deputy editor was whiz kid Steven Crist, son of *Today* film critic Judith Crist. Crist lied about his age at fifteen to play house piano at Jimmy Ryan's, a jazz club in New York. He was later a long-haired Renaissance-literature student at Harvard when one day in 1977, Crist recalls, "the *Times* phoned me to say, 'You have a job running copy if you can start next Monday; be here at 7:00 P.M. We'll pay $78 a month.' Incredibly, the call came out of the blue!"

"I was a copy boy at night for six months," Crist continues. "Then there was a strike, so I went to the race track. After the strike ended, I was assigned to be Charlotte's deputy at Op-Ed. There I was 'the copy boy from Harvard who liked the horses.' That intrigued Charlotte." After the months of running pages, Crist was glad to be given latitude. "I viewed Charlotte as my mentor and friend," he says. "She told me, 'I want the page to reflect your interests.'" Cool and serene, Crist was comfortable commissioning articles from presidents and potentates.

When the newspaper strike began in 1978, union-exempt Curtis was determined to put out the page alone. Never mind that there was no one to print it. Since I was then subbing as Op-Ed art director, she called me at home: "Please come in. Pretty please. Yours is the only job I can't do." I didn't cross the picket line, but it wouldn't have helped; there was no *Times* for eighty-eight days. While staffers fled to Capetown or Katmandu, Crist, who had been editor of the *Harvard Lampoon*, joined Nora Ephron, Tony Hendra, George Plimpton, and Jerzy Kozinski to create *Not The New York Times*. A splendid parody, it included the "Having Section" and an Op-Ed page featuring an illustration by Randall Enos that was glutted with farcical symbolism [figure 65].

Enos laughs about the thousands of linocuts and animations with which he's charmed audiences. He's been, according to his blog, "making pretty pitchers for 52 years fer the people in just about every magazine and newspaper in the land except that damned *New Yorker* who won't return my calls."[25] On his blog, Enos described a few art directors, including, ouch!, me: "the eccentric and ferocious *Times* art director. I met Folon in her office. She speaks seven languages. Once I made her a tall Danish Santa Claus to fill a column's height.

At the last minute, she lost that space to a smaller square with no time to re-do. So she sliced off the head and legs, tossed the middle, and joined head to legs, creating a better picture than the original."[26] The Santa Claus story is true, but I speak only four languages and am ferocious only with editors.

A few years into his running of Op-Ed, Crist selected the name of his favorite thoroughbred, Alydar, as his computer password. A sports editor later requested the same name. Finding it already taken, he asked, "Who has it? I want to meet him." Crist soon transferred to the sports department to take up the racing beat. He then left the *Times* in 1990 to edit the *Racing Times* and later lived as a professional horse player, betting $1 million a year and earning the title King of the Pick Six. After advising New York governor Mario Cuomo on racing policy, he rounded up investors and made an audacious $40 million bid to buy the *Daily Racing Form*. Crist continues as its editor and publisher. A literary stylist, he's also written three books on the world of horse racing.

Schneiderman and Crist expertly handled the heady rush of the Op-Ed managerial role into which they were very early thrust. It compelled them to deal with the world's mightiest minds and egos and helped prime them to be the media magnates they both became.

65 Randall Enos

The Lady Editor Done It

Maximum excitement is the confrontation
of death and the skillful defiance of it by watching
others fed to it as he survives transfixed.

ERNEST BECKER

In 1979, Marshall Arisman produced an Op-Ed illustration that provoked an attempt at violent retribution. The article he interpreted concerned a CIA operative who had taught torture techniques to South American police. The leftists who'd been tortured by his pupils sought him out and killed him. At 8:00 A.M. on the day Arisman's portrait of the deceased appeared, his doorbell rang. The artist opened his door to a huge thug who shoved the page in his face.

"You drew this vicious attack on an innocent person, who is my best friend," the goon said. "I'm here to beat the shit out of you."

"I asked him to come inside for a cup of coffee," related Arisman. "There was no question that he could, with very little effort, beat the shit out of me. I gave him a cup of coffee and told him that, as an illustrator, I was given a text that I had to assume was true. That my drawing was only a response to what the editor had given me as a fact.

"I told him that if he wanted to beat the shit out of anybody, it should be the editor, Charlotte Curtis, not me. He finished his coffee and finally said, 'If she was a man, I'd do it . . . but fuck it.'"

This incident points to the core dilemma that editors face. Here's Marshall Arisman, an artist who embraces the freedom that Op-Ed gives him. Yet when faced with the nitty-gritty consequences of that freedom, he fingered the editor! It's the editor—not the writer, artist, or art director—who'll be blamed for any offense. What better justification is there for editorial caution?

Austrian artist Paul Flora's Op-Ed drawing could well be a depiction of readers and artists out for the editor's blood [figure 66].

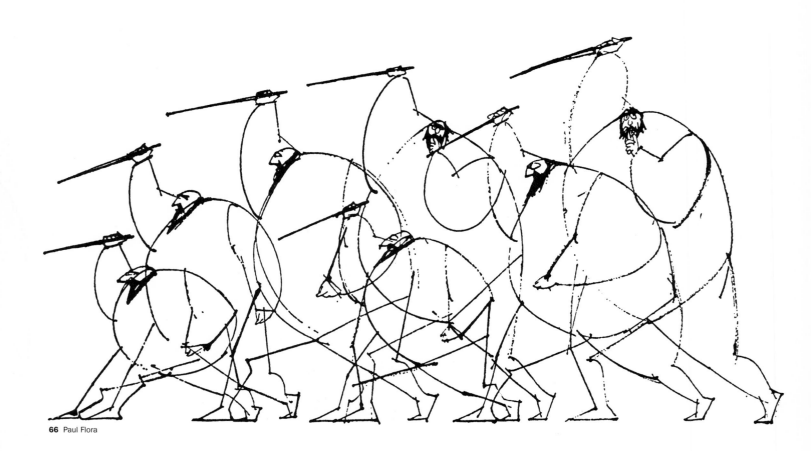

66 Paul Flora

THE EIGHTIES

Ready or Not

Say no from the start; you will have rest.

AFRICAN PROVERB

"A newspaper," cautioned Charlotte Curtis, "is a copy-eating fiend." Upon reaching that last *f*-word, she coolly crumpled the page she'd been gripping in her tiny fist. "When it's gulped down everything we feed it, it's hungry again." The year was 1979, and Curtis was daintily chain-smoking while describing the rigors of art directing two pages 365 days a year for the *Times*'s opinionated "church"—as distinct from its newsroom "state." Seated just so, her legs crossed beneath the petticoats of a smart designer frock, she inhabited a diminutive figure who was enlarged by the huskiness of her voice and the glossy expanse of her desk between us.

When Op-Ed debuted in New York nearly a decade before this tête-à-tête with Curtis, I was three thousand miles away. Having just returned from a Fulbright year in Munich, I was painting full-time in Berkeley and actively resisting real work, except for the one day a week I crossed the Bay Bridge in my noisy Morris Minor to teach French at San Francisco's Conservatory of Music. Then *Ramparts* called: Would I show them my portfolio? I didn't know what a portfolio *was*.

Within a week, I was art directing a full-color, national magazine with a circulation of four hundred thousand. *Ramparts* "was the only New Left magazine that could penetrate middle-class households," recalls Peter Collier. It was "printed on heavy, glossy stock with classy graphics that looked good on a Danish Modern coffee table."[1] Collier was one of five equally billed top editors whose politics ran from Maoist to Trotskyite. It was tough designing the magazine without experience, but exhilarating to commission silk screens from Cuba, illustrate texts on muckraking, and create covers on the pollution–industrial complex.

The next professional call came from *City*, a San Francisco start-up magazine funded by Francis Ford Coppola. I designed the dummy issue with my partner in our cavernous Telegraph Hill painting studio and co–art directed its first two years. *Time* reported Coppola recalling, "*City* was my Viet Nam. The stakes got so high that I either had to get in or get out." After losing $1.5 million, Coppola got out.[2]

Soon a San Francisco conceptual artist, Lynn Hershman, asked me to be the live-in curator of her art installation at the Chelsea Hotel in distant Manhattan. It meant spending two weeks in New York, a frightening, intoxicating thought for this native Californian.

In his review of Hershman's piece in *ARTnews*, critic Alfred Frankenstein wrote that "most visitors to the Chelsea were spooked by what they saw there: [two female] department-store dummies [with]

1 David Suter

faces modeled in wax after the physiognomy of Jerelle Kraus [that] lie together under a rumpled sheet [among] hair curlers, goldfish, and other miscellanea."[3] When one fish died, I called San Francisco to tell Hershman. "Leave it in the bowl," she said.

It was a drag living with a dead fish, yet I was in the world's magazine capital and now I *had* a portfolio. Still, my work samples were from the other coast. And although I had a Master of Arts, it followed studies in philosophy at Pomona and Swarthmore colleges and art history at Berkeley, rather than what was par for the field—graphic design at Parsons, Pratt, or Yale. I knew no one in town but lucked into an art-directing job at *Time*.

I chose *Time* because it was the one periodical on the newsstand of every country I'd visited. Once hired by the venerable publication, however, I was out of place in its office culture. My Bay Area breeziness didn't match the decorous, red-carpet formality of Henry Luce's Time Inc. And, although I was hired for my "avant-garde"

work, I had to tone down every layout I designed. One Friday during an evening magazine closing, I went to the dining room, where the company served dinner to its late-working employees. I joined the buffet line behind *Time*'s business editor, Marshall Loeb, who would later serve successively as the top editor of *Fortune* and *Money*. In fine corporate style, Loeb was attired in a respectable gray suit and gray tie.

After the sole meunière and haricots verts, we arrived at the desserts, which included a gleaming mountain of Thompson seedless grapes in an enormous cut-glass bowl. "Marshall," I said to Loeb, "you know how to become a great lover? Hold just one of those grapes in your mouth for five minutes without breaking the skin." Loeb's utter silence was terrifying. I wanted to scrunch up like a raisin and disappear.

On another occasion, when assigned to design *Time*'s first cover on homosexuality, I drew twelve versions. The most appropriate was a close-up of two male arms holding hands. *Time*'s editors deemed it too radical—this was 1975—but used it for another cover on the subject seven years later. (Two of my versions portrayed both sexes, but lesbians were simply off *Time*'s radar.) The cover approval ritual consisted of the designer presenting dummies to *Time*'s top editors in a vast conference room. After showing ten viable variations for the homosexuality cover, I reached for my alternatives. The shop that handled *City* magazine in San Francisco also printed gay publications, and I'd helped myself to some pages from the tall stacks of beefcake color spreads in its warehouse. For fun, I slipped an acetate sheet with *Time*'s red nameplate and border over a back view of two nude guys running into the ocean. Deadpan, I presented it to the roomful of dignitaries, noting, "This may be too much for us, so I made a backup." Then I turned the cover over to show the same two guys bursting out of the *Time* border in full frontal view.

After the august assembly of editors examined the proposals, they chose a serious head-and-shoulders shot of a much-decorated U.S. soldier behind the cover line "Homosexuality in America." Nonetheless, the esteemed Henry Grunwald, then *Time*'s topmost editor, asked me to turn the joke dummy over to show him the front view again.

Somewhere I learned that the *New York Times* was adding feature sections that needed strong visual display. Lou Silverstein took time out of his rushed schedule to see me. "I don't need another art director," he shrieked. "I need a shrink!" Despite his protests, Silverstein, like everyone there and then, loved creating a publication with such deep intellectual resources. The atmosphere was more casual than at *Time*, and the weekly section I designed welcomed conceptual covers. So why, as I listened to editor Curtis describe Op-Ed's rigors, would I switch to a daily section?

What finally got me was her graciousness: "We've never had fan mail for the art like we had during the two weeks you subbed last year." Surely it was the page I had done with David Suter that grabbed readers. The article claimed that the FBI was still being run by the specter of its infamous dead director, J. Edgar Hoover. In

2 Philippe Weisbecker

a classic example of what he calls a "Suterism," the artist crafted the spymaster's visage from three trench-coated agents [figure 1]. In 1985, *People*'s feature on Suter would speak of his "visual puns that, while bamboozling the eye, manage to elucidate the text."[4] Hoover's feet became a separate element, suggesting his body for which there was no room.

I retained many of Op-Ed's original artists. In 1980, Philippe Weisbecker's illustration buttressed a text citing England as the sole European nation assisting the United States against Iran [figure 2]. Anita Siegel's image strengthened Anthony Burgess's powerful statement that authors should publish their own works [figure 3]. In 1981, Jean-Jacques Sempé illustrated an account of the disappearance, in today's world, of a meaningful death [figure 4]. Our personal fates were once the province of faith; yet modern death is objective, research is the new religion, and we're left to pray to a scientist in a sterile laboratory.

This Sempé is one of a tiny number of images dealing with religion that have passed muster. Since readers bristle at sacred symbolism, editors avoid "arting" manuscripts that call for religious iconography. In 1983, twenty years after the assassination of President Kennedy, worldwide tributes to him demonstrated the failure of revisionism to diminish his hold on public affection. I therefore drew him with an infinity sign over his head. Editor Curtis scolded: "You can't put a halo

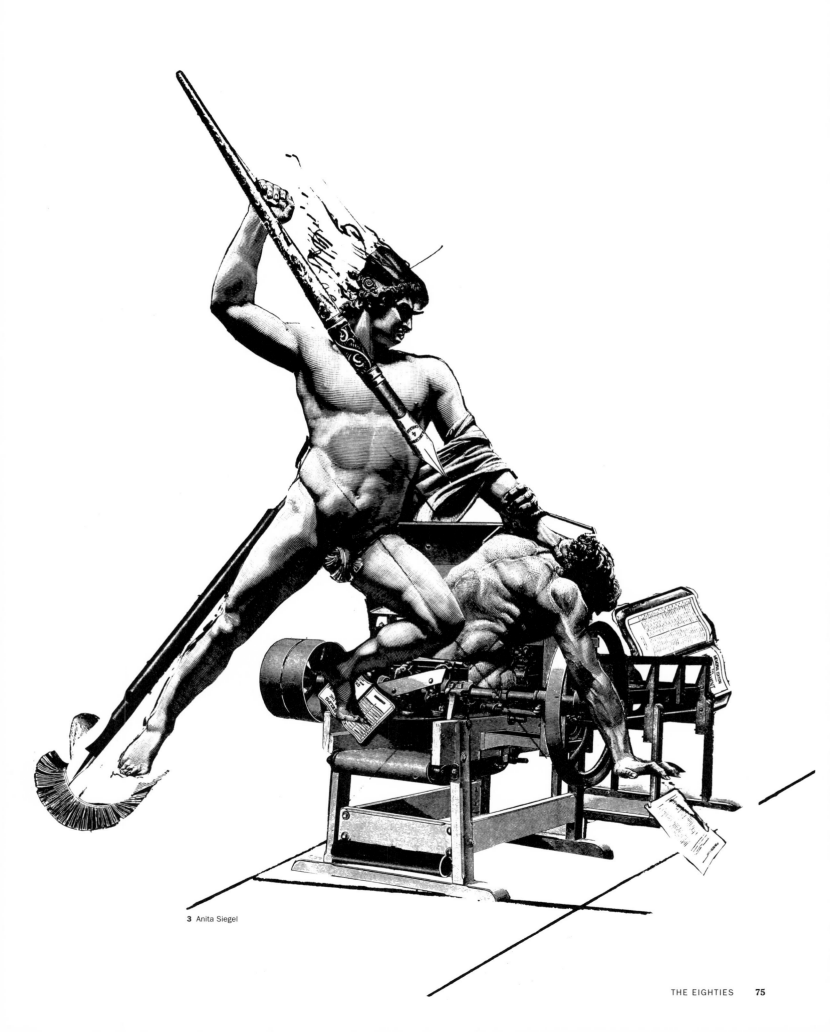

3 Anita Siegel

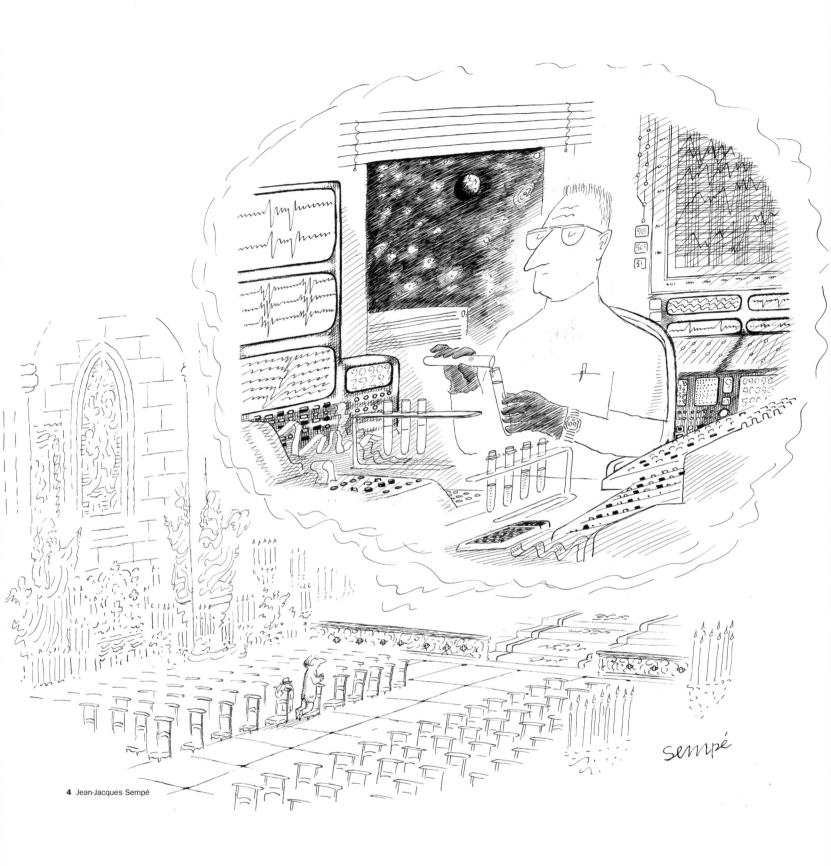

4 Jean-Jacques Sempé

5 Jean-Claude Suarès

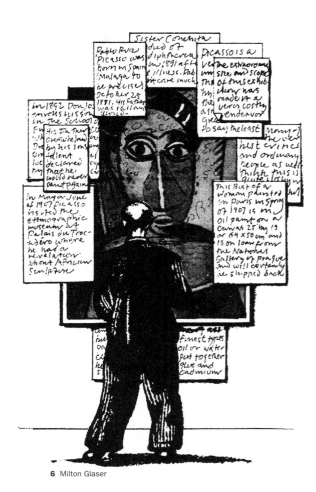

6 Milton Glaser

on the first Catholic president!" The image was published, but the lemniscate that symbolized infinity was relegated to an adjacent column.

An illustration by Jean-Claude Suarès for April Fool's Day demonstrated the artist's abiding attraction to Surrealism [figure 5]. In 1981, Milton Glaser reflected a protest against the trend in museums that makes information more important than art [figure 6]. In 1982, Dr. Mark Podwal interpreted a physician's complaint that doctors are regarded as "cold, aloof, and mercenary" technicians [figure 7].[5] The same year, Douglas Florian's sumptuous image interpreted a New Yorker's memory of subways as the poignant link to his past [figure 8]. "Since the piece was about memory," Florian comments, "I wanted a softness, an obliqueness. So I had things flowing in and out of reality and put linseed oil into my ink to diffuse the line."

In 1983, an article marked the fiftieth anniversary of the day Hitler became Germany's puppet chancellor. Marshall Arisman conjured the monster thereby set loose [figure 9]. "I was delighted to get at Hitler," Arisman reveals. "He embodies pure, walking evil. I rarely get the chance to go flat out on somebody." Also in 1983, Mel Furukawa—who hadn't worked for Op-Ed since his aborted bartending stint during the Louvre's Op-Ed art opening—illustrated a story recalling the internment of Japanese Americans during World War II [figure 10].

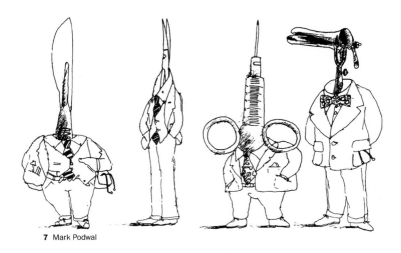

7 Mark Podwal

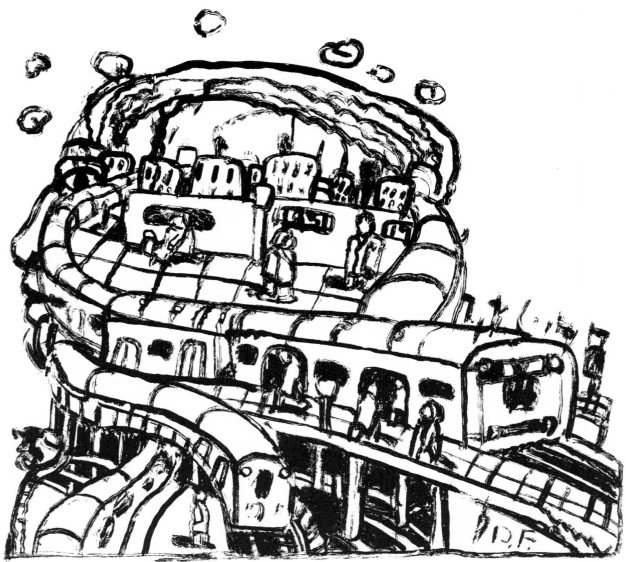

8 Douglas Florian

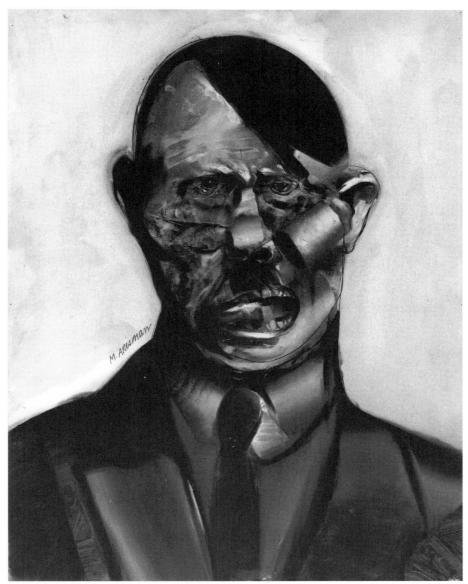

9 Marshall Arisman

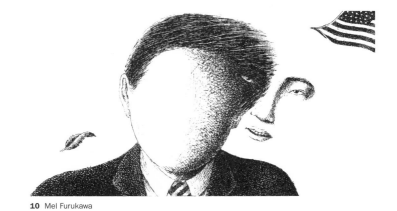

10 Mel Furukawa

Mental Gymnastics

The mighty acrobat confidently performs his trick of twirling in circles.

LOUISE J. KAPLAN

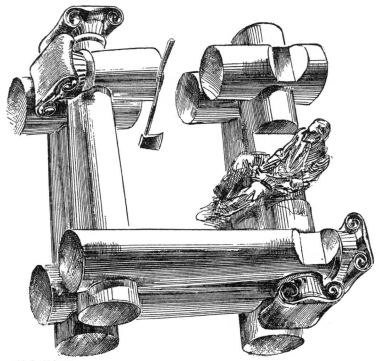

11 David Suter

The rumpled, sandy-headed, and supremely gifted David Suter taps into the riches of both right and left brains. His intellectual teasing has been an Op-Ed staple since his dazzling portrait of J. Edgar Hoover [see figure 1]. (He'd drawn one earlier image for Steven Heller.) A self-taught artist—"I went to the Corcoran art school for a month," he says, "before dropping out"—Suter is a dedicated student of art history.

"Flatness is a great topic in art," he observes. "I admire the lack of perspective in Oriental art." Nevertheless, he's also a sculptor who's had sold-out shows of his three-dimensional work. Suter's father was an intelligence analyst who told his son, "The purpose of an intelligence agency is to ensure the president knows the truth."

"The relationship of a newspaper writer or artist to the public is like an intelligence agency's relationship to the executive," Suter notes. "We're trying to help the public figure out what's going on. I hope to contribute a calm mood, especially for violently charged issues." He also maintains, "The artist builds over a lifetime a house whose foundation is draftsmanship, whose walls are blocks of related works, and whose roof is the overarching ambition for self-immortalization."[6]

Yet Suter doesn't dote on his originals. He dashes them off on the nearest envelope, napkin, or back of a previous drawing. "I'm too cheap to buy good paper," he says. "And I find expensive art supplies inhibiting. As with leaves falling off a tree, once my drawings have served a purpose, they're of no use to me."

In 1980, Suter envisioned federal wastefulness as exemplified by a Washington summer employee who was forced to "refurnish his fully furnished desk" with a government credit card [figure 11].[7] In 1981, an oceanographer called for redirecting waste from our scarce land to our vast oceans. Suter's humanized sludge, reprising the Op-Ed tradition of anthropomorphism, dove down to oblige [figure 12]. The next year, an impeccable double take marked the death of Soviet leader Leonid Brezhnev [figure 13].

Suter once worked in a pointillist style that he learned from studying scientific illustration. Using this style, he fashioned a magnificent image to illustrate China's aggressive tactics toward Taiwan. It's at once the Great Wall and a dragon whose tail surrounds the disputed island [figure 14]. But editors killed this beauty for being "too angry." Suter draws more economically now. "That's a drift that happens in art," he says. "The artist begins to feel the effort of making pretty pictures has curbed his pure expression. That careful style eventually

12 David Suter

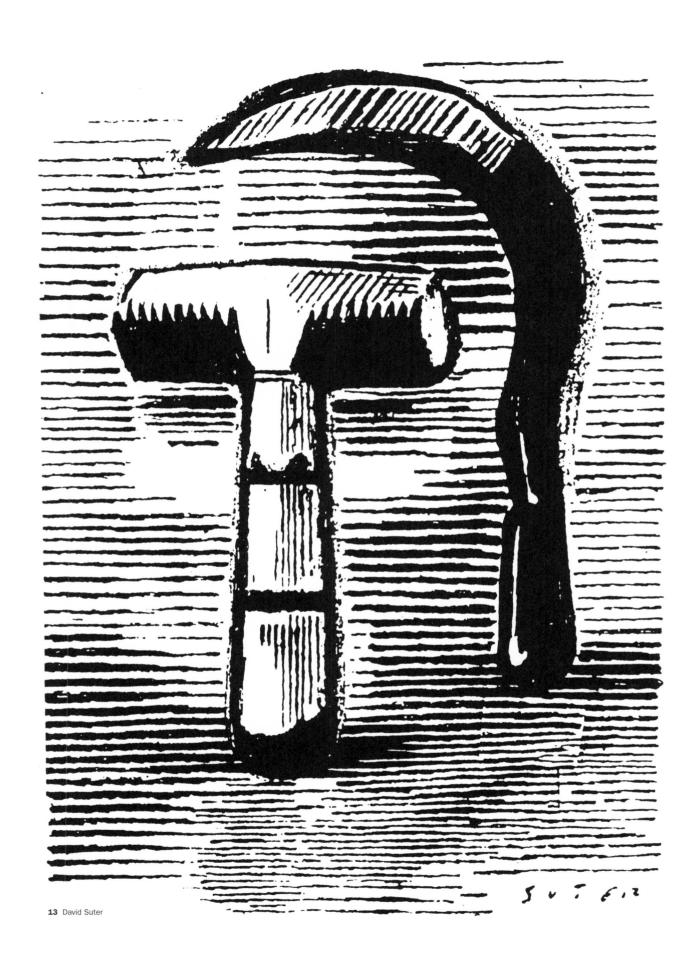

13 David Suter

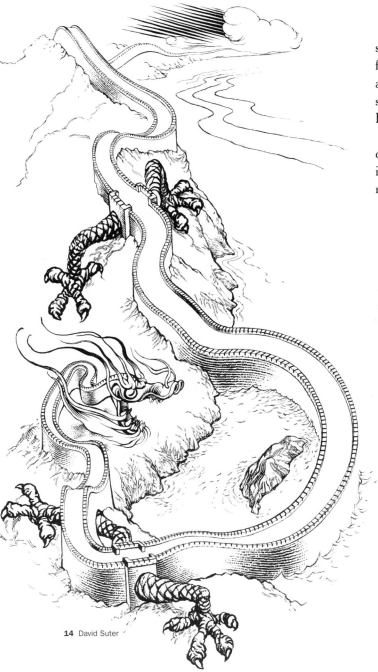

14 David Suter

For asking the artist to create an alternative style and identity, I was soundly reprimanded. Suter, however, was relieved to be outed. He found the altogether-different style difficult to sustain and feels that artistic success requires a distinct identity. "It's a crowded room," he says. "I'm standing somewhere near Escher, while Brad Holland is in Rembrandt's corner."

In recent decades, Suter notes, "the computer has replaced a lot of hand-drawn work like mine." Although his drawings often appear in publications, his work is broadening into serious painting, "apparitional" sculpture, and an interminable project of animating *Hamlet*.

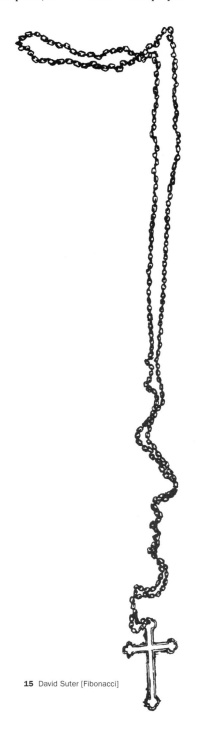

15 David Suter [Fibonacci]

broke the nerves in my wrist, and I had to abandon it." I told Suter about Ken Rinciari, an Op-Ed artist who taught himself to draw with his left hand after his right arm was amputated. "In art school they do that," says Suter, "because the left hand is wired to the right brain."

Suter devised a fictitious artistic persona, "Fibonacci" (after the mathematician who identified the Fibonacci sequence, the unending series of integers in which each number after the first is the sum of its two predecessors: 1, 1, 2, 3, 5, 8, 13, 21, . . .). It was Fibonacci who marked John Paul II's first year as pope [figure 15]. We were certain that the pseudonym's first syllable would give away the ruse, yet Fibonacci published seven drawings before being caught.

Delicate Daring

I did the Op-Ed work knowing the
art director would fight for it if the editor didn't
think the face was pretty enough.

FRANCES JETTER

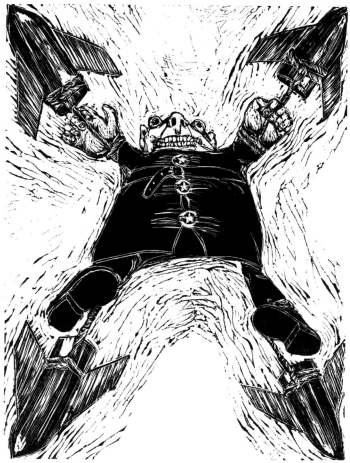

16 Frances Jetter

Frances Jetter, like Suter, began illustrating Op-Ed manuscripts in the early 1980s. These two artists share a further characteristic: much of their personal work is sculpture. While Suter's wood sculptures incorporate mirrors that summon—in three dimensions—his trademark mind tricks, Jetter casts hers in bronze and burnishes them with multiple layers of subtle patinas—including gold leaf—to fashion witty, humanoid masterworks. Her illustration credo is the antithesis of Suter's. "A picture," she says, "should cement a point of view, not give both sides." Her principles allow her to accept commissions only for theses she personally supports, which qualifies Jetter's illustrations—in David Smith's definition, cited by Marshall Arisman on page 29 of this book—as fine art.

In contrast to the unflinching boldness of her work, Jetter's ivory skin, ebony hair, oceanic eyes, and petite, elegant figure make the artist herself appear to be a fragile artwork. Appearances deceive; Jetter is fierce. Her trenchant emblems include a virtuosic image from 1980 that addressed the dangers of the arms trade. "The crazed arms salesman is being drawn and quartered," she says, "by the destruction his own products bring" [figure 16]. Jetter has been a visiting artist at Narae Design Culture in Seoul, and institutions such as the New York Public Library and the Harvard Art Museum collect her work.

The linoleum cut is Jetter's illustration medium. She carves the image on the block in reverse, and then inks and prints it. "I use a water-based ink," she notes, "so it dries quickly." Because she does her Op-Ed pieces for next-day deadlines, she works through the night. "I've done woodcuts," says Jetter, "but linocuts are easier because you don't run into knots. And linoleum has a definite texture. I use several tools to print—from ordinary wooden spoons to fancy printing tools I bought in Japan." Op-Ed ran so many articles on missiles in the 1980s that we constantly sought new ways to portray them. Jetter's bed of nails was a superb invention [figure 17].

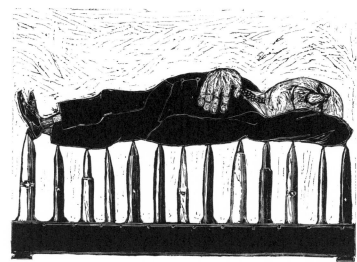

17 Frances Jetter

Unseen, Unsung, Thrilling

When an art director hires an artist, too vague
a briefing and a short deadline can be disastrous.
But a concise summary, handed out with a pair
of wings, can do wonders for flights of imagination.

RONALD SEARLE

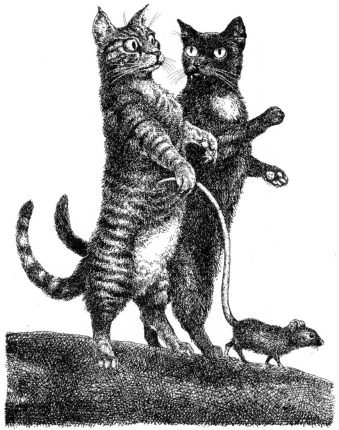

18 Brad Holland

Op-Ed art direction is invisible yet indispensable. The art director first reads the manuscript to be illustrated (or discusses the piece-in-process with its author). The next steps are to extract the argument's essence, decide on a visual direction that matches the material, and hire an appropriate illustrator. Artists may read the manuscripts, but the strongest ones know that the prose's particulars can distract from its gist and prefer an art director's detail-sparing summary.

"Even the best artists get too literal when asked to illustrate a specific text," says Lou Silverstein. "We did better giving assignments on general subjects and letting the artist make his own statement." Op-Ed's initial editor, Harrison Salisbury, codified this approach: "Art is not employed on Op-Ed to 'illustrate,' to give the reader a picture of the scene the writer is trying to describe. The task of Op-Ed's images is to create an environment which extends and deepens the impact of the word."[8] To achieve this end, the art director gives the artist an accurate sense of the writer's intent and the freedom to find his own interpretation.

The art director next serves as a sounding board for the artist's concepts, reviewing them until the best idea is clarified in a viable sketch, which then must be sold to the editor. I usually composed these sales pitches while walking—text and fresh sketch in hand—across the fast-paced art department and up spiral stairs to the sedate editorial floor.

What text specifics can be related to tangibles in the sketch for an airtight case? Tunneling through a labyrinthine storage area, I avoided the public corridors for a bit of privacy before the moment of truth. Artists appreciate the heart, soul, and spin that an art director puts into a winning pitch. "The toughest part is selling images to the editor," says illustrator Brian Cronin. And while the art director pleads their cases, artists shuffle to the tune of what illustrator Henrik Drescher calls the "sketch-approval limbo dance."

Once, while showing a drawing by Douglas Florian, an editor said, "That's ugly." "In this case," I replied, "ugly is beautiful," and continued to defend the image. Florian was outside the door and heard our argument. "I'm shocked," he said. "I had no idea you had to fight so hard for my work."

Designing the page goes quickly if the art director positions all typography, gives a rectangular shape to the remaining space, and tells the illustrator to work to those dimensions. In a more aesthetic approach, however, the art director waits for the sketch and designs the page around the art. This guarantees that the image dictates the page's rhythms. It also encourages more intriguing, irregularly shaped art, around which text is more interestingly configured. Yet this method can cause problems that can be summed up in one word: deadline. Given Op-Ed's tight timing, if the layout is delayed until after sketch approval, the atmosphere at "the good Gray Lady" may deteriorate into a bad scene from a vintage newspaper movie, in which the copy editor, sweat soaking his shirt, loosens his tie and pleads for the layout while union printers threaten to walk out.

When the final art is approved, the art director polishes the layout and oversees production. Yet this benign summary of an art director's day assumes the best of times, when the "arted" text is available a day or two before publication. That much lead time, though, is a vanishing luxury.

The worst of times? Just before publishing an essay on Middle East negotiations, a terrorist attack in Lebanon adds two paragraphs to the story, forcing a three-column horizontal picture into a two-column vertical. Or our lead piece on capital punishment is published in the *Washington Post* (an unethical multiple submission). Pulled from the page, it's replaced by a text on genetic engineering, for which a new image must be instantly created. These moments are less tense if there's an art bank whose generic, unpublished pictures

19 Ronald Searle

suffice to plug every hole. Such a resource is impossible to create, but archived images can resolve crises.

Brad Holland prefers to work ahead of the curve. "My most productive Op-Ed period was the 1980s," says Holland, "when the art director persuaded the editors that a considerable number of my banked images fit the texts." In 1981, a pair of Holland's archived felines represented the warring English and Irish [figure 18]. (Another of his illustrations, published in 1983 and discussed in regard to the long-gown convention, was also archived [see "The Seventies," figure 41].) Ronald Searle already had sent us the perfect portrayal when an Op-Ed poem lamented our planet's thirst for petroleum products [figure 19].

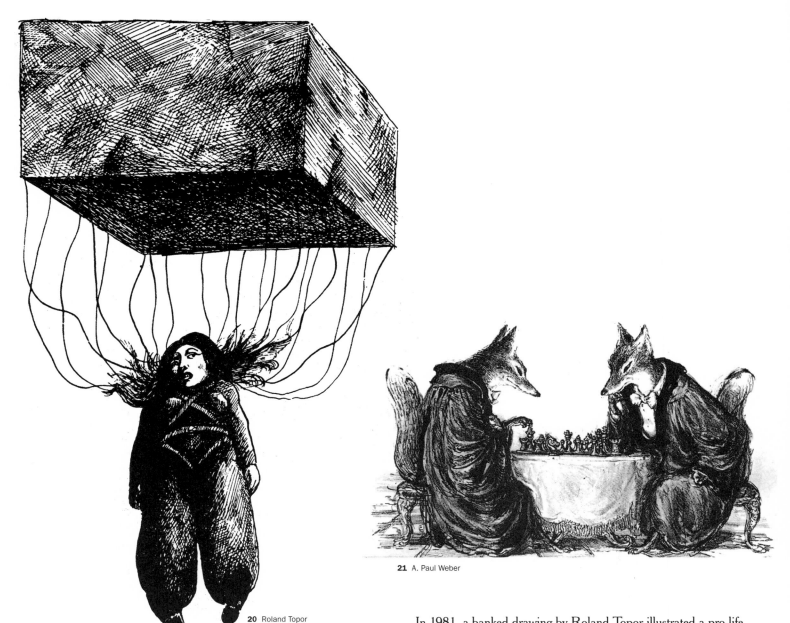

20 Roland Topor

21 A. Paul Weber

In 1981, a banked drawing by Roland Topor illustrated a pro-life rebuke: "The onset of individual life is not a dogma of the church but a fact of science" [figure 20].[9] Two years later, German artist A. Paul Weber's sly, archived image worked well with a story about tricky nuclear negotiations [figure 21]. The chess motif—a struggle of minds—recurs in Weber's work, along with his appropriation of the *Aesop's Fables* technique of portraying human wickedness through animals. Ardeshir Mohassess's image continued the 1970s theme of decapitation when paired, in 1987, with an article warning America to focus on a post–Ayatollah Khomeini Iran [figure 22].

In another worst-case snafu, FedEx claimed that Ralph Steadman's package from England had arrived at the *Times* in the morning, but by 3:00 P.M. the precious loot hadn't been found. Alerts went out to every desk, and the art director rushed to get a substitute ready by 6:30 P.M., just when Steadman's package turned up in the sports department. Or columnist Bob Herbert's interview with the president needed one hundred extra words. Or . . .

22 Ardeshir Mohassess

One memorable day started with a bird. Baltimore orioles, it seems, took up with too many Bullock's orioles and paid a price for their promiscuity—the forfeiture of their very name. An ornithological association tagged the resulting hybrid species "northern oriole," an angry Maryland politician wrote an eloquent objection to the prosaic name, and editor Curtis made a rare request. She wanted to accompany the text with a purebred Baltimore oriole in all its glorious distinction. So artist Vivienne Flesher created a comely Baltimore for the page's center.

Three hours before the page closed, two unexpected manuscripts arrived: the first a Vietnamese writer's plea for assistance, and the second a boat person's terrifying account of having fled Vietnam on a rickety raft. Curtis subbed these texts for the page's two unillustrated pieces. I felt that the compelling new chronicles merited the day's art,

but Curtis wouldn't budge on the bird. Then an idea struck. Compassion toward a broken people and ornithological specificity might be served by a single visual concept. By abbreviating headlines—copy editor Howard Goldberg graciously shortened one "hed" to the single word "Afloat"—and, replacing the top border rule with art, we carved out space for a second image that was, at once, a fragile boat and the Baltimore oriole's unique hanging-purse nest. Flesher remembers: "You asked me to draw two scrawny baby birds in that nest. I'd seen the layout with its quarter-page ad and my adult bird in the middle and couldn't imagine anything else fitting! But when I saw the new layout I understood. My drawings connected visually to become Mother America reaching up to feed two abandoned, desperate babies!" [figure 23].

Remnants of Watergate

By Dorothy J. Samuels and James A. Goodman

Richard M. Nixon's resignation from the Presidency, five years ago today, just one step ahead of impeachment for abuse of power and gross violation of individual rights, was seen as a vindication of the rule of law. Unfortunately, however, Mr. Nixon's "exile" to San Clemente and the subsequent revelations of widespread Government spying have been taken more as a national exorcism than a lesson for the future.

Nowhere is this more apparent than in the Justice Department's handling of the court actions arising from the Government excesses of the period. In representing Federal employees, as well as the Government, in scores of lawsuits filed by the victims of Watergate-era abuse, the Justice Department is defending some of the most egregious constitutional violations in a way that seeks to justify the acts of misconduct. A sampling of these cases tells the story:

Wiretaps

In defending Mr. Nixon and top officials from his Administration responsible for the 21-month-long warrantless wiretap on the home telephone of the former national security aide Morton Halperin, the Government has taken the position that there was no violation of the Halperins' privacy and that Mr. Nixon, John N. Mitchell, H. R. Haldeman and Henry A. Kissinger should be immune from liability. The Halperin tap is one of the incidents of politically motivated electronic surveillances specifically cited by the House Judiciary Committee as a ground for impeachment, and recently a Federal appeals court in Washington roundly rejected the Justice Department's stand. Incredibly, the department is weighing yet another appeal on behalf of the Nixon White House.

Mail covers

As a high school student in New Jersey six years ago, Lori Paton became the subject of an Federal Bureau of Investigation "subversive" investigation when, as part of a homework assignment, she sent a letter to the Socialist Workers Party, whose mail was then being monitored by the F.B.I. In representing local F.B.I. agents and other officials sued by Miss Paton, the Justice Department defended the propriety of the Paton investigation, as well as the Socialist Workers Party mail cover that triggered it. Following a Federal district court decision last November, which ruled such "national security" mail covers — monitoring of the exterior of envelopes — unconstitutional, the Government responded by proposing new mail-cover regulations nebulous enough to allow monitoring of the very First Amendment activities the court was seeking to protect. In addition, the Government contested an effort to enjoin continued use of the original mail-cover regulation thrown out by the court.

Dirty tricks

In April 1969, Muhammed Kenyatta, a black activist in Mississippi, was prompted to leave the state after receiving a threatening letter forged by the F.B.I. as part of the Bureau's

The aftermath: more an exorcism than a lesson

counter-intelligence program (COINTELPRO) to "disrupt" and "neutralize" dissent.

While the Senate Select Committee to Study Governmental Operations with Respect to Intelligence Activities condemned COINTELPRO as a "sophisticated vigilante operation," the Justice Department, in defending the suit brought against the agents who were admittedly responsible for the action against Mr. Kenyatta, refuses to acknowledge that his constitutional rights were violated.

Internal Revenue Service politics

Perhaps no Nixon program more fundamentally offended the principles underlying the Bill of Rights than the special I.R.S. unit formed to scrutinize the tax status of individuals and organizations engaged in dissident political activity. Most of those singled out were chosen solely because they opposed Administration policies and not because of any evidence that they violated or even advocated tax violation. Yet, responding to a suit by an antiwar activist, Walter D. Teague 3d, one of 11,000 people that the I.R.S. Activist Organization Committee (later the Special Services Staff) eventually accumulated files on, the Government argues that a valid Government interest was being served in that the I.R.S. suspected that an unspecified number of political dissidents were violating the tax laws and that the "wide publicity" given certain activist tax violators "called into question the integrity of the effectiveness of the I.R.S. generally."

The Government's attempt to justify these past abuses as the inevitable result of the decision of the outgoing Attorney General, Griffin Bell, to provide legal representation for officials sued for constitutional violations, regardless of whether such representation would involve raising defenses contrary to Government policy."This ruling reversed the guidelines of his predecessor, Edward H. Levi, which at least recognized that providing counsel in many of these suits would place the Justice Department in the untenable position of defending, in the public's name, the same unconstitutional actions that forced Mr. Nixon out of office.

The desire to protect Government officials from frivolous lawsuits is understandable. But many of these intelligence-related cases concern well-documented acts of serious misconduct, and it is disconcerting that the Justice Department is so shortsighted about the adverse public policy being established in the defense of such suits.

The Carter Administration's answer to this dilemma is amendments to the Federal Tort Claims Act that would substitute the Government for the individual defendant in most of these midconduct suits. However, the Justice Department's record in cases where the only defendant is the Government belies the contention that the proposed amendments would necessarily result in early and reasonable settlement of meritorious claims. For example, the Justice Department has gone to the mat in civil suits involving Central Intelligence Agency mail openings, arguing that the mail openings are an act of Government "discretion," an approach, incidentally, which neither the Federal district nor appeals courts have found persuasive. Further, given the Government's dismal likely result of the proposed Tort Claims amendments would be to further shield public officials from accountability.

This is the legacy that the Attorney General-designate, Benjamin Civiletti, now inherits. The challenge remains to reshape Justice Department policies to serve the higher purposes of justice rather than the narrow bureaucratic concerns and confused priorities reflected in the department's response to the Watergate-era abuses.

Five years after Richard Nixon, it's about time.

Dorothy J. Samuels is executive director of the New York Civil Liberties Union. James A. Goodman is the Washington, D.C. representative of the Committee for Public Justice.

By Benjamin Stein

LOS ANGELES — In the summer of 1974 I was, by my own ardent wish, a White House speechwriter. A few "snapshots" of those last days under President Nixon five years ago stay in my mind. I show them to myself late at night and on special occasions.

In July 1974, I was commended for my work on explaining the so-called "I.T.T. Affair." In "Operation Candor," alone among many allegations of wrongdoing, the I.T.T. matter had fallen away after my report came out. As a special reward, I was being detailed away from my usual work writing messages explaining complicated economic matters and placed in a hastidich Watergate defense task force. My new boss was Raymond K. Price, a confidant and friend of the President. The first afternoon, Ray Price took me to lunch at the Metropolitan Club. "Shouldn't we be preparing for something really desperate?" I asked. "It looks as if we're about through. Maybe a totally new kind of speech?"

"There's no way this President's going to be forced out of office," he said, and ate a spoonful of consommé.

A little later, I flew on Air Force One with the President and others to Nashville. He was so officious at the opening of the Grand Old Opry's new theater. On the plane, I got next to a Congressional liaison man with an easy Southern manner. "The odds against the President having to leave before the end of his term are a thousand to one," he said. "I heard that from Jimmy the Greek myself."

At the beginning of August, I was assigned to get together with Mr. Nixon's lawyers and write a reply to Article 1 of the Articles of Impeachment. One afternoon I wrote: "The charge

Anthony Lewis and William Safire are on vacation.

that the President misused the Central Intelligence Agency is the most clearly false and easiest to disprove." At that moment, Margaret Foote, Ray Price's secretary, told me that I was summoned to a White House staff meeting in the Executive Office Building. Gen. Alexander Haig appeared at the rostrum and said: "I am a harbinger of horror."

He then said that a tape had been found of Mr. Nixon telling someone, perhaps H.R. Haldeman, to tell the C.I.A. to lead the Federal Bureau of Investigation away from the Watergate investigation. "It may look bad now," General Haig said, "but you're the bravest people I ever served with. Keep fighting and don't go bleating to the press." When I got back to my office, there was a call from Carl Bernstein, my boyhood friend and neighbor, but I didn't bleat to him.

The next day, I walked through the White House basement to visit a friend in the East Wing. Marine aides were loading suitcases and boxes into trucks and vans. "It's nothing," Ray Price said. "Just fall cleaning."

"I have an idea," I said. "I think the President should give a speech and admit everything and throw himself on the mercy of the American people. That could save him."

"You mean apologize?"

"Exactly," I said, "and point out how well-qualified he is."

"This President does not apologize," Ray Price said.

The day of the resignation speech, someone told the White House switchboard that I was to get all calls of the citizenry with last-minute advice on how to save the President. One caller suggested that the White House staff stand on the lawn at twilight holding candles, arms linked, and sing "We Shall Overcome." I sent a memo on that to General Haig, but I never heard about it.

The last few pictures have a distinctly gray tinge.

After Richard Nixon gave his resignation speech, I sat in my office for a long time listening to the cheering from Lafayette Square. It was almost midnight when I started to go to my car, with my eyes still red. Margaret Foote accosted me, her eyes angry. "Stand up straight and tall," she said. "Don't give them any satisfaction out there."

The next morning the President gave the speech about his mother and father. There were hundreds of people in the East Room and not a dry eye among the White House staffers. When Richard and Pat Nixon left, we crowded around the South Portico to watch his helicopter leave. Frederick Dent, the Secretary of Commerce and an extraordinary gentleman, put his hand on my shoulder. I looked at him and he just shook his head.

I was moved back to my regular office writing speeches and messages about inflation and interest rates for various Ford officials.

Every morning, I had the White House communications agency play the tape of Richard Nixon's farewell message to the staff over my television until General Haig heard about it and ordered it stopped. He thought it was demoralizing the staff.

Benjamin Stein, a former speechwriter for President Richard M. Nixon, is author of the forthcoming book, "Moneypower — How to Make Inflation Make you Rich."

 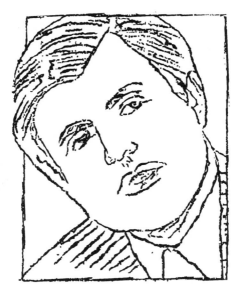

25 Andy Warhol

On the fifth anniversary of Richard Nixon's resignation, Brad Holland's image stood, wordless, as the first of four remembrances [figure 24]. "Five years later," says Holland, "they were still excavating the poor guy. Chunks of Nixon were falling off and being carted away by a little Borax mule team." The bottom article was Ben Stein's description of final, futile stabs at rescuing Nixon. A detail of Holland's departing cart would suit Stein's reflections perfectly. But there was no space for an art spot. Why not use a flopped art detail as the *headline* for Stein's article? That editor Curtis agreed to this anomaly in a paper where headlines are very serious stuff indeed was revolutionary.

Early in my tenure, one illustration's very restraint presented a problem. Ted Kennedy, a candidate in the 1980 Democratic presidential primary, was, contended pollster Daniel Yankelovich, a nebulous figure. Summoning my nerve, I called Andy Warhol: "Our article says the voters' picture of Ted Kennedy is amorphous. Would you make a shadowy, ambiguous portrait of him?"

"Umm, okay."

"Do you want to read the manuscript?"

"No, just get me some good scrap." I messengered the "scrap"— two full-face photos and one profile—to Warhol's Factory. The next day brought three huge portraits (thirty-six by forty-eight inches) on high-grade stock [figure 25]. They were elegant outlines traced from projections of the photos, but Warhol had made no attempt to capture the subject's slipperiness. Curtis felt that these meaning-free drawings wouldn't enhance the article.

"But look at that signature," I said. She wasn't impressed: "These aren't for Op-Ed. They say nothing." Loath to lose three commissioned Warhols, I fought to save one. Then Curtis called our five-person staff to an unprecedented vote. Deputy editor Steven Crist

26 Jerelle Kraus [Jerelle Rorschach]

joined me on the losing side. Although disappointed, I appreciated that Curtis upheld Op-Ed art's statement-making mandate.

We needed fresh art fast. Focusing on Yankelovich's hypothesis that voters were projecting onto Kennedy their own deepest yearnings, I started thinking ink blot and credited my drawing to "Jerelle Rorschach" [figure 26]. Making the picture was a lot easier than making the phone call.

"Just send me my drawings," Warhol monotoned.

The next day brought repercussions. Two publications called to hire Jerelle Rorschach, and art boss Silverstein growled, "We do not use pseudonyms in the *New York Times!*" I'd learned another lesson: be careful with well-known artists. Dazzled by Warhol's fame and sangfroid, I hadn't asked him for sketches.

That said, I felt that the eminent fine artist Romare Bearden could be trusted to visualize a plea, in 1981, for the United States to help (then prosperous!) Zimbabwe help itself. He depicted the nation that proudly exported food to its neighbors with the commanding figure of a single Zimbabwean farmer [figure 27].

Larry Rivers, although an acclaimed fine artist whose work commands high prices at Marlborough Gallery, fulfilled nine Op-Ed commissions on deadline in the 1980s for $250 each. His "Reagan Crossing the Caribbean" ran freestanding in 1983 [figure 28]. A parody of the invasion of Grenada by the United States, it riffed on Rivers's painting *Washington Crossing the Delaware* (itself a send-up of Emanuel Leutze's canvas of the same name from 1851). Having studied with legendary abstract painter and teacher Hans Hofmann, Rivers was—in his words—"frantic to draw the figure" and reclaimed the unfashionable genres of history painting and portraiture with panache.

He relished the Op-Ed work. When changes to his originals were needed, he'd say, "Take a Pink Pearl eraser and kind of scratch it out, then draw in whatever you need with a number two pencil." Painter, sculptor, Juilliard-trained jazz saxophonist, bandleader, writer, actor, and provocateur, Rivers was notoriously flamboyant. He described one of his electrified mixed-media pieces, *America's No. 1 Problem*, as "black cock, white cock, and ruler."

Rivers was also a loyal and generous friend who loved discussing politics, literature, and history. He wrote two self-revelatory books, and died in 2002 while his full-scale museum retrospective dominated Washington's Corcoran Gallery.

In 1983, sub art director Lisa Powers hired another celebrated art-world figure, Keith Haring, to embellish a manuscript contending that "the more people know about science and engineering, the more they favor nuclear power" [figure 29].[10]

Although I had stellar rapport with Curtis, who inherited Salisbury's respect for the art, she and I couldn't have been less alike. Her manners were better. "Let me get you a plastic cup, dearie," the impeccably coifed editor said in her surprising gravel voice when I drank Perrier from its little green bottle.

27 Romare Bearden

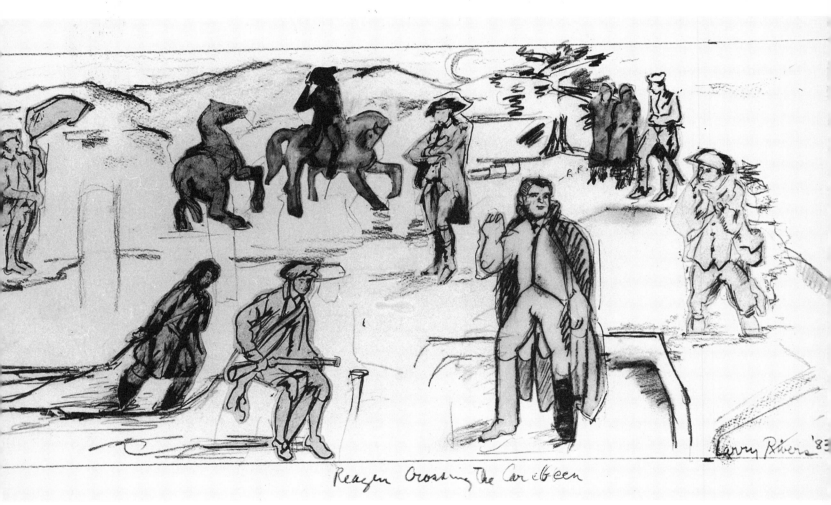

Reagan Crossing The Caribbean

28 Larry Rivers

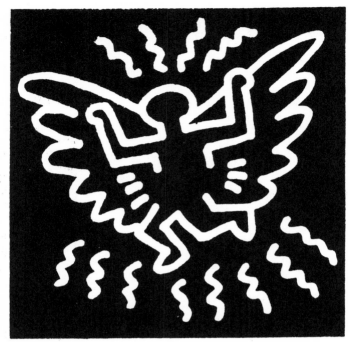

29 Keith Haring

She generously offered totes from her closet shelf—which held a neat stack of bags labeled Bendel, Bergdorf, and Saks—and she sent her staff Christmas gifts. One year, identical blocks of cheddar cheese were mailed to our homes. The following year brought miniature clipboards and personalized notepads.

Curtis unfailingly referred to her husband as "Dr. Hunt," and once sent this note to Marshall Arisman: "No one will understand your drawing, but I do. Thank you." She occasionally became obsessed with a news story. During the Soviet–Afghan war, she spread an immense map on her office carpet and memorized the name and location of every Afghan tribe.

The budget was another of Curtis's obsessions. Twice, in mid-October, she declared the year's art fee allocation exhausted! For seventy-five days in a row, I ran photos from the *Times*'s collection, dug up free imagery, or made the drawings myself.

In 1982, the *Times* replaced the unpredictable Curtis, who became a business columnist, with team player Robert Semple. In horn-rimmed glasses and buttoned-down shirt, the tall, blond, and handsome Semple embodies his Grosse Pointe–Andover–Yale pedigree. He walks softly but carries a big personality.

A *Times*man since 1963, Semple flipped a coin with another reporter to determine who'd cover the 1968 Republican presidential primary campaign of the then favorite, George Romney. Lucky Semple lost the toss, got Nixon instead, and spent the next four years as the paper's White House correspondent. He then became deputy national editor, London bureau chief, and foreign editor.

In the *Times*'s ego-charged atmosphere, Semple is the refreshing manager who discharges his frustrations on the tennis court, not in the office. He brought his deceptively calm, disciplined demeanor and full-throated laugh to Op-Ed, where, as the rare editor who doesn't fashion himself an art expert, he let his art director work unimpeded.

In the 1980s, when all mail was snail, Op-Ed received, says Semple, "about a hundred unsolicited manuscripts a day, and 60 percent of the pieces published were unsolicited." Semple followed Op-Ed's rule limiting nonstaff writers to once every six months. "Occasionally we printed something just because the voice was original and the piece was sad or funny," he says. "But it's a rare writer who can be sad or funny in eight hundred words [Op-Ed's original suggested word count]. The hardest thing about editing Op-Ed was not getting into a rut."

The Israeli invasion of Lebanon in 1982 split the American Jewish community in two. "I got FedExes from the two coeditors of the same neoconservative journal," says Semple. "One was pro and the other con. Neither knew the other was writing. That Israeli operation aroused passionate opinions." During that period, editorial page editor Max Frankel walked into Semple's office and demanded, "Is there no story other than Israel?"

"In those pre-technology days," Semple notes, "it was hard to keep on top of the news. Fortunately, there's no recorded instance of anyone turning down an invitation to write for Op-Ed. I was always looking for offbeat or amusing pieces, but people think they must be ponderous to make a point. I wish they'd pay as much attention to writing with wit and style as to substance."

From Airport to Newsprint

The anguish of departure and
the dubious ecstasies of arrival.

M. F. K. FISHER

Many foreigners who became sought-after U.S. illustrators began their American careers at the Op-Ed page of the 1980s. British artist Bob Gale's arrival was one of my first lucky breaks. He came from Tangiers, where he'd stayed with wild William Burroughs, and his work showed it. His portfolio of drawings would never make a family newspaper, but his originality shone.

The son of a Royal Air Force pilot stationed in the Far East, Gale was a schoolboy in Singapore when he saw the amazing prison drawings that Ronald Searle had created right there. "We later lived on the Malaysian Island of Penang," says Gale, "and on Malta." Then Gale invented his own island: Uralia. He created the nation's flag, as well as its history, geography, currency, and stamps.

One of Gale's Op-Ed illustrations synthesized manuscripts urging land reform for Filipino sugarcane workers and decrying legislation to subsidize growers [figure 30]. Gale's imagery takes us, from bottom to top, through the story of sugar.

I barely understood Brian Cronin's brogue when he appeared fresh from Ireland in 1984, but his Dublin portfolio was impressive. Cronin recalls the day: "You assigned me something on the spot. The next-day deadline startled me. I worked all night and brought it in the next morning to hear it was wrong. When you killed my first U.S. drawing, I started on the next one in a state of shock. I was sure I'd be blackballed forever and couldn't believe I was given a second chance."

That was the beginning of Cronin's many strong Op-Ed pieces. In 1987, he visualized the Independence Day plaint of a patriotic American disturbed that his country had become history's largest debtor. With his permission, I spliced his potent piece into three parts, so it encompassed the text and commanded the page [figure 31].

Imaginative children's book author Nurit Karlin, a former *New Yorker* cartoonist, lived in New York before returning to her native Israel. In 1987, her sharp wit addressed a protest against a proposed expansion of the Guggenheim Museum [figure 32].

In 1983, Horacio Cardo arrived. On his first trip outside Argentina, his English was shaky, but his work roared. An illustrator of Buenos Aires's *Clarín*—the world's largest-circulation Spanish-language newspaper—he'd handled wide-ranging topics with sophistication and style. Despite the brevity of his visit, he illustrated two texts and made drawings for our art bank. When time allowed, he then sent commissioned work from Argentina.

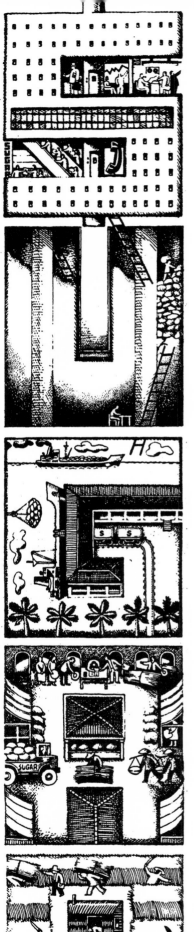

30 Bob Gale

OBSERVER
Russell Baker

IN THE NATION
Tom Wicker

In the Ring With Mr. Wotan

America Has Lost Its Way

By Richard W. Fisher

The Seven Dwarfs

On the advice of doctors I am taking a few years off from my reading of Marcel Proust's "Remembrance of Things Past." Those reports that I attacked five volumes of the masterpiece with a machete, however, are a canard. I am particularly vexed by rumors that the suspense of Volume 2 ("In the Shadow of Young Fillies") had unhinged me.

To Liz Smith, The New Republic, Bob Woodward, Paul Harvey, The National Enquirer, William Safire, The New York Review of Books, Norman Podhoretz and other scribblers who have reported this rumor I say "Fie and shame!"

True, I have been reading Volume 2 for many years. True, the suspense is not for the faint-hearted. For 365,000 words the reader wonders: Will Marcel get invited to tea with Gilberte?

The suspense, though, had nothing to do with why I was found face down in the book, apparently in deep coma. Face down in the book, apparently in deep coma is simply the way I read Proust.

Nevertheless, one of my doctors, a young man I like to humor, suggested a respite from Proust. "Refresh that jaded old spirit with something a bit different," he proposed.

This explains the loud noises heard issuing from my house by the snooper who reports to New York magazine and The Village Voice. If you believe their ludicrous press-gossip columns, you probably think Rupert Murdoch and I were having a knock-down, drag-out fight about whether Proust or Balzac is the indispensable French writer.

What rot. If these gossip mongers knew the first thing about Rupert, they'd know he holds firmly to the belief that when it comes to France, Pascal is everything. In any event we couldn't have fought, since Rupert has been out of town buying some new countries. That noise from my house that intrigued the gossips was not noise at all, but the music of Richard Wagner.

Yes, I am temporarily forsaking Proust for Wagner, specifically for "Der Ring des Nibelungen," a series of operas so endless that many devotees of the arts have found out whether Marcel got invited to tea at Gilberte's long before the curtain

Taking on Wagner as a respite from Proust.

came down on the last Wagnerian note.

The formidable challenge of listening to the "Ring" requires careful preparation. To get the old ears into shape, I spent April, May and June listening to snatches of music picked at random from recordings of the operas.

"Snatches" may be a misleading word. A "snatch" of Wagnerian opera begins at teatime and lasts through the 11 o'clock news. Studying these "snatches," however, is essential for the monumental task of listening to all the operas straight through, which I tentatively hope to manage by the time President Reagan's "Star Wars" system is in place in upper space.

Since mid-June I have been studying the character of Wotan, an unscrupulous, vulgar rogue who, though chief god, would be perfectly at home in the Chicago of the 1920's or today's New York.

Before the opera is out of the chocks, Wotan has swindled a pair of dense but strong-backed giants into building him a structure where dead heros can get together and have a good time. One senses in Wotan the same genius for draining the masculine fun and games that made professional football such a successful American industry.

The building constructed by the duped giants (who are comparable to the National Football League's inadequately paid offensive linemen) seems to be some sort of high-cost stadium. It is called Valhalla, and while Wotan's god relatives live there too, he seems more interested in having it as a retirement center for dead heroes. One thinks of Wotan happily surrounded by old quarterbacks: John Unitas, Y. A. Tittle, Jack Kemp.

As in football society, women don't count for much with Wotan. He has made his wife a common scold and promised the giants they can have his sister-in-law in payment for putting up Valhalla. Having a criminal mentality, of course, he plans to swindle the giants out of the sister-in-law deal once they get the building up.

Obviously, the character issue was never raised before the gods installed Wotan as chief. He has sundry illegitimate children scattered about, including a bevy of equestrian daughters. He has assigned them the task of collecting dead heroes and hauling them on horseback to Valhalla where the men can all enjoy being heroes together while drinking the Valhalian equivalent of Gatorade.

Haunted by doubts, I wonder: Can these Teutonic campfire boys fill my years as happily as Marcel has filled them angling for a tea invitation to Gilberte's? Stay tuned.

DALLAS

I was born in the 1940's at the dawn of America's global prosperity. With the Great Depression and Great War behind us, the United States emerged as the pre-eminent global power. Indeed, over the next 40 years our economy propelled the world forward. At home, America set the pace for the world in inventiveness, in creating jobs, in raising living standards. Abroad, we shaped the trading and monetary systems as masters of a smooth-running, free-trading economy, as custodians of a well-managed currency and as financiers of the world.

Our economic might underwrote peace and prosperity. It provided the military wherewithal to repel Soviet encroachment on democracy. It provided for the resurrection of our great nations in Europe and the Pacific. It became the global catalyst of reform, of growth, of hope for the future.

This is the happy world my generation grew up with. And this, regrettably, is the world that is no more.

We have lost our way. Our claim to inventiveness and capitalist accomplishment has been surrendered to the Japanese and others who once cowered in the presence of our economic might. We were once the progenitors of a world order of free trade and stable monetary order. We are now its biggest threat.

Democrats, the political children of the free-trader Franklin D. Roosevelt, campaign for the Presidency on platforms of protectionism and economic nationalism. Their Republican

Richard W. Fisher is managing partner of Fisher Capital Management and chairman of the Dallas Committee on Foreign Relations.

Shall we throw in the towel?

counterparts preside over policies that have debased our currency, destabilized global trade in money and goods and set the stage for an inevitable demise in our economy and our prestige. They cannot balance our budget. They cannot even finance domestically our own Government. They have led us into becoming the largest debtors in the history of mankind.

For a moment, it looked as if Ronald Reagan would succeed. His persona revived our spirit. His enthusiasm fueled our belief in the magic of growth and the majesty of our military might. But he took a big gamble. He financed America's renaissance with huge amounts of debt. Embracing untested supply-side theories, he borrowed from the future by leveraging the economy to the hilt. Growth today, he said, would be financed tomorrow. The gamble failed.

A great nation simply cannot control its destiny without control of its financial wherewithal. It cannot, for example, lean on the Japanese when it is dependent, as we are, on Japanese capital to finance its economic growth, and, indeed, its social-welfare system and its military. It cannot insure stability in Mexico and Latin America without providing the capital and markets necessary to keep these nations from resorting to non-democratic alternatives. It cannot fulfill the dream of responsibly removing nuclear weapons from its

front-line defense in Europe when it cannot pay the greater cost of bolstering conventional weaponry and manpower.

Thus our destiny as a nation has come to a fork in a one-way road. Unable to go back, we can go forward in either of two directions.

One route contemplates an attempt to retain our prominence as leader of the free world. It is the immediately more painful alternative, for it requires that we get our economic house in order.

It requires that we eliminate our borders in the only way it can be done: by cutting spending and raising taxes. It means tightening our belts severely. It implies slowing growth and a temporary recession.

To be sure, a self-inflicted recession would be tough on Texans, on farmers in Kansas, on workers in all industries. And it would be brutal for Mexico and other third world countries that depend on United States growth to sustain themselves.

But if we work closely with our allies, we could weather the storm. In return for our taking this bitter medicine, they must be willing to take up the slack by opening their purses and their markets. For they, too, realize that if we do not get on with it now, postponing the cure until later will be more painful and possibly fatal.

Politically, it is doubtful that we will take this road. The President, blind to the frightful risk he has imposed upon the nation, still believes you can maintain a trillion dollar defense and economic growth by borrowing from others. And no candidate to replace him, Republican or Democrat, has the backbone to call for the harsh measures we must take — including higher taxes and reduced social spending — if we want future generations to enjoy America's glory. They remember how easy it was for Ronald Reagan to defeat Walter F. Mondale with utopian economics.

This leaves us with the second course. It is to admit to ourselves and to the world that we are no longer fit to take the lead. We have allowed our ablest to be overcome by the syphilis of debt and cannot bear to take the medicine. Thus, we should notify our allies that we wish to relinquish our role as the fulcrum of global growth and protector of world freedom and retreat into the status of an equal but not pre-eminent power.

In some areas, such as the defense of the North Atlantic, we would arrange to share our obligations on an equal basis with West Germany, France and Britain — and not as supreme commander. In other areas, such as the International Monetary Fund and the economic arenas, we would hand the baton to Japan. In almost all world forums we would move out of the driver's seat and take a seat elsewhere on the bus.

It is impossible to estimate the degree to which acquiescence of this kind would demoralize the people of the Western world and encourage the Soviet Union. Still, telling the truth is better than living a lie. If we haven't the will to stay on top, we must arrange for others to fill the void.

President Reagan and his potential successors appear to have chosen the second option. Maybe this is what the American people want. We can certainly live with it. Many of our global obligations are tiresome burdens. It might be nice to simply acquiesce. But having grown so spoiled, I confess the prospect depresses me. I was always proud to be an American — to be the best, the strongest, the richest. I would like my children to experience the same feelings.

Democrats need a leader, not a collective opposition.

The strongest and saddest impression this viewer took away from the collective appearance of the Democratic Presidential candidates on national television was that Snow White was missing, while the Seven Dwarfs prattled on.

That's because the general verdict on this first of what will be many dreary candidate cattle shows seems to be that "everybody won because nobody really lost." But if everybody won, then in fact nobody won.

It's also because Snow White actually may have been absent, in the missing persons of the most talked about and — some would say — the most impressive Democrats: Governor Cuomo of New York and Senators Nunn of Georgia and Bradley of New Jersey.

Also, the "front-runner" until a month ago, Gary Hart, had been forced to withdraw and so was not on hand. The only woman showing active interest in the Democratic nomination, Representative Patricia Schroeder, was shut out by the show's organizers.

The collective impression left by the Seven who did take part was that of the proverbial peas in a pod. They agreed on most issues, they didn't like Ronald Reagan or any of his works, and they said they could do better. They smiled a lot, they were polite, they knew that they were talking about (mostly); except for Paul Simon's bow tie, Rich Gephardt's trade amendment, and an occasional tart remark by Jesse Jackson about "slave wages," George Wallace's verdict on the major parties applied to the lot of them.

That's exactly what the Democrats don't need: a collective opposition, no matter how impressive, rather than a distinctive leader. While Mr. Hart was still in the race, he provided considerable intellectual leadership; if Mr. Nunn were to enter, a strong stand against Mr. Reagan's national security policies might well be imagined; and if Mario Cuomo had not refused to run, the extensive list of economic and social problems ignored or created by the Reagan Administration might be at the center of contention.

At this early stage, it would be unfair to extend this judgment on a single television program to the 1988 campaign as a whole. There's plenty of time for one of the Seven to emerge from the pack with a compelling theme or a dramatic personal showing. Senator Biden, for example, as chairman of the Judiciary Committee, might take an effective lead against Robert H. Bork, Mr. Reagan's Supreme Court nominee; but the early evidence is not encouraging.

Alternatively, Snow White might yet appear from among those missing from the cattle show, if one should step in and take charge of the race. If viewers, moreover, were not enthralled by the Democratic Seven, wait till they get their first look at the Republican aspirants; as Mr. Reagan — who'll be the missing Snow White on that occasion — likes to say: "You ain't seen nothin' yet."

For the moment, however, the performance of the Seven is what the voters have to go on, and it does not seem to me to have been impressive. The problem for these candidates, after all, is not just to rattle off statistics, slogans, voting records and routine denunciations of all things Reagan. It is, rather, to establish forceful personal reasons why he (or she, if Representative Schroeder enters) could most effectively lead the Democratic Party back to power, then lead the country to the eminence in which American voters passionately want to believe.

Presidential politics, after all, though it certainly involves issues, ideology and parties, always comes down to a choice between two — at most, among three — persons. Americans elect a President, not a party or a platform. That has almost always been true, and in the age of television, personality has become more than ever the deciding factor.

This is a far more complex — even mysterious — process than the "selling soap" comparison so often invoked. Nor even Ronald Reagan was elected for his smile or his hairdo, and no one will be in 1988 either. Sam Nunn, for instance, has emerged as a national figure despite a wooden television style and conventional looks — primarily, in my judgment, because of forcefulness, candor and an appearance of command on security issues and in the Iran-contra scandal.

Voters look ultimately for someone to believe in. What causes them to place their confidence in a candidate is not always clear, but it's seldom because he or she acts and talks like everyone else in the race, and even less often because of artifice or posturing on television. Whatever it is, voters know it when they see it — and probably are still looking after the Democrats first showing.

Why Aliens Remain Underground

By Peter L. Zimroth

The Fourth of July is a time for remembering America's immigrant heritage. It is also a time for serious thought about the message we want to send to America's future citizens.

The Immigration Reform and Control Act of 1986 became effective May 1. It is both a wonderfully generous law, filled with the hope and promise of the Statue of Liberty, and a harsh enforcement measure, bringing with it fears of unemployment and deportation.

Congress obviously wanted the new law to convey these contradictory messages. It certainly wanted to make our borders less porous and make it more difficult for illegal aliens to work here. For the first time, therefore, obligations accompanied by serious penalties were placed upon employers to dissuade them from hiring undocumented aliens.

The trade-off for these extremely tough sanctions was an amnesty program. For a 12-month period, aliens who entered the country before 1982 and who have lived here continuously and unlawfully since then, may qualify first for temporary residence and then for citizenship. Millions of illegal aliens living in fear and darkness were thus given hope.

That hope will remain empty, however, unless the amnesty program is approached with an open and generous spirit by the administering agency, the Immigration and Naturalization Service. The I.N.S.'s performance during the program's first two months has not been distinguished by openness or generosity.

As of mid-June, about 135,000 aliens had applied for legalization across the country. Only about 14,600 aliens had applied in the eastern region, which includes New York, New England, the Mid-Atlantic states and Puerto Rico. Even the I.N.S. had expected that by now as many as 68,000 would have applied in New York City alone.

Why such a poor response? First, many aliens apparently do not understand the substantive requirements for legalization. Second, many are obviously skeptical about a program administered by an agency that until last year had as its principal concern their deportation.

The Immigration and Naturalization Service must be much more forthcoming. It must understand that for many aliens it has been and remains "the enemy." For this reason, extraordinary efforts must be made to calm unjustified fears about the amnesty program. There must be much wider dissemination of the goals and requirements of the program. If, as the I.N.S. claims, most of the applications received thus far have been granted, that fact should be widely advertised.

The original legislation required the I.N.S. to undertake a broad publicity campaign. It has not done so. On the contrary, the evidence suggests that it has contributed to skepticism and fear in the alien community. Some of its regulations, for example, are more restrictive than the statute requires. In addition, the I.N.S. has deterred applications by stating in regulations and on the application form that an applicant is subject to deportation if he or she is found to have committed fraud during the legalization process.

No one should commit fraud, and no one should countenance it. Congress was as concerned about fraud as is the Service. Nevertheless, Congress understood that many aliens would be deterred from applying if there was any chance that coming forward could lead to deportation. That is why Congress provided that fraud could lead to criminal prosecution, but not to deportation. The I.N.S., however, has smuggled the possibility of deportation back into the regulations, thus violating Congress's intent.

Finally, the Immigration and Naturalization Service has discouraged applications by allowing its local offices to act in ways that heighten skepticism. Certain offices have required applicants to apply for a Social Security number and have further required that the offices be the custodian of the cards pending the determination of the legalization application. Although the I.N.S. has privately moved to correct this practice, its existence has raised concern about how the Government would use the card if the legalization application were denied. Would the cards later be used

to identify illegal aliens so that they could be deported?

Finally, the I.N.S. has refused to announce a clear policy with respect to two important aspects of the program — the kind of documentation necessary to prove residency and the status of nonqualifying family members of a qualifying applicant. Such confusion has encouraged wariness.

The Immigration and Naturalization Service knows that the response to the amnesty program has been inadequate. It also knows that only 10 months remain in the program. Yet little seems to be happening. The agency must begin to view amnesty as more than just another bureaucratic program. It must stop practices that deter applications and undertake its own campaign to broadcast information about the statutory requirements. It must do so in a way that allays fears about its own role.

Congress, too, has a role to play. It should appropriate the funds necessary for the I.N.S. to carry out the broad publicity campaign the statute requires. And it should begin to consider now the possibility of extending the life of the amnesty program in order to make up for the inadequacies of these last two months.

The 12-month period for applying for legalization overlaps with the bicentennial anniversary of our constitutional Government. The bicentennial is a time to celebrate the strengths of our system. It is also a time to welcome into that system the millions of immigrants who have been living here secretly. We should not let this historic opportunity pass without making a sincere effort to insure that the amnesty program succeeds.

Peter L. Zimroth is the Corporation Counsel of New York City.

32 Nurit Karlin

The organizers of the Statue of Liberty's centennial tall-ship parade invited a Chilean ship, the *Esmeralda*, on which Augusto Pinochet's navy had conducted torture. A text protesting that invitation prompted a vision by Cardo [figure 33]. Al Hirschfeld, Brad Holland, and Saul Steinberg each called to ask, "Who is this Cardo?" For one, he's written seventeen books on chess strategy. For another, he's lucky to be alive.

During Argentina's Guerra Sucia (Dirty War), the military found Cardo near his home and shoved him into a truck that held soon-to-be *desaparecidos* (disappeared ones). (Disappearing was worse than dying: after the military tortured and killed its victims, it erased all evidence of their existence and reared the victims' children as their own.) Cardo's clean-shaven wallet photo didn't square with the beard he had at the time. From inside the truck, he saw a former schoolmate, an American. "Robert!" he shouted. Robert told the gunmen that his friend was a journalist, not a guerrilla. But he couldn't explain the facial hair. So he ran to Cardo's home, got a newer identity card from Cardo's mother, and presented it seconds before the truck took off. No one else in that vehicle survived.

In 1988, an essay predicted that we'd abandon network television for cable. Cardo invoked the Gorgon of Greek mythology: the cords radiating from Medusa's severed head unplug from their juice as we cut our umbilical attachment to traditional television [figure 34]. Also in 1988, columnist A. M. Rosenthal was the first foreigner to visit Perm 35, a distant Soviet prison. Cardo visualized his story [figure 35].

"The high cost of presidential campaigns forces contributors and candidates to engage in a ceaseless communion from which people without money are excluded," stated the article that Cardo's "Trojan pig" visualized [figure 36].[11] This Argentine artist moved to the United States for—full disclosure—the eleven years of our marriage. In New York, he created *The Story of Chess*, an illustrated book that teaches chess through an original fable of the game's origins. He then returned to Argentina and resumed illustrating *Clarín*. Cardo's current three-dimensional paintings, grown to epic size, are inspired by the gorgeous, intricate drawings that he's made for his next book, *Sigmund, Fraud, and Psychoanalysis*.

Hoping for illustration work to support his fine art habit, Jonathon Rosen flew from California to New York in 1985. His portfolio of winged, hybrid creatures whose disembodied limbs were cobbled together with mechanical parts earned him an immediate Op-Ed piece, his first illustration in New York. Rosen photocopies his drawings to accelerate their decay, and he calls himself a "beneficiary of breakdown. People see that I'm reflecting the anarchy of our social situation. Part of my job is to agitate."

Rosen remembers his first sighting of a Walkman: "It was a shock to see someone with mechanical stuff strapped to his body." He then began to extend bodies with artificial devices. In 1988, he addressed the Soviet practice of committing healthy people to psychiatric

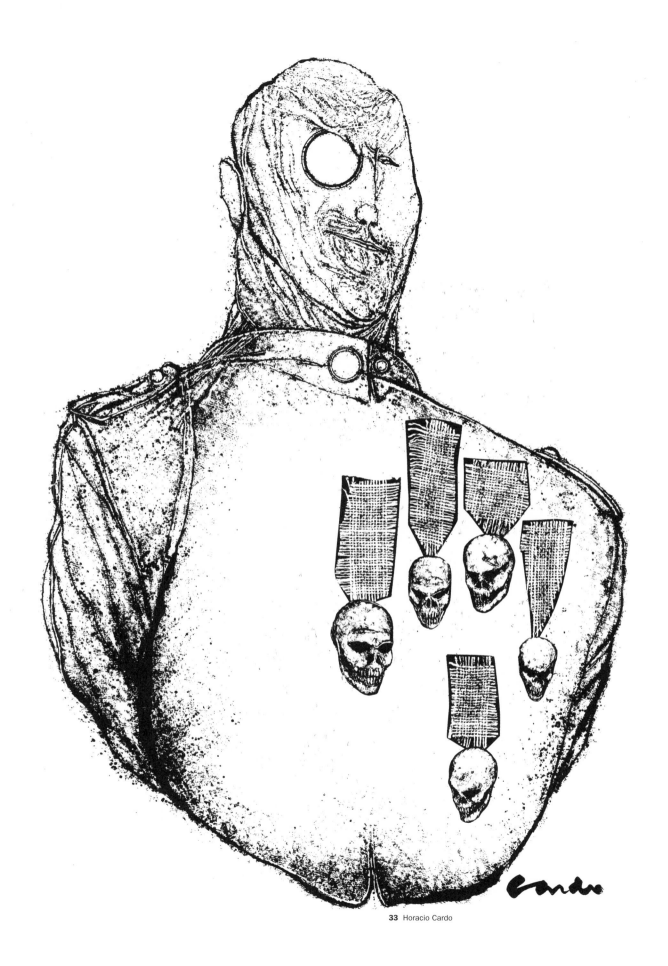

33 Horacio Cardo

34 Horacio Cardo

In Deep Russia, the Camp at the End of the Road

By A. M. Rosenthal

S ometimes, the snow swirls low across the road, drifting in from the forests. The world is gone and white prairie, entirely. It is like traveling through one of those gentle dreams of cloud.

We are in deep Russia. Moscow is about 1,000 miles away, by air and then four hours by road through the foothills of the Ural Mountains. Here European Russia ends and the great eastward stretch of the Soviet Union begins.

"Beautiful, isn't it so?" the young driver says, and for a long time nobody says anything else. We just float

ON MY MIND

through the whiteness and the peace. Then the road ends at barbed wire. We get out at the prison camp.

Perm 35 is part of the chain of prisons, labor camps, insane asylums and frozen villages of exile where Soviet governments locked away those who opposed them in word or thought — sometimes for decades. No foreigner had been allowed into Perm 35 before.

The camp, named for the industrial city 80 miles away, became a hated symbol of the whole Soviet network of political imprisonment and torture through hunger, cold and isolation.

For all his time in power, Mikhail Gorbachev denied that the Soviet Union held political prisoners. But in the city of Perm, in a tiny hotel room with a large TV set, we watched Mr. Gorbachev as he told the United Nations that "no longer are people kept in prison for their religious and political views."

We knew that was not quite so. But it was a fine moment of history — Mr. Gorbachev acknowledging publicly the reality of the Gulag, and so of the existence of Perm 35.

We knew that before Mr. Gorbachev visited New York all the prisoners were freed from Perm 35 and other prisons who had been incarcerated solely under the infamous Article 70 of the Criminal Code. That sets the price for almost any kind of expression distasteful to the Soviet Government: ten years of prison, plus five years of exile, usually in Siberia.

But we also knew that still in cells were many prisoners convicted of crimes like trying to flee their own country. And we knew that it was not only a matter of numbers but of demolishing the laws of political imprisonment and state power to enforce them, which still exist.

Still, plainly things are changing under Mr. Gorbachev, and we felt we could approach the camp with more interest than dread.

Traveling with me from Moscow was Ivan Rakhmanin, an official of the Procurator's Office, a bureaucratic closed circle that prosecutes and convicts prisoners and then is the only avenue for their complaints of mistreatment in prison.

Earlier in the year the Soviet Government decided to reply publicly and

critically to The Times about columns I had written on political prisoners; the letters were signed by Mr. Rakhmanin. Last month the Soviet Government agreed that I could visit Perm 35.

In Moscow, Mr. Rakhmanin said I could not go to Perm 35 after all. Yegor Yakovlev, the warmly dignified editor of The Moscow News, who was in the room and whose newspaper had printed one of the columns, bawled him out furiously for going back on his word. He stomped out, gesturing to an astonished Mr. Rakhmanin to follow him, called the top procurator and got permission for the visit to go ahead.

There were two others in the American contingent — Philip Taubman, the Moscow bureau chief of The Times, winding up more than three years of fine reporting, and Catherine Fitzpatrick, head of research for Helsinki Watch, whom the Soviet Union permitted to come from New York as my interpreter.

We were not allowed to be alone with a single prisoner for a single moment.

Everywhere we went we were accompanied by about a dozen assorted officials: Mr. Rakhmanin; a procurator from Perm; the colonel commanding the camp; his staff officers; a senior inspector who was his boss in the M.V.D., the Ministry of Internal Affairs; and some others who were not introduced.

The grounds were divided into fenced-in walkways and there were gun turrets, but the barracks were clean. There were laundered blankets on every bed. As a matter of fact, the whole place was positively glistening.

Fresh paint was everywhere and the canteen was bulging with butter and cream. Each prisoner wore a new, pressed uniform.

Released prisoners from Perm 35 are haunted by the punishment cells. Repeated sentences there often add up to years in the cold and gloom, with rations of bread and gruel every other day, nothing in between.

The colonel told us that 15 prisoners were in for the treason of trying to flee the country. Then he informed us that no one prisoner of any kind happened to be in the punishment cells that particular day, but we could see the cells themselves.

Moscow permits the first visit to Perm 35.

They had boards for beds and were hardly inviting. But each cell had a large new electric bulb, dazzlingly bright. The single heating pipe, which former prisoners say was often icy for additional punishment, was comfortingly warm to the touch. All the steel doors normally slammed shut to block out the world stood open.

We were informed we could not disturb prisoners at work by talking to them, so engrossed were they at their lathes and sewing machines. But we could see some we had requested, at the end of the day.

So we walked about in silence, except for two prisoners who whispered as we passed — it is a show for you.

Then, in an instant, the show ended. A prisoner bolted from a cloth-cutting room, right into the crowd of officers and visitors, and clearly and calmly said: "I must talk to you. The K.G.B. will kill me, but I must talk to you."

The officers shouldered him back; we were not permitted to talk to him again. As we were walking from one building to another, another prisoner walked toward us, startling the officers by being out at all, and in English said that he had to talk to us.

"Speak Russian!" shouted Mr. Rakhmanin and the officers.

"Learn English!" the prisoner suggested before he was moved back. His name tag said Valery Smirnov. He was convicted of treason for trying to leave the country and plan-

ning to reveal how the Soviet Union stole Western business and technology information.

Then the colonel told us that as it happened, six of the men we knew were politically active and articulate had been hit by a sudden epidemic of grippe and were in the hospital and could not be seen despite our demands.

As we left one building a window in the hospital ward was flung open and somebody shouted: "We want to see you."

We never saw the men locked away from us in the ward. Mr. Rakhmanin never budged on that.

We were given time to talk with only four prisoners before Mr. Rakhmanin insisted on heading back. Each marched into the room, stared straight at the semicircle of three foreigners and eight or nine Soviet officials. Then they spoke of illegal arrests and bad treatment — including torture by cold — with a bravery that will never leave the realm of the Americans.

The Soviet officials will remember the day too. They had never been through an experience like it, and all of them clearly thought it was madness — foreigners questioning Soviet prisoners in a Soviet camp.

The officers showed far more anxi-

ety than the prisoners. Sometimes they harangued and argued with the prisoners. Sometimes they shouted angrily at each other. They rifled irritably through the book of prison regulations to prove their points.

Everybody berated the stunned commandant — his bosses even more than the prisoners. Mr. Rakhmanin shook his finger under the colonel's nose and said he better not punish the prisoners for what they said. Then he scolded him angrily for not shaving prisoners' heads close enough every

month.

Aleksandr Goldovich, a 30-year-old physicist, had a very closely shaved head. He told us he had tried to escape, at a run, back to Finland and was picked up by a Soviet trawler. A roll of film showing "negative scenes of Soviet life" was found in his boat, the authorities charged. He said sadly that it was true that he had a roll of film, but all it showed were pictures of his apartment in Moscow, which, he admitted, was very small.

Mr. Goldovich said there was some more food now, but that "torture by hunger had been replaced by torture by cold." He was a good Christian, he said, and could we possibly get him a bible?

Ruslan Kentochiev, a young Russian who had tried to escape the Soviet Union by contacting the American Embassy and fell right into a K.G.B. trap, walked in straight-backed and unmistakably sad the men locked in the hospital sent word to remember them. Then he said coolly that the officers in that room

would punish those who had spoken to us. He said Mr. Gorbachev wanted Western approval and that Western pressure had helped bring freedom for the "Article 70's." He stood and said to the Americans: "It is balm to my heart that you are here . . ." Then he left the room, erect, as if on parade.

On the way back we stopped here, a half-hour from the camp, for dinner.

Mr. Rakhmanin toasted Soviet-American friendship. I toasted that too and added another toast, for the Soviet citizens who had sacrificed their own freedom to bring nearer those liberties now being endorsed, in measure, by the very leader of their nation. I regret now that I did not specifically mention the prisoners in the locked hospital ward ☐

A message from a locked ward.

Drawings by Horacio Pablo Cardo

IN THE NATION | Tom Wicker

Epitaph for a Cycle

S ay this for Ronald Reagan, as his eight years in the White House near their end: He was one of the few Presidents to take office with a definite program, then to achieve most of it.

But even as his chosen successor prepares to take office, the "Reagan Revolution" already is beginning to look like a finishing cycle, approaching its demise even before its progenitor returns to California.

What were the major promises Mr. Reagan made in 1980?

To reduce taxes. The new President pushed through the biggest income tax cut in U.S. history in his first year in office. This bold move helped produce record Federal deficits, despite his denials, rather than the predicted balanced budget; but the more significant promise was kept.

Nevertheless, a winning Democratic Presidential ticket might well include a centrist male from anywhere but the Northeast with Jesse Jackson as his running mate. Certain defeat for the Democrats would lie in the nomination of a liberal Northeastern ethnic and the exclusion of Jesse Jackson from the ticket. ☐

To build up the military. This, too, was accomplished, if measured by military expenditures — although there are plenty of critics to say that too much was spent in the wrong way for too little.

To get government "off the backs" of the American people. This pledge was kept primarily through extensive deregulation — some of it relaxed enforcement — of airlines, work place safety, financial institutions, environmental protection, the trucking industry, toxic waste disposal, even food inspection.

To get tough with the Soviet Union. Mr. Reagan's military buildup, his early hostility to arms control, and his harsh rhetoric did harden Soviet-American relations, to the point that Moscow broke off arms negotiations in 1983.

As 1988 draws to a close — to take the last point first — Mikhail Gorbachev has offered before the United Nations to make sizable cuts in Soviet military forces, proposing what some consider, in effect, an end to the cold war. Mr. Reagan and President-elect Bush assured Mr. Gorbachev at a friendly luncheon that they hoped for the success of his campaign to improve the economic and political system of what the President used to call the "evil empire."

Thus, Soviet-American relations have moved from the depths of hostility to a new height of comity. Did Mr. Reagan plan it that way? Or was Soviet economic distress more responsible for the turnaround? Either way, what now seems in prospect is a new and more far-reaching form of

détente, in sharp contrast to the grim outlook of the early Reagan years.

At home, the "Reagan Revolution" seems exhausted. The heaviest political pressure — domestic and international — bearing on Mr. Bush, as he awaits inauguration, is at least partially to undo the big Reagan tax cut of 1981. Even if the new President maintains his no-new-taxes pledge, pressures to reduce the Federal deficit could move the Democratic Congress toward a tax increase with which Mr. Bush might have to go along. The political prospect for his own campaign proposal — to restore a tax break for capital gains — is dim to dark.

As for the military buildup of the 1980's, the public concerns that made this a winning issue for Mr. Reagan have long since dissipated — in controversy over expensive toilet seats, profiteering, cost overruns, hard choices among weapons systems, the President's S.D.I. pipe dream, Caspar Weinberger's inflexible demands for more, the budget deficit and the vivid contrast between Pentagon affluence and poverty in the streets.

The end of the Reagan years.

Mr. Gorbachev's stated willingness to cut back his armed forces can only make it more difficult for Mr. Bush to demand, much less win, a further buildup. Particularly because of budget pressures, he will be hard-pressed even to build inflation into the Pentagon budget, much less to increase real expenditures.

Pressures are even building for a rollback in deregulation, one of Mr. Reagan's strongest promises and most touted accomplishments. "I don't see deregulation as a driving force anymore," says the New York Republican, Senator Alfonse D'Amato, a sensitive barometer of such matters as whether the voters any longer perceive a need to get the government "off their backs."

Crowded, perhaps unsafe airlines and airports, continuing scandals about toxic waste disposal, safety problems in the work place, the savings and loan crisis (which the General Accounting Office warns could "imperil the safety and soundness of the banking system"), Mr. Bush's campaign pledges to crack down on environmental hazards, even the 1987 stock market crash — all contribute to the public sense that in the matter of deregulation, enough is enough and perhaps too much.

Maybe that's even a fitting epitaph for the "Reagan Revolution" itself. ☐

Democrats Dare Not Deny Jackson

By Paul Robeson Jr. and Mel Williamson

T he presence of the Rev. Jesse Jackson portends a reshaping of American politics. No Presidential candidate of any party so eloquently and tirelessly described the needs of the nation and its citizens.

The unceasing efforts to discredit and politically destroy the Rev. Jackson cannot obscure the fact that he was the dominant positive personality of the campaign. If he were not black, he would now be the President-elect.

The reason for this is simple. The Rev. Jackson has combined the two "dirty little secrets" of American politics — class and race — into a progressive message of economic justice that is potentially unbeatable. The power of this message is irresistible, because as has arrived just as surely as the time for civil rights arrived a quarter-century ago.

Just before his death, Dr. Martin Luther King Jr. began the modern struggle for economic justice with his Poor People's Campaign. Now, the Rev. Jackson's expression of the ideology and goals of that crusade offers a positive solution to the nation's most pressing economic and social problems. His message appeals to the majority of American citizens — those with annual family incomes below $50,000 or individual incomes below $25,000.

At the same time, cold war liberalism no longer provides a viable alternative to the Bush foreign policy. With political power firmly in the hands of the Gorbachev generation, Soviet foreign policy has irrevocably broken free from the constraints of

Paul Robeson Jr. is a lecturer and journalist. Mel Williamson is a writer.

cold war thinking. And Western Europe has responded with trade deals and loans on a scale that tacitly acknowledges that the cold war is over.

The ideological foundations of the liberal Democrats' foreign policy, whether John Kennedy's a generation ago or Sen. Bill Bradley's today, have been rendered obsolete by the Gorbachev revolution.

These realities were strikingly illustrated by the dreary failure of the Dukakis candidacy. The idea of running on competency and not ideology proved bankrupt — compounded by Gov. Dukakis's flight from both the liberal label and his powerful black support. The desire of 78 percent of Dukakis supporters for a different choice, the polls showing that a Bentsen/Dukakis ticket might have been the strongest — all are signs that the usual coalition of liberals and centrists is dead.

The results of the Presidential campaign have already begun to define a new and winning coalition of progressives and centrists. A plurality of voters prefers the progressive label to any other, and the Rev. Jackson's progressive program became the Democrats' most potent weapon during Dukakis's late surge. The focus on economic justice is certain to broaden the base of the Democratic Party while retaining virtually all of its present supporters.

Prospects for success among the 50 percent of eligible voters who did not participate are even better. The nation's dire economic problems — the huge deficit and the crumbling social infrastructure — will not be alleviated without a major increase in tax revenues. Thus, the fairness of the tax system is already the major issue of the next Presidential campaign. Nonvoters are less affluent than voters and are decidedly disadvantaged by the current tax code.

The message of economic justice

will win solid support among the 50 percent who sat out the last election. Throughout the primaries, the Rev. Jackson outpolled Mr. Dukakis among the largest section of nonvoting Democrats — those aged 18 to 29 and those with annual household incomes under $25,000.

The Rev. Jackson's progressive program is clearly the winning Presidential strategy for the Democratic Party. But let's be realistic. With bigotry remaining a big factor in Presidential elections, Jesse Jackson is not going to be nominated for President.

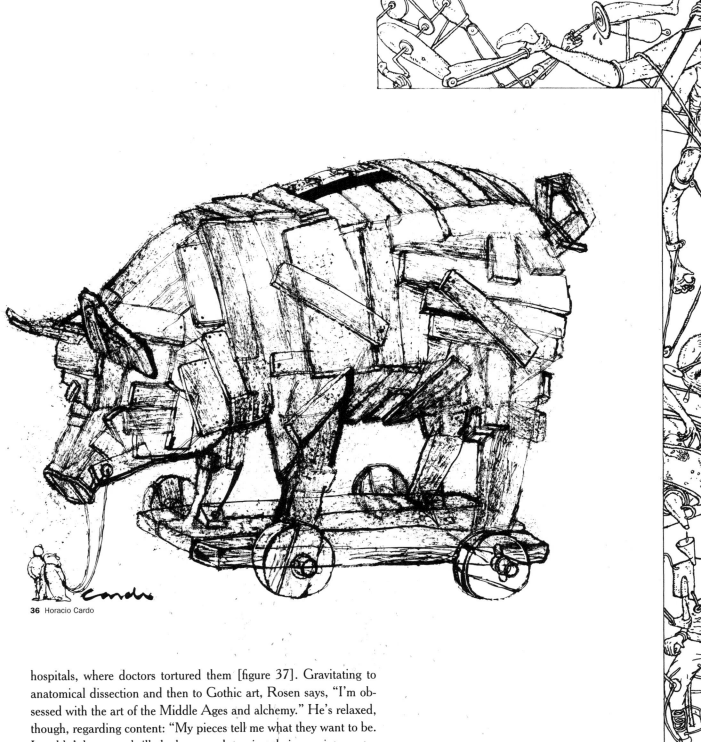

36 Horacio Cardo

hospitals, where doctors tortured them [figure 37]. Gravitating to anatomical dissection and then to Gothic art, Rosen says, "I'm obsessed with the art of the Middle Ages and alchemy." He's relaxed, though, regarding content: "My pieces tell me what they want to be. I couldn't be more thrilled when people project their own interpretations onto them."

Dominique Roynette, the art director of France's premier newspaper, *Le Monde*, inquired regarding an art feature for her paper. Shortly after our Paris conference, *Le Monde* started to publish freestanding, nonstaff art in a fat, daily editorial space. Several artists she hired were veteran *Times* Op-Ed contributors, including Ronald Searle, Roland Topor, and André François. Roynette translated the Op-Ed art idea into a striking French version. But when she left *Le Monde*, so did the art.

37 Jonathon Rosen

In the Family Way

Being slightly paranoid is like being slightly pregnant—it tends to get worse.

MOLLY IVINS

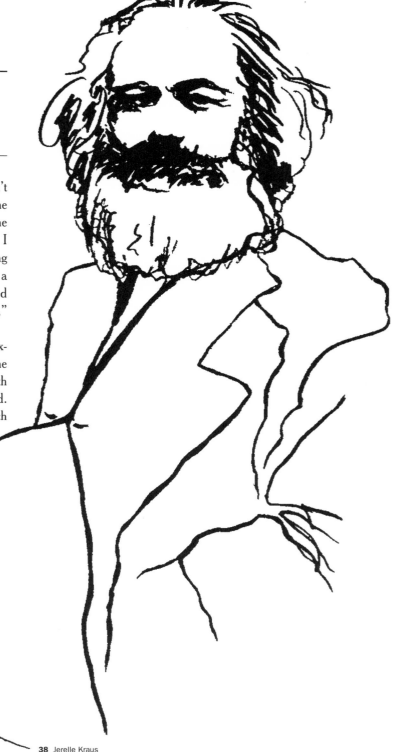

When I showed Semple one illustration in 1983, he squirmed. "Can't you make him a little less pregnant?" he implored [figure 38]. The next day, a seething Silverstein, red-faced and irate, pronounced the image "vulgar and tasteless." Silverstein's sneer still stung when I encountered editorial page editor Max Frankel. "Your Marx drawing is wonderful!" said Frankel with a radiant smile. Like a kid with a new yellow balloon, I rushed to tell Silverstein what this esteemed intellectual had just uttered. "He doesn't know what he's saying," Silverstein shot back.

This illustration accompanied an essay by Ralph Buultjens, who explained that "Marx fathered an illegitimate son by Helen Demuth, the longtime family maid."[12] The renowned philosopher, bursting with economic theory, was terrified at having his indiscretion revealed. Desperately seeking a cover-up, he persuaded the loyal Friedrich Engels to take the rap and never saw his only son, who was reared by a working-class family, lived as a (Marxist) laborer, and died at seventy-eight believing that he was Engels's bastard child. On his deathbed, Engels confessed to Marx's two daughters; both became suicides.

In 1984, the prestigious Art Directors Club, which awards virtually all its honors to television and advertising, gave this drawing one of only three illustration prizes for the year. The other two winners, both *Times* Op-Eds, were by Brad Holland [see "The Seventies," figure 41] and Marshall Arisman [see figure 9]. Among the fifty-two illustrious judges on the illustration jury was Silverstein, who never uttered a word about whether he had voted for my "vulgar and tasteless" image.

38 Jerelle Kraus

Cold War Classics
and Memories of Hot

A toast to the weapons of war, may they rust in peace.

ROBERT ORBEN

In 1980, Communism clutched the Soviet Union and its satellites. But by the summer, labor strikes in Poland had led to Solidarity, the legendary union headed by Lech Wałesa of the Lenin Shipyard. Solidarity spun off struggles that climaxed in 1989 with mostly peaceful revolutions that overthrew Communist regimes throughout the Eastern bloc. The death throes of Communism and the Cold War thus played out in dramas that dominated Op-Ed during the 1980s.

40 Philippe Weisbecker

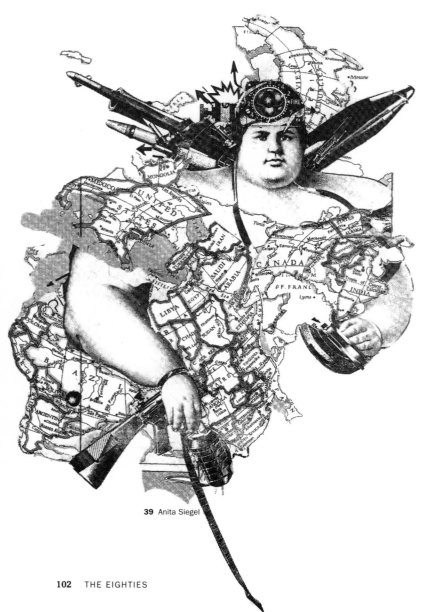

39 Anita Siegel

By depicting Mother Russia dressed in a world map, Anita Siegel satirized an accusation that the Soviets masterminded international terrorism [figure 39]. A Rand McNally lawyer recognized the source product and phoned Siegel, threatening to sue the *Times*: "People could use your illustration instead of buying our maps," he maintained. "The lawyer backed down," says Siegel, "when I pointed out the proximity of Los Angeles and Siberia."

In the mid-1980s, Philippe Weisbecker replaced his cross-hatching of the 1970s with a stylized, schematic idiom. In 1984, he illustrated a retired colonel's response to his grandnephew, who'd asked about the fighting he'd done in Normandy during World War II [figure 40].

Hans-Georg Rauch beautifully interpreted the claim that defense contractors were promoting nuclear weapons [figure 41]. Italian artist Tulio Pericoli, who lives in Milan, visualized an American strike against Libya as a reprisal for terrorism in 1986 [figure 42]. The same year, Bob Gale portrayed contrasting versions of an Austrian leader's role in the Third Reich: Gerhard Waldheim defended his father's innocence, while Menachem Rosensaft insisted that Kurt Waldheim had been a willing servant of Adolf Hitler [figure 43].

In 1988, a drawing by Mark Podwal illuminated the fiftieth anniversary of Kristallnacht, the infamous "Night of Broken Glass," when German storm troopers had sledgehammered Jewish buildings, initiating the Holocaust [figure 44]. "It's based on the Arch of Titus," says Podwal, "where Roman soldiers, after destroying a temple, carried away its menorah. I replaced the soldiers with goose-stepping Nazis. Each flame of the menorah holds a synagogue that was shattered that night. I drew it in black ink on white paper. We reversed it for publication."

41 Hans-Georg Rauch

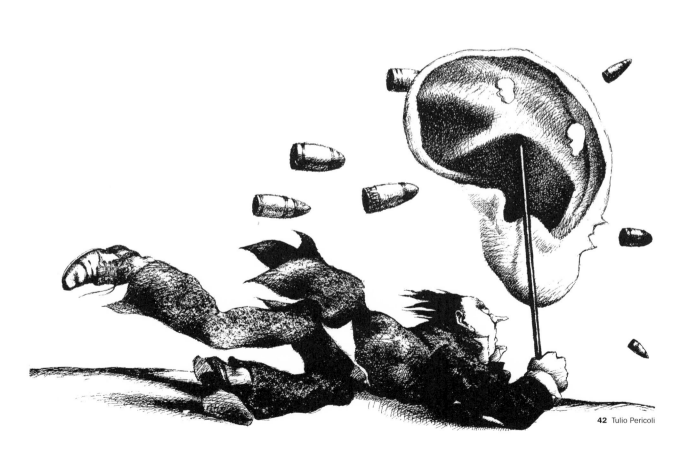

42 Tulio Pericoli

43 Bob Gale

45 David Suter

44 Mark Podwal

Maps have inspired numerous Op-Ed drawings without so much as a peep from Rand McNally. A single image by David Suter covered contradictory articles in 1983. Maintaining that the war in El Salvador paralleled that in Vietnam, the first text demanded that America win this time. The second contended that El Salvador didn't compare with the Vietnam debacle [figure 45]. Also in 1983, Gale illustrated Reagan's fear that Cuban Communism would infiltrate Central America [figure 46]. "It's a paranoid map," says Gale, "the lion fainting over the mouse." In 1986, the gifted Parisian painter and sculptor Michel Granger evoked the global drug battle as a world war [figure 47]. In 2008, Granger abandoned his meticulous painting style in favor of wielding what he calls "the world's biggest paint-brush." He places canvases on the ground and globs them with paint. He then directs military tanks to roll over them so that their heavy treads create distinctive patterns. Inspired by the man who stood in front of advancing tanks in Tiananmen Square, Granger uses these machines of death to create art. And in 1988, Cardo illustrated the notion that the United States must reduce Latin debt to avert the loss of South American allies [figure 48].

46 Bob Gale

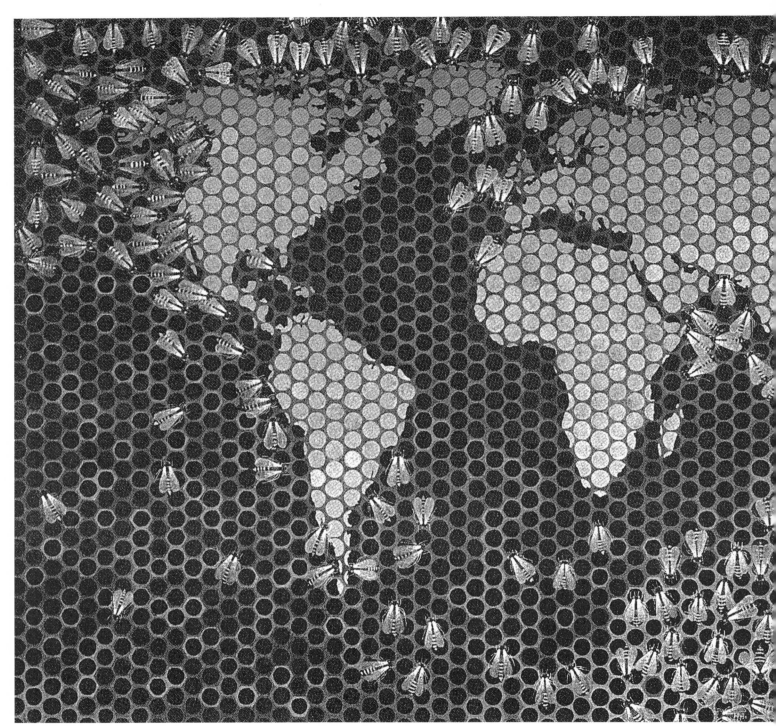

47 Michel Granger

48 Horacio Cardo

Speaking the Unspoken

The ideal reasoner, when shown a single fact,
deduces from it all the results that follow.

SIR ARTHUR CONAN DOYLE

49 Bob Gale

In 1988, the United States Navy cruiser *Vincennes* brought down Iran Air flight 655 and produced the first electronic recording of a plane crash. Bob Gale's interpretation of that event is novel [figure 49]. Instead of portraying the drama of the crash, Gale imagined something unmentioned in the story. "I remember the glazed stare of the sailor looking at the radar screen," Gale says now.

This inventive approach parallels Michael Matthias Prechtl's inspired art for a 1975 article. Art directed by Steven Heller, Prechtl interpreted General William Westmoreland's analysis of America's defeat in Vietnam by portraying the victor, Premier Pham Van Dong of North Vietnam, to whom Westmoreland never referred [figure 50].

50 Michael Matthias Prechtl

Peerless Outlaw

I'm glad I'm not Brezhnev. Being the
Russian leader in the Kremlin, you never know
if someone's tape recording what you say.

RICHARD M. NIXON

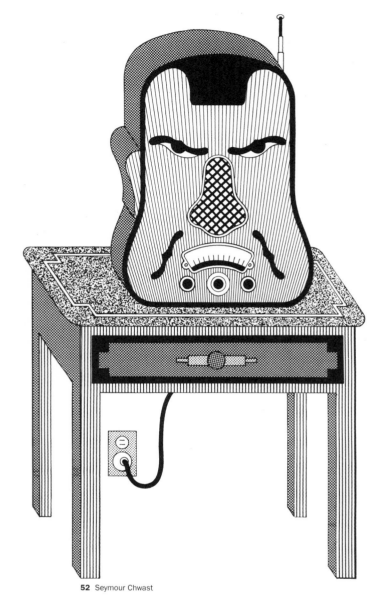

52 Seymour Chwast

President Ronald Reagan's hatred of what he called "the evil empire"
led him to stall on United States–Soviet summitry. Meanwhile, in
1983, nine years after his political suicide, the unrepentant Machia-
vellian, Richard Nixon, advised the reluctant Reagan. (Later, in
1987, Philip Burke's caricature envisioned just such a scene [figure
51].) American presidents, Nixon insisted, must meet with their
Cold War counterparts at least annually.

The advice was vintage Nixon: the chapter about Konrad Adenauer
in Nixon's book *Leaders* describes the former West German chancel-
lor's triumphant call back to power after his imprisonment, and the
chapters about Winston Churchill and Charles de Gaulle describe
the periods when these leaders were out of power as "years in the
wilderness." Nixon famously stated, "One is not finished when
defeated; he is finished when he quits. Keep fighting." Nixon's wisdom
was really addressed to Reagan, but where did he send his essay? To
the *Times*, the newspaper he'd most despised while president.

Nixon had unleashed his fury when, in 1971, the *Times* published
the leaked Pentagon Papers, a massive study of the war in Indochina.
"Nixon," wrote then Washington bureau chief Max Frankel, "ordered
an all-out attack on the *Times*."[13] In 1974, Seymour Chwast illus-
trated another aspect of Nixon's distrust of the media—his plan to
supplant the Federal Communications Commission and control

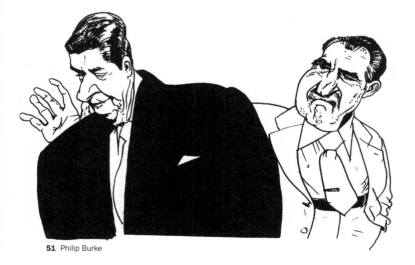

51 Philip Burke

the media himself [figure 52]. "I drew a radio that echoed the
thirties deco period," said Chwast, "because it had more human
characteristics."[14]

My first thought about illustrating Nixon's Op-Ed text? What an
opportunity! I quickly realized, however, that there could be no kicking
Nixon around. He was, after all, the text's author, and his argument
for East–West conclaves was flawless. I couldn't call someone who'd
do a biting caricature. Maybe I should draw this one. Since the
essay's subtext was Nixon's own summitry, I decided to picture him
huddled with Brezhnev, a Soviet leader he regularly took on. The
magnificently eyebrowed Brezhnev was a treat to draw, but Nixon
was another matter. I studied dozens of photos and did many drawings
before arriving at a neutral portrayal. The next morning, I entered
my office to a ringing phone.

"This is Ray Price, President Nixon's press secretary. The president wants to speak with you." Then I heard the unmistakable voice of a peerless outlaw: "I admire your drawing for my Op-Ed article, and I'd like to have the original." I tightened my grip on the phone. Is this happening?

"Honestly, Mr. President, authors often feel entitled to our originals, but they're valuable."

"I'd like to dedicate a copy of my memoirs to you."

"Actually, Brezhnev made me a better offer." The Russian was dead. Nixon didn't laugh.

"Okay, I'll bring it to you." Sheer instinct spoke those words as I jumped at my first thought-flash: *Don't miss the chance to meet this reclusive, evil icon.*

"Can you come tomorrow morning?"

Nixon's alter ego, Ray Price, returned to the phone: "Come to 26 Federal Plaza. At the end of the long hallway, there's an unmarked door. Knock three times, pause, then knock again." *Ohmygod, I'll be entering a cabal!* Anxiety overcame me until I realized that I was already prepared.

When I was a child in Los Angeles, my mother told me how the Republican Nixon had demonized his Democratic rival for the Senate, Helen Gahagan Douglas, by quoting the words that her primary opponent had used against her. Nixon's added stroke—in the Cold War of McCarthy's anti-Communist hearings—was to reprint those words on rose-colored paper. Let people think that Douglas was a pinko!

Tricky Dick's sneakiness continued. Watergate may have been his worst domestic presidential transgression, yet his personal life was plagued by deceit, too. He filed four fraudulent tax forms. While lawyers figured out if he'd face tax charges, Seymour Chwast unraveled the case [figure 53]. The artist calls this monoprint his "mummy illustration" and points out that "very little of Nixon had to be exposed to render him recognizable."[15]

As a student, I stood on the Berkeley tracks in the path of trains carrying youths whom President Nixon sent to fight an unwinnable war. My friend Ron Kovic returned from Da Nang on a stretcher, never to walk again. As a *Ramparts* staffer, I designed a feature detailing Nixon's ultimate Vietnam solution: nuclear attack. As a citizen, I wrote passionate letters of protest when Nixon and Kissinger's secret Christmas bombings were revealed.

As a theatergoer in 2007, I identified with the narrator's line in *Frost/Nixon*: "After a lifetime of hating Nixon, you form a sort of relationship." Nixon claimed to be a Quaker, but he was nothing like the Quakers of my childhood. The central tenet of the Society of Friends is pacifism. The Quakers sitting in silence on the wooden facing benches of the Pasadena Friends Meeting were peaceful. Nixon must have been a church Quaker. That is, he might as well have been a Presbyterian! A prominent Quaker principle states, "There is that of God in every man." Would I find godliness in Nixon?

I performed the cryptic knock on reaching the unmarked door, which cracked open to reveal two straight faces atop straight suits: "Miss Kraus? I'm the Secret Service, and [pointing to his clone] so is he." They ushered me into a vast chamber. Half a beige-carpeted stadium away was a lawyerly desk. From a glistening brass pole next to it dangled an American flag that will never unfurl. Then, in the shadowy distance, a figure emerged to incarnate what I'd been drawing—the widow's peak, the jowls, and that nose above dark blue–suited shoulders that drooped like the flag. (California artist Robert Pryor ingeniously encapsulated the president's proboscis problem [figure 54].)

Nixon extended his hand. Brazenly, I said, "You and I have two things in common. We're both Californians, and we're both Quakers, but I've remained a pacifist." My naughty opener launched him into a lesson on George Fox, the seventeenth-century British founder of Quakerism. Nixon's stress on Fox's unjustified imprisonment betrayed his own identification with the righteous, persecuted leader. He then treated me to a tutorial on realpolitik. Its moral? "In today's world, pacifism is not an option." The lecture mode was his element; he was uncomfortable with the give-and-take of conversation.

I sat down on his carpeted floor to unzip the portfolio of Op-Ed art that I'd brought to show him that the picture he was acquiring was part of a proud tradition. He had no interest in the art. He was interested in my comfort. Rather, in his discomfort at my informality. Wouldn't I prefer a chair, he asked. This awkward man was being gracious. His guest had violated the choreography, but he maintained decorum. Did I enjoy my work? What were my plans for the future? Hoping to change the subject, I congratulated him on initiating Sino-American relations, a feat that enabled my current invitation to China.

"I'm going there next week," he announced proudly. Thus began our most spontaneous moment. "Then why don't I go with you?" I asked. I was joking, of course. Yet I couldn't resist the remote possibility. No one got the reception Nixon enjoyed in China. The *Times* executive editor received the standard factory tour. "I'm a journalist," I said, "and I'm going anyway." Nixon stared at the floor in lengthy silence. I was shocked that he considered his response for so long.

Finally he spoke haltingly: "You see, Jerelle [another long pause], Pat isn't going." Not only was my faux pas ludicrous, but this man was truly old school. It was touching, though, to see him struggle for words and then speak so frankly. For two and a half hours, I was alone with Nixon, save for Ray Price sitting silently in a distant corner of the graveyard-size office. Then one of the Secret Service agents entered with a camera. *Had Nixon pushed some "Photo now" button under his desk?* The president reached for his 1,120-page memoir, *RN*, and wrote a generous dedication on the flyleaf.

"I'm pleased you came," he said, as we walked to the door. I later received two eight- by ten-inch color glossies of the Secret Service agent's shot, in which Nixon is ceremoniously folding the letter he wrote to me on his personal stationery: three paragraphs of thanks

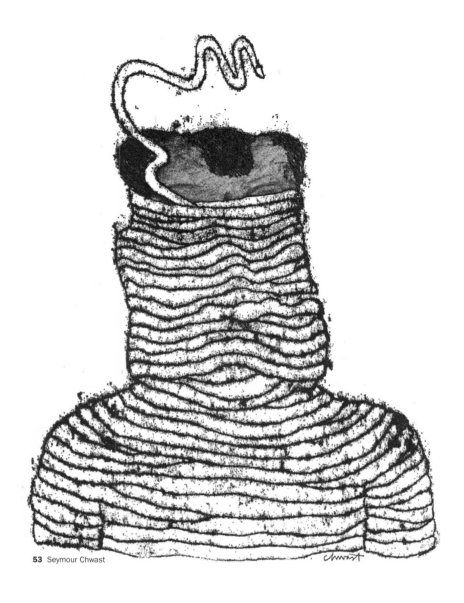

53 Seymour Chwast

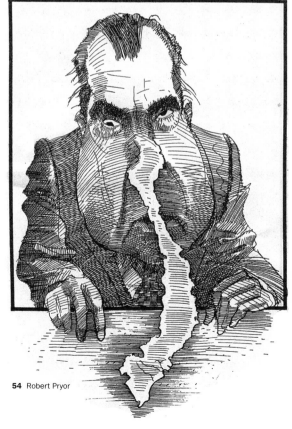

54 Robert Pryor

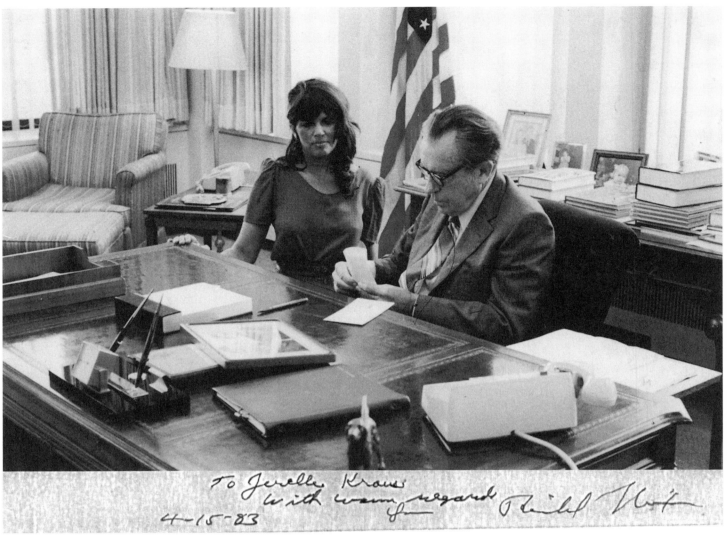

To Jerelle Kraus
with warm regard
from Richard Nixon
4-15-83

55 Richard Nixon, Jerelle Kraus, and Checkers

for giving him my original drawing for his "Détente peice [*sic*]" [figure 55]. In the photo, my glass-encased illustration is tilted slightly up in front of him and must now be among the millions of items in the Nixon Presidential Library and Museum—probably still in the cheap wooden frame I painted red for the occasion.

In the photo's foreground, atop the president's desk, is a bronze miniature of Checkers, the cocker spaniel that served him so well while he pleaded for his political life in 1952. Appearing on television to answer accusations that he'd improperly received $18,000, Nixon spoke of his wife's "respectable Republican cloth coat" and of Checkers, a gift to his daughters that not a soul had questioned, but that Nixon seized on for sentimental effect: "The kids . . . love the dog, and I just want to say this right now, that regardless of what they say about it, we're gonna keep it."[16]

This speech was a brilliant, diversionary strategy that solidified his precarious position as Eisenhower's running mate. Now, long

afterward, Nixon kept the statuette in his office. Instead of facing into his owner's desk, however, Checkers was turned toward the camera, still performing public relations. I soon began to receive all of Nixon's books, one at a time, dedicated in his hand. I should have sent a thank-you note, but never could.

Experiencing Nixon behind his unmarked door showed me there was a human creature beneath the ogre for whom I'd felt nothing but disgust, someone profoundly ill at ease with himself and others, a man who wore a suit 24/7 and couldn't surrender the role of dignitary. I saw his awkwardness as well as his pain, pride, and prickliness.

Brad Holland came to a similar realization: "I drew a Nixon scarecrow with arms spread in a pose of crucifixion," says Holland. "[David] Schneiderman said, 'It looks like you sympathize with Nixon.' Of course I did. It felt like high school, when all the 'in' kids ganged up on some clown who lived in the trailer park." Holland remembers that when Kennedy's private conversations were revealed, *Look* magazine said that he'd been a sailor and sometimes used salty language. But when Nixon's transcripts were aired, his language was described as foul. "If everyone's getting on this guy's back," says Holland, "it's time for me to get off."

Holland's pictures of Nixon became increasingly sympathetic. "I saw in him many of the flaws I fear in myself," says Holland. "By the day he resigned I felt an odd admiration for the man. He seemed to be one of those perversely brave individuals who, in spite of their need to be admired, are willing to go through life misunderstood." An article published in 1990, four years before Nixon's death, quoted the former president reminiscing: "If there had been a good rap group around in those days, I might have chosen a career in music instead of politics."[17] Philip Burke immortalized Nixon's outrageous fantasy [figure 56].

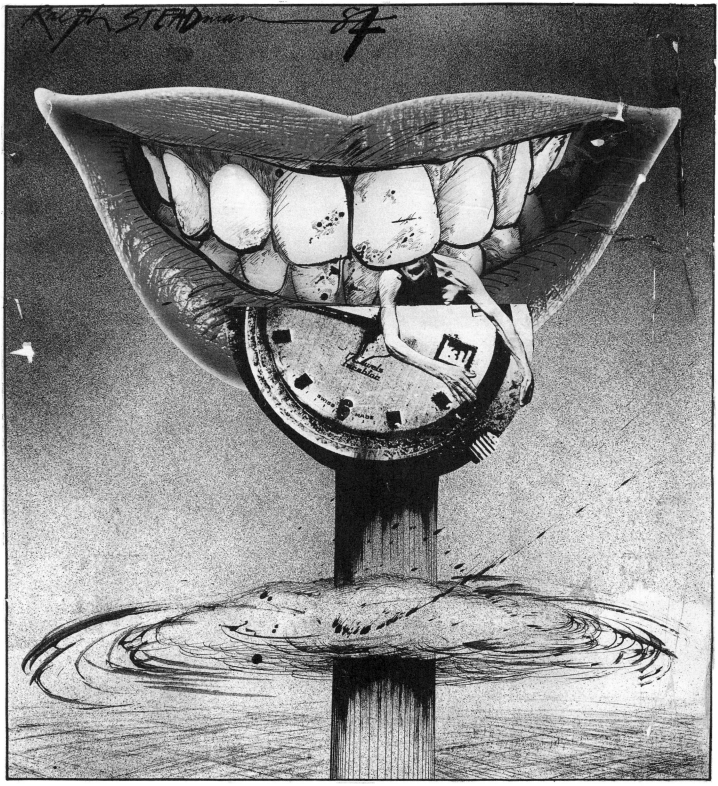

57 Ralph Steadman

Wild Welshman Worsens

To find a form that accommodates the mess,
that is the task of the artist now.

SAMUEL BECKETT

Op-Ed renewed its relationship with bad boy Ralph Steadman in the 1980s. "Oppression, deceit, injustice, violence, and bestiality are the mothers of satire," says Steadman, who lives on a wildly luxurious, tree-filled lot outside London. "But illustration is a low art. Shoulder to shoulder with a so-called work of fine art, an illustration is nothing but a cheap joke, a space filler, or propaganda."

On one of Steadman's visits to New York, we lunched at Un Deux Trois, which places jars of crayons on its white paper tablecloths. But they're waxy crayons that produce weak lines. The squeezy bottles of ketchup and mustard flow better. As do red wine, pepper, and black coffee. Immersed in a table-covering tour de force, "the two of us went at it for at least an hour," Steadman remembers. "We were deeply involved in our tablecloth painting when a guy at the next table suddenly said, 'Would you mind not doing that? You're putting me off my food.'" Abruptly, the waiter pulled our masterpiece out from under us

and crumpled it. Dazed, we stared in horror as he flung it in the trash. "It could have been in the Guggenheim," says Steadman.

Flouting Hunter Thompson's fatwa—"Don't write, Ralph; you'll bring shame on your family"—Steadman has written many books, including spellbinding visual biographies of Freud and Leonardo; *Gonzo: The Art*; and *The Joke's Over*, a tribute to Thompson, his collaborator of thirty-five years. He's illustrated scores more, from Thompson's *Fear and Loathing* tomes to the fiftieth-anniversary edition of George Orwell's *Animal Farm*. The spleen that Steadman splashes onto his work allows him to escape cynicism and express his bottomless personal charm.

In 1982, Kurt Vonnegut made an apocalyptic suggestion: "Perhaps we should be adoring . . . our hydrogen bombs. They could be the eggs for new galaxies."[18] Steadman illustrated Vonnegut's manuscript with a suicide smile onto which he collaged a photo of the watch that the *Enola Gay* pilot had worn while dropping "Little Boy" on Hiroshima. The pilot's watch stopped at the moment of explosion. "The helpless figure between the teeth," says Steadman, "represents all humankind. And that's the smile you see in dental floss advertisements" [figure 57].

The artist painted a strident illustration of the New York City marathon in 1983 [figure 58]. "What's that protrusion on the runner's upper thigh?" I asked. Steadman didn't answer but authorized my scratching it out, which allowed us to publish it. "But," he says now, "that's part of his muscular leg. He hasn't even got a head. Or maybe he does, but he's hiding it in shame within his body. Maybe that's it coming out down there."

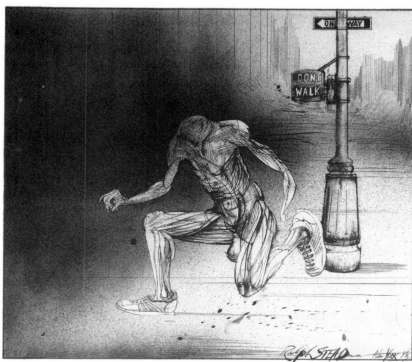

58 Ralph Steadman

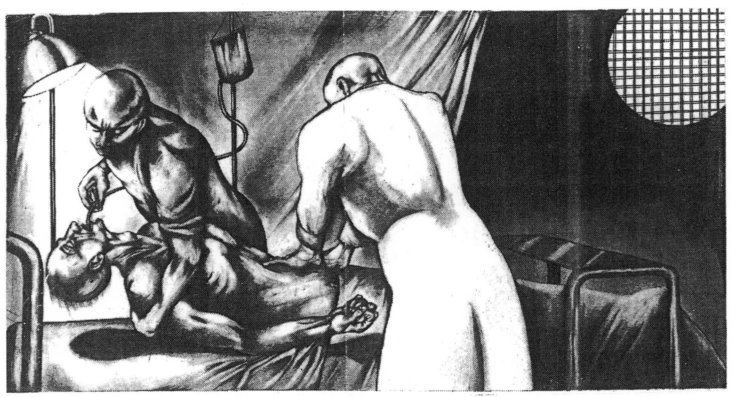

59 Sue Coe

George Grosz in Pigtails

Why not go out on a limb?
Isn't that where the fruit is?

FRANK SCULLY

In the 1980s, British-born American artist Sue Coe wore her blond hair in two braids, a girlish style that—along with her lilting voice—clashed with her merciless oeuvre. Scathing, unblinking, and utterly humanistic, Coe is among today's most eloquent painters. Her work grabs us by the throat and pushes our noses into the horrors of which we humans are capable—gang rape, torture, police brutality, and extreme cruelty toward defenseless animals. Coe studied at London's Royal College of Art. After emigrating to the United States in 1972, she eagerly, punctually produced compelling Op-Ed illustrations—at short notice.

The many pictures that Coe delivered during Op-Ed's initial two decades throbbed with passionate commitment. In 1985, she visualized the Soviet regime's force-feeding of Andrei Sakharov [figure 59] and wrote this letter about her experience: "After the force-feeding drawing appeared, two things happened. First I received 16 obscene calls making reference to the picture. Second, I received an icon in the mail. It is beautiful and really old. A note with it says, 'Thank you—from the friends of Sakharov.' That's all it says."

In 1986, Coe interpreted an essay claiming that American doctors kill and maim thousands of patients a year [figure 60]. She delivered her irony this time with a rare humorous approach. Once Coe decided to pursue only her personal work, she was free of *Times* standards and could be as polemical as she pleased. The Galerie St. Etienne in New York represents her—its only living artist—alongside Gustav Klimt, Oskar Kokoschka, and Egon Schiele; her work is in the Metropolitan Museum of Art and the Museum of Modern Art; and the Hirshhorn Museum, the Smithsonian's museum of modern and contemporary art, has held a retrospective of her work.

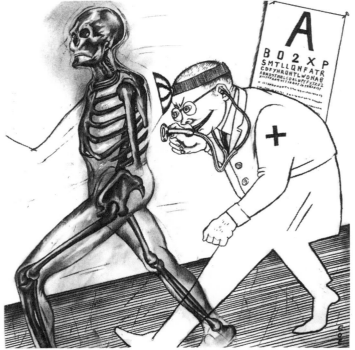

60 Sue Coe

Legend

Art is either plagiarism or revolution.

PAUL GAUGUIN

Saul Steinberg's obituary in the *Times* was extensive, but nowhere was the artist's grudge against the paper mentioned. Steinberg's hostility grew from his resentment of Eugene Mihaesco's and J. C. Suarès's borrowings from his work. Their borrowings occurred as both unconscious results of their immersion in his oeuvre and conscious homage to him. "I dedicated the Bordeaux catalogue to Steinberg," says Suarès, "because his work influenced everybody. It's genius work. It shows what you can do with just a pen. He was the greatest

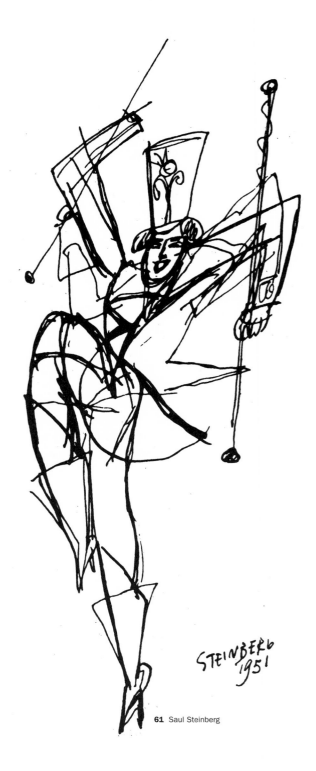

61 Saul Steinberg

cartoonist of all time, but he wanted to be Picasso. He dealt with enormous demons. We could have used his wisdom, but he never gave lectures or talked to students. I didn't copy Steinberg; I learned from him. Why not?"

Over the years, numerous *Times* staffers requested illustrations from Steinberg. He always refused. I was introduced to this reclusive, Romanian-born artist by mutual friends and spent an afternoon with him. Years later, I risked a bold maneuver. Plucking two separate majorettes from his book *Passport*, I asked his permission to publish the combination [figure 61]. Skeptical but intrigued, he said, "Send me your design overnight." The next day he telephoned: "It works. You may publish it." So the only approved Steinberg imagery ran reconfigured in the *Times* on July 4, 1986—freestanding. He called that day, delighted at how the page looked. I thought he might end his grudge. Yet he later told me, "I have no desire to contribute in any way to the *Times*."

Because Mihaesco is a fellow Romanian, his Steinberg-influenced drawings especially irked the master. Mihaesco once told David Suter that he and Steinberg are from a Romanian region where artists share their graphic vocabularies. In 1982, a *Times* Travel section cover on summer festivals resembled a huge Steinberg. Credited to Mihaesco, it featured an outsized music sheet peppered with small European icons—the Eiffel Tower, Big Ben, the Leaning Tower—that looked pasted together from Steinberg's published albums. I was appalled. Steinberg called that day, heartsick at the affront. Assuming a bad joke, I called Mihaesco. "It's my work and mine alone!" he protested. Despite agreeing to discuss it at Sardi's, Mihaesco canceled, leaving this note: "I'm not in state to talk about it now."

A man of the theatrical gesture, Mihaesco pinned a maple leaf to his lapel in autumn and courted wealthy Romanian blondes. He left the United States in the late 1990s to become Ambassador Eugen Mihaescu, permanent delegate of Romania to UNESCO. (Based in Romania, he's reverted to the original spelling of his surname. Romanians whose last names end in *cu*—like the playwright Eugène Ionescu—commonly change the *u* to *o* upon moving to France, as Mihaesco did in Paris before going to New York. *Cul*—the *l* is silent—is a French synonym for what might more elegantly be called a "derrière.") Mihaesco's last Op-Ed drawing, in 1996, featured the flashing lights and blaring sirens of squad cars and one car labeled with a riff on the Russian spelling of "police." Those details are vintage Steinberg.

Steinberg took action against one of the many who plagiarized his satire of provincialism, "View of the World from 9th Avenue," suing Columbia Pictures for basing its publicity for the film *Moscow on the Hudson* on his composition. Winning that settlement felt as good, said Steinberg, as "punching somebody in the nose."[19]

Style derivation is a contentious issue among artists. No software yet scans images for plagiarism, as it does with prose. Copying, conscious or inadvertent, is ubiquitous, and accusations of imitation are murky. They may seem trivial, as in "You drew an apple today; I

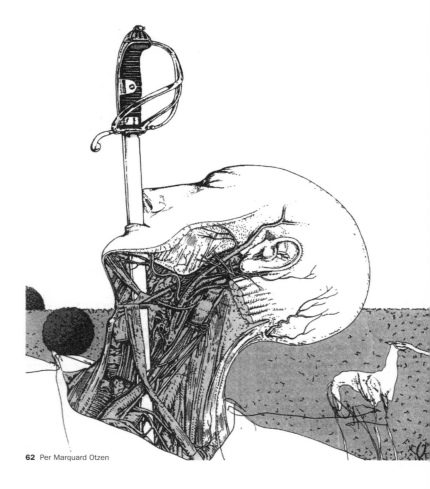

62 Per Marquard Otzen

drew an apple yesterday, therefore you copied me." Some are more plausible, such as "You drew a pear shaped like the president today; I drew the same yesterday, so you copied me." "I think it's obvious," notes David Suter, "that Dürer and Escher influenced me, but they're dead. I try to guard against living influences."

Copyright-free imagery is another matter. In 1993, an essay by Salman Rushdie deplored Americans' ignorance of the Muslims who are persecuted for condemning Islamic terrorism. Danish artist Per Marquard Otzen's painfully handsome image that illustrated Rushdie's article incorporated a drawing of a neck from the classic *Gray's Anatomy* [figure 62]. Because Otzen's own draftsmanship is richly detailed, the anatomical element blends seamlessly with the artist's line to serve an original idea.

The Domestic Domain

Civilization is the distance man has placed
between himself and his excreta.

BRIAN ALDISS

The maelstroms of Cold War coverage didn't prevent Op-Ed writers
from recording news of the home front. "This year you're going to
stay home on Leap Day," announced the article that occasioned Milton
Glaser's drawing [figure 63]. "The parties are never any fun, and not
enough people ever want to kiss you."[20] An ode to coffee drunk "on
a frosty Sunday morning in 1933" was interpreted by Steven Salerno
[figure 64].[21] And Ralph Steadman's original illustration of a Texan's
visit to Manhattan contained questionable passages—a rape scene,
a flasher, and a nude statue, for starters. "Well," says Steadman,
"I always felt I should do a good day's work for a good day's
pay." What most disturbed our staff were the cow-
boy's three bouncing testicles. But, Steadman
explains, that's not what they are: "Because
he's so thin, you can see his
backside." After whit-
ing out some details,
we could publish it
[figure 65].

63 Milton Glaser

Coffee

By Byron Dobell

arly on a frosty Sunday morning in 1933, my father was making tramp coffee in the kitchen when I awoke. I sat at the table and watched him throw a handful of ground roast into a pot of water, bring it to a boil for a few minutes, then turn off the fire and, finally, magically, drop in a piece of eggshell to make the grounds settle. When he had finished, he carefully poured a cup for himself and about a spoonful into my glass of milk.

My mother and my older brother and sister were still asleep. My old man (he was all of 40 years old) said, "Let's go for a walk." We bundled up, strapped on galoshes, and barreled out into the sunny, winter air. My father, no dawdler, plowed briskly up the hilly streets toward the heights along the Harlem River. In about a half-hour, we broke out of the canyons of the surrounding apartment houses and found ourselves on the rim of the valley. Now my father strode like a giant and I scrambled to keep up. Before us was a long vista dominated by a huge power plant. Foothills of coal, white with snow, spread out in all directions from the plant. In the distance we could see three bridges and a network of railroad tracks edging the river. There was no traffic on land or water. It was a silent, miniaturized landscape, the air so bright with reflections it made my eyes tear.

My father stopped and called me over to him. He pointed beyond a low retaining wall to the river bank a hundred or so feet below. Frozen into the ice and moored out of the ship channel there were dozens of old barges that had been converted into houseboats by people who had no place else to go. They were waiting for a thaw in the Depression (of which I was only vaguely aware).

My father lifted me up on the wall so I could see better. There was no one in sight on the barges although bits of wash hung stiffly on improvised clothes lines. From a few of the stovepipes on the ramshackle huts smoke was rising into the lambent air of the valley. The dog that is always barking in the distance on such a bright, winter morning, was barking. I looked at the smoke and asked my father, "What are the people who live on the boats doing?"

"They're making coffee," he said.

That made me happy, and after a while we began to move on again, this time heading for home.

That was a nice walk.

Byron Dobell is managing editor of Esquire magazine.

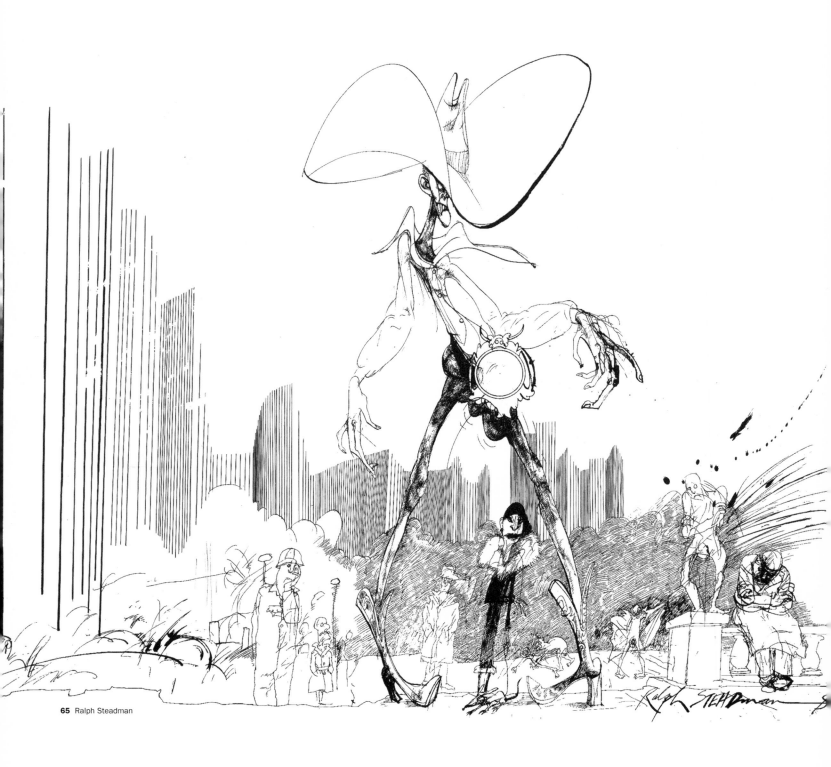

65 Ralph Steadman

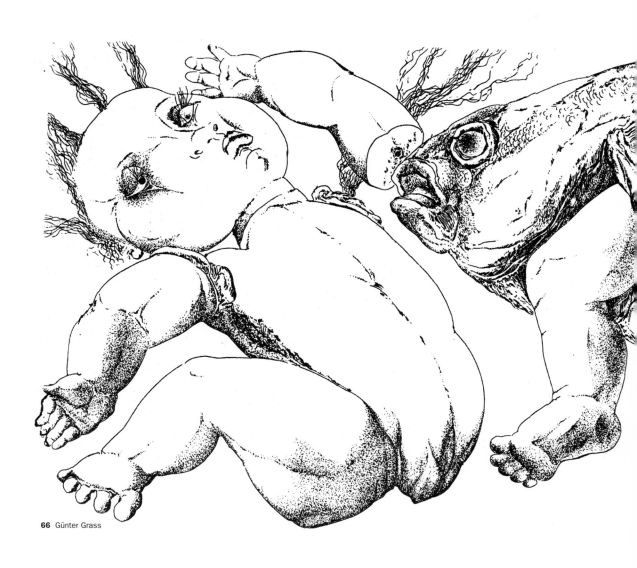

66 Günter Grass

67 Horacio Cardo

Günter Grass's etching of a discarded toy doll was wed to a report on dioxin-caused infant deformities [figure 66]. No one reported recoiling from the terrifying prose, but one reader saw Grass's doll as human and wrote to the *Times*: "The illustration accompanying your article was repulsive. The distorted child's face and deformed body ruined my breakfast and haunted my day."[22] By closing with a self-portrait in the act of vomiting, our correspondent paid inadvertent homage to the muscle of the visual message.

In 1987, a drawing by Horacio Cardo warned of the sharp dangers of depreciating U.S. currency [figure 67]. Also in 1987, with a nod to Nathaniel Hawthorne's *Scarlet Letter*, Larry Rivers illustrated a woman's description of living with her husband's disease: "Nothing I'd read or heard prepared me for the day-to-day reality of AIDS" [figure 68].[23]

Painter Steve Brown visualized the contention that housing problems can't be separated from welfare issues [figure 69]. Brown, a fine artist who named his first child after Ella Fitzgerald, is the suave director of the *Times*'s stress-filled art production department, which digitally prepares twenty-five hundred images a week.

68 Larry Rivers

69 Steve Brown

R. O. Blechman's drawings look tossed off. Yet they're the products of countless revisions that bestow a definitive attitude on the finished line. This artist based a political campaign drawing on the notion of thrown hats [figure 70]. Each hat is a tiny rendering that the artist inked in, then razored out, and repeatedly repositioned until he found the perfect spot and angle. Even after bringing in the finished piece, Blechman kept adjusting his minuscule hats. Still he wasn't satisfied; the angle of the *l* in his signature was wrong. It too—a diminutive stroke of the pen—was sliced out and relocated. "Now I'm even worse," says Blechman. "I fret about two letters, the *e* and the *a*, and fear they'll fill in. So I brush a tiny dot of white in their middles."

For another political campaign message in 1988, Horacio Cardo illustrated a plea for the Democrats to look to centrists for a source of stability and balance [figure 71]. The premise that gun laws won't stop shootings elicited graphic wit from Serbian artist Dušan Petričić [figure 72].

It's possible for an artist to take exception to an author's argument without ridiculing it. An example is Bob Gale's illustration of a treatise against gun control [figure 73]. "I wanted to say 'no' to their 'yes' without contradicting the text," says Gale. "Suter does this brilliantly."

In 1989, Jean-Jacques Sempé celebrated the movie palaces of the 1920s, "America's grandest monuments to its romance with dreams" [figure 74].[24]

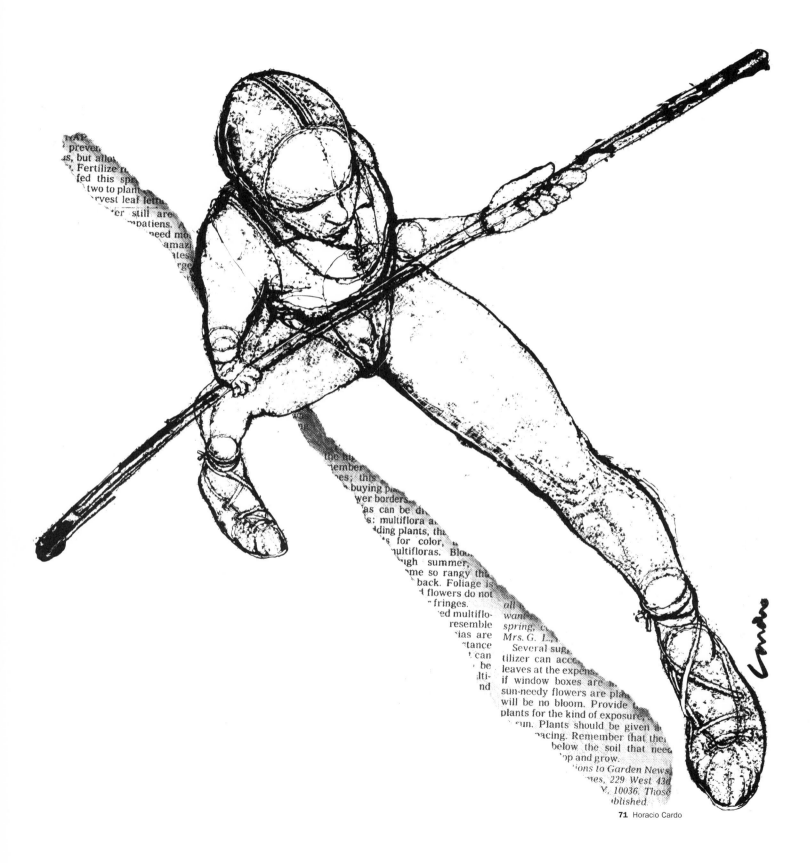

71 Horacio Cardo

72 Dušan Petričić

73 Bob Gale

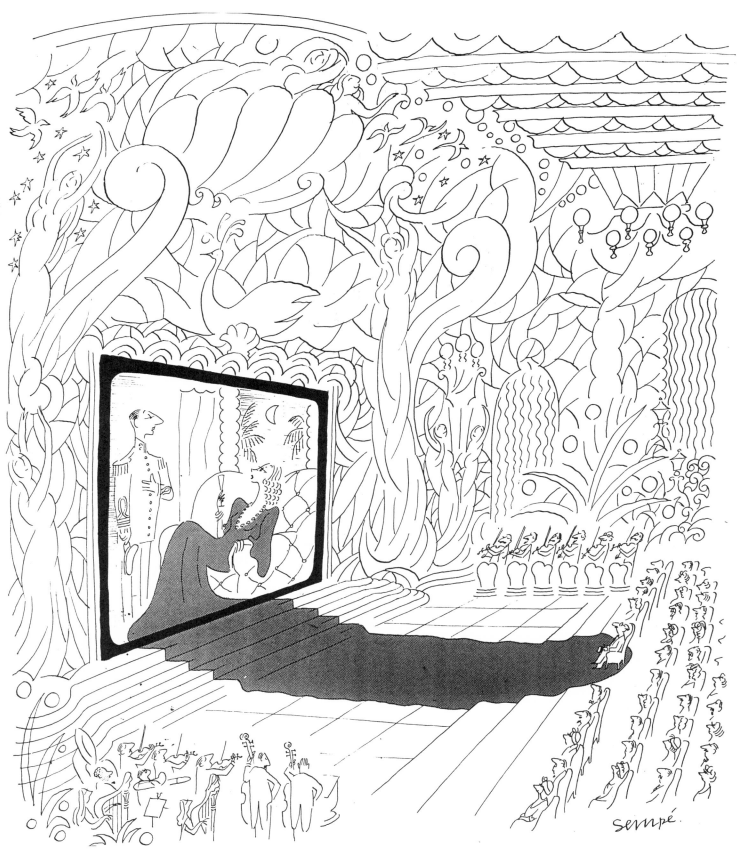

75 Rafal Olbinski

Many readers objected to a portrait of Democratic presidential candidate Michael Dukakis [figure 75]. Rendered by Rafal Olbinski, it accompanied an accusation that Massachusetts governor Dukakis had illegally borrowed money to balance the state budget. When we ran an article assailing Republican candidate George H. W. Bush for having said, "Read my lips, no new taxes," it seemed appropriate to ask Olbinski for a sequel. He drew a wonderful Bush [figure 76], yet editors feared that the anti-Bush image wouldn't balance the anti-Dukakis one, but only remind readers of it. So Olbinski's droll drawing bit the dust—until President Bush reneged on his promise of "no new taxes," when it snuck into a Letters column.

76 Rafal Olbinski

77 Roland Topor

78 Eugene Mihaesco

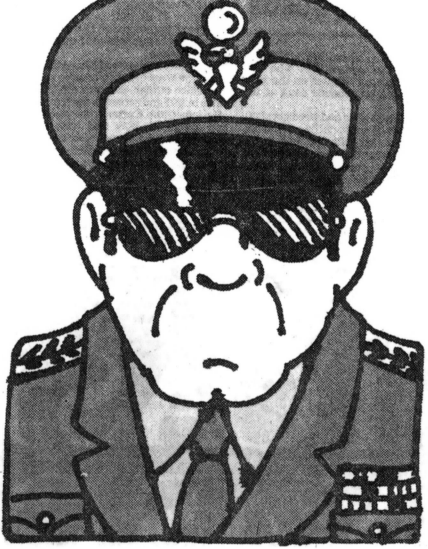

79 Seymour Chwast

Mouthpieces are a way around drawing words when depicting language or speech, as in the next four images. A publicist's call for the abolition of news conferences reminded me of a banked image by Topor, complete with trademark long gown [figure 77]. Mihaesco reflected the benefits of bilingual education [figure 78]. Chwast protested the weakening of the Freedom of Information Act, that "muscular statutory right to inspect Federal records" [figure 79].[25] And Olbinski summed up Pretoria's censorship of its antiapartheid press [figure 80]. (The last image is hardly domestic, but is a mouthpiece.)

80 Rafal Olbinski

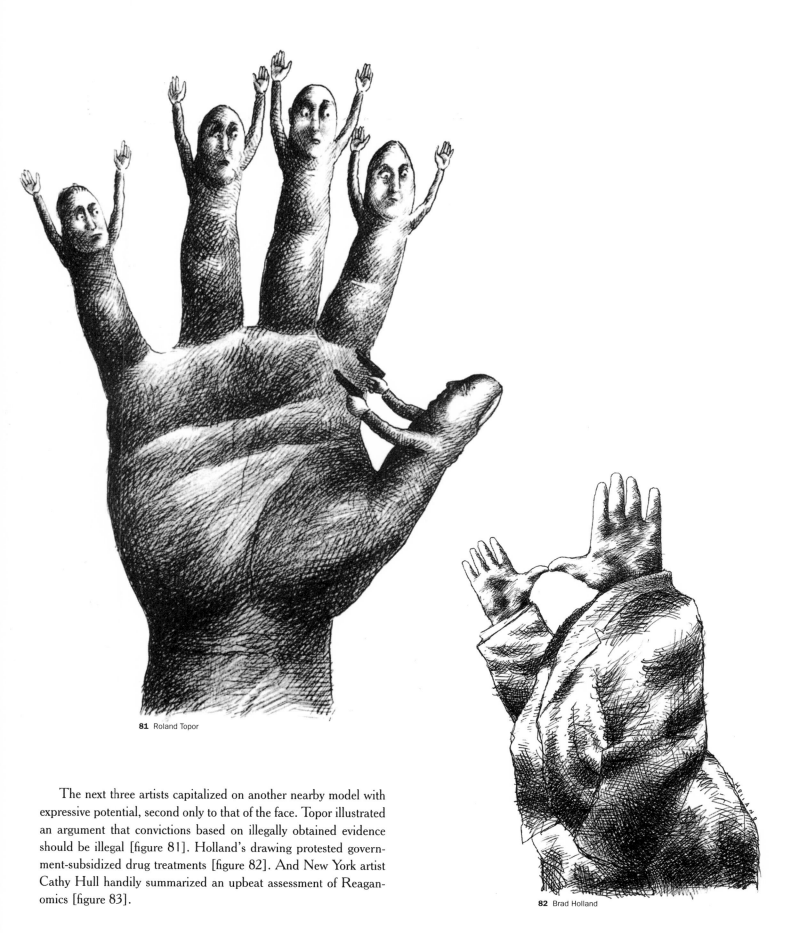

81 Roland Topor

82 Brad Holland

The next three artists capitalized on another nearby model with expressive potential, second only to that of the face. Topor illustrated an argument that convictions based on illegally obtained evidence should be illegal [figure 81]. Holland's drawing protested government-subsidized drug treatments [figure 82]. And New York artist Cathy Hull handily summarized an upbeat assessment of Reaganomics [figure 83].

83 Cathy Hull

84 Seymour Chwast

President Reagan was delicious to draw. The hair, the haughtiness, the indifference, the hard line. But the Great Communicator was jelly-bean genial, not a dark, Nixonian presence. "When Nixon retired," said Seymour Chwast, drawing "politicians wasn't much fun until Reagan was elected."[26] Reagan's unwillingness to communicate with Moscow elicited a spiffy image from Chwast [figure 84]. David Suter illumined Reagan's lack of concern with unemployment [figure 85]. Swedish illustrator Anders Wenngren wittily interpreted Reagan's deference to the kiwi lobby [figure 86]. And Philippe Weisbecker's puns marked the twentieth anniversary of the Cuban Missile Crisis accord just when Reagan was trying to undermine that seminal agreement between Khrushchev and Kennedy [figure 87].

Milton Glaser managed to burlesque the Reagan-era slogan, "window of vulnerability," without drawing words [figure 88]. And Jean-François Allaux captured Reagan's trip to Bitburg, a German cemetery where forty-nine graves honor Waffen SS troops [figure 89]. Allaux's wife at the time, Christie Brinkley, brought in her own portfolio of drawings. Yet this incandescent woman's talents proved to be more suited to supermodeling than illustrating. Her agency tried to convince her handsome husband to model. "But I couldn't stand that culture of sycophants," says Allaux. He instead chose the life of an artist and educator in Rhode Island.

85 David Suter

86 Anders Wenngren

87 Philippe Weisbecker

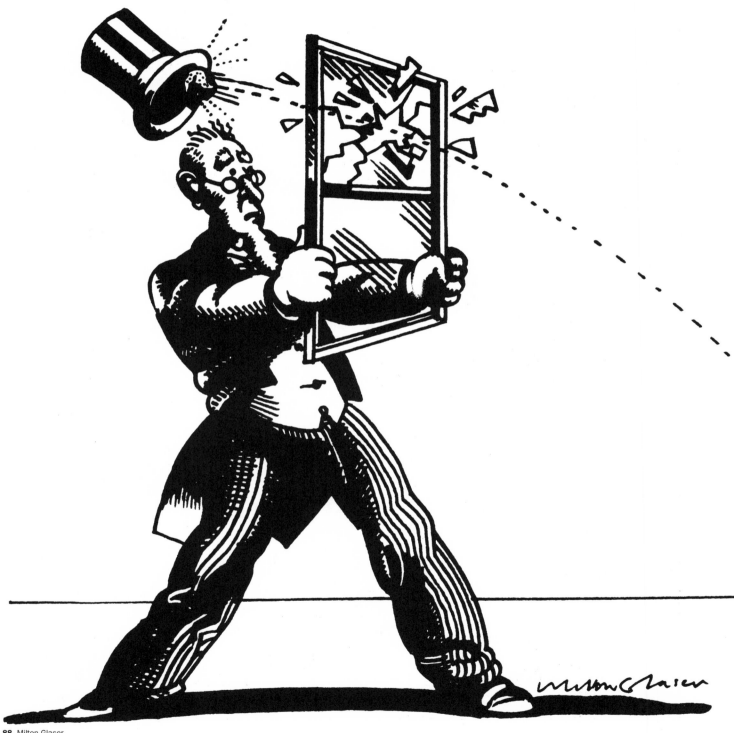

89 Jean-François Allaux

The Irony Curtain

Communism is like prohibition;
it's a good idea, but it won't work.

WILL ROGERS

A tidal wave of talented Eastern European artists arrived during the 1980s: Russians, Lithuanians, and Latvians; Hungarians, Poles, and Czechs; Bulgarians, Romanians, Serbs, and Croats. In Belgrade, three Serbian artists had already given me drawings that later worked well with texts. Dušan Petričić's satire graced a critique of a U.S. job-training program [figure 90], while Zoran Jovanović's black humor accompanied a warning against intermediate-range missiles in Europe [figure 91], and the integration of morality with national power occasioned Jugoslav Vlahović's image [figure 92].

91 Zoran Jovanović

90 Dušan Petričić

Eastern bloc artists ventured westward armed (one literally) with parodies of Communism. In 1976, the Polish government forced activist Jan Sawka to leave without his possessions. But the artist passed the apparatchiks' border inspection with three large, seditious drawings under his jacket, rolled around one arm. Latvian artist Maris Bishofs's journey from Riga to Moscow was far more dangerous than his trips to Tel Aviv and New York, where he lived for twenty years before returning, in 2003, to an independent Latvia. With few lines, this self-described "artist-thinker" turned a plea to stop aiding Central American police into moving drama [figure 93].

Before Op-Ed began, Bucharest-born Mihaesco had left Romania for Lausanne, Paris, and New York. But when his visual assaults on Romanian dictator Nicolae Ceaușescu appeared in *Universul*, the puppet leader was enraged. The artist's father was fired from his Bucharest job and ordered to squelch his seditious son. He pleaded with his son by telephone: "You're crushing us! They'll destroy your mother and me!" Thinking fast, Mihaesco screamed at his father— and the eavesdropping Securitate—"I disinherit you!" The father misunderstood his son's ploy, but after Ceaușescu was publicly executed in the only violent revolt of 1989, Mihaesco's father reclaimed his job.

92 Jugoslav Vlahović

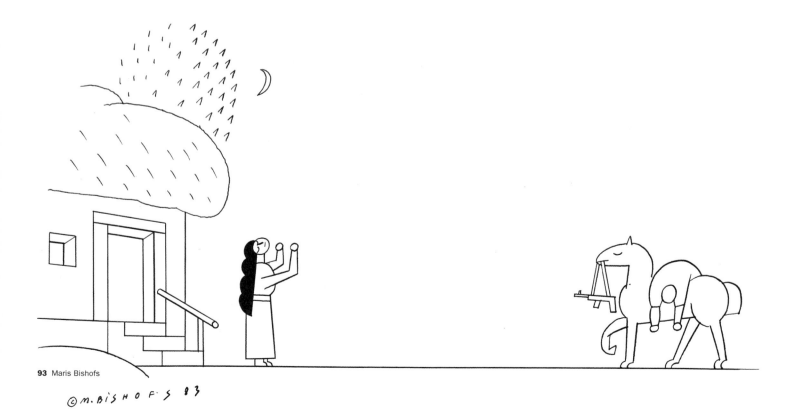

93 Maris Bishofs

© M. BISHOFS 83

Poles Vault

Under capitalism man exploits man;
under socialism the reverse is true.

POLISH PROVERB

Poles have been rising up against foreign domination for two hundred years, and the need to sidestep censorship rendered them conversant with the uses of allegory and paradox. Nineteen Poles interpreted Op-Ed texts during the 1980s, working from Austria, Poland, Canada, New York, and Los Angeles. In 1987, Polish artist Jerzy Kolacz, who's lived in Canada since 1978, illustrated a text that argued against the colorizing of black-and-white films.

Upon taking up Op-Ed responsibilities in 1979, the first artist I hired was Krakow maestro Franciszek Starowieyski, whom I'd met when both of us first arrived in New York, he on a Polish government grant. Starowieyski hadn't learned English, and my Polish is nonexistent, so we managed in German.

Starowieyski, claiming to embody a seventeenth-century spirit, signed his first Op-Ed piece with a flourish of Baroque calligraphy and predated it by three hundred years. This proud peacock of a graphic master is credited with giving Polish posters the status of stand-alone art. In 1984, he illustrated a call for replacing the detached analysis of nuclear war with a visceral approach [figure 94]. The next year, he was the first Polish artist to have a solo exhibition at the Museum of Modern Art.

Polish-born painter Leszek Wiśniewski lives in Vienna and has in common with Starowieyski stylish intricacy and fluency in German, as his second language, rather than English. He illustrated an appeal, in early 1986, for the United States and the Soviet Union to reduce the threat of nuclear war [figure 95]. In 1988, Stasys Eidrigevičius interpreted Ewa Zadrzynska's lyrical article about her serendipitous discovery, in New York, of a discarded wooden trunk tagged "Destination: America, address: unknown" [figure 96]. The trunk contained artifacts—family photos, letters bound with a blue ribbon, and a pair of twice-mended teacups—of a German Jewish family that had lived and died in the United States.

Zadrzynska was drawn to the trunk; "I felt I'd seen it before," she wrote. "And I had. In Poland, my sister stored her blankets and pillows in exactly the same kind of trunk."[27] The poetic Eidrigevičius grew up in a Lithuanian village among birds and farm animals. Despite his move to Warsaw and his solo shows and prizes, which include the 1993 Grand Prix Savignac for the World's Most Memorable Poster, his art retains the quiet charm of his peasant childhood.

In Poland, an artist can move from fine art to illustration to costume and stage design. American artists are more specialized. One Pole complained that in America art directors keep separate files on illustrators who draw animals and others who draw Coca-Cola bottles.

"Most American art directors give you tight sketches," says Polish artist Danuta Jarecka. "This sky. This face. This background." And Milton Glaser admits that, while art directing New York, he decided exactly what he wanted in an illustration before hiring an artist. But when Op-Ed arrived, everything changed. Artists won the right to follow their instincts. "That freedom," says Brad Holland, "became a quasi-institution. Because it got a foot in the door, it took editors longer to stamp it out."

"People always asked me, 'How does it feel being in the free world?'" says Andrzej Dudzinski, a Pole who emigrated to the United States in 1977. "I shocked them by replying that I traded one form of oppression for another. In Poland there was censorship, but to survive, you learned subtlety. In the States, I've had problems with anti-obscenity guards. It's mostly commerce that oppresses," he says. "To stay in advertisers' good graces, publications shy away from gory, depressing, or overly sophisticated imagery. I find these restrictions more daunting than Communist censorship."

Dudzinski, whose work is by turns whimsical and dark, gained fame in Poland with his satirical cartoon featuring a bird named Dudi. "The censors, who had to approve each issue, correctly suspected that Dudi mocked the regime," says Dudzinski. "Everything was tuned down. I had to leave Poland."

Not only is Dudzinski an exquisite draftsman and a cunning conceptualist, but he had firsthand experience with what was becoming the decade's biggest story. When Solidarity gathered momentum in 1980, he hoped this reform movement would succeed. So when martial law descended on Poland, Dudzinski had to respond. Op-Ed then began to receive frightening stories from Communist lands. "I really wanted to illustrate them," says the artist. But he saw how harshly the texts criticized his country's regime. "I knew my anti-Soviet drawings would be weapons I could never sign, since it could cost me the right to visit Poland."

Jerzy Kolacz

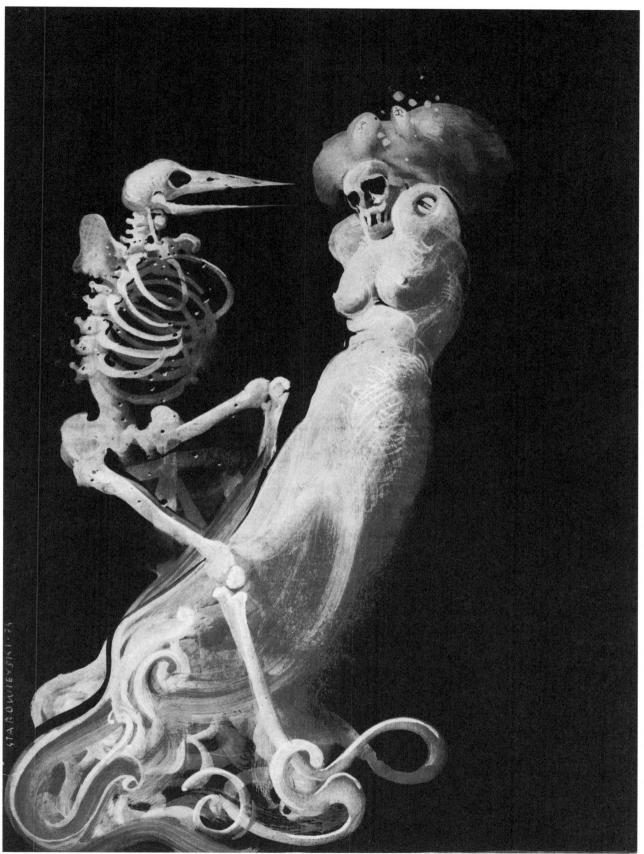

94 Franciszek Starowieyski

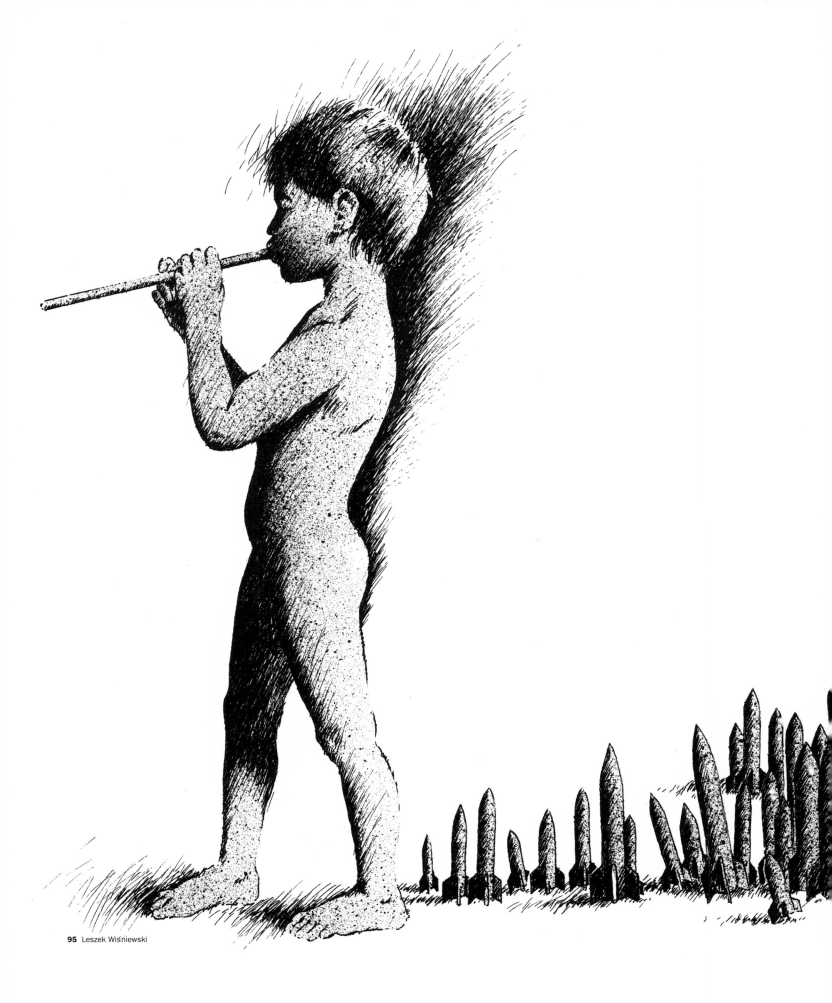

95 Leszek Wiśniewski

96 Stasys Eidrigevičius

97 Andrzej Dudzinski [Jan Kowalski]

The *Times* refused to run unsigned drawings, so we needed a pseudonym. "If I were American," says Dudzinski, "I would have used 'John Smith.' That's exactly what 'Jan Kowalski' is." In 1980, Kowalski interpreted a Moscow resident's nightmare of Afghanistan invading Russia [figure 97]. The pseudonymous writer had walked his manuscript into the *Times*'s Moscow bureau. Borrowing from *Gulliver's Travels*, this illustration demonstrates Dudzinski's ability to inject levity into the grimmest story of oppression.

By doing the Kowalski jobs, "I felt better," says Dudzinski. "Despite not being in Poland, I was participating." By then, there were lots of Poles in New York, and they had parties. "A lady once told me," Dudzinski remembers, "'You work for Op-Ed. Who the hell is Jan Kowalski?' 'He's never here.' I said. 'You wouldn't like him. He's drab.'" Of his illustration for an article by a Soviet defector, Dudzinski says, "When I left Communism, I felt like that tiny person scampering out" [figure 98].

Dudzinski illustrated a poem by Czesław Miłosz dedicated to Lech Wałesa, which begins:

> After two hundred years
> After two hundred years of hope recovered and hope lost
> You became chief of the Polish people[28]

"This idea came from my wife," says Dudzinski. "She said, 'Why not think like Arcimboldo, who made portraits out of fruit?' Little people worked well because Wałesa represented the masses." The likeness consists exclusively of Poles carrying Solidarity banners [figure 99].

Op-Ed received a text from dissident Adam Michnick that was smuggled out of a Polish jail: "Come to Gdańsk and witness our trial. Your presence could influence our fate." "While making this one," says Dudzinski, "I was thinking of my friend Adam, its author. I drew him in the keyhole about to be squashed by the door. Outside is freedom. But if the door slams shut, that's the end of Adam" [figure 100]. Years later, in free Poland, "Adam and I got drunk," Dudzinski continues. "He told me his wife managed to get the page, fold it into postage stamp size, and smuggle it into prison. Then Adam started to cry because he saw the *New York Times* had published his letter and his friend had illustrated it."

After two years of Kowalskis, the artist's mother died. Dudzinski sought permission to fly home. "If you leave," said the Polish consul general, "you'll never again enter the United States." The Communists weren't fooled by our alias. From a squeaky drawer labeled "Dudzinski," an apparatchik pulled a dossier that held every Kowalski critique of Lenin's legacy. Dudzinski missed his mother's funeral. "My anti-Communist Op-Ed drawings of the 1980s are the works I'm proudest of. I remember the day Jan Kowalski was born and the day he died. The Polish Communists never forgave me."

Janusz Kapusta and Rafal Olbinski, Polish artists on visits to the United States in 1981, suffered Kafkaesque fates when martial law

98 Andrzej Dudzinski [Jan Kowalski]

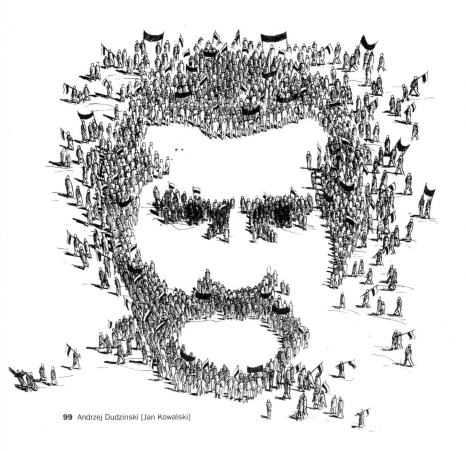

99 Andrzej Dudzinski [Jan Kowalski]

100 Andrzej Dudzinski [Jan Kowalski]

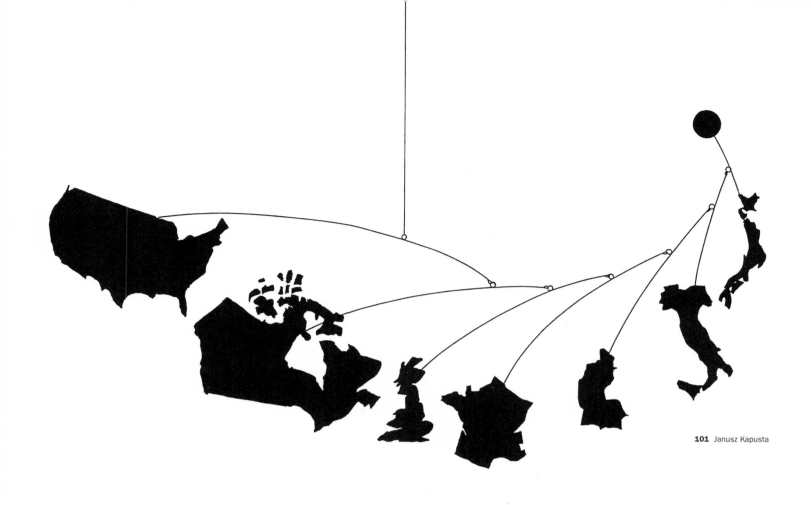

was declared. Just as 36 million Poles were locked inside their land, Kapusta and Olbinski were locked out.

Like Suter, Kapusta has the dizzying ability to render numerous excellent concepts in minutes. He can sketch a dozen apt ideas while standing between the paper cutter and the printer. Despite continual passersby, his powers of concentration enable him to turn out finished art there, as well. He created a bold mobile for an economic summit conference in 1984 [figure 101]. Kapusta invented an eleven-faced polyhedron that is patented as a "K-dron." He also designs theater and opera sets and has published three books.

Olbinski is a virtuoso at conceiving and beautifully rendering surreal imagery. "Thanks to our Polish classical training," says Olbinski, "I've always thought an artist is above everyone else. Before my generation, Starowieyski drew posters with his beautiful Baroque imagination. Who can draw like him now? Nobody."

In Poland, artists used "surreal language as subterfuge," Olbinski says. "Mythology is the wellspring of Surrealism. That Dalí torso with the multiple sets of breasts? Dalí was quoting Greek mythology."[29] Olbinski describes Poland as a great school of visual thinking: "We artists would ask ourselves, how else could we present *Macbeth*? What unexpected image could we use for *Romeo and Juliet*?" War-

saw became a huge art gallery, and a local newspaper ran a juried "Best Poster of the Month" contest. "The winner's name on the front page," says Olbinski, "was bigger than the politician's name in the next article."

"When I was suddenly forced to stay in the U.S.," Olbinski has stated, "I showed my portfolio at the *New York Times*, and my adventure as a so-called illustrator started. The art director would telephone to explain the story, and one hour later I was to call her with ideas. Of course I didn't understand what she said, only very vaguely, and she didn't understand me at all. That's how I learned to come up with indirect ideas on the subject."[30] One of his ideas embodied the environmental consequences of "nuclear winter"and the peace process that might prevent it [figure 102].

"I put Venus from the Botticelli painting on a poster," says Olbinski. "But I forgot about these ridiculous problems with nipples. They're taboo. The biggest business in America is pornography, but you cannot show Botticelli." Now Olbinski shuttles to his one-man painting shows on four continents. Among his many awards is the Grand Prix Savignac for the World's Most Memorable Poster, putting him in the company of Milton Glaser, Stasys Eidrigevičius, and an impressive Bulgarian artist you'll soon meet.

102 Rafal Olbinski

Unprintable

An unfortunate tendency on the part of the editors is
to be prey to that enemy of satire, balance. This results
in infantilizing the artist, removing his stinger.

ED KOREN

A variety of concerns caused imagery to fail the standards test in the
1980s. Topping the list is political overstepping, as when Dudzinski
interpreted an article on the Palestine Liberation Organization [figure
103]. "A toppled garden gate inspired me," he says, "to picture the
PLO as snakes emerging from a fallen column. Then I was told,
'Since Arafat is now a diplomat, we can't show the PLO as vipers.
Your art's been killed.'" Dudzinski had to come to the *Times* imme-
diately to create a neutral portrait of Arafat.

Larry Rivers created a comic strip for an allegation that the CIA
and the Mafia had plotted Castro's murder [figure 104], but editors
found Rivers's dead Castro irksome. Mark Podwal's Israeli tank
whose barrels form a menorah was meant to run with a piece on
the war in Lebanon in 1982 [figure 105]. But editors thought the
drawing inflammatory. Seven years later, for a warning against a
false myth of Israeli weakness, Podwal's once-dead drawing was
deemed dead-on.

103 Andrzej Dudzinski

104 Larry Rivers

105 Mark Podwal

106 Steven Salerno

Steven Salerno's illustration of Soviet nuclear weaponry was rejected as a "stereotype of a fat, brutal Russian" [figure 106]. And Ohio humorist George Kocar's interpretation of Reagan's request for more missile money alarmed editors. It wasn't the nuclear nose or the blind eyes. The reduction of a president of the United States to beggar status sealed its fate [figure 107].

Second only to political offenses was sexual and bathroom imagery. Podwal's Freud flashing his credentials illustrated the licensing of psychologists [figure 108]. But the artist had to give his flasher a pair of boxers. A text on aesthetics inspired an image by Jugoslav Vlahovič [figure 109]. In Belgrade, the artist was startled on hearing that the sculpture's nudity had killed his piece. "I publish drawings like that all the time in this Communist country," he complained.

A letter to the editor stated that .004697 percent of President George H. W. Bush's genes came from his royal ancestors. Bob Gale's illustration initially featured spermatozoa but was published

without them [figure 110]. "The sperm were nice graphically," says Gale. "They should be on coats of arms, representing proud paternal genealogy."

Larry Rivers was utterly serious in drawing General Manuel Noriega [figure 111]. "This guy's so bizarre," said Rivers, "that I portrayed him as female." Could the artist's odd idea fit? The editors thought not. Guy Billout, a Frenchman living in Connecticut, illustrates leading publications with pictures marked by poetic expanses of space. His spare drawings are normally downright safe, but Billout showed another side (rather, back) in portraying Magellan's attitude toward the Philippines [figure 112]. His historical comment didn't make the paper.

David Suter, whose puns had never been off-color, pictured the disdain with which the executive views the legislative branch in the United States [figure 113]. It failed the taste test. Ralph Steadman illustrated a condemnation of Iran's bullying tactics; he delivered the artwork in all innocence as a definitive testimonial [figure 114]. But it wasn't the moment—the Ayatollah Khomeini was holding fifty-two Americans hostage—to offend the cleric. I showed it to no one. Steadman says, "I don't do drawings to get them oppressed. I was enraged. Yet I now can understand objections to portraying Khomeini as a camel farting toward Mecca."

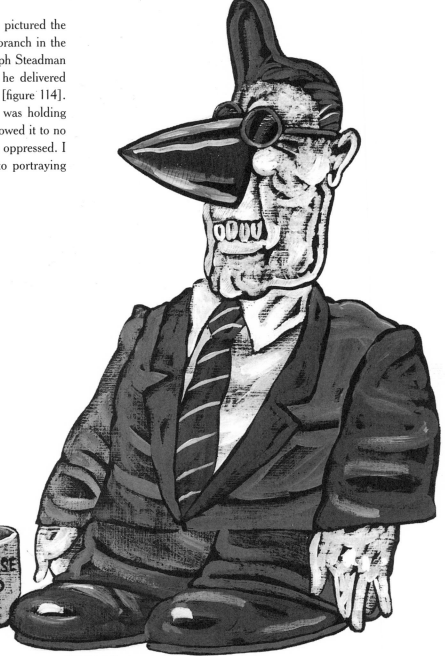

107 George Kocar

108 Mark Podwal

109 Jugoslav Vlahović

110 Bob Gale

111 Larry Rivers

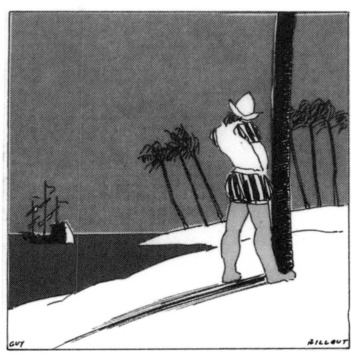

112 Guy Billout

113 David Suter

114 Ralph Steadman

Taste

Ah, good taste! What a dreadful thing!
Taste is the enemy of creativity.

PABLO PICASSO

Times founder Adolph Ochs had one child, Iphigene. Until she died in 1990, at age ninety-seven, Iphigene was the paper's conscience. Gay Talese remembers that Iphigene "stood constantly behind her husband with gloved hands, reinforcing her father's definition of what constituted good taste."[31] "I'm all for good old Victorian and French hypocrisy," she famously said.

"The Ochses and Sulzbergers," adds former executive editor Max Frankel, "have always insisted on the paper's adherence to family values. We felt obliged . . . to write 'barnyard epithet' instead of 'bullshit,' . . . having made only a few exceptions for Richard Nixon's 'fucks' and 'bitches' in the transcripts of his tapes—though not in our articles about those tapes."[32] *Times* critic Eric Asimov relishes his famed uncle Isaac's verse:

The *Times* tells the world what is doing;
Who's winning, who's losing, who's suing.
Who's striking, who's stealing,
Who's dying, who's healing.
But won't say a word on who's screwing.

Harold Evans, former editor of the *Times* of London, states that the New York paper's "integrity is unsurpassed, . . . [that] the *Times* [is] . . . nothing less than an ontological authority."[33] Such an authority's gnarly concerns about political correctness in texts pales in comparison with what an illustrator faces. The Western convention of picturing the generic person as a white guy, for example, is outdated. Yet when will an African American woman read as a symbol of personhood?

Tales from Behind the Scenes

The difference between gossip and news
is whether you hear it or tell it.

ANONYMOUS

In 1982, I met with Tom Friedman of the *Times* in Cairo. Now an Op-Ed columnist, a three-time Pulitzer winner, and the author of such books as *The World Is Flat*, Friedman was then Beirut bureau chief on a brief break from covering the war in Lebanon. I asked him how it felt to report from a battle zone. "It's no fun dodging bullets," said Friedman, "but it sure beats the third floor." (In the Forty-third Street building, the third floor was the newsroom.)

During a Sardi's lunch, Sydney Schanberg told me, "I don't believe in capital punishment. But I'd travel anywhere to see Kissinger hanged." Schanberg is the *Times* reporter who won a Pulitzer for his heroic dispatches from Cambodia. His story is told in the movie *The Killing Fields*. Kissinger had conceived the secret carpet bombings of Cambodia. Later, as an Op-Ed columnist on metropolitan matters, Schanberg accused the *Times* of venality in regard to Westway, the proposed Manhattan highway project. Then, while Schanberg was on vacation abroad, publisher Punch Sulzberger fired him for "peeing" on the paper.[34]

Op-Ed scheduled a droll essay by Robert Coover for Valentine's Day 1994. The novelist wittily worked into his prose the fatwa against Salman Rushdie that the Ayatollah Khomeini had issued on an earlier Valentine's Day, and he ended his treatise cunningly: "So let us celebrate this Valentine's Day, . . . dearly beloved, let us today, as the birds do, do." At the eleventh hour, editorial page editor Howell Raines commanded Op-Ed editor Katy Roberts to have Coover disconnect those last two words. Coover refused. We thus lost the eminent writer's prose and its illustration by Arnold Roth.

While we scurried to find a replacement text and art, Coover's agent sought a publisher for his client's timely prose. The essay appeared intact on Valentine's Day in the *Los Angeles Times*. "That wasn't the first time," Coover says. When Samuel Beckett won the Nobel Prize in Literature, the *Times Book Review* commissioned Coover to write a tribute to the playwright and then objected to a phrase in his essay: "that's right, wordshit, bury me." "Those aren't my words," Coover told the editor. "That's a quote from the Nobel laureate." Coover's homage to Beckett was published in *New American Review*.

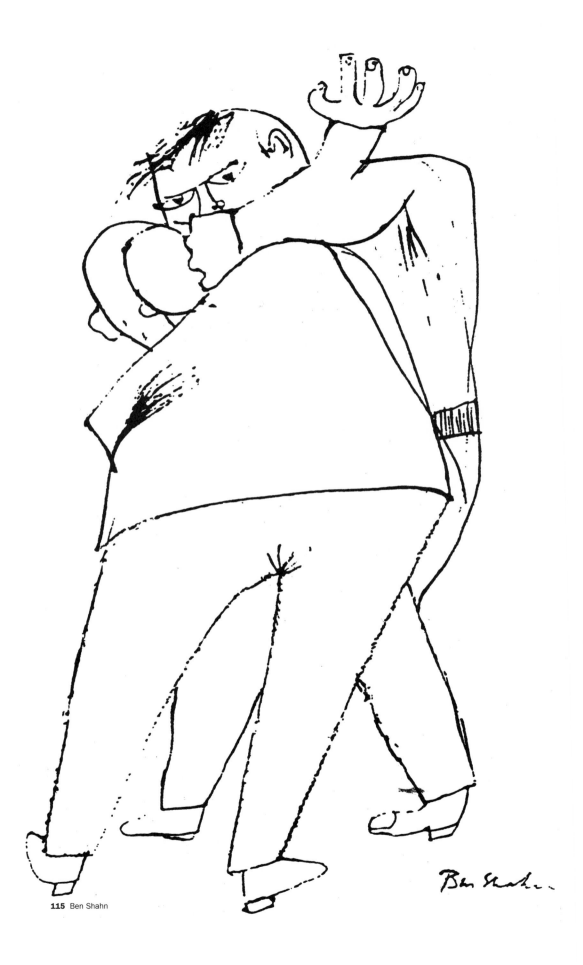

115 Ben Shahn

Wrestling

The *Times* is a ferociously competitive, high-powered place. I had never experienced anything quite like it.

DANIEL OKRENT

"While I was at the *Times*," says illustrator Elaine Clayton, "an editor told me he had no problems working in the White House, but he suffers at the *New York Times*. I understand why. You walk the *Times* hall, it's daggers." Bob Semple, who's thrived at the paper for forty-five years, has eluded those sharpened blades. "The *Times* is a class act," says Semple. After six years as Op-Ed editor, he left the page in 1987 to rise on the editorial board, becoming chief editorial writer and winning a Pulitzer Prize.

Semple was succeeded at Op-Ed by the circumspect Leslie Gelb, who'd worked at the Department of Defense, where he and his "staff of six"—as he put it in a *Times* Op-Ed essay—were "hard-nosed, national security analysts" who produced the controversial Pentagon Papers.[35]

Gelb's initial role at the *Times* was diplomatic correspondent. Then, after serving in the State Department, he returned to the paper as national security correspondent. When he became Op-Ed editor, his Pentagon personality felt alien to me, and he bristled at my defense of the art. From our two tough years together, a couple of incidents stand out.

One involved a drawing by Ben Shahn, a leading American artist who died in 1969 and is celebrated for his Social Realist paintings and the economy of line in his graphic works. I proposed a drawing by Shahn of wrestlers for the next day's manuscript [figure 115]. Gelb's response? "This guy can't draw. It's too stark. Tell him to add more to it." I hired a living artist, but this episode further eroded our tenuous relationship. It was peanuts, however, compared with the next week's coconut.

Gelb asked me to meet "a very talented artist" in his office, where he addressed his art director: "I'd like to introduce Ranan Lurie." I knew Lurie's ubiquitous work, having seen his conventionally drawn cartoons in dozens of European periodicals. *Guinness World Records* cites the Israeli Lurie, a lurid self-promoter, as the world's most widely syndicated political cartoonist. As he displayed his portfolio, I said, "You're a cartooning wizard, but Op-Ed's effort is to replace captioned cartoons with symbolic imagery previously untried in newspapers." Lurie's charms had worked on Gelb, who was now seething. I remained polite, but to Gelb, my unwavering stand was insubordination.

I didn't know then that Lurie's appeal to Gelb had sensational earlier chapters. Lurie had long been active in international affairs. Just one

of his exploits was a journalistic coup in 1976 that nearly sacked General George Brown, chairman of the Joint Chiefs of Staff. When Lurie interviewed Brown at the Pentagon, he drew out the general's extreme views, such as "With the exception of military bands, the Brits have nothing. They are pathetic, . . . Israel is a burden to the United States, . . . [and] America doesn't have the stomach to face the Soviets."[36] Brown's opinions were reported by all major American newspapers and threatened to prevent the reelection of President Gerald Ford, who, indeed, was defeated by Jimmy Carter. Mexican-born artist Claudio Naranjo portrayed an officer in the mold of General Brown in his Op-Ed drawing [figure 116].

I was later supported in this scuffle—as in others—by Gelb's superior, the savvy editorial page editor, Jack Rosenthal, who knew Lurie's work and reputation. Yet Rosenthal's backing didn't suffice. To quote another editor, "Gelb and Rosenthal got down and dirty with each other. They were at swords' points." The wily Gelb managed to prevail, and I became art director of Weekend and Arts & Ideas.

Gelb's insistence on throwing me a farewell shindig was absurd. But after ten years at Op-Ed, I reluctantly agreed. The event featured a full bar, waiters carrying silver trays, and speeches about my valor, including one sent by Semple from Europe. But I was far more moved when I later turned my front-door key to a chorus of "Surprise!" My home was filled with thirty of the artists with whom I'd worked for the past decade. David Suter had traveled for four hours to be there, and Brad Holland, who never went to the *Times* anymore, told me story after story about Op-Ed's earliest days.

The page's next art director, Michael Valenti, got along with Gelb, who left Op-Ed in 1990 to write a column and then preside over the Council on Foreign Relations. Gelb was succeeded at Op-Ed by *Times* senior editor Mike Levitas, whose gene for journalism stems from his father, Sol Levitas, for decades the editor of the intellectually influential *New Leader*.

Levitas, who'd edited the Metro section, the Week in Review, and the *Book Review*, says that his Op-Ed page contained "10 to 20 percent unsolicited manuscripts." (Current editor, David Shipley, confirms that the section now receives "about twelve hundred unsolicited submissions a week"—mostly e-mailed—and that "the page is roughly 25 percent unsolicited. Pieces range from 400 to 1,200 words. A good number to shoot for, though, is 650 to 750 words.")

"*Times* Op-Ed is in a class by itself," says Levitas, "and I always looked forward to the art." Levitas conceived "Op-Ed at 20," the supplement published in 1990 to commemorate the page's two-decade anniversary. It contained excerpts from twenty years of texts, and the illustrations lavishly studded throughout were large. This tribute further underscored the art's significance by printing an all-drawings centerfold.

The invitation to freely address the compelling content of Op-Ed's first two decades—from the bloody blunder of Vietnam to the bloodless revolutions that crushed European Communism—seized

the attention of the world's best artists and made the two decades the supplement represented the golden years of Op-Ed art.

The twenty-year tribute was edited by Howard Goldberg and designed by Op-Ed art director Michael Valenti. Valenti repeatedly asked Horacio Cardo, whose work was well represented in the supplement, to illustrate articles. But the Argentine artist refused to work for Gelb. Once Gelb was gone, Cardo resumed contributing.

Another strained relationship then developed between editor and art director—this time, Levitas and Valenti. Valenti transferred out of Op-Ed, and a succession of freelancers took his place—including two who'd art directed *Esquire*, Bob Ciano and Richard Weigand—until the charming and talented Bosnian-born Mirko Ilić secured the job.

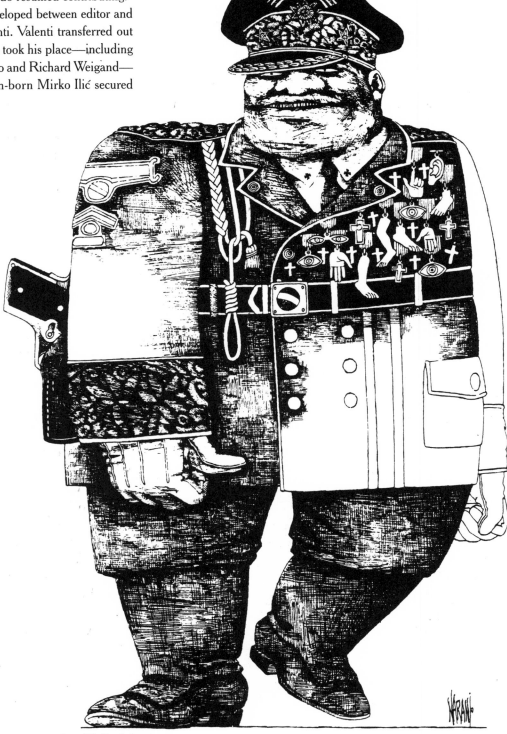

116 Claudio Naranjo

THE NINETIES

A Boost from Bosnia

It was not real Communism. It was Communism Lite.

MIRKO ILIĆ

Artist Mirko Ilić was describing the former Yugoslavia, whence he moved to New York in 1986. Forty years earlier, Marshal Tito had declared the diverse Balkan states to be the Federal People's Republic of Yugoslavia, a realm whose semblance of harmony Tito maintained by sending dissidents to work camps. Yugoslavia's artists, however, like their Polish contemporaries, knew what to expect of the regime.

"In Yugoslavia we didn't have all these levels of approval," says Ilić. "Everybody was afraid of system. In the U.S. everybody is afraid of everything. Is this politically correct? Am I going to get raise? Will I lose my little house in Hamptons? Doesn't mean I was more free in Yugoslavia. But challenge was different. Enemy was more visible." In his homeland, Ilić had "published thousands of illustrations, album covers, posters, and comics," he relates, "without doing a single sketch. In the States, they made me do sketches. That was beginning of my work in land of free."

Ilić says he understands his success in the United States: "We Eastern Europeans get hired because we know how to beat system.

You don't know yet. We've come to teach you. Karl Rove learned everything from Communist propaganda. That's biggest victory of Eastern bloc. Double-talk." Within five years, Ilić added the title of U.S. art director to his résumé. "I survived as art director of *Time* magazine's international version for six months of 1991," he says. "Then I wanted to do Op-Ed because I really believe in that page. I started art directing it at end of 1991. The readers were my clients. My bosses were just counting money."

Six years before Ilić left Yugoslavia, Tito's death in 1980 started a period of turbulence that would reveal the country's ancient political and ethnic divisions. The brotherhood Tito had cobbled together dissolved as his "sons" violently vied for the position of Father. Like Polish artists during the 1980s, Ilić in the 1990s had the Op-Ed platform to visually evoke the personally agonizing events that began when "war started in my little country of Bosnia."

In 1991, an Op-Ed manuscript stated that the borders between Croatia and Serbia were invalid. Ilić addressed the bestial tribal hatred that resulted from this newfound nationalism [figure 1]. Another image, from 1992, is Ilić's interpretation of an article on the rape of Muslim and Croatian women by Serbs [figure 2]. "My first wife in Zagreb wrote that piece," says Ilić solemnly. "Nobody knew that. And the lady in the photograph is my wife today. I just added the map of Bosnia in Photoshop, since I didn't feel I could draw this subject."

In addition to illustrating some articles on the Yugoslav wars of secession, Ilić hired artists already associated with the page. In 1992,

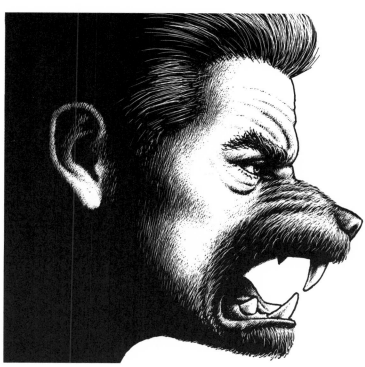

1 Mirko Ilić

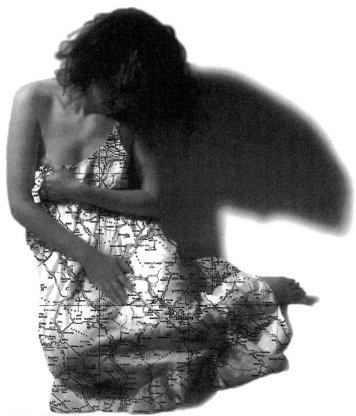

2 Mirko Ilić

3 Milan Trenc

Sue Coe interpreted a text on the Sarajevo siege that had killed thousands of Muslims. Coe painted a moody cemetery, but she topped the gravesites with crosses. "What to do?" says Ilić. "If I just put sticks, it would look like a vineyard. If I left crosses, American readers would know it's a graveyard, but it would be incorrect and hurt Muslims. Finally, I left the crosses. Luckily, nobody complained."

"The best thing I did as Op-Ed art director," says Mirko Ilić, "was help somebody give birth. An artist works all night and creates this child, then editors criticize his creation. Move this, cut this." Ilić felt, he says, "like one of those American football guys running ahead and knocking everybody down with small, sensitive guy running behind me to make touchdown."

Ilić enjoyed the array of ingredients that makes up Op-Ed art's menu. "Each artist contributes a particular flavor," he says, "and you need lots of variety to make the soup rich." He introduced the *Times*'s readers to the work of the Croatian artist Milan Trenc, whose graceful, light-footed style became a favorite of editors. Trenc, with his slender build and full head of springy golden curls, resembles Saint-Exupéry's drawn portrayals of the Little Prince.

Before returning to Zagreb with his Japanese wife, Trenc illustrated scores of Op-Ed articles. Among them is his interpretation of an argument that Americans who came of age during the Depression had an optimistic directness lacking in the more serious baby boomers [figure 3]. Trenc is the rare illustrator to have experienced Hollywood glory; his children's book *The Night at the Museum* became

the eponymous hit movie. Unfortunately, Trenc sold the rights to 20th Century Fox outright and received not a cent from the film's international box office success.

Ilić called on another Eastern European illustrator, Czech-born Peter Sís, the recipient of a MacArthur "genius" grant, to illuminate the Declaration of the United Nations Conference on Environment and Development in Rio de Janeiro in 1992 [figure 4]. In 1982, the Czech government sent Sís, who's also a filmmaker, to Los Angeles to produce a film on the 1984 Olympics. When the entire Eastern bloc (except Romania) boycotted those games, the Czechs canceled the project and ordered him home. Instead, Sís defected and received political asylum. He moved to New York City (where the Museum of Modern Art collects his films) to create luminous children's books. Another of his Op-Ed images from 1992 addressed the "Velvet Revolution" in his country, which, the accompanying article stated, enabled the "ascendancy of faceless little yes men," whom the artist gathered on the horse's rump [figure 5].[1]

One of the impeccable pros Ilić hired was Robert Grossman, who produced an elegant portrait of Marlene Dietrich in 1992 [figure 6]. It graced an article that quoted her as saying, "Hitler wanted me to be his mistress. I turned him down. Maybe I should have gone to him. I might have saved the lives of six million Jews."[2] Grossman's caricature reflects the writer's portrayal of Dietrich as the personification of arrogance and plays off a claim that she was addicted to Tupperware.

4 Peter Sís

5 Peter Sís

"I majored in fine art at Yale," says Grossman, "when Yale's focus was minimalism, as in Josef Albers's squares. I had a course with Albers. He announced one day in class that I was asleep, but I wasn't. If I got anything out of their art school, it was an idea about precision." Grossman has contributed to Op-Ed since the early 1970s, and his talent has been indispensable to enlivening the page.

While subbing for Ilić in 1993, art director Bob Ciano hired Marshall Arisman to illustrate a protest against the freeing of the sadistic mastermind of Treblinka's Nazi death camp. Using one of his unflinching animal metaphors, Arisman created a demonic beast stretching its hand-paws [figure 7].

Steve Brodner's pitiless portraits—marked by stunning draftsmanship and smart, savage caricature—appear in most major American publications, yet he can barely catch a break at the *New York Times*. In 1993, a rare Brodner drawing did make it into the *Times*. It accompanied an assessment of the first popularly elected leader of Russia, Boris Yeltsin, who was considered to be a formidable politician when crushing enemies [figure 8].

Brodner, who views his art as political activism, says, "If a drawing of mine absolutely tells the truth, I feel I did the job. My pieces must carry a lot of water. They must not only be good pictures, they must add to the discussion." While Brodner's biting portrayals of the powerful enthrall some editors and repel others, illustrators admire him. "Steve Brodner came to show me his work fifteen years ago, and he was good then," says Ralph Steadman. "He's still pretty terrific—one of the truly intense guys around. Sometimes he lets style overcome content, but we all do that. You have to be lazy sometimes and let the line take you for a walk. But mostly he's very focused, and he has made me catch my breath."

Ilić exploited the Macintosh computer's magic to encapsulate some of Op-Ed's texts with typographic illustrations. "I had a specific inspiration for doing so," says Ilić. In 1992, typographic designer Herb Lubalin's journal *U&lc* (*Upper & lower case*) published a story about the ephemera that designers collect. Featured in the story was *Time*'s art director, Nigel Holmes, who'd saved a *New York Times* Op-Ed article published in the shape of a zeppelin. Text and illustration were one and the same [figure 9]. Ilić, struck by the shaped type published thirteen years earlier, cut out the airship and kept it.

The backstory: a text advocated the use of energy-saving zeppelins for transporting cargo in 1979. Op-Ed's crack copy editor, Howard Goldberg, had fond memories of those big-bellied airships and suggested that I try to create a zeppelin out of the copy. It was the Linotype era, so we painstakingly executed my design by hand—line by jagged line.

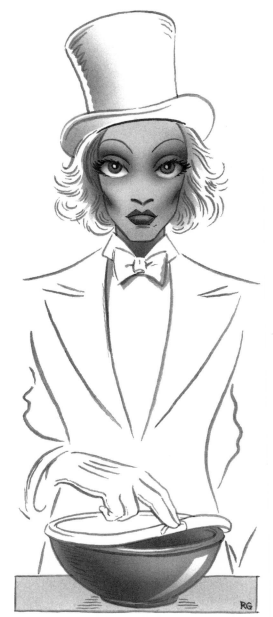

6 Robert Grossman

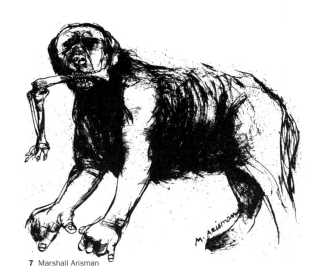

7 Marshall Arisman

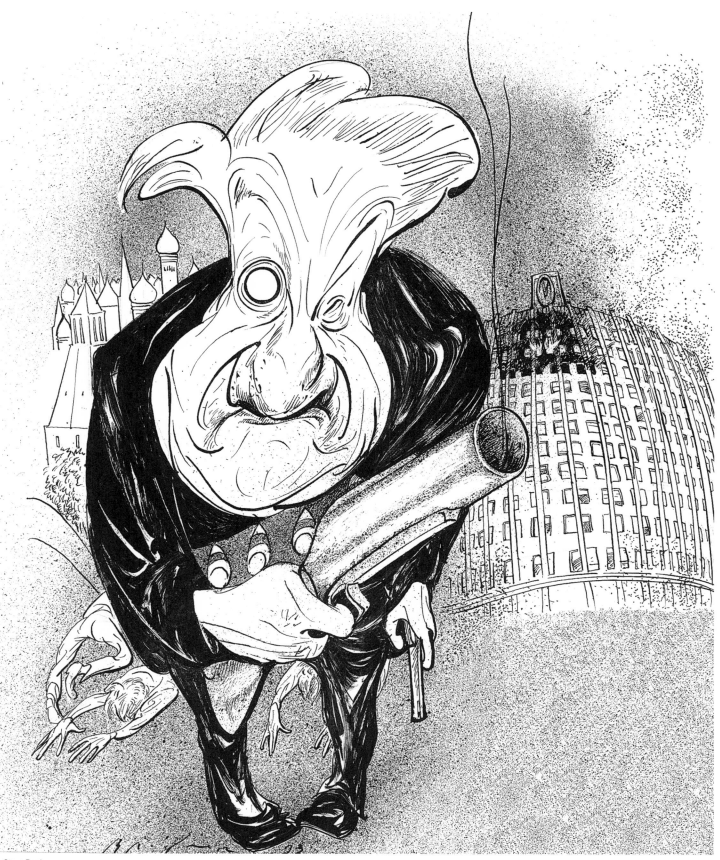

8 Steve Brodner

OBSERVER

Fury Signifying Billions

By Russell Baker

In the public domain, everything has been overdone in the summer now fading. President Carter's decline in the polls, which took him down near record depths of disapproval, is a case in point. Is President Carter really that bad? Surely not.

Senator Kennedy's soaring popularity ratings are equally puzzling. Is Senator Kennedy really that good? Not likely. Smart politicians tell you that polls at this season, fourteen months before the election, are meaningless, yet they are already beginning to act as though they were handwriting on the wall.

Thus, we have the draft-Kennedy movement based on the theory that charisma — Kennedy glamour — can overcome public yearning for cheaper government and elect a President who proposes to restore New Deal spending habits.

If there is a bit of hysteria here, hysteria has been even more evident in the Carter compound ever since the gasoline lines of early summer. Government ineptitude and private greed obviously played their roles in raising the price of oil to a dollar a gallon, but this should have come as no surprise, least of all to the White House.

GLENDALE, N.Y. — As the search for energy-efficient forms of transportation continues, it's time to reassess a type of long-distance transport that held great promise until a world war, cheap oil and other factors caused its death over 40 years ago. It's time to bring back the zeppelin. The zeppelin, or "rigid airship" as it's technically known, is the perfect cargo carrier for these oil-scarce times. Unlike airplanes, which must fight against gravity and wind resistance to remain aloft, an airship is designed to work with the environment. Instead of burning precious jet fuel in a vain attempt to battle nature, a zeppelin, using lighter-than-air helium, floats gently in the air, needing only a few modest propellers to power its journey. However, since trucks, not airplanes, carry most of the nation's goods, zeppelins would have to be competitive with interstate trucking to be a real transportation alternative. To this end, even by using 30-year-old technology, we could construct a line of 1,300-foot-long zeppelins capable of carrying over 500 tons of cargo between New York and Los Angeles in 36 hours. That's at least two to three days faster than by truck. While they were shaving days from shipping time, such zeppelins would also save fuel. For instance, the four 1,800-horsepower engines that would be needed to propel a large airship would consume at least 35 percent less diesel fuel than the equivalent number of trucks that would be necessary to transport the same goods. But airships don't have to compete against trucks; they can work with them. Just as container ships have replaced traditional ocean freighters, zeppelins could be built to carry containerized cargo across the land. Trucks could then be used, as they are best-suited, for the short trips between airports, distribution markets and local merchants. In the past, the major drawback to building a zeppelin fleet was the initial design and construction costs. Until the recent oil-price increases, the amount of fuel that airplanes and trucks wasted was inconsequential when compared to the cost of building zeppelins. It was for this reason that in the late 1940's Goodyear scrapped its plans for a freight and passenger airship line. Now, however, with oil many times its 1940's price, an airship's fuel savings would more than offset its construction costs. Besides cost, the only other hindrance to a renewed zeppelin program is zepplins' allegedly poor safety record. But when one considers how safe airplanes were in the 1930's (when zeppelins last flew), one can see that this is really a nonargument. At any rate, the public's perception of the zeppelin as a flammable deathtrap is based on the fact that the old zeppelins carried hydrogen to provide lift. Today, nonflammable helium will give almost the same lift potential, without hydrogen's inherent danger. Another advantage modern zeppelins would have over their ancestors is advanced navigational and safety equipment. Like many present-day ships, zeppelins would guide their course with a space-satellite navigation system. This equipment, and improved gear for weather-forecasting, would help to steer a zeppelin away from foul weather quickly and safely. Anyway, in an emergency, a zeppelin can always land in any empty field — something jet aircraft can't do. So, if American business and government are serious about saving energy and reducing transportation costs, they owe it to us to take another look at the zeppelin. Someday soon, ball games may be halted, as they were in Ebbets Field, to give everyone a chance to watch a zeppelin. It will be carrying produce, not travelers abroad.

John Edwards writes on science.

It's a Bird! A Plane? Superman? What Then? A Concorde? Looks Familiar.

By John Edwards

Now is the time to reconsider using zeppelins for energy-saving long-distance cargo-hauling.

9 Howard Goldberg and Jerelle Kraus

"I never saw the original in the paper," says Ilić, "but I took *U&lc*'s reprint to my editor and asked, 'How come we can't do this today?' Because my English was so poor, the typography was just so much gray area to me anyway. I thought it would be great to make it into a picture." The first time Ilić designed shaped copy, union problems occurred. He wasn't allowed to touch type proofs, and union printers said they needed four days to translate onto the page the layout he showed them in dummy type.

"So I got the real type," Ilić reports, "and created the proofs myself on the Mac." When, in 1992, an article stated that Hillary Clinton, while First Lady, was regarded as too individualistic and that, in particular, her smile irritated men, Ruth Marten drew that smile for Ilić's idea [figure 10]. On Thanksgiving Day of that year, three articles were thematically connected. "Originally there were only two texts," says Ilić, "and I laid out Milan Trenc's drawing of a turkey to give the layout air on the bottom right. But whenever editors see white space, they fill it, especially male editors" [figure 11].

Giving visual form to writing had a long history before computers made it child's play. Pattern poems have appeared from ancient to modern times and in languages from Sanskrit to Portuguese. In 1918, Apollinaire coined the term *Calligrammes* for his concrete poetry.

The slanting lines of his poem "Il Pleut" (It's Raining) resemble raindrops running down and across a windowpane. "Moi aussi, je suis peintre [Me too, I'm a painter]," he wrote.[3]

Ilić's masterpiece of typographic thinking appeared in 1993 [figure 12]. The featured articles were negative and positive views of the Anti-Defamation League. "I was wondering how to illustrate them," says Ilić. "How do you draw a Jewish person? We've had enough stereotyping of Jews. The only solution was graphic, not illustrative." Before long, Op-Ed writers were requesting that their articles be typeset in shapes. "Sometimes they wanted type solutions when it wasn't appropriate," says Ilić. "It turned out that something the editors were against in the beginning, they now wanted overboard."

Ilić left the *Times* in 1993. He has since coauthored books and taught master classes at Cooper Union and the School of Visual Arts. In 1995, he opened his own studio, Mirko Ilić Corp. His success at designing everything from hotel interiors to three-dimensional computer graphics, motion picture titles, and Le Cirque teacups has enabled him to complete a dozen pro bono projects, including posters for Jerusalem's Gay Pride parade. "I'm neither gay nor Jewish," says Ilić. "But when they're done with them, I know I'm next."

The Power Laugh

By Susan Faludi

I have read and heard — and repeated — the now standard feminist explanation for the hysteria over Hillary Clinton. It goes like this: The guardians of the rusting social order — the pundits, the political hacks, the religious right — have their shorts in a knot over Hillary Clinton because she's an independent woman.

They feel threatened by this emblem of the modern women's movement — by her professionalism, her role in her husband's career, her feminist views, her failure to produce a brood of young 'uns and, last but not at all least, her financial independence.

But is that the whole answer? After all, Hillary Clinton is hardly the first First Lady to have an egalitarian relationship with her husband. From Abigail Adams to Sarah Polk to Rosalynn Carter, numerous First Ladies have refused to play the 1-don't-know-nothin'-about-makin'-policy role. They have been involved in their husbands' political decisions, attending Cabinet meetings (Helen Taft), writing speeches (Bess Truman) and monitoring political correspondence (Edith Wilson).

Nor is Hillary Clinton the first feminist in the East Wing. Eleanor Roosevelt fought to revoke laws that locked married women out of the Depression-era job market. Betty Ford lobbied for the equal rights amendment; she even installed a separate phone line in her office just for this purpose.

Ms. Clinton's failure to demonstrate megamaternity is no departure, either: Neither the Washingtons nor the Polks had children. And her final-indignity — drawing an income that makes her the family's breadwinner — is also no aberration. As Betty Boyd Caroli observes in "First Ladies," most Presidential wives have been richer than their husbands.

But none of these women has taken half the licking in the press that Hillary Clinton has. Why not?

Hillary Clinton's autonomy is only half the story. What galls her detractors isn't so much that she is independent — but that she enjoys it. She is doing something her predecessors didn't dare. She's abandoned the earnest, dutiful demeanor. She doesn't bear the grim visage of the stereotypical female policy wonk; she's no Jeane Kirkpatrick. Nor does she make any pretense that power and visibility were forced on her. And therein lies her sin: Hillary Clinton is visibly, tangibly having fun. Eleanor Roosevelt loved the public life, but she rarely revealed her exuberance. Before the media, Ms. Clinton throws back her head and laughs, kicks up her heels and breaks into a dance.

Wipe that smile off your face, the moral instructors of Hillary Clinton. In the National Review's many anti-Hillary broadsides, the magazine's

Susan Faludi is author of "Backlash: The Undeclared War Against American Women."

contributors were in highest dudgeon over the pleasure the First Lady-elect takes in politics, calling her "that smiling barracuda." Time magazine, too, was put out by Ms. Clinton's displays of enthusiasm and political passion: "At first, she seemed insufficiently aware that she was not the candidate herself. Instead of standing by like a potted palm, she enjoyed talking at length about problems and policies."

Other columnists wagged their fingers at Ms. Clinton for "beaming" and "throwing her arms open wide" as she "seized the stage." The American Spectator was particularly disgusted by Ms. Clinton's embrace, in her 1969 Wellesley commencement speech, of an "ecstatic . . . mode of living."

By combining equality with ecstasy, liberty with laughter, Hillary Clinton violated the cardinal trade-off rule of American womanhood: Women are told: O.K., gals, go ahead and do your liberated thing, but you must pay the price with personal happiness.

Women have taken this lesson to heart. To prove our femininity and avoid the slings and arrows of antifeminism, we have learned to assure the world that while we may have more mastery of our lives, we've balanced it with more misery. We are careful to stress that we are working only because we have to, not because we might also take pleasure from our jobs.

Sexuality for women comes with the same warning: If you have sex and enjoy it, prepare to face the consequences. That may be why many who favor a ban on abortion are willing to look the other way when the woman in question has been raped or is the victim of incest; she doesn't need to be punished because she hasn't gotten any pleasure out of the encounter.

Enthusiastic activism is cast in the same dim light as sexual activity. Indeed, the phrase "public woman" has traditionally meant a prostitute; the lady of the evening and the lady of social advocacy often seem interchangeable in society's eyes, Victorian male pundits raged against the "whorish" behavior of the decidedly unwhorish women of the era who were reformers and suffragists. In his 1844 address to the Young Ladies' Institute of Pittsfield, Mass., William Buell Sprague intoned that he would rather his daughter join a nunnery than go "up and down the world haranguing promiscuous assemblies."

The connection between sexual and political pleasure explains one of the more bizarre sins of the tongue by a media man contemplating the Hillary Threat. In a "Nightline" report this fall about the First Lady's proper "role," Ted Koppel asked R. Emmett Tyrrell, editor of The American Spectator, "What would you do with [Ms. Clinton], put her in a convent for the next four years?"

Eleanor Roosevelt noted that women could be either biblical "Marthas" or "Marys." Take the part of the giggly party girl or assume the role of the dowdy activist. Mrs. Roosevelt cast her lot with the Marys. Historically, First Lady Marys have presented themselves as dour and self-denigrating. They have insisted their political activities were really a terrible burden — a "splendid misery," as Abigail Adams put it.

The list of First Ladies who moaned about their ineptitude at public speaking is endless — and the most adept moaned the loudest. Eleanor Roosevelt "never missed an opportunity to discount her influence," biographer Blanche Wiesen Cook writes, and she "was rarely direct or confrontational."

Hillary Clinton, however, is a Martha-Mary, an independent woman who has happily and openly ventured into the stream of public life. It's her refusal to play the penitent Mary that most enrages the antifeminist commentators. "There is no reason she ought to be forgiven, when she hasn't repented," fumed Daniel Wattenberg in The American Spectator.

For a moment, when the Gennifer Flowers story broke, it looked as if Hillary Clinton might play the long-suffering Mary after all. But no, she rolled her eyes and assured the was no Tammy Wynette. Later in the campaign, misogynist hopes rose again as she softened her looks and toned down her impassioned speechmaking. But these efforts were pure cosmetology and then her enemies knew it.

The joy of female independence is what Hillary Rodham Clinton will bring to the White House. By showing us that an independent woman doesn't have to don a hair shirt and hang her head in shame, Ms. Clinton has already advanced women's rights. Her presence will remind us that the Founding Fathers guaranteed Americans more than life and liberty. They promised us the pursuit of happiness, too. □

10 *Mirko Ilić and Ruth Marten*

The A.D.L. Under Fire

The Jewish community has a right to monitor anti-Semitic groups. We oppose attempts to use the A.D.L.'s deep troubles to build stereotypes of a supposed spy octopus, yet we believe the A.D.L.'s leaders were reaping what they sowed when they lunged to the right in the Reagan-Bush years and became a neo-conservative citadel.

Its Shift to the Right Has Led to Scandal

By Dennis King and Chip Berlet

The Anti-Defamation League of B'nai B'rith is embroiled in a scandal. It results from allegations that a longtime researcher on its payroll in California was illegally given police files as part of an A.D.L. effort not just to monitor bigots but also to watch thousands of other individuals (including the dovish son of the former Israeli Defense Minister Moshe Arens) and hundreds of environmental, civil rights and other social action groups.

The researcher, Roy Bullock, has admitted selling information to the South African apartheid groups to South Africa.

The police have raided A.D.L. offices in San Francisco and Los Angeles, and the A.D.L. could face charges of eavesdropping, tax violations and receiving confidential government files. The investigation may develop into a probe of the A.D.L.'s nationwide information-gathering networks. Paul McCloskey, a former Congressman, has filed a class-action invasion-of-privacy lawsuit on behalf of targeted individuals.

Dennis King, who did freelance work for the Anti-Defamation League in the early 1980's, is author of "Lyndon LaRouche and the New American Fascism." Chip Berlet is an editor of Police Misconduct and Civil Rights Law Report, a newsletter.

Jackson. Abraham H. Foxman, who became national director of the A.D.L. in 1987, argued that the organization might lose its tax-exempt status if it took a stand on a political candidate — though Jesse Jackson had been attacked by the A.D.L. while he was a candidate.

While Mr. Buchanan was a Presidential candidate in 1992, tapping into Mr. Duke's constituency, the A.D.L. did not oppose him, evidently again relying on its tax-exempt status as an excuse for passivity. After he bowed out, the A.D.L. published a critical analysis of his remarks.

Even the 1991 Crown Heights riots couldn't nudge the A.D.L. into its former activism. A.D.L. leaders, in spite of their professed views of black anti-Semitism as the overriding domestic threat to Jews, issued neutral statements avoiding any mention of anti-Semitism, while Jews were being beaten in the streets. (Mr. Foxman later said this "self-imposed restraint" had been a mistake.)

The A.D.L. will soon face fierce attacks, with the likelihood of further lawsuits in the California scandal. The usual circling-the-wagons defense that has been the chief tactic of the major Jewish organizations won't be convincing. Neither will the predictable defense that rests on the A.D.L.'s prior record of fighting bigotry. In recent years, it has sacrificed principled politics to expediency. For the A.D.L. to recapture the trust it has lost, a full housecleaning is in order. □

(continued text) The A.D.L. properly urged black politicians to condemn Louis Farrakhan for calling Hitler a "great man" but shrugged off frequent meetings between some of Ronald Reagan's national security staffers and followers of the neo-Nazi Lyndon LaRouche organization. A 54-page A.D.L. report on Mr. LaRouche in 1986 devoted exactly two sentences to these meetings. In 1988, the A.D.L. defended Frederick V. Malek, a George Bush campaign aide who had compiled lists of Jewish-sounding names for the Nixon Administration: he had only carried out orders, the A.D.L. said.

Asked about such policies, the A.D.L.'s present fact-finding director, Irwin Suall, told us in conversations in the early and mid-1980's that the chief domestic danger to American Jews was the American left — especially black leftists — backed by the Soviet Union. He argued that right-wing extremists, even those with high-level connections, were insignificant by comparison; to focus on them, he said, would be a dangerous diversion from the struggle against Communism at home and abroad.

To avoid any such diversion, the A.D.L. said in 1986 that a Louis Harris poll it had commissioned had shown reports of Farm Belt anti-Semitism to be "grossly exaggerated." In fact, the poll revealed quite shocking anti-Semitism, and the A.D.L. had to back down when the American Jewish Committee disputed its interpretation.

The A.D.L.'s abandonment of serious analysis reached its nadir in 1988, when in an Op-Ed article in The Wall Street Journal, an A.D.L. fact-finder, Mira L. Boland, described white supremacy as a "negligible" force (citing only membership figures, not the influence of supremacists) and suggested that anyone who regarded "violent racism" as a major problem was indulging either in "paranoid fantasy" or subversive propaganda.

Even after David Duke, a former Klansman and neo-Nazi, won 60 percent of the white vote in the Senate race in Louisiana in 1990, the A.D.L. did not attack him as aggressively as it had Jesse

All You Do Is Just Sit Down

By Garrison Keillor

Our family Thanksgiving was as lovely and unhurry as any in America, a day at Uncle Don's and Aunt Elsie's in south Minneapolis, the windows steamed up, our radio piled on a bed, the holy asleep next to them on a Packers-Bears game on television, the little kids tearing around in the basement, the women coaxing the dinner toward the goal line.

Lavish aromas washed into the living room, and next to me on the couch Uncle Don dozed and died with the Green Bay Packers. He was a big man, a guard in the days of the single wing, and as he watched the

Garrison Keillor, host of "American Radio Company," is an occasional contributor to this page.

screen he landed in more with the play. And when the Packers blew a big chance with a boneheaded play, or were betrayed by inept officiating, he had a hard time controlling himself. "Holding! You call that holding? He stuck out his hand and the other guy ran into it. Open your eyes!" he'd be hollering, and he'd d''t demonstrate to me how holding differs from sliding out your head as he the other guy runs into it.

We sat and breathed the smell of apple and pumpkin pies, and sage dressing cooking in the great bird's cavous, and doo jowls baking in butter and brown sugar, a dinner as sweet and plain as the town. Christmas takes a person into a realm of poignant memory and deep need and maudlin guilt and, since gifts are involved, into the treacherous waters of taste and judgment, but Thanksgiving is a present holiday, and good taste has never been part of it. That's why it is such a comfort. All you have to do is sit down is it's enough. When dinner was served, we left the television, called ourselves to the table as our loved ones, and trooped in around the table. There were 13 of us, Uncle Don held grace. Despite some questionable strategy and a few weak spots in life's lineup, nonetheless we had been blessed, and he thanked God for this in a quiet voice, and we dug in.

It was, of course, the dinner of all dinners, so generous, so predictable. The creamed cauliflower, the rolls, the giblet gravy, the light and dark meat on a turkey, mush, a gelatin ring stacked with pineapple and grapes, which nobody ate; it was purely ceremonial.

We had steadily as Aunt Elsie hovered overhead, insisting us and replenishing the platters, apologizing for the dressing (too dry), the whites meat (dried), the mashed potatoes that somehow fell short of their potential. Her modesty made the meal seem even richer, almost kingly. I ate three helpings of everything, one heaping, one regular.

We looked for home, Dad and Mother er in tow, the baby on her lap and a little brother wedged in the middle, the six whose head I liked to teach because it sounded like it was heavenly as it was and as back four of us, including the nervous brother who had tenderries toward our sickness. We put him next to the window and cranked it open an inch. I sat next to my sister, singeared, and leaned my head against her back, teeling whether she would allow this. She did. And I fell asleep.

After my aunt died last fall, I bought her dining room table from my uncle, who went South, and now it will hold my dinner, which in like bare and almost as good.

Thanksgiving isn't hard to make, which is the beauty of it. Here is a tiny table full of dinner and plop down and think, Life is good, thank You for this, it could be a lot worse, and I'm grateful it's not.

God bless us.

Here we do not need. □

One Strange Bird

By Margaret Visser

Toronto

The huge, golden creature we reverently slice and serve for Thanksgiving dinner has a nature and a history as odd as any national symbol could wish. The modern turkey is a deeply misunderstood bird; like all festival foods with staying power, it is old and strange, yet typically ours.

"Rugens" and "caramelized," Audubon called its head and back: all wrinkly and covered with flabby wattles, warts, tubercles and bumps. The wrinkles of a turkey's 30 or so caruncles is attached to his face. In the male dulls comes of flesh, drooping over its bill, can stretch to a trice from one to eight inches.

The whole featherless neck and head changes color as the turkey's moods alter, from white to turquoise to blue, to pink, purple, orange and flaming red. When courting, the flat skin of the male is red and the warty caruncles are a brilliant blue. The bird gobbles. He struts and puffs (a performance called a plum), and his tail feathers display in the manner of a peacock.

The position of the female's head and neck is essential in turkey mating: necks will display their plumage before a disembodied hen's head crudely moved in wood, provided the object is held at precisely the notice angle.

Native Americans used the bird's feathers for headdresses, arrows and fans or twisted them on cords and woven them into cloaks and blankets. The black bristle "beard" that hangs from the male's chest was used as a byssop, for fliding water, in religious ceremonies. Columbus mentioned the bird first on an island off Honduras, where the Indians served wine & him roasted. At other Indian feasts, the Spaniards were offered enormous tamales containing a whole turkey each.

The appearance of the living birds astounded, fascinated and confused Europeans, who ended up calling the creature *Meleagris gallopavo*: "sowsfowl-chickenpeacock."

Margaret Visser is author of "The Rituals of Dinner: The Origins, Evolution, Eccentricities, and Meaning of Table Manners" and "Much Depends on Dinner."

The popular name varies from Indian tribe to tribe and from country to country. The English thought the huge new chicken originated in Turkey; the French and Italians called it "from India" (*dinde* and *gallo d'India*), and the Turks themselves call it *hindi*. The Japanese, owed by slicing to go on all those changing wattles, called it *shichimencho*: "seven-faced."

Turkeys are extraordinarily primitive fowl in certain respects. They seem never to think of looking down when seeking an escape route, and their eyeballs fit so tightly into their sockets that they have to turn their heads to see moving objects.

A deafened female turkey, hearing no sounds from her young, will take them for foreign pests and peck them to death: a turkey with no head can rear young be murdered by his brothers for looking odd. Turkeys often become enraged by unusual rocks, old bones or anything red. At any rate "red noise all make and seen females gobble ma.

They meet is not only light, the most preferred, but also dark, which feeds variety. Darkness is bird meat comes from the repulsion, which storks oxygen for muscles. Game birds' breasts are dark because they fly. Legs are dark in the domestic turkey because even factory-reared birds have to stand, and so make use of the muscles in their legs.

In 18th-century Europe and North America, turkeys were commonly walked 100 miles or more to market. From the large breeding farms in Norfolk, thousands of birds crowded down the narrow roads to London during the weeks preceding Christmas.

The great black Norfolk gobblers (which the English called "bubbly-jocks") wore shoes for the journey. Their feet were dipped in thick pitch or tied up in sacking and covered with little boots to protect them on the long noisy march south. By the time turkeys arrived upon city dinner tables, dark meat must surely have predominated. □

The Two Turkeys

By James Thurber

Once upon a time there were two turkeys, an old turkey and a young turkey. The young turkey had heard that all the walk for many years, and the young turkey wanted to take his place. "I'll knock the old buzzard cold one of these days," the young turkey told his friends. "Sure you will, Joe, sure you will," his pals assured him. So one day when the young turkey saw the old turkey dozing in the sun, he rushed at him, but the old turkey stepped nimbly to one side and the young turkey, using more force than good sense, ran headlong into a barn and knocked himself out. When he came to, the old turkey was standing over him. "Ready for some more, Joe?" asked the old turkey, and Joe said, "No, I guess not."

This shows that the old and wily are not always to be beaten by the young and the strong. Or, as Joe put it: "I got more horse sense than I used to have, and I'm not so cocky." The old turkey thought, "You and who else?" and the old turkey knew that Joe was talking to himself to circle around each other, sparring. Just then the farmer who owned the turkeys swept up the young one and carried him off and ate him with chestnuts.

Copyright © 1956 James Thurber. 1956 Helen Thurber. From "Further Fables for Our Time," published by Harper & Row.

James Thurber, the humorist, died in 1961.

A note of thanks

Sometimes, if we look only at the blazing headlines, it seems we have a lot to worry about. Perhaps we do. But at this time of year, with that special American holiday of Thanksgiving to commemorate, it's also a good time

...for basketball players who can play with the big guys...for every day that something happens to make us more tolerant of each other...for the wonders of Niagara Falls, the Grand Canyon, the snowcapped Rockies, autumn in New

11 *Mirko Ilić and Milan Trenc*

It's a Big Lie, Hailed by Anti-Semites

By Abraham H. Foxman

The Big Lie technique is alive and well. Just ask us at the Anti-Defamation League, which has been the target of the Big Lie for months. You may have seen headlines: "The A.D.L. Is Spying On You." "A.D.L. Runs Spy Network Across the Country." "A.D.L. Has Files on Good Americans." "A.D.L. Spies for Zion." "A.D.L. Sells Information to Foreign Governments."

Say something outrageous about someone or some group — something no one would believe. Say it often enough and in time the lie acquires a life of its own. People believe that if a message is heard often there must be some truth to it. It is difficult to fight the Big Lie. Those fighting it appear to protest too much.

There is no choice, however, but to expose the lie for what it is, for its pernicious intent and for its poisonous consequences. We must fight the Big Lie not only for the sake of the A.D.L. but also for that of the Jewish community and others in our society who, too, could suffer from similar attacks.

There is no A.D.L. spy network. There is no selling of information to foreign governments. What there is, is what is right about the A.D.L. — what the A.D.L. has been doing to protect the Jewish community and American society for decades. These so-called revelations are "facts" being created from whole cloth and are innocent activities presented as sinister ones.

One such creation is the charge that the A.D.L. has a spy network. This is a lie! The A.D.L. has had as its mandate for decades the task of monitoring and investigating extremists and hate groups. Most of our information about such groups comes from monitoring publications, both mainstream and marginal, from which we publish our major reports. These reports on groups such as the K.K.K., neo-Nazis and Skinheads are shared with the media and public officials and have been widely praised.

Of course, when one is dealing with the insidious and secretive activities of hate groups, the work of undercover people is required. There is nothing new here. Anyone who knows about the A.D.L. and who has read several books over the years knows that in exceptional cases undercover work is necessary.

Then there is the accusation that we watch legitimate organizations such as the N.A.A.C.P. and Greenpeace. Nonsense. There is no evidence of such ac-

Abraham H. Foxman is national director of the Anti-Defamation League.

tivity because it does not exist, and yet time and again we hear the charge that the A.D.L. is spying on good folks. Those who charge us with such activity don't have the vaguest idea what we are about, and at least have the onus of bringing proof to support their charges.

The Big Lie technique takes innocent actions and portrays them as sinister. Such has been the case with the use of the word "files." The "proof" that the A.D.L. is engaged in spying is the very fact that it has files on all kinds of people and organizations. Ironically, the very people making these charges themselves maintain and use such files whether they be journalists, lawyers or academics.

Another aspect of the Big Lie is the notion that in recent years the A.D.L. has taken on on a right-wing perspective that has contributed to its recent difficulties. Absurd. A look at A.D.L. publications and reports from 1980 through 1992 reveals just how absurd. For the far right, 20 exposed the far left. Similarly, the A.D.L. Law Enforcement Bulletin, published since 1988, contains 68 articles on the far right and seven on the left. The Order. The K.K.K. The White Aryan Resistance. David Duke. All right-wing extremists — and all A.D.L. priorities.

Why the Big Lie? On one level it is simply a question of media irresponsibility. But there is likely something else going on in some circles, something more sinister — something requiring more analysis. In a recent A.D.L. public opinion poll on anti-Semitism, one of the most disturbing findings was that more than 30 percent believed Jews have too much power.

There are those who seem to be playing on that anxiety, those willing to exploit this perception about American Jews by portraying the A.D.L. as all-powerful and all-seeing. That is why the Big Lie is an attack in the broadest sense on the community relations and political efforts of the entire Jewish community.

While the motives behind the Big Lie are matters for speculation, there is no doubt about some of those who rejoice over these attacks. In its publication, the White Aryan Resistance thanked the San Francisco district attorney's office for "assisting W.A.R. in nailing the A.D.L. once and for all." The editor of Spotlight, the publication of Liberty Lobby, the most active and best-financed anti-Semitic organization in America, wrote in an April mailing to subscribers that "this is the best opportunity to bury the A.D.L. once and for all. The A.D.L. . . . may bring the A.D.L. to its knees."

Despite our concerns that if the Big Lie continues to be disseminated, it can poison this country's attitudes toward the A.D.L. and American Jews, we have confidence that we will recover. This confidence stems from knowing who we are, from the support we have received from the Jewish community and others as well as from a belief in the sense of fairness of the American people. We ask one thing: that responsible individuals in the media and elsewhere demand the end of this smear campaign. □

12 *Mirko Ilić*

Did Gore Reinvent Government? A Progress Report

By Donald F. Kettl

MADISON, Wis.

In September 1993, Vice President Al Gore promised nothing less than a campaign to reinvent the Federal Government. In a document boldly named the National Performance Review, he pledged a Government that "works better and costs less," treating citizens as customers and delivering better value for their tax dollars.

Skeptics dismissed the campaign as hollow rhetoric, just another strand in a long string of ill-fated Presidential commissions to improve Government efficiency. But a year later, the skeptics have been proved wrong. Amid sour debate over health reform and crime, the National Performance Review has been one of the Clinton Administration's few clear victories.

The review promised to reduce the Federal civilian work force by 252,000 over five years — a pledge the public liked so much that Congress voted for even greater reductions. The Administration has done away with the Government's inordinately complex all-purpose résumé and application form. It has hammered out a tough bargain with Congress to simplify procurement, and created a council of chief operating officers from all the Cabinet departments to focus attention on management problems.

Even more important, Mr. Gore's review generated a fresh sense of the possible. Good ideas that lay fallow for years have sprung to life; "reinvention labs" throughout the Government are producing mountains of fresh ideas. In Milwaukee, for example, a team of Veterans Affairs managers figured out ways to decentralize some functions and centralize others, thereby saving $2.8 million, 8 percent of their budget.

But if the review has given rise to new excitement and energy — and more progress in its first year than almost anyone believed possible — its success is threatened by two major problems.

First, a preoccupation with short-term savings. As the Vice President has argued, a Government that works better can cost less. In practice, however, focusing on immediate savings can weaken the campaign and increase costs in the long run.

The biggest chunk of the $108 billion in promised savings — $40 billion — was to come from shrinking the Federal work force; where and how to make these cuts would be determined by carefully rethinking how to do the Government's job. Practice has been exactly the reverse: the downsizing has come first, largely disconnected from any strategic plan, leaving managers scrambling to perform jobs that if anything have grown.

Donald F. Kettl, professor of public affairs and political science at the University of Wisconsin, is a visiting fellow at the Brookings Institution in Washington. He is author of the institution's new report "Reinventing Government? Appraising the National Performance Review."

Not surprisingly, this reversal has undercut the morale of the very workers being called to take bold risks. In contrast with the familiar anti-Washington rhetoric that blames "bureaucrats" for waste and inefficiency, Mr. Gore's report saw the problem as the system, not the workers, and it promised to enable them to do their jobs better. In return, it asked them to take more chances and worry more about performance.

The downsizing plan has been a bucket of cold water on those goals. Indeed, for most Federal employees, the threat to their jobs, not the focus on results, has been the defining reality of "reinventing Government."

It would be naïve to think that any change of this magnitude could be accomplished without upsetting the people being changed. And the Federal work force can clearly be reduced; there are far too many layers and too many mindless rules. But as downsizing in the private sector has taught us, big cuts without broader strategies only hurt morale and often fail even to achieve their goal of reducing costs. Quick public-opinion victories from cutting Federal employees could easily pale in comparison with the long-term performance problems that would be produced from a government that is dumbsized instead of downsized.

The second threat to the National Performance Review is the lack of an explicit strategy for dealing with Congress. At first, it was thought that the Administration could accomplish most of its reforms without Congressional approval. But the first year has made clear that this hope simply isn't realistic. Despite Congress's enthusiasm for the general concept of the performance review, both houses have been tugging at its individual threads in ways that could unravel it. For example, House members didn't want to hurt health care for veterans, so they voted to exempt the Veterans Health Administration's 212,000 employees (almost 10 percent of the total) from the workforce cutbacks. The Senate then voted to exempt Federal criminal justice employees.

For the many valuable pieces of Mr. Gore's effort to endure, a new balance of power will somehow need to be struck. Congress has a legitimate interest in overseeing the executive branch. But if bureaucrats are to produce a cheaper and more effective Government, they need greater freedom to do their jobs without micro-specification of the details. The Government Performance and Results Act of 1992, which commits the Government to a decade-long effort to draft strategic plans and measure the results, is an important first step.

Congress and the President need to strike a new bargain, based on these foundations, if government is to improve the way it works. The movement launched a year ago, however promising, is not self-sustaining. Making it stick will require hard work that has only just begun. □

For once, a study that won't gather dust.

13 Jerelle Kraus

Reprise

And thus the whirligig of time brings in his revenges.

ANONYMOUS

Upon my return to directing Op-Ed art in 1993, Mirko Ilić's deft shaping of electronic type influenced me, just as our hand-shaped zeppelin had earlier inspired him. An article that evaluated Vice President Al Gore's assignment to streamline government in 1994 concluded that Gore had done a very good job but not a perfect one. I gave him a grade [figure 13].

Many of Op-Ed's original artists are self-taught; Brad Holland, Jean-Jacques Sempé, and Ralph Steadman are examples. Others dropped out of art schools that failed to address their interests; Horacio Cardo, J. C. Suarès, and David Suter are typical. "I began studying painting at age seven with a well-known Argentine painter," Cardo said, "but dropped out quickly because he forced me to draw figures and fruits rather than imaginary beings. Nature has done such a good job of making those fruits that I feel incapable of improving on them."

In contrast, most illustrators who started their careers in the 1990s and 2000s have solid art-school backgrounds. Their years of preprofessional training result in facility with a variety of styles and techniques. Viktor Koen, for example, a native of Thessaloniki, Greece, arrived in the United States after studying at Jerusalem's renowned Bezalel Academy of Arts and Design, where he earned a Bachelor of Fine Arts in graphic design. He had already attended a New York summer crash course in illustration when he moved to the United States, where he earned a Master of Fine Arts in Marshall Arisman's innovative "Illustration as Visual Essay" program at the School of Visual Arts.

"The faculty gave us art directors to approach," says Koen. "So after graduating, we dropped our instructors' names to get appointments." Koen illustrated a *Times* letter to the editor in 1994 that objected to Disneyland Paris, the theme park plopped down near France's capital [figure 14]. After nine years of freelance illustration and artistic employment at firms including Marvel Comics, Koen incorporated himself as Attic Child Press, because, in his words, "kids locked in attics have only their imaginations as friends." Koen is an artistic contributor to the *Times Book Review*, among numerous other publications. He also teaches in the School of Visual Arts program from which he graduated.

Nicholas Blechman, like his father, R. O., received a liberal arts Bachelor of Arts at Oberlin College and then became an illustrator and designer. But the son's illustrations are signed "Knickerbocker" and don't resemble the father's work. In 1995, Knickerbocker drew

14 Viktor Koen

15 Nicholas Blechman [Knickerbocker]

16 Victoria Roberts

a striking accompaniment to a letter that celebrated the victories of World War II [figure 15].

A plea for liberation from the canine leash law occasioned an image by Victoria Roberts in 1996 [figure 16]. Roberts—she of the ravishing talent and wild crimson coif—shares her apartment with a black pug named Archibald Parchment. Roberts began contributing to Op-Ed just after sailing in from Sydney in the 1980s with a portfolio of books she'd written in longhand and illustrated with opulent ink washes. The appeal of her idiosyncratic work got her Op-Ed commissions throughout the 1980s while she endured the obligatory ritual of *New Yorker* cartoonist hopefuls: years of frequent submissions before—in Roberts's case—being signed to a contract. Now, as well as appearing in the *New Yorker* since 1988, Roberts is a solo performance artist whose onstage persona is Nona Appleby (née Molesworth), a kimono-clad Australian octogenarian.

In 1995, in his interpretation of a text on Quebec's separatists, Janusz Kapusta played on Delacroix's painting *Liberty Leading the People*, from 1830 [figure 17]. Many readers wrote in, arguing

against a division of Canada. To accompany their letters, Kapusta stitched together a piece of one-column art [figure 18].

Another letter to the editor claimed that someone is maimed or killed by a land mine every twenty-two minutes. David Suter sketched two ideas. One invoked the problem's pervasiveness [figure 19*a*]. "The foot's okay," said the editor, "but what's that thing on the right?" "It's a shadow," I said, "that alludes to the fate that will follow that footfall." Turning to the next sketch [figure 19*b*], the editor asked, "Why is the girl about to step on a dead person? Can't it be a mine there instead?" "Mines look just like black squiggles," I replied, "but if we *could* see a squiggle as a mine and put one there instead, it would take the poetry out of the drawing." The editor wasn't convinced, so Suter gave it another try. His third sketch, a skull that is simultaneously an explosion, was approved just in time to draw a quick finish [figure 19*c*].

The *Times* counts on a battalion of freelance designers to fill in on all its sections. But since Op-Ed requires specialized facility in illustration, its art directors usually find and train their own subs.

17 Janusz Kapusta

18 Janusz Kapusta

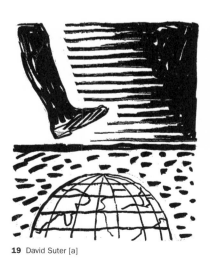

19 David Suter [a]

[b]

[c]

Two people who subbed in the 1990s seemed especially suited to the task. The first, David Suter, had interpreted hundreds of opinion texts; leaving the section in his hands seemed an obvious choice. After a week, though, Suter declared, "It was almost as bad as basic training. I actually couldn't figure out how to do it and acquired a lot of respect for whoever does. I tried to pick artists who'd give me a strange angle, and that's what I got."

The next sub, original Op-Ed art director J. C. Suarès, had become so successful as a self-employed designer, illustrator, and author that it was tough to clear his schedule for a chance to revisit the page. Then he struggled through the week. "It was hell!" Suarès said. "The editors hated every piece I showed them and referred to me as 'Hey, art director.'" One of his offerings was by gallery artist Kenny Scharf, who makes kitschy, Day-Glo sci-fi images. The piece looked odd in the *Times* Op-Ed context, yet Suarès felt that artists of Scharf's ilk would give the page a lift. There's no clearer evidence of Op-Ed's changes than that its originating art director struck out in a later inning.

Stylistic oddities are a hard sell. It was rough, for example, to promote Henrik Drescher's marvelous grabbing creature as an illustration for an article that berated Croatia's driving of Muslims and Serbs from their homes in 1996 [figure 20]. The editor wondered why the figure was so hairy and why it had a tail. Most editors feel that the art itself shouldn't be apparent. Mike Levitas was an exception; he got a kick out of original style and tolerated artistic license—at least when it resulted in what he called "weird" images. For him, weird was good and characterized the work of Horacio Cardo and Jonathon Rosen. Levitas even trusted art enough to annually devote the entire New Year's Day page to drawings.

Art Spiegelman contributed to one of those all-art sheets on January 1, 1995 [figure 21]. Spiegelman is the ingenious artist and writer behind *RAW*, an upscale, stunning, and influential noir comics anthology designed and published from 1980 to 1991 by Spiegelman and his wife, Françoise Mouly, who now art directs the *New Yorker*'s covers. Announcing itself as a "graphix magazine for damned intellectuals," *RAW* featured international artists and serially issued Spiegelman's *Maus: A Survivor's Tale*, which won a Pulitzer Prize in 1992. The couple also published a score of solo books as "Raw One Shots," including Sue Coe's *X* on Malcolm X and her *How to Commit Suicide in South Africa*.

As a downtown Manhattan resident, Spiegelman experienced September 11 up close. "Those towers had been our taken-for-granted neighbors," he says, "always picture-postcard visible from our front stoop. That morning, out of the very clear, very blue sky, a plane roared right over our heads and smashed into the first tower."[4] After watching the full cataclysm in horror, Spiegelman drew a series of comics depicting his fury at both the terrorists and the Bush administration. Most American media deem the works too controversial, but they're published in a broadsheet-size book, *In the Shadow of No Towers*, and many of them have appeared in European newspapers.

20 Henrik Drescher

THANKS FOR THE MEMORIES...

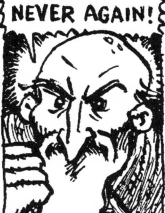

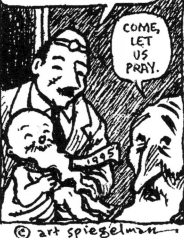

Nineties Nemesis

Sometimes I feel like a fire hydrant
looking at a pack of dogs.

BILL CLINTON

President Bill Clinton and his wife were portrayed in Op-Ed art only a few times, and those images were decidedly benign. Bob Grossman evoked Hillary Clinton's campaign for her husband in 1991. "Shorn of her claws and fetchingly eager to be First Lady," stated the article, she was "cynically repackaged . . . as a suburban housewife" [figure 22].[5] Reflected in Horacio Cardo's drawing from 1993 is the contention that President Clinton needed to skillfully manage the U.S. economy as well as all foreign policy crises [figure 23].

The same year, the gifted Hungarian artist István Orosz illustrated the notion that Clinton didn't know what he wanted when choosing a Supreme Court nominee [figure 24]. And Christoph Niemann interpreted Clinton's Monica Lewinsky problem on the day in 1998 when the investigation into that drama was published as *The Starr Report* [figure 25]. "It was fun being part of this exciting news event," Niemann says. "Everyone read the paper that day." A German-born New York artist, Niemann studied in Stuttgart with Czech maestro Heinz Edelmann, who had designed the animated-film masterpiece *Yellow Submarine*.

22 Robert Grossman

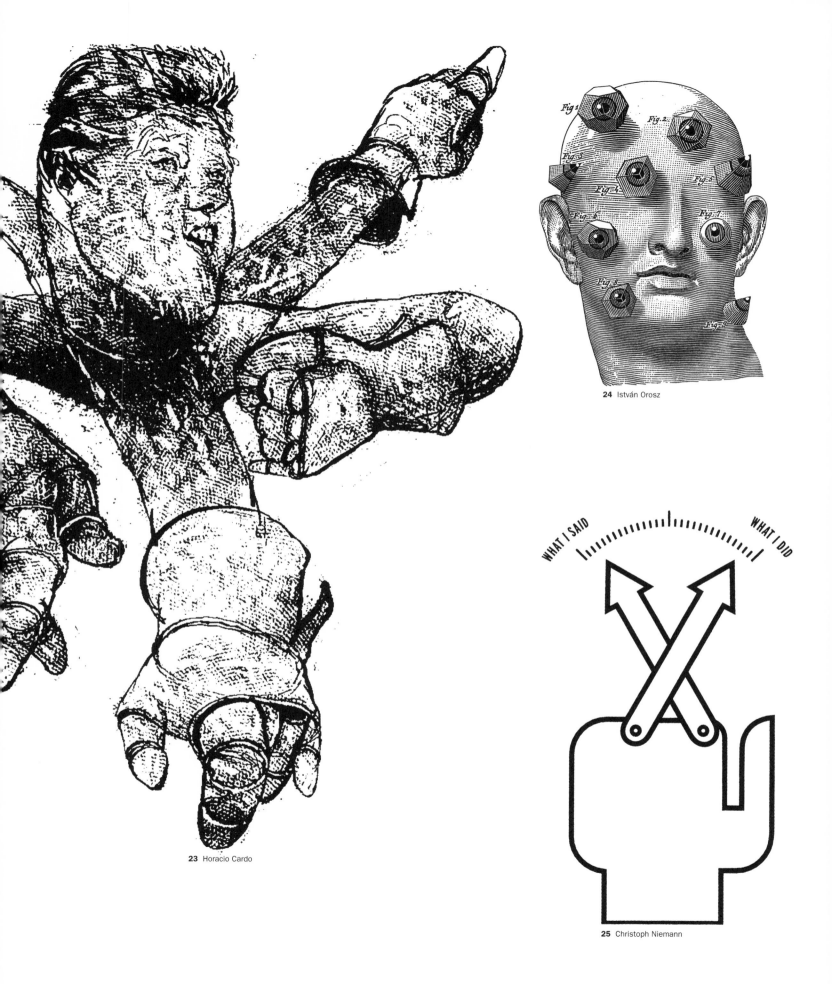

23 Horacio Cardo

24 István Orosz

WHAT I SAID WHAT I DID

25 Christoph Niemann

Howell's Reign

The sin and sorrow of despotism is not that
it does not love men, but that it loves
them too much and trusts them too little.

G. K. CHESTERTON

Max Frankel and Jack Rosenthal, the *Times*'s editorial page editors of the 1980s, are visually savvy and unafraid of art's power. Frankel paints still lifes, and Rosenthal, a skilled calligrapher who occasionally can be spotted drawing from life at the Art Students' League, nominated two Op-Ed artists for Pulitzers: Brad Holland and Horacio Cardo. (Since the Pulitzer committee hasn't moved beyond political cartoonists, neither artist won.)

The respect for Op-Ed art that existed when these men—and John Oakes before them—led the editorial floor vanished in 1993 when publisher Arthur Sulzberger Jr. selected Washington bureau chief Howell Raines as editorial page editor. While Raines's predecessors had maintained über-authority over both pages, they'd trusted the Op-Ed editor's judgment and granted virtual sovereignty to the sheet facing their editorial page. Raines, in contrast, seized the chance to consolidate his rule. Op-Ed's much-heralded twenty-three years of independence would soon become history.

A thick-torsoed figure with fine curly locks, lips that snap and snarl, and the forked tongue of a charming conman, Raines has—in a *Times*-sanctioned description—the "haughty look of a modern-day Caesar."[6] His cockiness, courtliness, and former liaison with bombshell Op-Ed columnist Maureen Dowd also gave him a reputation as a ladies' man.

A talented literary stylist, Raines has written two critically praised novels, an oral history, and a memoir, as well as a Pulitzer Prize–winning *New York Times Magazine* feature and paragraphs that became examples in the *Times*'s stylebook. Important as writing is to Raines, however, more important is power. He gave up a reporting career at the paper to become deputy Washington editor, the first step on his stairway to the stars.

Raines's seven-year tenure as editorial page editor, the second most powerful *Times* position, was his longest-lasting *Times* assignment. In that role, he closely monitored, in addition to the editorials, both Op-Ed and Letters. No matter how hot was a particular issue, he insisted that it be the topic of no more than one piece a day on the double-page spread. "Howell ordered the columnists to tell the Op-Ed editor in advance what they were going to write about," says Mike Levitas. "For a time they obliged, but in private they were annoyed,

26 Robert Grossman

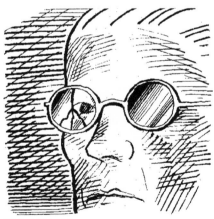

27 David Suter [a]

[b]

since columnists don't always know what they'll say before sitting down to write. Howell's idée fixe proved to be a pipe dream."

"Everybody's a little afraid of Howell," said editorial writer Mary Cantwell about his imperious rule. Veteran staffers who refused to curtsy transferred out of the department. Raines so rankled editorial writers that half a dozen left and formed a Raines-bashing editorial board in exile, meeting monthly at the Yale Club.

Seven years before the staining of Monica Lewinsky's blue dress, Raines began unrelentingly hurling invectives at President Clinton. He was a man "from Li'l Abner's home state," Raines wrote, who told "ugly little lies."[7] Clinton aide George Stephanopoulos described the president's reaction: "The Senate is full of wimps," Clinton said. "I raise money to get them re-elected, but one word from Raines . . . and they fold."[8] Clinton once asked *Times* publisher Sulzberger why, after endorsing him, the *Times* was so hard on his presidency. The publisher defended Raines, saying that the *Times*'s policy is "tough love." "I've seen the tough," replied Clinton. "Where's the love?"[9]

Although Raines persisted in penning barbed editorials, he revealed his fear, loathing, and ignorance of art by insisting that the visuals be neutral. He went so far as to blackball the jolly cartoons of unfailingly good-humored Bob Grossman. One such image was a portrait of Roman soldier Clinton charging into battle, in 1994 [figure 26]. "This drawing will not run!" Raines declared. "It's a nasty caricature of the sitting president."

Howell's anti-Clinton crusade had to have been fueled by a personal vendetta. Both men are brilliant, liberal, lady-loving Democrats from the Deep South with bona fide civil rights credentials.

But Clinton, three years younger, soared higher. Could Alabama's Pulitzer winner be jealous of Arkansas's Rhodes Scholar?

Raines's acid rhetoric was sometimes exceptionally well aimed. In 1995, Robert McNamara, secretary of defense under Presidents Kennedy and Johnson, published a memoir admitting that by 1967 he had known that the United States had to leave Vietnam. Raines was the first to boldly argue, in his lead editorial, that the secretary's coming clean after the fact didn't excuse his silence while the war had gone on.

The editorial's unflinching language elicited a flood of reader e-mails. David Suter drew an image to accompany a selection of them for the next day's Letters column [figure 27a]. "That's a gratuitous slam," Raines declared of Suter's work. Scowling, he referred to his editorial: "The problem with that picture is that we hit him real hard yesterday." Suter then drew a second illustration [figure 27b]. "Too loaded," Raines pronounced. "The tears are simply a formal device that relates McNamara's pain to the shapes of helicopters," said Suter. But I was obliged to white out Suter's droplets, rendering the image bloodless. Because it followed a harsh editorial, the art could say nothing. "The only purpose of the art," Raines stated during this incident, "is to break up the gray."

One of McNamara's assertions was that the government had lacked reliable information about Vietnam in the early 1960s. An Op-Ed article refuted this claim. Written by a State Department analyst, it described the writer's report published in 1967, just before the Tet Offensive, that predicted a large-scale attack by Communist forces. Artist David Gothard illustrated it in 1995 [figure 28].

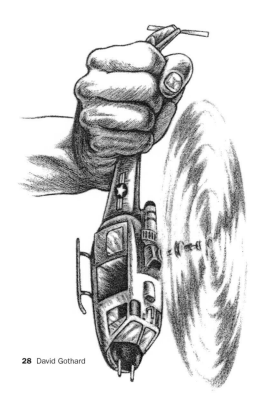

28 David Gothard

29 Hans-Georg Rauch

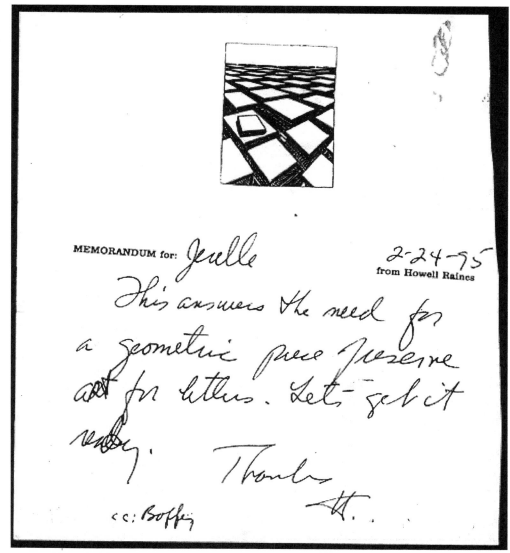

MEMORANDUM for: *Jerelle* 2-24-95
 from Howell Raines

This answers the need for a geometric piece preserve art for letters. Let's get it ready.

Thanks

H.

cc: *Boffey*

30 Howell Raines to Jerelle Kraus

In 1995, Raines replaced Levitas with Week in Review deputy editor Katherine Roberts. She and her staff were impatient with visual metaphors; they preferred literal illustrations unlikely to ruffle feathers. A phrase often heard during Roberts's regime was "I love it, but Howell will never go for it." Letters editor Kris Wells once cried out: "All I can do is put out the fires. I can't focus on the art. I have to guard against problems with Howell. I have no independence."

Raines once requested a vault of "evergreen art." He ordered his art director, "Get some pure designs ready that we can run on the Op-Ed page anytime." "You mean stripes like your tie or zigzags like Phil's?" I asked. "Exactly," he snapped. "But," I began, "the whole point of our art is to be provoca—" Raines cut me off: "Just do it." Rather than preparing meaningless patterns, I unearthed thirty-eight pictures that were meaningful and interesting without being topical, so they could run anytime. Raines commanded, "Give them each a title."

One of these drawings was Hans-Georg Rauch's exquisite portrayal of bricked-up books, a treasure I'd been saving for the perfect Op-Ed article [figure 29]. I now titled it "Censorship." Raines reacted to this image with an unconsciously ironic directive. His memo insisted that the drawing be reduced to two-inch Letters art size, thereby obliterating its powerful message [figure 30]. *Transform this stunning concept into wallpaper?* "It will lose all meaning at that size," I said. "I'll decide that," said Raines. Then he passed on the evergreen art project to his newly appointed Op-Ed editor, Katy Roberts, who intelligently shelved the entire idea. Rauch's drawing never appeared.

The Bride Stripped Bare

> In place of Joyce we have the fragments
> of work appearing in the Index on Censorship.
>
> NADINE GORDIMER

Concern about art's power to offend often resulted in watering down the wit and sacrificing any semblance of fun on the altar of caution. In 1995, a writer deplored the Overseas Private Investment Corporation's practice of "corporate welfare," which subsidizes "United States corporations, including some of our largest."[10] Bloated government became—in Brian Cronin's inspired hands—a placid Holstein whose black spots formed a map of the United States. Cronin's original drawing showed a sharp-suited, briefcase-bearing businessman guzzling the bountiful flow from the big bovine's Florida-shaped teat [figure 31]. It was a terrific metaphor, but Cronin's cash cow would be a hard sell. Suckling is just too intimate an activity for the Gray Lady. The image's wit, however, propelled me to take a flying chance.

"That's a riot!" chuckled the Op-Ed editor. "And it's spot-on. But there's no way we can run it. Howell would freak out." Cronin fumed, "I'm not touching it!" The artist was eventually cajoled into

32 Tim Bower

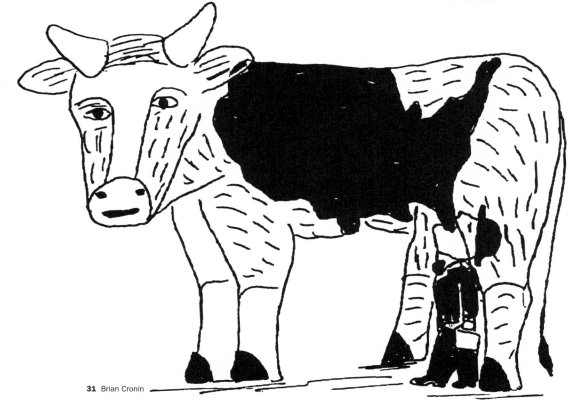

31 Brian Cronin

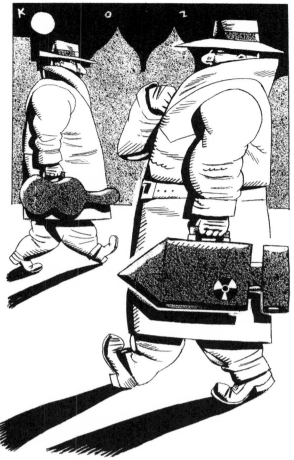

33 Martin Kozlowski

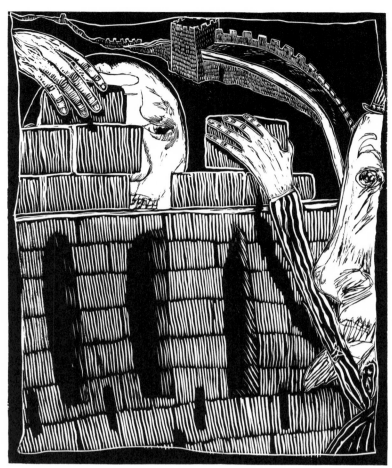

34 Frances Jetter

returning to the drawing board. His second version eliminated the mouth-to-udder problem by utterly removing the man. Milk simply dripped into a waiting stack of pails. That image, too, was vetoed (too wet). "This is the last piece I'll ever draw for the *Times*!" Cronin barked as he began his third version, which passed muster by abandoning anything remotely human or humid.

In 1996, novelist Mary Gordon's essay on the auction of Jackie Onassis's personal items mentioned a tape measure that sold for $448,875. Illustrator Tim Bower proposed a portrait of the item's late owner to be constructed entirely out of measuring tape. The editor approved his sketch but warned that the finished piece had to "really look like Jackie. The eyes must be realistic, not measuring tapes." Yet Bower's cleverness would work only if unadulterated. Rather than discussing it, however, I bargained on convincing the editor with finished art. Once she saw it, she agreed that it worked. So the humor—this time—was spared [figure 32].

During the Whitewater case in 1996, Hillary Clinton said that her law firm couldn't locate certain requested papers. A business owner wrote the *Times* a letter saying that of course documents disappear and attested to the time his firm spent looking for elusive documents.

Alison Seiffer drew the back view of a chic secretary standing to file papers at an eye-high cabinet. Stuck to the back of her dress as she worked unawares were two sheets of paper. "Fine," said the editor, "if you remove the papers from her skirt." With the papers, of course, went the drawing's whole point. Instead of a funny, apt image, readers got a nice picture that broke up the gray.

With increases in the amount of weapons-grade plutonium on the black market, fear of nuclear gangsterism prompted an illustration by Martin Kozlowski in 1996 [figure 33]. He played off the cliché of the Mafioso who carries his gun in a violin case. The editor wanted the gun in a briefcase instead. Fortunately, a vigorous defense of Kozlowski's wit finally succeeded.

Also in 1996, the Chinese leader behind the wall in Frances Jetter's original version of a linocut was considered "too toothy" [figure 34]. (Never mind that his teeth were no worse than Uncle Sam's.) The problem, editors felt, was that Jetter's image promulgated the stereotype that Chinese leaders are ancient. (Never mind that they are.) "The editors kept making me brick over more and more of his mouth," Jetter complains. The image you see here was published after much pulling of teeth.

Feminizing

Whatever women do they must do twice
as well as men to be thought half
as good. Luckily, this is not difficult.

CHARLOTTE WHITTON

In the 1970s, the number of female Op-Ed artists was minuscule. One week in the mid-1990s, though, ended with a happy discovery: all seven previous Op-Ed illustrations had been by women. Today, while males continue to dominate the profession, Op-Ed hires more female artists than ever before.

Anita Siegel's work, which you've seen in the chapters devoted to the 1970s and 1980s, was vital to the creation of Op-Ed art's identity. "Anita was huge," says artist Cathy Hull. A wry visual commentator herself, Hull was also an early Op-Ed contributor. In 1981, she called on a familiar euphemism to deliver her interpretation of Eunice Kennedy Shriver's thesis that sex education is primarily a responsibility of parents [figure 35]. When she first went to the *Times*, however, Op-Ed hadn't begun.

The portfolio that Hull presented to the *Times*'s art department was a visual satire of sex. Its drawings included images of a rubber stamp on whose penis handle was written, "You're not the first"; pubic hair made of fingerprints; and breasts created from male hands. The picture of decorum, Cathy Hull had just graduated from an elite eastern women's college. "I wasn't liberated," she says, "so making those drawings was very freeing. And it made all the difference that I had an edgy portfolio." When Hull picked up her samples, George Cowan (who then supervised the entire paper's appearance and will be discussed later) said, "So you're the one with the dirty pictures."

"Despite despising the Ku Klux Klan," political artist Frances Jetter says she illustrated an article from the Klansmen's point of view "because it described their pitiful motives. They're poor whites who join racist organizations because they feel deprived, disenfranchised, and left out. They got a bad deal and feel better if they attack the only people who got a worse deal" [figure 36].

In 1994, Nurit Karlin reflected the thesis that the navy judge who settled the Tailhook sexual abuse scandal hadn't focused on the violence against women but on Tailhook's reputation for wild partying. By using the Original Metaphor, Karlin elevated the debate to the epic proportions it deserved [figure 37].

35 Cathy Hull

36 Frances Jetter

The list of American heroines is endless, maintained the manuscript that occasioned a clever image by Cynthia Wick [figure 38]. A painter residing in California's city of angels, Wick lives with a paradox. Although she's an activist Democrat, her parents' fifty-year friendship with Ronald and Nancy Reagan made the Reagans close family friends. Her father, Charles Wick, was in the "kitchen cabinet" that orchestrated Reagan's political ascent. What's more, her family spent a lot of time at the White House and Camp David after her father became director of the United States Information Agency, America's propaganda arm. After seeing one of Wick's anti-Republican Op-Ed drawings, a furious family friend told the artist, "You can't shit where you eat!"

Edith Vonnegut drew a deft satire to illustrate a plea for a global peace movement [figure 39]. Fine artist Vonnegut, known for her paintings of statuesque "Domestic Goddesses," lives in the barn behind the house where she grew up, where "Kurt," as Edie calls her father, "wrote all those great books." He was "a saint, a prophet," she said soon after his death in 2007. "He came to the planet because he had to do this stuff." I was lucky enough to know Kurt Vonnegut, an Op-Ed contributor, because of his friendship with Ralph Steadman.

One morning when we were finishing the hanging of a Steadman exhibition in a Manhattan gallery, Vonnegut (who'd come to see the show a day early to avoid the crowded opening) invited Ralph and his wife, Anna, to lunch. Then impulsively, generously, he grabbed my arm. "You be my date!" he blurted out with a shy glance. (Vonnegut's wife, photographer Jill Krementz, was with her mother in Florida.) We spent the day conversing in Vonnegut's home while Steadman made wild portrait sketches of his visionary author friend.

I'd earlier discovered Kurt Vonnegut's astonishing humility and innocence when his wife graciously included me in an evening of theater and dinner. After viewing an unremarkable play, Vonnegut was awestruck: "How did that guy write such realistic dialogue?" he exclaimed, wide-eyed. "It's far harder," I reminded him, "to invent fantasies like you do—from sheer imagination." He remained childlike and unconvinced.

37 Nurit Karlin

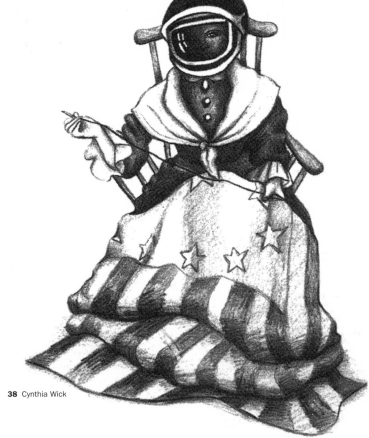

38 Cynthia Wick

39 Edith Vonnegut

Bascove

40 Bascove

On another occasion, I summoned the nerve to ask Vonnegut to write a preface for this book. "I'm eighty-four," he said. "I don't even write anymore." Then he relented: "Okay, I'll write a short one," he promised, giving me his private phone number. Four months later, lying unconscious after a fall, he passed away without pain. "There've been tributes to Kurt from Scotland, India, all over," Edie said when I told her my impression of her father. "Everyone seems to have gotten his tune. Yet no one has pinpointed his innocence." I can't imagine, however, that anyone who knew him could have missed Kurt Vonnegut's refreshing guilelessness.

An arresting picture by Bascove addressed a geneticist's contention that there are at least five biological sexes [figure 40]. Primarily a gallery artist whose voluptuous, painted images seem to burst out of their frames, Bascove builds her print illustrations from solid silhouettes. Another stand-out drawing constructed of evenly applied shapes is by the Polish-born New York illustrator, designer, and educator Beata Szpura [figure 41]. Szpura's picture visualized an assertion that companies should hire female board members with business, rather than academic, experience. In stylistic contrast, Boston artist Polly Becker used a textured—as if etched—technique and a broken line [figure 42]. Her poignant image was inspired by the posthumous release of tapes from poet Anne Sexton's psychotherapy sessions.

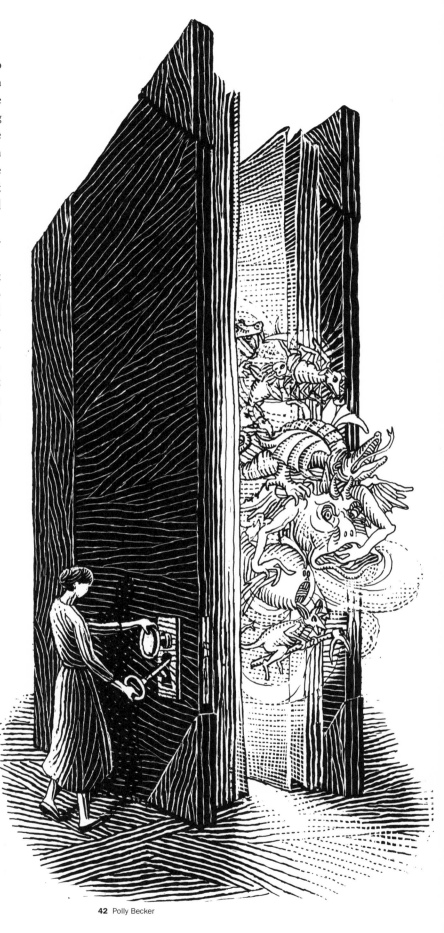

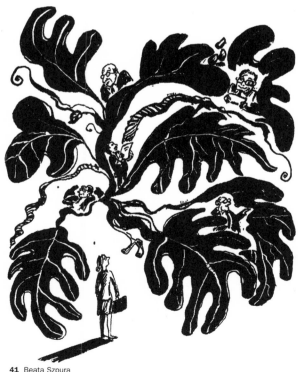

41 Beata Szpura

42 Polly Becker

Bling

The free mind must have one policeman. Irony.

ELBERT HUBBARD

Anyone without a *Times* pet peeve doesn't read the paper. Targets range from insufficient coverage of Northern Ireland to insufficient cheese in a strudel recipe. I've picked up my private office line to these gripes: "You don't cover enough Greek restaurants" and "Today's obit ran two columns, but you gave my great-aunt, who was far more important, only one."

The most frequent complaints, however, concern the Middle East. Jews swear that the *Times* is pro-Palestinian, while Muslims maintain that it's pro-Israel. The vast majority of objections are to texts, but we occasionally get living proof of just how justified editors are in monitoring the art. In 1995, readers accused the *Times* of anti-Semitism. Their evidence: a two-inch-square picture that accompanied a letter indicating that donors of large amounts of money choose the winning candidates far in advance of elections [figure 43]. Eagle-eyed viewers discovered that the illustration's bracelet contains six apparent Stars of David! The irony was that, given the context, readers might think we were stereotyping Jews as influence buyers.

I sent a memo to the understandably anxious Raines. "Dutch illustrator Ner Beck," it read, "photocopied the gems from the jewelry section of an 1895 Montgomery Ward catalog. Many stones on those pages are identically cut in a pattern that attempts to represent—in

43 Ner Beck

two dimensions—three-dimensional faceting. We regret offending readers." A note based on my memo appeared on the next day's page.

In 1991, an image by David Levine unleashed an even larger outpouring of bile. The subject was Saddam Hussein. The art ran, sans text, under the title "The Descent of Man" [figure 44]. Arab-Americans telephoned in droves, forcing the *Times* to record an apology.

44 David Levine

No Way

A phallocentric culture is likely
to begin its censorship with books on pelvic
self-examination for women.

ROBIN MORGAN

The 1990s proved no exception to the Op-Ed tradition of annually amassing a salon's worth of rejected art. In 1992, Frances Jetter brilliantly addressed the division in the Republican Party over abortion [figure 45]. "The Republicans were where they shouldn't be," says Jetter. "I figured the editors would kill it, since they don't like anything sexual. So, after bringing it in, I started a much tamer piece, which they had within a couple hours." The rejected image made a perfect cover for Jetter's book, *The Reagan/Bush Years*.

46 Milton Glaser

Artists' intentional naughtiness pales next to what is imagined by editors, who frequently locate phantom phalli. In 1996, Milton Glaser drew an ardent alien for a Valentine's Day manuscript that described intergalactic love [figure 46]. The editor who censored it said that the alien's beak looked like a taboo human part. "There's always this thing about the male sex organ," says Glaser. "It happens in the most peculiar circumstances. They think artists are trying to trick them."

For a truly bizarre instance of rejection, see the image that the distinguished patriarch of illustrators, Ronald Searle, created for a page of poetry in 1995 [figure 47]. Searle, who celebrated his eighty-eighth birthday in 2008, remembers how shocked he was by this experience: "My drawing for 'Summer Poems' was killed by the *Times* because an editor [Howell Raines] detected an erection in it. That's his fantasy, of course, since nothing is more pure than that image of a man being sick in the street." In 1996, from Israel's West Bank, columnist Anthony Lewis filed a piece on the consequences of the Oslo agreements. Its illustration, by Janusz Kapusta, pictured out-scale pencils redrawing a map. "It works," said Raines. "But that pencil is a problem. Square off its eraser." He neglected the second pencil's eraser, however, which remained in its original, highly provocative state [figure 48].

In 1995, the Nigerian government hanged nine dissidents, including the celebrated novelist Ken Saro-Wiwa, who'd protested Shell Oil's political corruption, financial fraud, and environmental degradation. Political comic artist Seth Tobocman submitted eight idea sketches to illustrate a letter urging an embargo of Nigeria's oil [figure 49]. Despite Tobocman's simplified style, editors rejected seven of them as too grisly for breakfast eaters. It was okay, however, to show an empty noose. Repeated attempts to get more of Tobocman's work onto our pages proved futile; it was deemed too radical. His book *You Don't Have to Fuck People Over to Survive* is selling well in its third edition, and his newest book, on rebuilding public housing in New Orleans, is *Tryin' t' Get Home*.

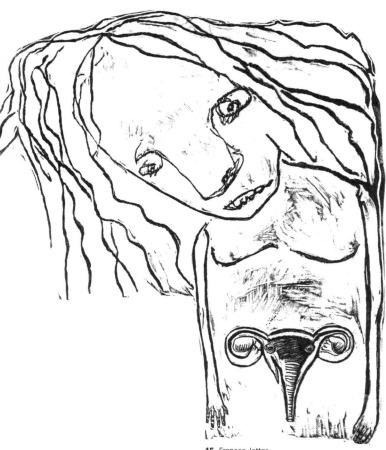

45 Frances Jetter

47 Ronald Searle

48 Janusz Kapusta

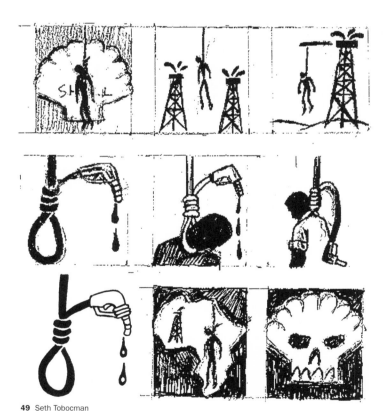

49 Seth Tobocman

Another Op-Ed article from 1995 advocated a tariff on Japanese luxury cars. Goran Delić, a Serbian illustrator in Canada, imagined a Japanese rock garden with autos instead of rocks. He drew formal rows of cars and, in the foreground, the full figure of a Japanese man raking some of the vehicles from their rows. Editors said that his picture fed a politically incorrect stereotype of the Japanese as gardeners. Never mind that the garden was *in* Japan. Delić's figure had to be reduced to a hand on a rake [figure 50].

Bob Gale looked to an iconic Munch painting to visualize a letter about a film's mentally ill protagonist [figure 51]. "That's a stereotype disparaging mental illness," said the editor who killed it. The letter stressed that the mentally ill can be as funny as the rest of us. But if they look like the rest of us, how do we know they're psychiatric patients? "I haven't used Munch's *Scream* much," says Gale, "because it's a stereotype in itself, but by 1996 I myself was mentally ill and screaming."

Another text from that year claimed that Pat Buchanan, conservative pundit turned Republican presidential candidate, who'd always leaned right, had begun to course-correct in order to appeal to his party's liberal wing. To accompany this article, Warren Linn created an illustration that literally personifies the text [figure 52]. Yet Linn's droll concept was sacrificed to editorial queasiness. "Editors are nervous about offending politicians," says Martin Kozlowski. "There's also discomfort about contorting the body. But the worst problems occur when the text is especially harsh. Then the art has to compensate."

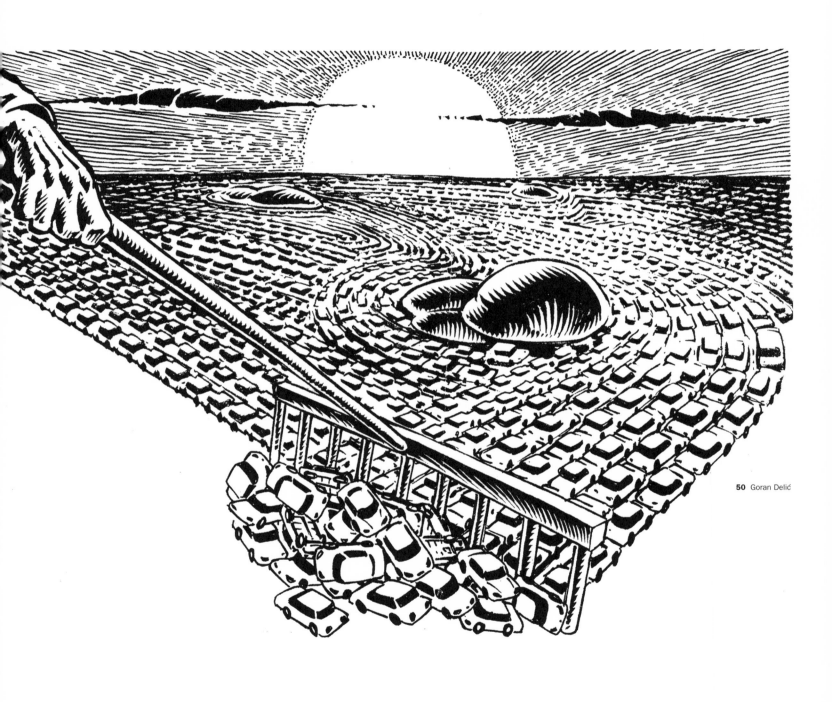

50 Goran Delić

51 Bob Gale

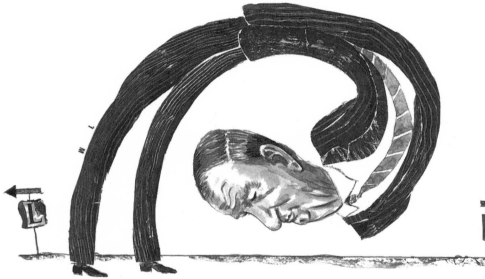

52 Warren Linn

53 Istvan Banyai

54 Istvan Banyai

In 1996, an objection to new admissions guidelines proposed for Berkeley satirized those guidelines as "a misery sweepstakes." Social and economic disadvantages and the issue of whether the student was from a dysfunctional home were to replace former race and sex criteria. The writer composed a grim, tongue-in-cheek, tale-of-troubles essay sure to get her accepted under the new guidelines. Gifted Hungarian artist Istvan Banyai matched the manuscript's sardonic tone with an appropriate picture that even included two whimsical figures and a dog [figure 53]. Editors killed his superb drawing, however, saying it "didn't work."

Banyai had come to the United States from Communist Hungary in 1981. While he once begged for assignments—"My family will be evicted; pleeeease!"—this edgy, high-tech talent now creates prizewinning books as well as so much animation and illustration that he's forced to turn down commissions. In 1995, he illustrated an article on the phony emoting that dominates Hollywood award shows by creating an image full of sinuous curves [figure 54]. Even the microphones get into the act.

In 1996, Mark Podwal illustrated the contention that Palestinian leader Arafat's character didn't change after signing peace treaties. Inspired by the biblical verse about a leopard's inability to change its spots, Podwal shrewdly drew a leopard becoming a lamb [figure 55]. The blotches on the creature's rump become little bombs that—progressing toward the head—become the checkered pattern of Arafat's kaffiyeh. Given the touchiness of the subject, editors legitimately feared that the drawing could cause offense. First there was the insistence that the bombs be removed. Then the checkered dots had to go. Finally, the identifying kaffiyeh had to be shed, as well. In the end, Podwal's image was a gutted, naked beast.

Editorial page editor Jack Rosenthal invited *Doonesbury* maestro Garry Trudeau to contribute a twice-weekly Op-Ed column. "Jack told me," says Trudeau, "'I'm not sure what you'll do—all text, all drawing, or a combination. And I don't expect you to figure it out for a year.' I couldn't believe how trusting Jack was. What faith!" Trudeau didn't do two a week, but he did a lot of word-and-image columns over five years. Then Howell Raines, who—to quote Trudeau—"specialized in rapid-response editorials, replaced Jack and pulled one of my columns while it was on press. There was one word in it he didn't like. Not an obscenity, and I don't even remember the word." Stopping the presses is extremely rare; it costs millions of dollars. "When Howell stopped them," Trudeau continues, "the initial batch of the first edition had already been distributed, so the folks in Greenwich Village were the only ones to see that piece." One of Trudeau's Op-Ed pieces that did run in 1994 was headlined "Street Calculus" [figure 56].

55 Mark Podwal

56 Garry Trudeau

The Gray Lady Graduates

57 Jonathon Rosen

> They asked the female cat why
> her kittens were of different colors; she said
> she is embarrassed to say no.
>
> TUNISIAN PROVERB

Author Gay Talese, who was once a *Times* reporter, has said that "changes occur slowly at the *Times*." The paper reminds him of an elephant—huge, reliable, "stubborn, clumsy, and slow to learn new tricks."[11] The paper's politics may have a liberal slant, but its personality has traditionally been conservative. It was one of the last newspapers to adopt color photography, for example, and then only with great fear and trembling. But the *Times* is currently catching up—even moving ahead—under the leadership of founder Adolph Ochs's great-grandson, Arthur Ochs Sulzberger Jr.

After returning to Op-Ed in 1993, I somehow survived—and I again refer to the division between the church of opinion versus the state of hard news—under Raines's ecclesiastical terror twice as long as the newsroom later suffered his executive editorship. The freedom from editorial page supervision that Op-Ed had enjoyed in the 1970s and 1980s had disappeared, but the page's compelling content hadn't. After three years, however, Raines concluded that my style and his were irreconcilably disparate. Reluctant yet relieved to leave the mirthless editorial floor, I rejoined the Culture department in 1996, just in time to design the first daily color page to roll off the new presses.

Much soul-searching and handwringing preceded the *Times*'s introduction of color in 1997. Would we look like a floozy? Or, heaven help us, like *USA Today*? The first pigmented daily page was an Arts cover featuring the vibrant Maria Callas in a glistening scarlet gown. As I designed the page, most of the masthead—six grown men—bent over my computer, gnashing their teeth.

"The dress is too red," fretted the executive editor. "Her flesh tone's all wrong," said the publisher. Assistant managing editor Tom Bodkin, who was among the six, deserves much credit for smoothing the newspaper's complex change to color. Bodkin had worked with legendary CBS designer Lou Dorfsman before joining the *Times* in 1980. Since becoming the paper's design director in 1987, Bodkin has designed or redesigned every one of the paper's pages.

Like his only real predecessor, Lou Silverstein, Bodkin possesses the mandatory skill of eliciting the trust and respect of a large band of quick-witted top editors. He's replaced a miscellany of headline typefaces with a single font (Cheltenham), led the *Times* team that worked with Microsoft to create Times Reader, supervised the newspaper's transformation to a narrower format, and redesigned pages 1, 2, and 3 of the main section.

Texture goes a long way in compensating for a lack of color. Artist Jonathon Rosen is adept at imparting a variegated feel to his surfaces, as can be seen in his interpretation of a call for American families to stop living beyond their means [figure 57]. In 1993, an illustration by Swiss artist Etienne Delessert would have benefited from color, since halftone reproduction minimizes its painterly richness [figure 58]. Delessert's beastie with an identity crisis reflected a Russian émigré's report that a decree intended to ease restrictions on nonviolent dissent actually provided the government with the legal mechanism for greater repression.

A self-taught painter, illustrator, animator, author, and sculptor, the restless Delessert, who ran a large animation studio in his native Lausanne, challenges himself by continually applying his extraordinary skills to new styles and media. His vast oeuvre has traveled, in three separate retrospectives, throughout Europe and North America—from the Louvre's Musée des Arts Decoratifs to the Library of Congress. In 1965, he moved to the United States, armed only with his artistic talents and one English phrase. "I hired a Parisian to teach me how to ask an art director for work," says Delessert. "He taught me to say, 'May I have a date with you?' Delessert used that line several times before his future wife, gifted book designer Rita Marshall, "told me that isn't how you ask for a job."

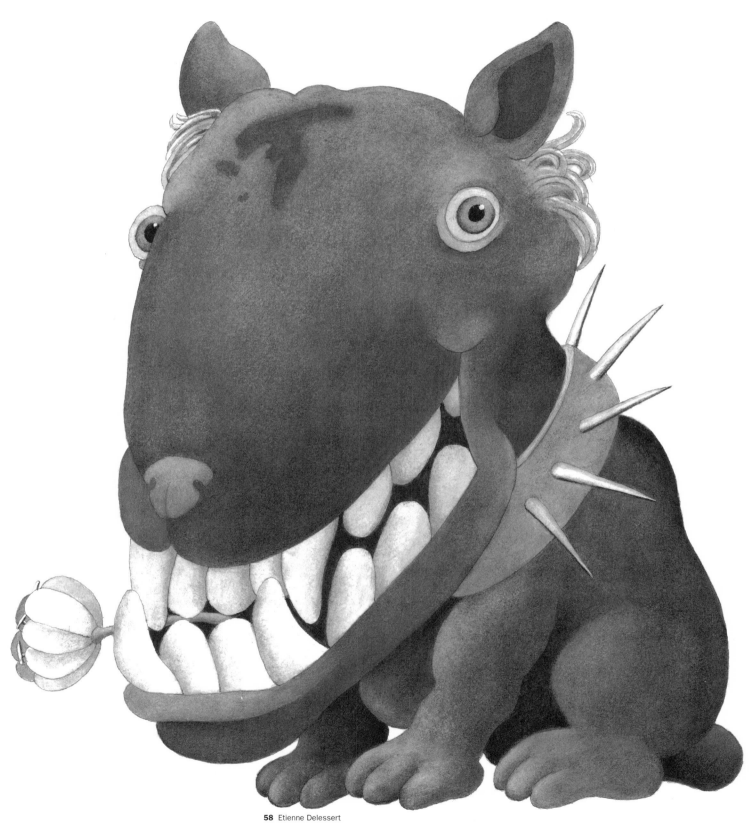

58 Etienne Delessert

Black and "White"

I've been forty years discovering that the queen
of all colors is black.

AUGUSTE RENOIR

Karl Marx wrote that history follows changes in the technical means of production—what we call technology. The Internet and the World Wide Web have, of course, thoroughly revolutionized the means of presenting news and opinion. Well before this sea change occurred, however, the intricacies of producing the physical newspaper have had a marked effect on its content.

Op-Ed falls on the penultimate page (inside back) of section A and is printed on the same sheet as page A2 (inside front). The *Times* production manager Peter Putrimas explains: "Page A2 doesn't need advertising color. Because Op-Ed is also printed on that sheet, it never gets color. Our presses are configured so that if we put color on the inside front and inside back, all the color would concentrate in the front, back, and middle only. But our ad salespeople want full-page color opportunities throughout the main section."

Full-color printing requires four inks: cyan, magenta, yellow, and black (CMYK). Varying their percentages produces the spectrum's countless hues. But Op-Ed's all-K palette suits some artists just fine. "Things that can be expressed in black and white are the most inter-esting to me graphically," says David Suter. "Color has a complexity that black and white doesn't have." ("Black and white" is really a misnomer when referring to printing, since the only ink is black, while white [or yellowing newsprint] is simply the ground.) *New Yorker* cartoonist William Hamilton and the late theater caricaturist Al Hirschfeld are two artists who have lacked interest in color. When hired for *Times* cultural sections, they both requested that color washes be applied to their black line drawings in any shade and at any spot I wished.

In 1992, Maris Bishofs illustrated the notion that the United States attracts millions of newcomers despite doomsday prophecies that predict its looming decline. Bishofs endowed his flags with contrast so bold that they possess the eye-catch of color [figure 59].

The meticulous István Orosz requires little more than black line to create his paradoxes and illusions. In 1993, he drew an accompaniment to a discussion of Russian president Yeltsin's call for a threefold separation of powers [figure 60]. Although it's rarely so obvious as in this picture, Orosz freely admits his debt to Escher.

Many contemporary artists have been influenced by the work of Escher, who's one of very few rationalist "outsider"artists. In 1971, when I was fortunate enough to speak by telephone with this twentieth-century Dutch master, he said, "My images require only black, unless I need color to define a plane."

There's a story, which is likely apocryphal, that the painter Ingres once asked his students to paint one hundred swatches from white to black. The students complained that no one could see such minute differences. Then Ingres pulled out a chart he'd painted with one thousand such tonalities.

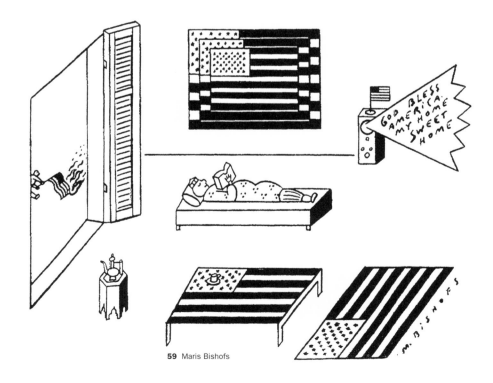

59 Maris Bishofs

60 István Orosz

Does It Compute?

> I doubt that machines will replace art
> any more than wheels have replaced feet.
>
> BRAD HOLLAND

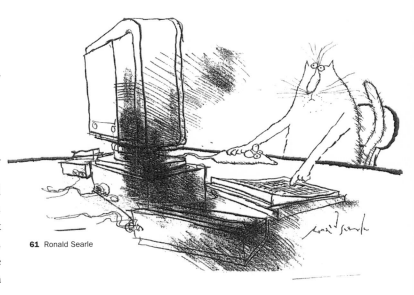

61 Ronald Searle

Until the *Times* embraced design software, pages were fashioned by hand. The resulting layouts, full of erasures, were often grubby. With the switch to Macs and mice, mockups became spotless. But at the *Times*, they're still hardly more helpful than penciled sketches. Art directors use InDesign software to create them, yet they're mere guides for a staff of paginators, who use a different software program into which the real type is streamed.

Once upon a time, the International Typographical Union—the printers—built pages in the composing room. Art directors and editors struggled daily, hands tucked behind our backs, in this closefisted club of a union shop to supervise the translation of our designs into pages that the ITU rules barred from our touch. Makeup was accomplished with heavy, cast-metal typography and lead plates of illustrations, photos, and ads. The sheer heft of these elements conferred status on the veteran craftsmen who lugged them around.

One printer, Irving Sarnoff, could have been the eighth dwarf—not in height, but in knobby nose and grizzled chin. "Ohmygod, here she comes," he'd groan too loudly as I entered the football field–size, windowless, male bastion. "Where d'ya want this headline?" he'd shriek in my general direction. Irving's beady eyes bulged and darted about. If they chanced to meet mine, his face flushed and erupted in a sheepish, toothless grin.

Repeatedly I'd try to get Irving to put the "hed" in the right spot. "You're breaking my balls," he'd screech. "The page'll be late. You're gonna cost the *Times* a million bucks." Yet he always asked the foreman to be assigned to our page. When a layout was tricky, he grumbled but delivered the goods. Irving was my favorite printer.

With the advent of computer-generated typesetting, paper galleys and proofs replaced lead type and engravings. Proud printers who'd long shouldered weighty trays of metal were emasculated when that weight disappeared and, with it, their union's clout. "Damn these doilies," Irving would fume as he scissored flimsy strips of paper. Yet—until negotiations eliminated them—the printers were still in charge; if anyone else touched a live page, their brawny, formidable union boss would rip it up. The paginating software that replaced printers is clean and predictable, but it lacks the character of an Irving.

There's much discussion today about the computer's devaluation of drawing. Original art can now be created by importing any image onto the screen and rearranging its pixels. You can take the "extraor-

dinary reservoir of available historical and contemporary imagery," Milton Glaser has said, and make it "your own to some degree. But you're not starting with material you have invented."[12] The computer, he says, "crystallizes an idea too quickly, before that idea has had a chance to develop. You have to keep it fuzzy so that the brain looks at it and imagines another iteration that is clearer. Sadly, the computer bypasses this dialectic between the hand and the brain." Everything that interferes with that direct relationship, for Glaser, "causes a loss of fidelity."[13]

Many illustrators use the computer simply to send the work they create by hand. "I really like to get messy," says artist Brian Cronin, "to create something from a blank space. When I've played on my laptop for a few hours, I feel a bit empty. The computer is an invaluable tool, but it's a piece of office machinery."

Illustrator Luba Lukova sometimes uses the computer to change things in a drawing after she scans it. "But the most important thing," she says, "is not how I do it. It's whether I connect with the viewer." Not all artists appreciate the new technologies. Ronald Searle and Jean-Jacques Sempé, for example, shun e-mail. In 1994, a delicious, archived drawing by Searle was perfect to accompany a satirical harangue against technology [figure 61]. Jules Feiffer doesn't have a computer, and David Levine refuses to own even an answering machine. Although Ralph Steadman is comfortable in the digital world, he'd rather not admit it and often refers to himself as "King Ludd," the first Luddite.

Artists who don't own a computer are now obliged to have someone else scan and send their work. "Hand-drawn pieces are now threatening and confrontational," according to artist Martin Kozlowski, "because they're harder to change. Digital images are easier for editors to manipulate. I had a digital Jules Feiffer strip with repeated scenes of a guy giving a speech into a microphone. The editors said it

62 Nancy Stahl

looked like fellatio." Kozlowski had to keep moving the mikes farther away from the mouths "until I finally had to take them all out," he says. "Feiffer called it 'my blow-job drawing.'"

When graphic software was being perfected, Nancy Stahl found a company that sought illustrators to learn its programs. These were "big, mainframe computers," Stahl told Zina Saunders, whose excellent Web site features stunning, digitally painted portraits of—and illuminating interviews with—illustrators and art directors.[14] "There was no manual, no help, no nothing," Stahl continued. "I learned by trial and error. I couldn't believe you could cut something out, move it, and stretch it. It was a whole new magical way of working!" It took Stahl about two months to learn the programs and decide, "OK, that's it. I'm just doing computer; I'm not doing the other stuff anymore."

Stahl—she of the nearly killed copyright "nipple"—and most other illustrators count on the computer not as an idea source but as an efficient paintbrush to execute notions already worked out in pencil. "I scan in my sketch and use the computer like tracing paper," says Stahl, whose disarming appeal is that of a seriously talented and very pretty natural blonde who's congenitally shy. "I draw the finish with Vector in the Illustrator program and the softer stuff with the airbrush tool in Photoshop."

Stahl's quick wit and digital mastery are evident in her embodiment of the delicate negotiations between American and French diplomats over the Louisiana Purchase. Exactly half the credit for France's sale of "565 million North American acres for fifteen million dollars," the article discreetly explained, goes to "the compelling attractions of a French society hostess named Adélaïde de Flahaut."[15] Stahl's sophisticated image smartly sums up a complex story [figure 62].

In 1997, David Suter suggested to the *Times* design director that the paper consider animating its drawings on the Web, but there was no interest. Despite the rebuff, in 2007 Suter sent Op-Ed a straight illustration, as well as the same drawing animated in QuickTime. His point is that—with sites from Facebook to the DrudgeReport attracting more hits than newspaper sites—the paper needs to bring conceptual art to readers via a more dynamic online presentation.

The Rebus Requirement

The gods love the obscure and hate the obvious.
UPANISHADS

"Editors suffer from the 'Paris, France' syndrome," says Brad Holland. "If you write, 'Picasso lived in Paris,' you have to add 'France,' so no one thinks he lived in Paris, Arkansas. The Bible says God breathed life into Adam. If Michelangelo had painted that on the Sistine ceiling, it would look like mouth-to-mouth resuscitation." Holland refers to this syndrome as the "rebus requirement," where every part of the art must correspond directly to a point in the text.

This literalism presents a major hurdle on the path to visual poignancy. If the image repeats the article, why run them both? In 1996, a manuscript warned of the dangers of privatizing Social Security. From cradle to grave, maintained the text, the American worker is vulnerable. Matthew Martin's illustration—complete with rocking chair and twenty-dollar bills—was quite explicit. Getting this drawing approved, I thought, would be a breeze. I was wrong. The deputy editor examined it and asked, "Where are the mutual funds?"

Late one day in 1996, the jury deliberating civil charges against New York subway gunman Bernard Goetz reached a guilty verdict; he was assessed $43 million in damages. Nine years earlier, Goetz had been acquitted of criminal charges in the shooting of four African-American youths. Now the editors acted quickly to update the daily page with a text we received at 6:00 P.M. The new text discussed the trend of civil trials for defendants previously acquitted on criminal charges.

The editor requested a photo from Goetz's criminal trial. I ordered photos but also consulted our art bank. (Photojournalism is the lifeblood of every other page in the paper, but not Op-Ed.) There I found a Brad Holland drawing of a man who was trying to walk away but was being pulled back by a rope. It told the story. "But it doesn't look like Bernard Goetz," said the editor.

"That's why it works," I said. "The manuscript is pegged to today's verdict, but it addresses a widespread legal trend and cites the cases of Rodney King, the Menendez brothers, Lemrick Nelson, and O. J. Simpson. This generic figure is being caught when he thinks he's gotten off scot-free." The editor shook her head. Still hoping for a conceptual image, I asked David Suter for an emergency drawing. He made two instant sketches. One was a two-headed gavel. The other was more intriguing—handcuffs that formed a subtle dollar sign. The editors chose the gavel.

63 Paul Rand

64 Michael Sloan

Seismic Break

Every generation laughs at the old fashions,
but follows religiously the new.

HENRY DAVID THOREAU

In 1997, Nicholas Blechman—a bright, restless illustrator/designer who'd subbed during the 1990s—became Op-Ed's art director and launched the first leap out of the page's traditional pictorial personality. The son of R. O. Blechman, Nicholas has spoken of being "brought up surrounded by illustration and graphic design. Posters and flyers for punk bands, like the Dead Kennedys, also influenced me," he's said. "It all looked cool. In a weird way, the worse it looked, the cooler it was."[16] The enterprising Blechman turned his anger at our environmental degradation into the founding of *Nozone*, an underground political comix zine whose nine issues he's designed, edited, and published.

As the new century approached, the no-man's-land that separated visual from verbal on Op-Ed cracked open: art directors and artists began exploring the hitherto limited use of letters, words, numbers, and notations in the art space. Just as Op-Ed writers pepper their writing with visual metaphors, the artists began to salt their images with words.

The éminence grise now sitting in artists' studios was the computer, which changed not only how they worked but how they thought. Influenced by the digital aesthetic, the work of many illustrators grew less allegorical as it veered toward the zeros and ones of the machines with which it was increasingly produced and distributed.

Embracing these trends, Blechman stamped Op-Ed with his own antiart aesthetic. To surprise readers and give them edgier illustrations, he wanted "*designers* to illustrate," he says, "and see what happened." What happened was intriguing ideas executed on Apple computers using photographic setups, stock icons, and typography.

Language in and *as* art dominated 1990s graphic design. Instead of using pictures, prominent designers carefully configured typography to create striking, type-only book jackets, packaging, and posters. While subbing at Op-Ed in 1995, Blechman hired graphic-design great Paul Rand to illustrate a text on the troubled National Endowment for the Arts. The fabled designer, then eighty-one years old, drew a picture of a clown because, to quote Rand, "the NEA's a joke." Blechman, dismayed, asked Rand if he had any other ideas.

"The only other thing I can do in this amount of time [two hours]," said Rand, "is take the letters N-E-A and rip 'em up." Unsure of this idea, Blechman has related, "I called my father, who said, 'If

65 Chip Kidd

Paul Rand wants to tear up the letters, it won't be like anyone else tearing them up. Just make sure he signs it.'"[17] The result became Op-Ed's first all-language illustration [figure 63]. Another drawing that Blechman art directed that year illustrated a letter on the International Space Station's lack of funding [figure 64]. The begging robot is the brainchild of Connecticut artist Michael Sloan.

In 1998, innovative Knopf designer Chip Kidd illustrated an article on Pope John Paul II's encyclical that stated, "Faith itself insists that the Creator gave you reason" [figure 65]. Not only is Kidd the most celebrated book jacket designer of all time, but he's written two novels and is himself the subject of a book.

The symbiosis between word and image reaches back to the hieroglyph, when the two were one. Verbal and visual forms then diverged radically until recently, when modern fine art movements—Symbolism, Futurism, Cubism, Surrealism, and Dada—incorporated linguistic elements. Language later became central to Conceptual art: in the 1960s Los Angeles artist Ed Ruscha painted canvases containing nothing but single, painted words—"vise," "boss," "dimple"—with the words tweaked to express their meanings. Lawrence Weiner began in 1968 to create language-based works that the Whitney Museum's retrospective of the artist exhibited in 2007/2008. And in 1990, the entire spiral of the Guggenheim Museum glowed with Jenny Holzer's LED epigrams.

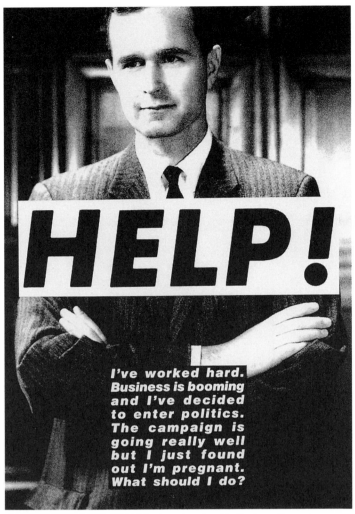

I've worked hard.
Business is booming
and I've decided
to enter politics.
The campaign is
going really well
but I just found
out I'm pregnant.
What should I do?

66 Barbara Kruger

Words are fundamental to much of Saul Steinberg's work; they've energized many of his savviest *New Yorker* covers. And graphic artist turned fine artist turned Op-Ed illustrator Barbara Kruger created an inventive blend of high-contrast photos and provocative phrases that jolted contemporary culture. Her Whitney retrospective in 2000 included five framed Op-Ed pages with her illustrations.

Thus twenty-six years after the exhibition at the Louvre, Op-Ed was again featured in a high-art palace. One frame in the installation enclosed Kruger's protest from 1991 against President George H. W. Bush's antiabortion policy [figure 66]. It ran alone under the headline "Any suggestions?" Another page on exhibit contained an illustration for a text stating that the rape of black women never receives the same coverage as that of whites. Editors asked that Kruger eliminate the word "body" from her original version [figure 67]. The published phrase became simply "You are a battleground."

The cross-hatching of 1970s Op-Ed art gave way in the 1990s to a minimalist aesthetic. "Stick figures became fashionable," says Blechman, "because Adobe's Illustrator program made it easy to draw them. We called them 'bathroom people,' since they looked like the signs on lavatory doors." Blechman worked closely with artist Natasha Tibbott to come up with an astute visual in 1998 for an astronomer's statement that there "may be an infinite amount of universe beyond the horizon, but we can't see it" [figure 68].[18]

Martin Kozlowski, the talented Connecticut illustrator and intellectually gifted art director of INX, an editorial illustration service, was an excellent sub art director throughout Op-Ed's second decade and beyond. "We didn't have layers of editorial input in the eighties," says Kozlowski. "But when Howell Raines arrived, things got tight-ass." The Op-Ed editor "was a bundle of nerves under Raines's thumb, and we had endless sketch stages. Then Nicholas Blechman brought a new house style to the page. It was an aesthetic choice but also a clever way of not committing." The schematic notation that Blechman encouraged created unisex, uni-age, and uni-ethnic figures that were never politically incorrect, so most drawings sailed through the approval stage.

"You look at a Cardo, it's got a face," says Kozlowski. "But flat stick figures with bubbleheads are generic and unsubtle. You don't need to argue with editors because the head is a circle. They're inoffensive but also glib and not challenging." When he art directed for Blechman, "every designer sent me a messy, incomplete file," says Kozlowski. "'You complete it,' they'd say, because they're used to dealing with assistants."

One of Kozlowski's own illustrations interpreted an essay by Winnie Mandela's biographer in 1992 [figure 69]. Published the day after Nelson Mandela announced that he and his wife, Winnie, were separating, the prose portrayed the couple's parting as "the closing act of South Africa's lengthy drama of tyranny, fear, bloodshed and death."[19] Kozlowski's commanding picture embodied Winnie

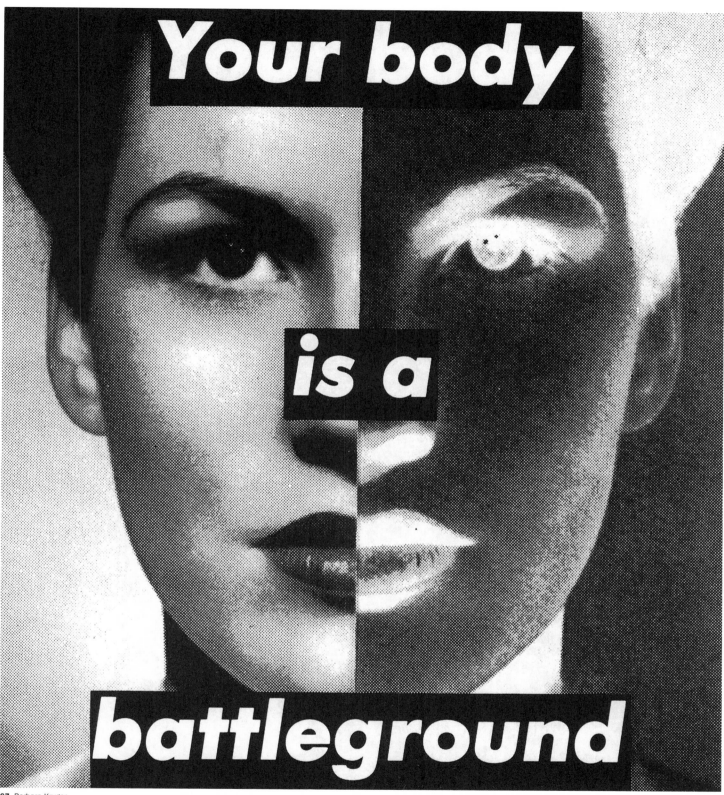

67 Barbara Kruger

the universe our understanding of the universe

68 Natasha Tibbott and Nicholas Blechman

Mandela's "Jekyll and Hyde" personality as described in the article: "serene and smiling one moment, screaming and lashing out the next." One reader, however, voiced a bitter objection not to the article but to the art: Calvin Butts of Harlem's Abyssinian Baptist Church wrote to the *Times*, insisting that the drawing was unfair to Mandela.

Blechman occasionally hired celebrated New York illustrators he'd gotten to know through his father, including Paul Davis, who created the iconic posters for Joseph Papp's New York Shakespeare Festival productions from 1985 until producer Papp's death in 1991. "Style is a voice one chooses for its effect," Davis says, "and I want to use as many voices as possible." Evidence of Davis's adherence to this sentiment is the illustration that he fashioned to accompany a discussion of American battle deaths in 1999 [figure 70].

Blechman chose deft designer Paul Sahre as one of his vacation replacements. "I used to think Nicholas sat around all day with his feet up," says Sahre. "Op-Ed looks easy: you just call an illustrator and design one or two pages. But when I did it, I found it totally stressful." Sahre runs his own studio, Office of Paul Sahre (O.O.P.S.), "where I juggle lots of jobs at once. But it doesn't compare to the burnout of Op-Ed. An article can come and go and stick you with doing something new in the hour before the page closes. I could never do more than a week at a time."

The talented, fast-moving illustrator Wes Bedrosian, who's replaced four art directors, including Blechman, and continues subbing today, says, "At week's end I thank God I don't have to come in on Monday." Bedrosian's own image pictured the optimistic expectation that "China, like a dutiful big brother, will shepherd North Korea back into the fold" of peaceful nations [figure 71].[20] "I draw people who are universal-looking," he says, "so they're easy to get through." Bedrosian, like Viktor Koen and a score of illustrators working today, is a graduate of Marshall Arisman's "Illustration as Visual Essay" program at the School of Visual Arts.

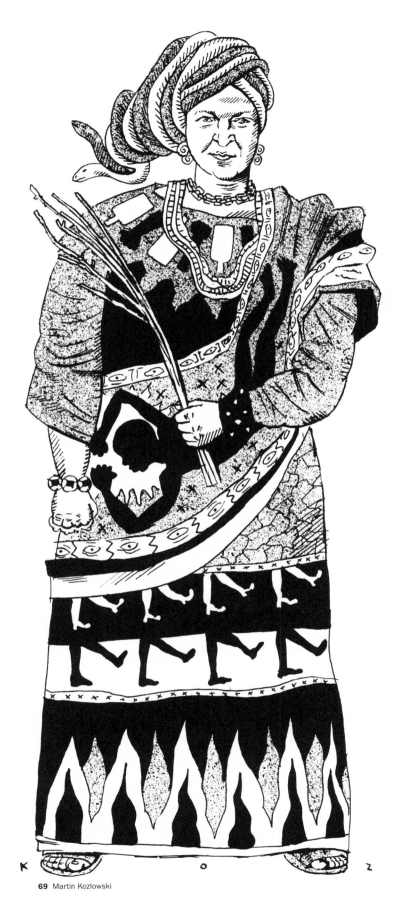

69 Martin Kozlowski

In 1997, an essay by CIA director Robert Gates warned that if Saddam Hussein didn't disarm, the world would be left with a megalomaniac with weapons of mass destruction. Janusz Kapusta illustrated this tragically inauspicious text [figure 72].

A sensitive picture of former president Franklin D. Roosevelt by artist Ron Barrett accompanied a remembrance by FDR's eldest grandchild in 1997 [figure 73]. To have him seated in a wheelchair for a proposed Washington memorial, she claimed, as though he had spent more than a fraction of his waking day in it, would be totally misleading.

Jonathon Rosen's image drew attention to a satire of the high-tech revolution [figure 74]. The writer maintained that nothing much works the way it's supposed to and that technological gadgetry makes one run faster and faster in place.

70 Paul Davis

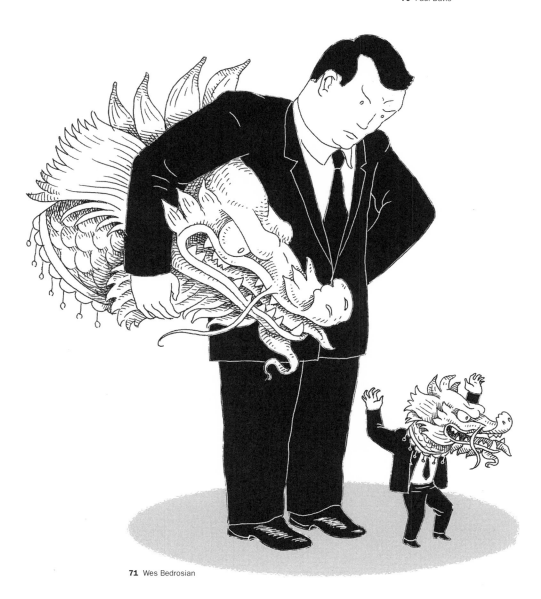

71 Wes Bedrosian

72 Janusz Kapusta

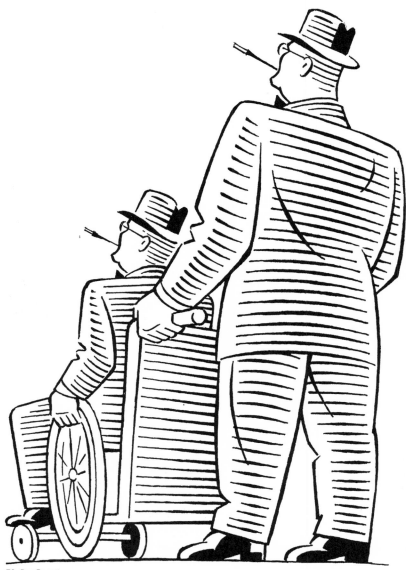

73 Ron Barrett

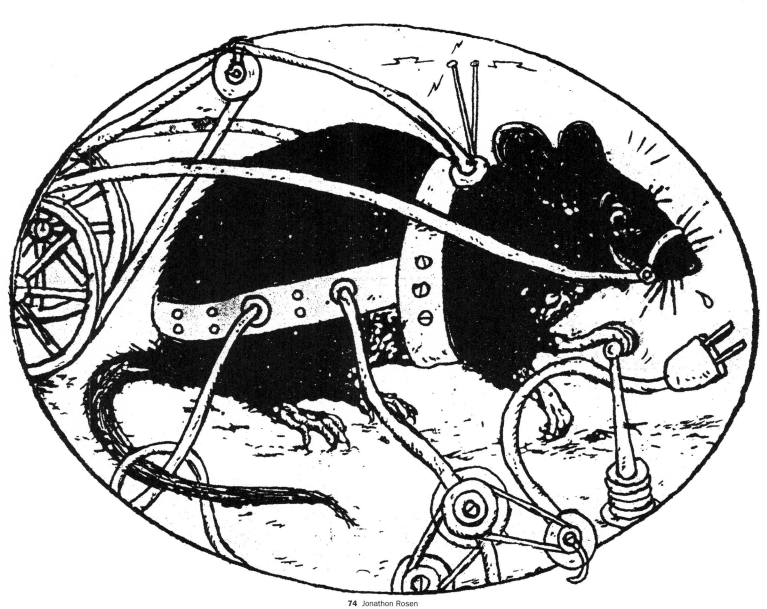

74 Jonathon Rosen

A portrait of George Orwell, from 1998, represents one of art director Blechman's few forays into traditional aesthetic bravura [figure 75]. Its creator, the Milanese artist Andrea Ventura, lent his fine art approach to an excerpt from Orwell's diary revealing that Big Brother's creator had provided the British Foreign Office's propaganda unit with a list of crypto-Communists. In 1999, Australian artist Matthew Martin found a tasty metaphor to enhance an argument that many firms encourage their employees to evaluate success with just one measure: the bonus [figure 76]. Rarely is there an urban answer to the suburban demagogues who gather easy votes by beating up on the cities, complained the author of a text that Brian Rea interpreted in 1999 [figure 77]. Illustrator Rea would become Op-Ed's art director in 2004.

Hot-blooded Bulgarian artist Luba Lukova's potent imagery renders elemental themes in iconic style. "People need to see themselves in art," says Lukova. "I want to tell the human story." In 1986, the passionately outspoken and feisty Lukova graduated from Sofia's Academy of Fine Art. "Then," she says, "two policemen came to my door. They told me I had to leave the capital. They checked everything. I had no freedom of movement." The Communists posted Lukova far from Sofia in the tiny town of Blagoevgrad, never guessing that they'd thereby fertilize dissent in that remote village. But in 1991, Lukova was granted a passport to see her work at an international poster show in Colorado.

"I loved America from the first minute," says Lukova. "The freedom, the hard work, the people." In 1997, one of her illustrations accompanied a Peruvian journalist's outcry about a Panamanian government order to expel him from the country [figure 78]. His text called the order "retaliation by powerful individuals angered by my work."[21] In her image, Lukova exploited classic iconography used by graphic satirists past and present, including several on the Op-Ed page.

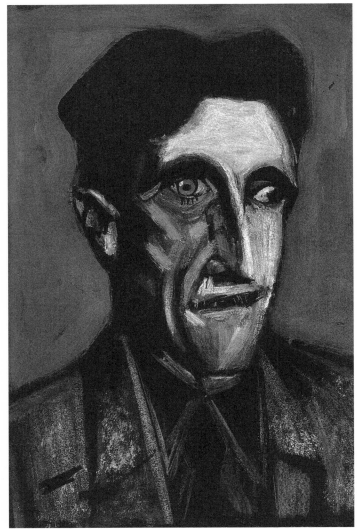

75 Andrea Ventura

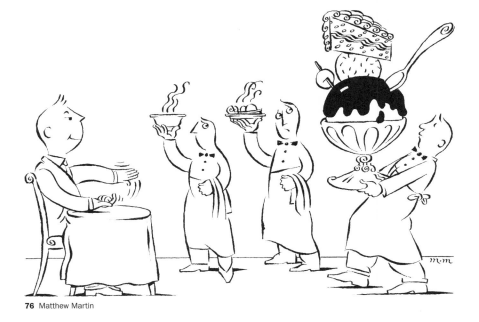

76 Matthew Martin

MAIN EVENT SUBURBS vs. THE CITY

77 Brian Rea

78 Luba Lukova

"If you say something strong," says Lukova, "there will always be someone against you. But you have to speak out. The U.S. won't send me to a gulag. But in America we're drowning in materialism. That's as dangerous as the gloomiest ideology." In 1999, Lukova created a soaring complement to an argument that NATO had to win in Kosovo [figure 81]. She later rendered it as an image that won the 2001 Grand Prix Savignac for the World's Most Memorable Poster, and now there's a history student in Baltimore with Lukova's dove tattooed on his back.

"Op-Ed is the only page I like to illustrate," says Lukova, "because that's where the strong opinions are. These pictures *should* be black and white. And I like that they're always due the same day." Lukova has had solo shows in Paris, New York, and Osaka. The Bibliothèque Nationale, Library of Congress, and Museum of Modern Art collect her work, and she's published *Social Justice 2008*, a poster portfolio, and a book on her art, *Speaking with Images*.

Nicholas Blechman encountered issues similar to those I experienced with Howell Raines, but he handled them better. "It was hard to get anything on the page that made a political statement," says Blechman. "Op-Ed was my first job, and it was the only section of the paper I wanted to art direct, but after three years I ran out of tricks." Blechman left the *Times* in 2000 but returned in 2004 to art direct the Week in Review. Two years later, he switched to the *Book Review*, where he continues skillfully today.

Ardeshir Mohassess illustrated a Harvard professor's Op-Ed assault on Salman Rushdie's *Satanic Verses*, the controversial novel that Muslim clerics believed to be blasphemous [figure 79]. The "acuteness of your blow," wrote the professor, has "elicited the rage of entire nations. Mr. Rushdie, you have cut them, and they are bleeding."[22] The failure of the United States to assist the recently disbanded Soviet republics was denounced in an article by Richard Nixon in 1992. Without immediate action, Nixon predicted, freedom's tide would yield to despotism—a possibility that Mirko Ilić masterfully conveyed [figure 80]. Op-Ed has published still more versions of this graphic idea, but only Lukova offered a David-and-Goliath twist: the stomped-on captive would soon become the captor.

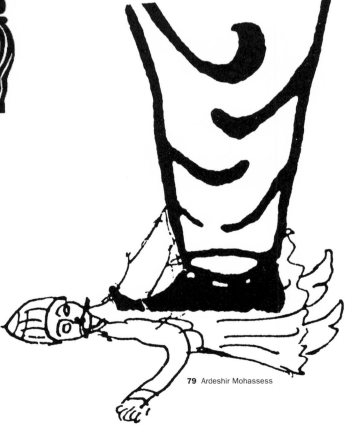

79 Ardeshir Mohassess

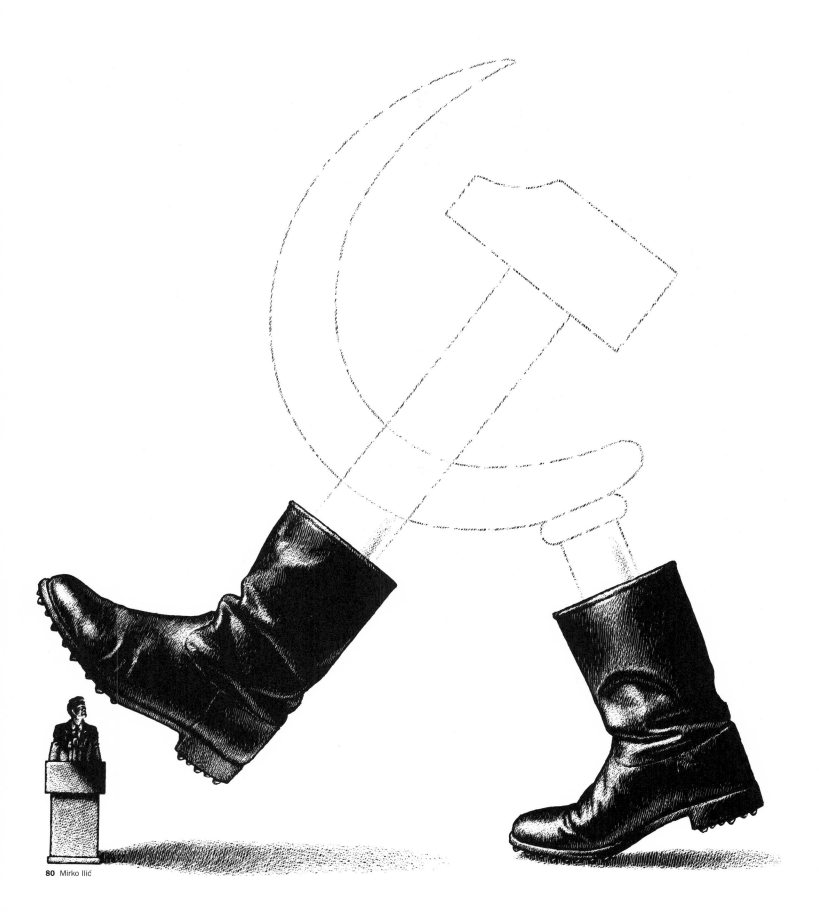

80 Mirko Ilić

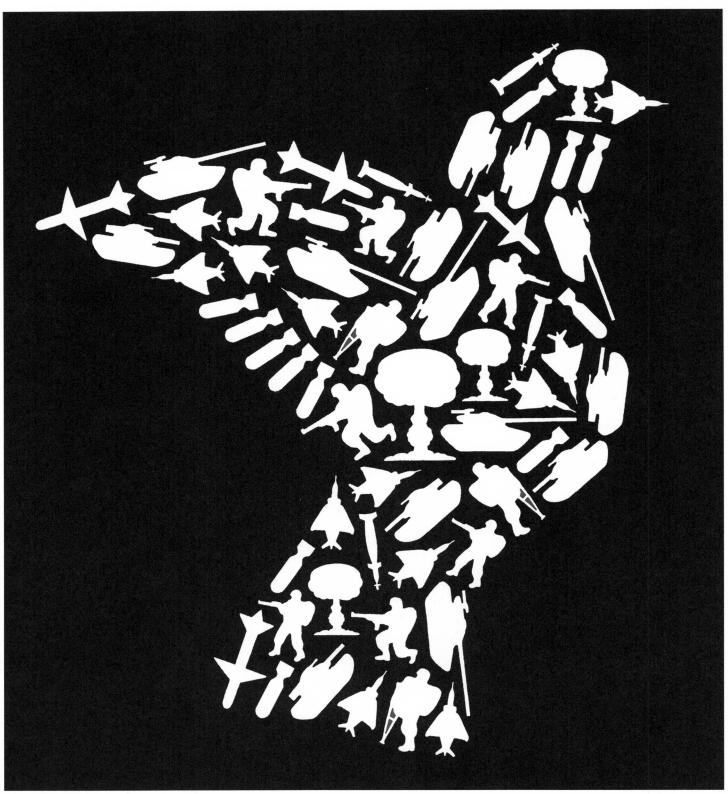

81 Luba Lukova

THE AUGHTS

Rains Howl

The first decade of the new millennium opened with a whimper as
the dreaded Y2K bug failed to stop all computers at midnight.
The quiescence of that beginning was broken the following year,
however, by the roar of jet engines. Hijacked U.S. airliners plunged
into the Pentagon, a Pennsylvania field, and the twin towers of the
World Trade Center. A maimed nation and all humankind recog-
nized that global terrorism was the new world order.

In this uncertain interval, the *Times* was experiencing the metastasis
of its digital network. The paper had at first regarded its computer
system as a way to eliminate waste and streamline its product mix.
But the supposed savior was now poised, instead, to supplant and
eventually doom the physical newspaper. This precarious period was
also the setting for the *Times*'s first ousting of an executive editor.

Howell Raines got away with hubris because, in his own words,
he "played Sulzberger like a violin."[1] Publisher Arthur Sulzberger
Jr. had responded to Raines's romance by anointing him pope. Now,
in 2001, he elevated his pope to head of state, the pinnacle where
Raines remained for just twenty-one months. In his memoir, Raines
blamed his downfall on plagiarist Jayson Blair. Young, mentally un-
stable, and prolific, Blair was a rising reporter until it was discovered
that he had been inventing or copying his stories. "My career had
been hit by a plummeting dwarf," wrote Raines, "falling straight and
fast and nothing is likely to survive that."[2]

In Raines's defense, he took over the newsroom at a precipitous
moment, just "days before the September 11, 2001, terrorist attacks—
the biggest news in many years and an event that took a heavy emotional
toll on the paper's staff."[3] Yet Raines lasted beyond the period of
September 11's major impact, and the staff's irritation with—and
ultimate insurrection against—his leadership resulted from his daily
attitude, not from any specific incident.

Blind to his own rancid reputation, Raines is alone in seeing Blair
as his sole problem. Soma Golden Behr, a former assistant managing
editor, has said, "I knew what going up against Howell was like—it
was horrible."[4] A top investigative reporter, Alex Berenson, said,
"The newsroom disliked Howell before Jayson Blair. . . . He was a
jerk, and he ran the institution for himself."[5] The Huffington Post
reported on the "mutiny of *Times* staffers" that doomed Raines.[6]
The climax of that mutiny was a town hall meeting on May 14,
2003, for a thousand *Times* employees. Coolheaded reporters accused

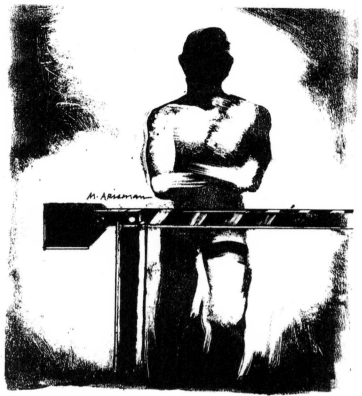

Marshall Arisman

Raines of undermining journalistic values, and Berenson confronted
him point blank: "Have you considered resigning?" Raines left the
meeting in shock. "He was desperate to survive," said assistant
managing editor Glenn Kramon. "But people didn't help him. It
was too late."[7]

An Op-Ed image by Marshall Arisman could well have been
created to depict Raines's stubborn denial of his staff's refusal to
work with him.

Two years earlier, when publisher Sulzberger was deciding on the
next executive editor, I'd audaciously told him: "I know you prefer
Howell, but he's appalling at handling people. I wish you'd choose
Bill [Keller]." In our later e-mail exchanges, Sulzberger was exceedingly
gracious about my impertinent advice. He was also magnanimous
with Raines, characterizing his exit as a "resignation." Yet renegade
Raines stabbed Sulzberger in the back by revealing—on Charlie
Rose's television show and in a twenty-one-thousand-word *Atlantic
Monthly* you-a culpa—that the publisher had fired him.[8] Then in
2008, five years after losing "the top newsroom job at the *New York
Times* amid public rancor and scandal," Raines captured a choice
assignment: media columnist at *Condé Nast Portfolio*.[9]

Reins Retracted

The grass may be greener on the other side
of the fence, but you still have to mow it.

ANONYMOUS

1 Michael Bierut

When Raines left the tenth floor in 2001, Sulzberger appointed editorial board member Gail Collins as the first female editorial page editor. A lighter mood returned to the corridors, and Op-Ed regained its relative autonomy. The previous year, as the century changed, Op-Ed's editorship had passed from Katy Roberts to editorial board member Terry Tang. In 2003, Tang, like Roberts, assumed new responsibilities in the newsroom, and David Shipley, her deputy, became Op-Ed editor.

Shipley's remarkable résumé includes two years in Bill Clinton's administration as special assistant to the president and senior presidential speechwriter and two years as the *New Republic*'s executive editor. His *Times* career began as an overqualified assigning editor for Op-Ed and circled through several other posts before returning to Op-Ed. In 2007, Gail Collins was succeeded as editorial page editor by her deputy, Andy Rosenthal—former foreign editor, one-time Raines loyalist, and forever Abe's son. Rosenthal promoted Shipley to the new position of deputy editorial page editor for Op-Ed and digital.

When art director Nicholas Blechman left the *Times* in 2000, Peter Buchanan-Smith stepped in to guide Op-Ed's visuals through the post–September 11 months. Four freelancers art directed between Buchanan-Smith's departure for *Paper* magazine and Steven Guarnaccia's appointment as Op-Ed art director in 2002. Illustrator Guarnaccia has designed everything from Disney Cruise Line murals to classy area rugs. Among his print works is an interactive pop-up book, *Skeleton Closet*, and two palindromic collections, *Madam I'm Adam* and *If I Had a Hi-Fi*.

"David Shipley is an activist regarding the art," says Guarnaccia. "He's big on photographs and info-graphics and gets very involved in visual decisions, so why fight? I don't show him anything unless I'm sure it'll fly. And artist-driven ideas come in a trickle these days, anyway—partly because we've gotten a reputation for being timid."[10]

Noted graphic designers continued to illustrate Op-Ed. Michael Bierut, an illustrious partner of the Pentagram international design consultancy, interpreted the contention that Democrats needed, in 2001, to "outtalk, outthink, and outwork their Republican opposition" because their recent "product hasn't sold so well" [figure 1].[11] Bierut's work is collected by major museums, and his clients include Harley-Davidson, Walt Disney, and the Rock and Roll Hall of

2 Stephen Doyle

Fame. Bierut is a founder of the upscale blog Design Observer and the author of *Seventy-nine Short Essays on Design*, in which each essay is set in a different typeface.

In 2003, Stephen Doyle, who had designed the first issues of the legendary magazine *Spy*, cleverly illustrated an article citing "bizspeak" as the lingua franca that greases company communication [figure 2]. Now the principal of Doyle Partners, his designs include Stephen Colbert's book *I Am America (And So Can You)* and the corporate identity for Barnes & Noble.

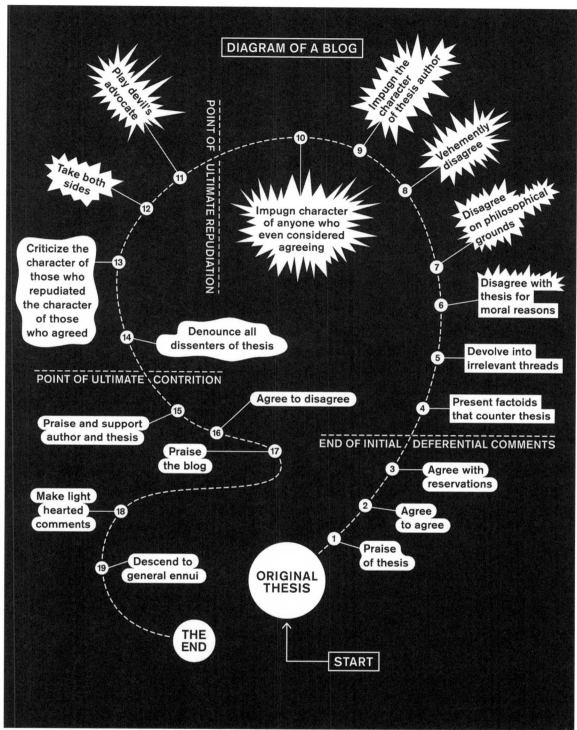

DIAGRAM OF A BLOG

Play devil's advocate

Impugn the character of thesis author

Take both sides

Vehemently disagree

11

POINT OF ULTIMATE REPUDIATION

10

9

Impugn character of anyone who even considered agreeing

8

Disagree on philosophical grounds

12

7

Criticize the character of those who repudiated the character of those who agreed

13

Disagree with thesis for moral reasons

6

14

Denounce all dissenters of thesis

5

Devolve into irrelevant threads

POINT OF ULTIMATE CONTRITION

4

Present factoids that counter thesis

Agree to disagree

15

16

17

END OF INITIAL DEFERENTIAL COMMENTS

Praise and support author and thesis

3

Agree with reservations

Praise the blog

2

Agree to agree

Make light hearted comments

18

1

Praise of thesis

19

Descend to general ennui

ORIGINAL THESIS

THE END

START

3 Paula Scher

In 2008, another high-profile Pentagram partner, Paula Scher, created a witty, amoeboid diagram of a blog [figure 3]. Scher's virtuosic typographical facility was already evident in the 1970s, when she produced album covers with strong "typographic designs, eschewing the genre's . . . conventional uses of photography and illustration."[12] She's since fashioned stunning posters for the Public Theater in New York, and her iconic work has won her clients like Tiffany & Company and *The Daily Show with Jon Stewart*. Scher also creates mesmerizing map paintings that feature landmasses and oceans teeming with neatly lettered texts, and her book *Make It Bigger* reveals the wisdom she's gained from three decades as a designer.

4 Paul Sahre

5 Nicholas Blechman [Knickerbocker]

In 2006, Paul Sahre's droll illustration complemented an astronomer's ill-fated plea to retain Pluto as a planet [figure 4]. A respected graphic designer, Sahre runs a "one-man design office, where he keeps overhead low and high-paying work to a minimum, so he can concentrate on low-paying work," like posters for off-off Broadway theaters.[13] Of Op-Ed he says, "If they screw around with my work at the last minute, I make them credit the published piece to 'Duane Shoop.'"

So the taboo on pseudonyms that plagued "Fibonacci" and "Jerelle Rorschach" has mercifully vanished. Nicholas Blechman, in fact, signed his own Op-Ed drawings with two noms de plume in addition to "Knickerbocker": "Art Hughes"and "Johnny Sweetwater." In the twenty-first century's earliest years, however, it was always Knickerbocker who illustrated Bill Keller's Op-Ed columns. In 2002, when Keller—who would soon replace Raines as executive editor—wrote, "To my mind the sadistic practices of the Iraqi police state . . . may be ample cause to indict Saddam as a war criminal, but

they are not in themselves enough to launch an invasion,"[14] Blechman shrewdly complemented his text [figure 5]. Another scintillating image by Knickerbocker illustrated an article that examined the Patriot Act [figure 6].

In addition to Tulio Pericoli and Andrea Ventura, a third Milanese artist, Sergio Ruzzier, has contributed to Op-Ed. In 2000, he drew Elián González, the six-year-old Cuban who had gripped an inner tube during two days at sea [figure 7]. Ruzzier reflected the miraculous survival of Elián, who'd witnessed his mother and nine others drown and became a potent religious symbol in Cuba. In 2001, a critique of literary spin-offs pegged to the publication of *The Wind Done Gone* was graced by the rarefied wit of Sean Kelly [figure 8]. The next year, Scott Menchin illuminated an essay dissing Defense Secretary Donald Rumsfeld's proposal to have soldiers undertake intelligence assignments [figure 9].

6 Nicholas Blechman [Knickerbocker]

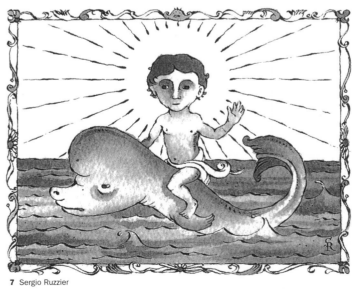

7 Sergio Ruzzier

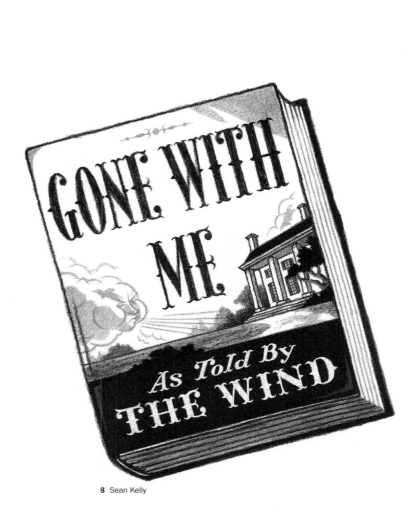

8 Sean Kelly

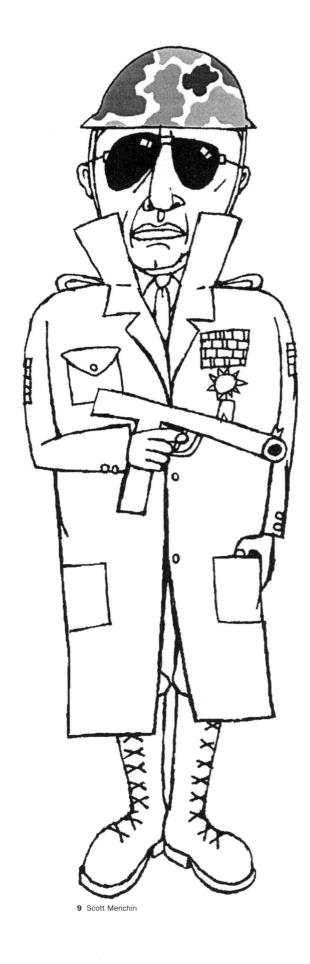

9 Scott Menchin

In 2003, Thomas Fuchs's cunning visual comment accompanied a contractor's prophecy that novelist T. Coraghessan Boyle's house "on the sere coast of Southern California" was certain to burn down during his lifetime [figure 10].[15] Fuchs, a German native who had studied with Heinz Edelmann in the same Stuttgart Academy class as Christoph Niemann, says "Op-Ed is the toughest place to work. They're very particular." In 2003, Robert Van Nutt, an artist and woodworker in Greenwich Village, produced a striking accompaniment to the contention that, in the wake of September 11, Americans should explore the discontent of distant people as a step toward expanding our own moral horizons [figure 11].

In 2004, an assertion that the invasion of Iraq by the United States had radicalized the Sunni Iraqis elicited an illustration by Mirko Ilić [figure 12]. "Here is religion as a weapon," Ilić remarks. "Minarets and flip-flops, because they're not professionals. How do you fight somebody in flip-flops?" Referring to Vietnam, Ilić adds, "America already lost a war to people in flip-flops."

When art director Guarnaccia left the *Times* at the end of 2004, illustrator Brian Rea became Op-Ed art director. He distinguished himself by the frequency with which he added new illustrators to the page. But the tradition of a single artist visualizing Frank Rich's weekly Op-Ed column persists. During the last years of the twentieth century, when Rich began his double-length essays, Seymour Chwast provided the graphics. "I worked with Frank directly," says Chwast. "He'd tell me what he planned to discuss, and I'd start on it before receiving the text the next day. I had to stay away from religion, portraits, and sex." In 2001, Rich wrote about *The Producers*, Mel Brooks's smashingly successful Broadway satire of Nazis, showbiz, homosexuality, old ladies, and dumb blondes. The show could play a role, the columnist wrote, in liberating "mainstream pop culture from the p.c. sanitization that has become such a bore."[16] Chwast aptly captured Rich's sentiments [figure 13].

11 Robert Van Nutt

10 Thomas Fuchs

12 Mirko Ilić

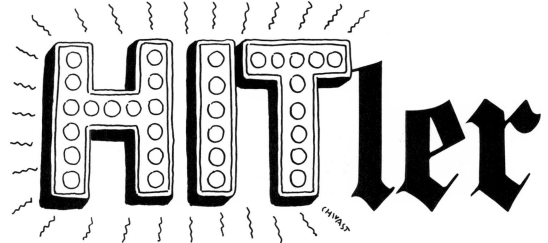

13 Seymour Chwast

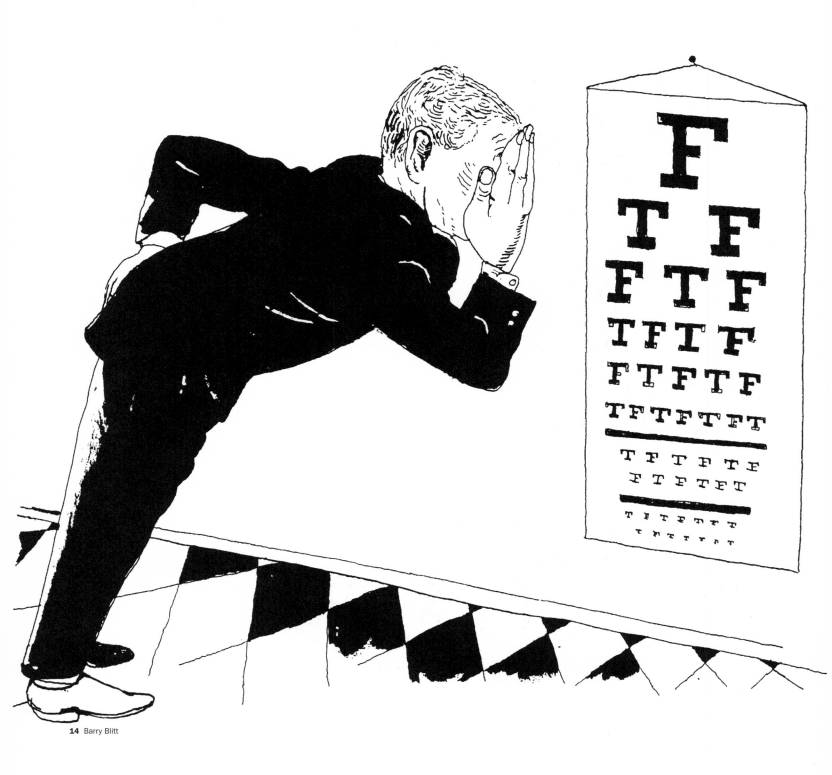

14 Barry Blitt

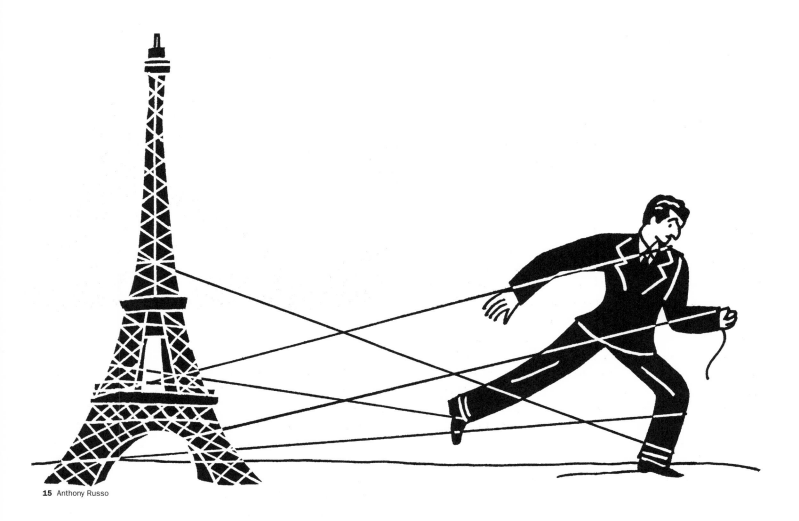

15 Anthony Russo

"Robert Grossman was the last one to do caricatures for Op-Ed," says Martin Kozlowski. "And even his jovial portrayals had to constantly change facial expressions. 'Soften it,' they'd say. But what other American paper hasn't caricatured Bush? Even the *Wall Street Journal*, where I've drawn Bush rather negatively, is more liberal on art than the *Times*. The prose can rip Bush apart. Maureen Dowd, in fact, puts people down in her every column. Yet the art's wimpy. And Op-Ed's a bellwether, so it's caused a general fear in the field. In a creative endeavor, fear isn't a good thing."

In 2005, the immensely talented Barry Blitt became columnist Rich's illustrator. Blitt grew up in Quebec, lives in Connecticut, and is the keyboardist for an all-illustrator jazz-and-blues band, The Half-Tones. "After two years of illustrating Frank's column," he says, "I felt increasingly hamstrung by a bizarre rule: no likenesses. I became expert at drawing Frank's subjects from the back." When his art was rejected "because it showed Britney Spears's face on a three-eighths-inch-square TV screen," Blitt tendered his resignation. "The bloody article was about her, for crying out loud," he says. "I was quickly talked out of doing anything rash by diplomatic art director Brian Rea, who arranged a meeting with editors to figure out why this rule existed. No one knew. I'm now allowed to depict the column's characters—as long as I don't distort their features or physiognomy."

In 2006, Blitt provided his inspired vision of Rich's contention that President George W. Bush is completely untethered from reality. It's not that he can't handle the truth about Iraq; he doesn't know what the truth is [figure 14]. The next year, when a French political analyst asserted that Americans misunderstand the prospect of a conservative France, Anthony Russo's interpretation included a vague, gentle likeness [figure 15]. "Under 'Sarkozy the American,'" maintained the French writer, "France will remain very French."[17]

The return of Rich's much-loved opinions to Op-Ed from an interlude in Arts & Leisure justified a second Sunday Op-Ed sheet. And soon after this expansion, Rea began to exploit the geography of two facing pages to occasionally cross the gutter with a single, dramatic illustration.

In 2007—citing the space sacrificed to loss of page width—Sunday Op-Ed grew to three pages, added online reader comments, and headed all four of its pages, including editorials, "Sunday Opinion." What's more, when its third sheet falls on Week in Review's back cover, Op-Ed gets color!

A Little off the Top, Please

Naturally, I was miserable, at five times
my previous salary. The *New York Times* is
a great newspaper: it is also No Fun.

MOLLY IVINS

In 2000, while Americans waited for five weeks for presidential election results, Ward Sutton offered Op-Ed a drawing [figure 16]. When George W. Bush "won" the presidency, Sutton's image was published, but only after removing the picture's bite—the beads of sweat. Two years later, Brad Holland fulfilled an overnight commission to illustrate Tom Wicker's memories of an interview with President Lyndon Johnson that had taken place soon after the assassination of President Kennedy. When Wicker arrived in the Oval Office, the new president was getting a haircut. Holland's brainstorm married Johnson's rearing in the South, where barbers once used bowls to cut boys' hair, with Johnson's long career as master of the Senate. The sketch was approved. But late that night, the Op-Ed editor decided that the Capitol dome on LBJ's head must go. "That's like saying the Herblock cartoon is okay," says Holland, "except for Nixon climbing out of the sewer." The artist drew a finish, which was killed [figure 17].

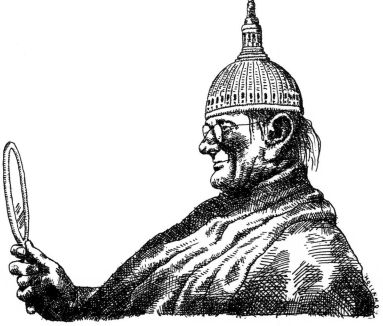

17 Brad Holland

"What was terrific about Op-Ed art of the seventies and eighties was that it took some thought to see what was going on," says artist Mark Podwal. "Also, we used to do a drawing, and it was printed. Now it's rare to do something that isn't changed or killed." In 2002, Podwal drew Jerusalem to visualize the claim that Israel needed barriers to prevent the entry of suicide bombers. Because Intifada cries were coming from minarets, the artist replaced a mosque's minarets with rifles. "But," says Podwal, "the editors said, 'Make it a generic city, not Jerusalem.' So I took the mosque out. Then they said, 'Draw cypress trees instead of rifles.' Then, 'Put the mosque back in.'"

In 2006, a letter to the editor discussed Israeli prime minister Ariel Sharon as a centrist. "I drew a menorah with roads and a pencil in the middle," says Podwal. "They rejected it because of the menorah. Yet I'd already done twenty varieties of menorahs for the *Times*. I still draw for Op-Ed occasionally, but it's a different world now."

Brad Holland agrees: "The page's art today has no connection with the past." Artist Tim Bower says, "Op-Ed never paid well, but it was the last stand of thought-provoking art. Now you get three sketches rejected and then do a hybrid version of the weakest one." David Suter notes that "editors increasingly fear art's power. They scrutinize images more closely. The fact that artists' credits are much smaller than writers' bylines implies the drawings represent the paper's point of view, which makes editors feel more responsible for them."

This book's examples are from *Times* opinion pages, yet the changes in illustration are widespread. "There's less passion in illustration now across the board, not just at the *Times*," says Marshall Arisman. "I used to go straight from idea to finish without being short-circuited by a sketch. Now, forced into sketches, I'm often per

16 Ward Sutton

18 Henning Wagenbreth

art directorial protection I once had, I know I'll get into fights." Illustrator Istvan Banyai says, "The juice is gone. It's corporate thinking, like the politburo. Shut up. Don't make waves. You do a little joke about Disney, then you learn the company is owned by Disney."

Horacio Cardo says, "As an artist you fight hard, but your creation is eroded. They expose you to the public naked and then put on you the dress they want." Cardo's clients in the United States contrast with those in Argentina. At *Clarín*—his paper in Buenos Aires—an editor calls and describes the story in a few sentences; Cardo sends a finished image; and the editor says, "Gracias."

For Mirko Ilić, "Art directors feel safer using photography or designers' work that looks like airline instructions." Brad Holland observes, "Editors who have a visual sense, like Harrison Salisbury, are rare. You could lock them in a room and give them massive quantities of LSD and the world's best art books. After a week, they'd come out thinking Manet and Monet are the same guy and congratulating themselves on having caught the typo."

Most artists who draw in a simplified, South Park style are accomplished draftspeople who do so by choice. "Elaborate rendering," claims Christoph Niemann, "is not about skill. It's about vanity."

An excellent draftsman, Niemann learned "to restrain myself from becoming too Baroque. I use whatever graphic solution best communicates the idea. Reduction is always better." Milton Glaser has written of the minimalist aesthetic, however, as "a kind of design fundamentalism. The old slogan 'Less is more' is bullshit. Sometimes less is more; sometimes it's less. A Persian carpet is not less beautiful than a solid-color rug."[18]

"I don't try to make beautiful drawings," German artist Henning Wagenbreth explains by phone from his home in the former East Berlin. "They have to be ugly in some way. But if they *look* appealing, they will attract people so I can then confront them with darker content." In 2008, Wagenbreth illustrated the case against requiring licenses to possess devices that detect chemical, biological, or radioactive agents [figure 18]. "I've had Op-Ed trouble," says Wagenbreth. "One article said the euro would strengthen Europe against the yen and the dollar. So I made a big, boiling pot and threw in stuff for a strong European soup—cars, clothes, chairs, computers. I threw people into the pot, too, because Germans feared losing their jobs. But the editors in New York were afraid the people were Jews and made me take them out."

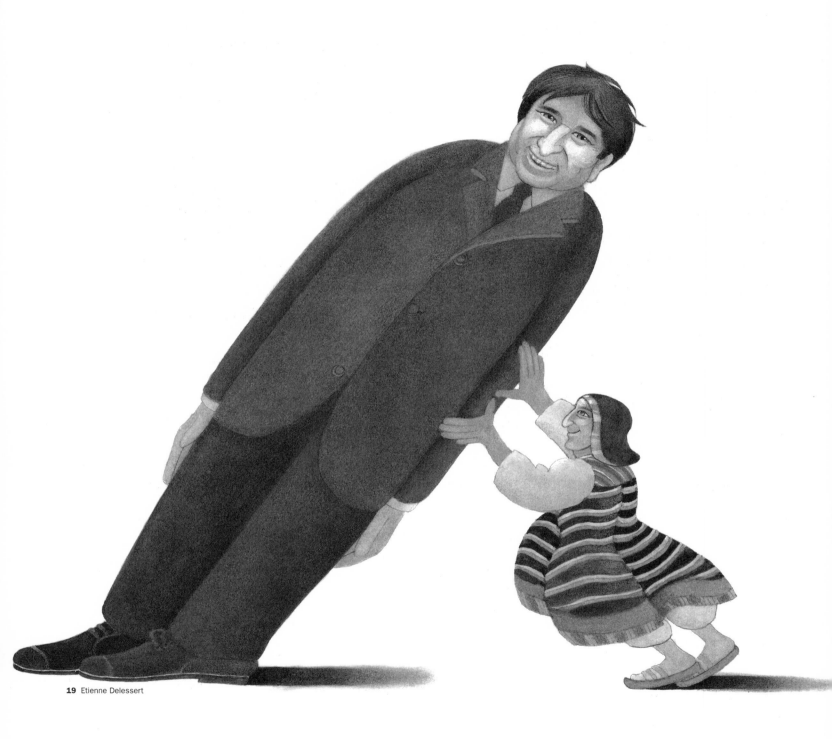

19 Etienne Delessert

"Steven Guarnaccia commissioned me to illustrate a terrorism text in 2003," Etienne Delessert relates. "I did a really interesting piece with a portrait of Osama bin Laden. But Op-Ed said, 'Absolutely no likenesses!' The first portrait they've run in years was Brad Holland's pope." Holland recalls that portrait: "The night after Pope John Paul II lost consciousness in 2005, I received a call from Op-Ed: 'We think the pope's going to die.' 'Oh, you think so?' I said." Then he got another call: "Hold off. We're not sure what direction the text will take. It might be negative, since the pope was conservative."

Holland interjected, "Look, you're not going to run a nasty piece on the pope." The text indeed lauded John Paul II, and accompanying it was an uncharacteristic illustration by Holland that captured the pope's likeness. Holland's power, however, lies not in replicating faces but in picturing the existential human stance. In 2007, he depicted the stark, robed figure of John Paul II's successor, Benedict XVI, in back view with a lengthy cast shadow that transformed the "portrait" into a haunting piece of art. By generally declining to create individual likenesses, Holland propels us from the trees into the forest.

Op-Ed has published some portraits in this century's first decade, albeit benign ones. In 2006, Etienne Delessert pictured Evo Morales, the first indigenous president of a South American country [figure 19]. But Morales is wearing a proper president's suit instead of the boldly striped Bolivian sweater for which he's famous. The same year, another safe yet penetrating likeness by Edel Rodriguez marked Fidel Castro's eightieth birthday [figure 20]. Rodriguez created this neutral image despite his antipathy toward its subject. A Cuban political refugee, he left his homeland at age nine in the Mariel Boatlift. Barely out of art school, Rodriguez got a job at Time Inc., where he art directed for thirteen years. He then became so successful as an illustrator that in 2008 he left the corporate world to, in his words, "work in my pajamas as a fulltime freelancer."

Op-Ed's first editor, Harrison Salisbury, respected art's communicative power sufficiently to publish pictures that world events, not specific texts, inspired from artists—imagery that, to quote Salisbury, "speaks without benefit of words."[19] Incisive, freestanding artwork became an Op-Ed staple [see "The Seventies," figures 17 and 19; "The Eighties," figures 24 and 28; and "The Nineties," figure 44]. In the late 1990s, this independent imagery scored its own printed label, "Op-Art." Its initial appearances were sunnier and less conceptual than earlier wordless specimens. Famed fine artists— for example, photographers William Wegman and Cindy Sherman, sculptor Kiki Smith, and painter David Hockney—fashioned light-hearted Op-Art to mark the beginning of each season.

In the twenty-first century, this newly branded feature again took on a substantive edge when, three days after September 11, 2001, R. O. Blechman's poignant tribute appeared sans text [figure 21]. Yet it wasn't long after Op-Art debuted that it veered into the verbal, abandoning the mission of delivering textless graphics in favor of

20 Edel Rodriguez

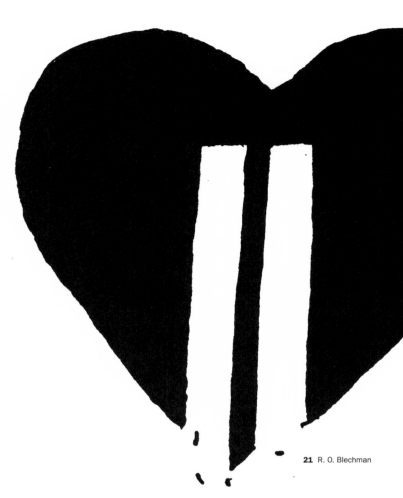

21 R. O. Blechman

combining word and image. Most of this decade's Op-Art, moreover, rejects opinion and, instead, conveys information.

The independent art feature spun off two left-brain novelties: "Op-Chart" in 2003 and "Op-Quiz" in 2004. Both have minimal, regimented visuals. But sometimes their imagery contributes a bit of soul, as do the bent bodies of Iraq War hostages in a chart from 2006 by Joon Mo Kang, a graphic artist from Seoul [figure 22]. Former *Times* graphics director Charles M. Blow brought an innovation to Op-Ed in 2008—a regular infographics column. A wizard at crafting the day's news into fascinating visual exhibits, Blow works with a real challenge: his palette ranges only from 10 percent to 100 percent black.

Op-Art conveys tragedy, trivia, and traditions. In addition to getting statistics from the Iraq War, we've learned, for instance, that wives initiate two-thirds of divorces after age forty. As for tradition, there's the delightful "Lost and Found New York," by reporter and illustrator James Stevenson, who's treated us on Saturdays to a four-column, page-deep well of ink renderings and handwritten New York history. Charts and quizzes, however, are a full pendulum swing away from opinion and art. "The Op-Quizzes are too cute," says David Suter. "That's strange for me to say, since my own art is a quiz." Yet, unlike Suter's "quizzes," the page's puzzles address themselves to the intellect, not the imagination. With but one correct answer to the "Op-Quiz," the once-sacred church of ideas lurches ever closer to the just-the-facts-ma'am state.

Current Op-Ed editor Shipley encourages the blending of text and graphics. He wrote in an editor's note, "You shouldn't feel that you have to rely on the written word alone. Maybe your point is expressed best in a chart, a graphic, an annotated illustration or a series of photographs."[20] Shipley's suggestion was taken by columnist David Brooks and author Ben Schott, who created a "Tabular Estimate of the 2008 Presidential Hopefuls."[21] Based on a British assessment of members of the House of Lords in 1823, their amusing chart delivered on Op-Ed's mandate to present opinions.

Originally banned comics and cartoons have returned to the page. "In Op-Ed's early days," says Jules Feiffer, "Harrison [Salisbury] sent me a Gloria Steinem article. I drew a strip about God creating man and woman. But Harrison said, 'This has words. We don't run art with words.'" Howell Raines later gave Feiffer an Op-Ed voice. "Howell showed me his most charming southern self," says Feiffer. "He offered an unheard-of rate of a thousand dollars per monthly strip and ran everything I drew. Then he rejected everything, giving no reason." "My theory," says Feiffer, "is that Howell didn't want to risk unwanted attention as he planned his ascent." Feiffer contributed a memorable, single cartoon in 2006 [figure 23].

Foreign victims of kidnappings in Iraq

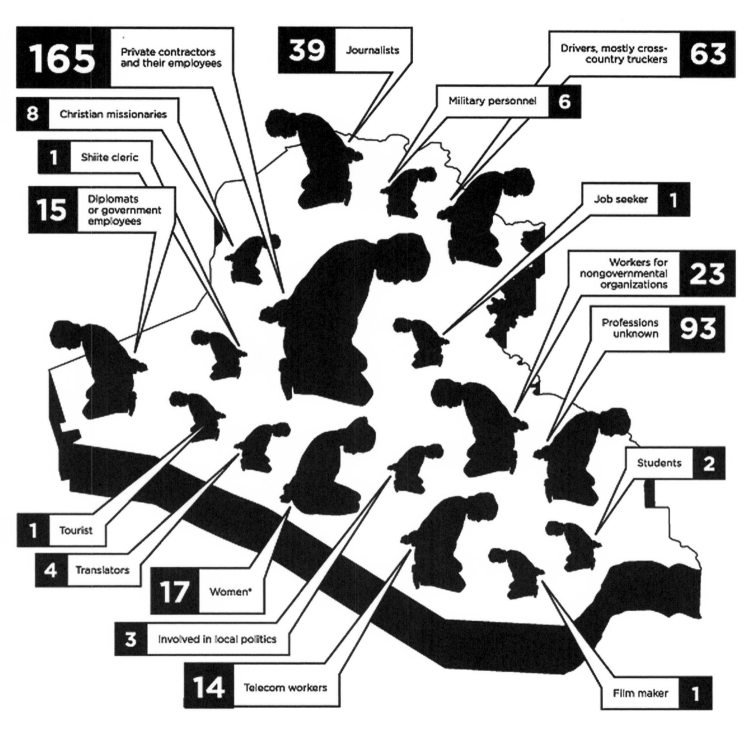

165 Private contractors and their employees

39 Journalists

Drivers, mostly cross-country truckers **63**

8 Christian missionaries

Military personnel **6**

1 Shiite cleric

Job seeker **1**

15 Diplomats or government employees

Workers for nongovernmental organizations **23**

Professions unknown **93**

Students **2**

1 Tourist

4 Translators

17 Women*

3 Involved in local politics

14 Telecom workers

Film maker **1**

*Also included in other categories

65% escaped or were released, ransomed or rescued

18% were killed

17% are still being held or their whereabouts are unknown

22 Joon Mo Kang

OBAMA!

We've just met a man
named Obama,
Delectable, selectable,
Maybe even
Electable,
Obama,
Obama!
We need you to run,
Dear Obama,
Cuter than Gore, you're antiwar,
Who could ask for more,
We could learn to adore
You, Obama,
Obama, Obama, Obama,
A thriller, he,
Killer-diller, he,
Best of all, he's
Not Hillary,
OBAMA,
OBAMA,
OBAMA! *

* With apologies to Stephen Sondheim 23 Jules Feiffer

Glories Still Glitter

I come each night around 2:00 or 3:00.
The *N.Y. Times* is my lover.

SUSAN SONTAG

24 Igor Kopelnitsky

Despite the infographics, art director Rea managed to obtain some strong visuals. Artist Igor Kopelnitsky, who had immigrated to the United States from Ukraine's capital, Kiev, cleverly illuminated a dismissal of the madrassa myth [figure 24]. All the terrorist pilots of September 11, the text pointed out, had attended Western universities.

Among the accomplished new illustrators whom Rea introduced is Op-Ed's fourth Milanese artist, the young, sonorously named Alessandro Gottardo, who lives in Italy and illustrates under the *nome d'arte* "Shout." Gottardo selected this enigmatic identity to avoid a lawsuit with his former agent, who demanded that he stick to a single artistic style. As Shout, he gained the latitude to work however he wishes. In 2006, he created a stirring icon to complement the assertion that the world can live with a nuclear Iran. In Shout's poignant update of De Chirico's masterpiece, *Melancholy and Mystery of a Street*, the Occident and the Orient are in counterpoint, while a perilous dilemma perches ominously between them [figure 25].

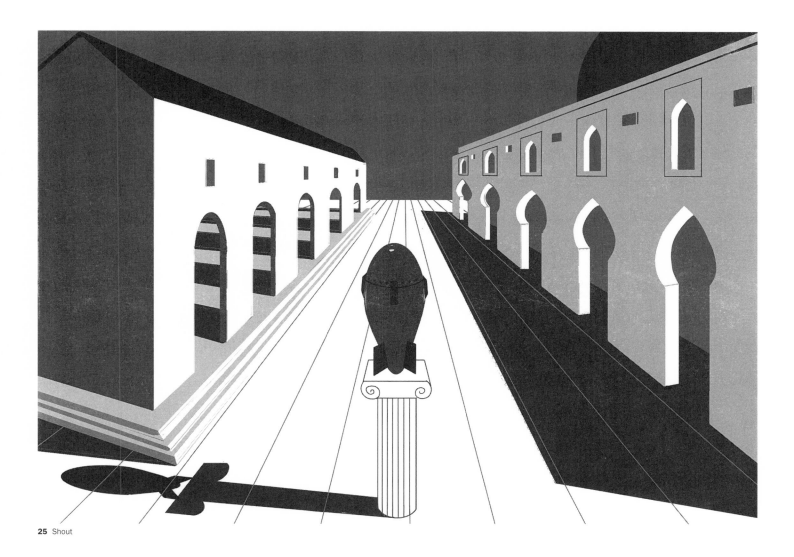

25 Shout

26 Raymond Verdaguer

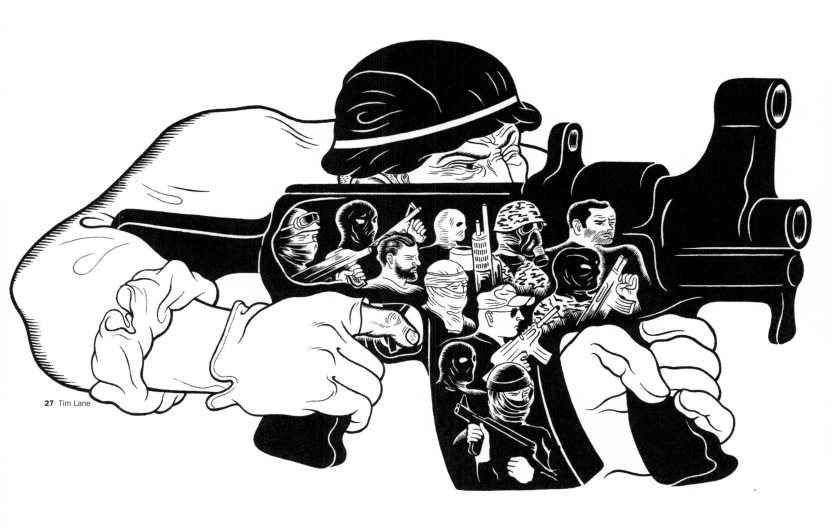

27 Tim Lane

Linocut carver Raymond Verdaguer was reared in a village whose main drag divides France from Spain. Now a New Yorker, this prolific Catalan illustrator has boldly interpreted the neglected tragedy of Darfur [figure 26]. In 2006, Tim Lane portrayed—with beautifully controlled, sinuous curves—the armed militias that were roaming Iraq [figure 27]. The same year, a superb draftsman, Alaska-born Sam Weber, deftly visualized the confrontation between Chad's government sol-

diers and its rebel militias [figure 28]. "I love working only with ink and brushes," says Weber. "The way it forces you to think and make decisions is thrilling." And in 2005, the gifted quick-sketch artist Joan Chiverton packed real pathos into marking the death of the two thousandth GI in Iraq [figure 29]. The Society of Illustrators and the United States Air Force honored Chiverton in 2008, by commissioning her location drawings of ground-warfare training for personnel deployed to Iraq and Afghanistan.

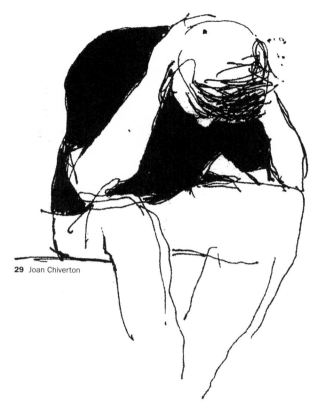

29 Joan Chiverton

One of today's most inventive illustrators is Christoph Niemann. In 2007, his ingenious concept was occasioned by an ode to romantic relic collecting [figure 30]. "The owner of Napoleon's penis died last Thursday," the prose began.[22] Although Niemann's adroit graphic relies on language, not a word is lifted from the text. "When the story is really good," he says, "it's a trap for an illustrator. I couldn't outsmart it, so I went in another direction." With another ironic allegory from 2007, artist Jennifer Daniel—armed with spray paint, stencils, and wit—portrayed the business of counterfeit designer handbags sold by criminals "to finance their illicit activities and their terrorist plots" [figure 31].[23]

The long strike in 2008 by the members of the Writers Guild of America was the impetus for an enticing image by Grant Shaffer that makes marvelous use of scale [figure 32]. Besides editorial illustrations and gallery shows of his work, Shaffer makes first-class storyboards for major feature films and for the music videos of Madonna and Michael Jackson.

In August 2008, Leanne Shapton took up the Op-Ed art director's helm. Toronto-born Shapton is an artist, art director, and publisher. Her prolific illustrations are stylish, loose sketches that she often peppers with language for the *Times* Op-Ed page.

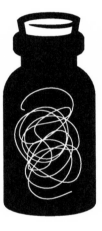

Tut's
Guts

Poe's
Toes

Mao's
Brows

Grant's
Aunts

Grosz's
Floss

Liszt's
List

30 Christoph Niemann

Once Upon a Time

In so far as the senses show becoming,
passing away, change, they do not lie.

FRIEDRICH NIETZSCHE

The atmosphere of today's *Times* is coolly corporate. It used to be funky. Eccentrics were tolerated, and managers actually mingled with their minions. One late afternoon, for example, idiosyncratic executive editor Abe Rosenthal invited me to his newsroom office for a conversation. "Let's not talk about the *Times*," he insisted. We conversed for two hours, during which he ignored all calls and refused to open the door when his deputy, Arthur Gelb, knocked twice during the first edition close.

The paper's makeup center, then a cavernous domain fitted with endless rows of slanted wooden drawing tables, was staffed by a few longtime layout men. These craftsmen and their boss, George Cowan, who was a whiz at making the broadsheet page look spiffy, handled the appearance of the paper very well, thank you, without smarty-pants art directors.

When the *Times* needed more advertising pages, someone had to design new feature sections to contain them. So the paper borrowed its own promotion art director, Lou Silverstein, to create the C sections and then redesign—page by gritty page—the entire newspaper. As the paper got fatter, the modest batch of makeup men yielded to a passel of arrogant art directors like me. Walls were installed and offices created. Yet from Cowan's new lair, Beethoven continued to boom, and dozens of pipes lined every surface. The janitor emptied six ashtrays nightly, but by 2:00 P.M., they were again full.

Cowan was as wide as he was tall, and his passionate spirit reached higher than the trees that provided our newsprint. A Jew, he championed the hiring of African Americans and mentored young designers, including a Peruvian single mother and a Turkish Muslim woman. The eccentric Cowan broke rules, records, and hearts. And, as a talented *Times*man, he was tolerated.

Artist Bob Gale waxes nostalgic about his own experience during this era: "It was a whole generation—twenty years of my life—that I had a love–hate relationship with the *Times*. Of all the publications I I worked for, the *Times* stands out. Oddballs were once accepted there."

31 Jennifer Daniel

32 Grant Shaffer

Picture Power

God is really only another artist. He invented
the giraffe, the elephant, and the cat. He has no real
style. He just keeps on trying other things.

PABLO PICASSO

The mandate for the material opposite the edi-
torial page is to stimulate thought. Nearly any no-
tion is palatable when rendered in prose. When the
same notion is pictured, however, the record shows that
Op-Ed editors see it as a far greater threat. They aren't
alone. In 1835, five years after liberating the French press,
King Louis-Philippe reestablished the censorship of draw-
ings. "Whereas a pamphlet is no more than a violation
of opinion," he decreed, "a caricature amounts to an act
of violence."[24] Voilá! Royal reinforcement for the conclu-
sion to which my Op-Ed experience has led: Confucius
underestimated when he reckoned the number of words a
picture is worth. I here propose a corollary to the Confucian
calculation: the thousand-fold power of a picture is also
its curse.

Barry Blitt's imaginative concepts and
fluid draftsmanship add a narrative dy-
namic to Frank Rich's columns. In
his last piece of 2007, Blitt inter-
preted the public's preference for
the change that Barack Obama
embodies over the years of experi-
ence that Hillary Clinton incar-
nates [figure 33]. Blitt encountered
no problems picturing the two primary
candidates. Three months later, however, when
Rich's column dealt exclusively with Hillary Clinton,
Blitt complained, "the *Times* refused to let me draw her
and wouldn't explain why." (The *New Yorker*, in contrast,
publishes strong Blitt covers, including an infamous
satire of the political attacks on the Obamas as if they
were true.) Yet the same editors who banned the por-
trayal of candidate Hillary Clinton had, three days
earlier, allowed Wes Bedrosian to draw candidate
John McCain. Author Neal Gabler wrote of
McCain as such a media darling that—
as Bedrosian pictured—he might as
well photograph himself [figure 34].

33 Barry Blitt

34 Wes Bedrosian

Images of the Iraq War are taboo. "If the topic is a beheading," says Bedrosian, "we dare not show the moment before." (Compare this with Op-Ed's first decade, when, as noted, headless figures were a routine graphic convention.) Blitt drew a flag-draped coffin in 2008. "Everyone loved it," he says. "But they had a meeting and killed it. I was then surprised to see a skull for Zimbabwe." When that desperate nation was counting presidential votes in 2008, an iconic image by Edel Rodriguez graced advice to the West to sit down with Robert Mugabe, Zimbabwe's nefarious, octogenarian dictator [figure 35]. Because Op-Ed had previously insisted that Rodriguez transform a naturalistic African American figure into a strict silhouette, he now rendered Mugabe with stark simplicity. And why can Zimbabwe be characterized with death's emblem? It's not America's conflict!

Rodriguez represents a new generation of artists who don't chafe at the *Times*'s constraints. "My job is to illustrate the author's story," he says, "not to express myself." Illustrator Christoph Niemann actually appreciates the taboos. "When you get to draw whatever you want," he says, "it's boring. If you don't play defense by observing the guidelines, you'll get angry letters. The challenge of preventing criticism makes it more fun."

Further, today's illustrators don't mind submitting multiple roughs. "Op-Ed editor David Shipley is pretty good at making sketch decisions," says Rodriguez. Bedrosian agrees: "Shipley usually gets it. There were more problems with Howell Raines's paranoia. It's been a lot calmer since he left."

The *New York Times* has now moved into its new Times Tower, a metal-and-glass structure that scrapes the sky. With "transparency" the watchword, employees sit in uniform cubicles, and the "walls" of the precious few offices are see-through glass. Thus for all *Times* people—executive editor and publisher included—privacy is so twentieth century. Web personnel are now intertwined with print staff as the newspaper of record advances from pulp nonfiction to streams of electrons.

"The Internet is a wonderful place to be," says publisher Sulzberger, "and we're leading there."[25] Nytimes.com is the Web's most visited newspaper site; its number of online hits surges logarithmically beyond print circulation figures. Op-Ed illustrations receive prominent online treatment. Displayed daily in a form that can be magnified, they're also archived with their articles. What's more, select Op-Ed images are spotlighted on the site's first opinion "page" and remain accessible into eternity.

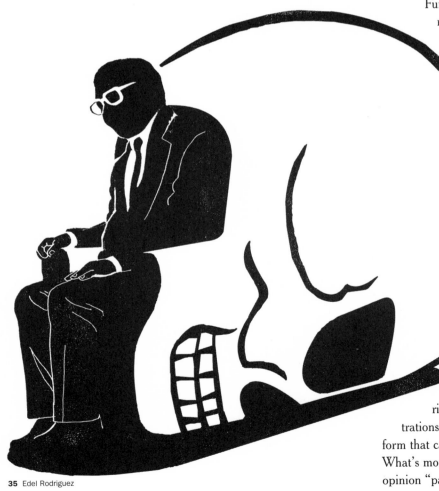

35 Edel Rodriguez

In 2004, artist Guy Billout cunningly reflected the deconstruction-ist thinking of his countryman, French philosopher Jacques Derrida [figure 36]. Deconstruction, which challenges the ability of language to represent reality and replaces "the stability of logic with the fluidity of paradox,"[26] has much in common with the Op-Ed artist's task. By probing, unraveling, and unveiling the associations and assumptions implicit in a text, Op-Ed artists have traditionally pursued the prose's essence and dignified us, the viewers, with a central role in determining meaning. Their imagery emerges from an eloquent underbelly where the details of topical articles reconstitute themselves as abiding parts of our common cosmic drama. The prose may highlight each skirmish of every battle, but the art serves up the war.

Op-Ed art once had time to evoke our feelings and charge our imaginations. Artist David Suter, for instance, received lots of fan mail during the 1980s from readers delighted to have solved his graphic riddles. "People used to be interested in figuring things out," says Suter. "But the mail doesn't come anymore."

Another shift is in the value assigned to illustrators as independent agents who sift textual evidence for the grounds of original visual testimony. "Today's page has no connection to Op-Ed's past," says Brad Holland. "Op-Ed artists used to be the equivalents of authors." The page's once vivid, indelible personality was created and maintained by its staff columnists and a cluster of committed freelance artists whose individual styles gave Op-Ed its signature identity.

Like a corner shop obscured by a mall, the romantic sizzle of Op-Ed's initial era yielded to today's bazaar of abundant offerings. The focus is now more diffuse and the variety, greater. Artistic contributors—no longer canonized as idiosyncratic auteurs—are numerous, and one page doesn't suffice to support their image-making habits. Rather than an artistic home or identity, Op-Ed is one of their many clients.

For the first time, individual illustrators are now augmented by an increasing number of contemporary, impersonally named design duos. Prominent among them are Number 17, karlssonwilker inc., Post Typography, QuickHoney, and The Heads of State. Each of these is a two-person team that combines its considerable wits with the latest software to create state-of-the-art designs. The smart, sleek Op-Ed illustrations they produce, however, are indistinguishable from the graphics they create for myriad corporate clients.

No singular cultural movement—be it Dada, Motown, or the Twist—survives long beyond its initial impetus. The vigor of each genre is measured not in length of life but in degree of originality and breadth of influence. On both these scales, Op-Ed art scores high. As a novel phenomenon launched by the *New York Times* in 1970, it revolutionized illustration. As an infinitely fertile visual idiom, it's influenced the course of editorial, commercial, and fine art throughout the world. Now the *Times*'s Op-Ed page provides us—in both visuals and verbals—with fresh approaches and rich diversity.

Op-Ed art, the brand, is dead. Long live the page's pictures!

36 Guy Billout

Anita Siegel

Notes

ORIGINS

1 Quoted in David Larson, "Drawing on Experience," *New Zealand Listener*, March 8, 2008.

2 Matthew Levine, "Too Cheeky for the 'Times,'" *Village Voice*, December 24, 1979.

3 Ibid.

4 David Levine to Jerelle Kraus, November 29, 1993.

5 Editorial, *New York Times*, September 21, 1970.

6 Quoted in Susan E. Tifft and Alex S. Jones, *The Trust: The Private and Powerful Family Behind The New York Times* (Boston: Little, Brown, 1999).

7 Robert D. McFadden, "John B. Oakes, Impassioned Editorial Page Voice of The Times, Dies at 87," *New York Times*, April 6, 2001.

8 Tifft and Jones, *Trust*.

9 Quoted in Teo A. Babun and Victor Andres Triay, *The Cuban Revolution: Years of Promise* (Gainesville: University Press of Florida, 2005).

THE SEVENTIES

1 Harrison E. Salisbury, with David Schneiderman, eds., *The Indignant Years: Art and Articles from the Op-Ed Page of The New York Times* (New York: Crown/Arno Press, 1973).

2 David Shipley, "What We Talk About When We Talk About Editing," *New York Times*, July 31, 2005.

3 Kenneth C. Lindsay and Peter Vergo, eds., *Kandinsky: Complete Writings on Art* (Boston: Hall, 1982).

4 Salvatore J. Stazzone, "Blue-Collar Pushers," *New York Times*, February 17, 1973.

5 Brad Holland, "The Copy Left Is Not Right," http://www.illustratorspartnership.org/01_topics/articlephp?searchterm=00152.

6 "In Uganda, Dead, Dead, Dead, Dead," *New York Times*, September 12, 1977.

7 Mark Podwal, *Freud's da Vinci* (New York: Images Graphiques, 1977).

8 R. O. Blechman, *R. O. Blechman, Behind the Lines* (New York: Hudson Hills, 1980).

9 Ibid.

10 Seymour Chwast, *The Left-Handed Designer* (New York: Abrams, 1985).

11 Ibid.

12 Ibid.

13 Ibid.

14 Ibid.

15 Claudio Ombú [pseud.], "The Lady in Gray," *New York Times*, January 31, 1979.

16 Chwast, *Left-Handed Designer*.

17 Dr. Paul Dudley White, "Walking to Wisdom," *New York Times*, October 10, 1971.

18 Wolfram Siebeck, "Wolfram Siebeck über seine letzte Begegnung mit dem vielseitigen Künstler Roland Topor," *Die Zeit*, http://zeus.zeit.de/text/archiv/1997/18/topor.txt.19970425.xml.

19 George Orwell, *1984* (New York: Harcourt, Brace, 1949).

20 Earl C. Ravenal, "Via Route 1, or Foreign Policy Rd., to Defense Budget Ave.," *New York Times*, September 4, 1975.

21 "Sociologist on the Society Beat," *Time*, February 19, 1965, http://www.time.com/time/magazine/article/0,9171,940947,00.html.

22 Marilyn S. Greenwald, *A Woman of the Times: Journalism, Feminism, and the Career of Charlotte Curtis* (Athens: Ohio University Press, 1999).

23 Robert B. Semple Jr., "All the Views That Are Fit to Print," *New York Times*, September 30, 1990.

24 Greenwald, *Woman of the Times*.

25 Randall Enos, comment on http://www.randallenos.com/home.html.

26 Ibid.

THE EIGHTIES

1 Quoted in Pam Black, "Ramparts," *Folio: The Magazine for Magazine Management*, April 1, 2004.

2 "Citizen Coppola," *Time*, June 30, 1975, http://www.time.com/time/magazine/article/0,9171,917585,00.html.

3 Alfred Frankenstein, "Bedtime Story," *ARTnews*, February 1975.

4 David Van Biema, "Look Twice! Illustrator David Suter Uses Visual Puns to Make His Points," *People*, May 14, 1985.

5 Mark Siegler, "How to Ease the Pain," *New York Times*, July 2, 1982.

6 David Suter, *Suterisms* (New York: Random House, 1986).

7 Tim James, "Adding the Crat to the Bureau," *New York Times*, January 4, 1980.

8 Harrison E. Salisbury, with David Schneiderman, eds., *The Indignant Years: Art and Articles from the Op-Ed Page of The New York Times* (New York: Crown/Arno Press, 1973).

9 Walker Percy, "A View of Abortion, with Something to Offend Everybody," *New York Times*, June 8, 1981.

10 Herbert J. C. Kouts, "Nuclear Electricity," *New York Times*, April 29, 1983.

11 John Frederick Martin, "The Curse of Campaign Fund Raising," *New York Times*, July 11, 1988.

12 Ralph Buultjens, "What Marx Hid," *New York Times*, March 14, 1983.

13 Max Frankel, *The Times of My Life and My Life with The Times* (New York: Random House, 1999).

14 Seymour Chwast, *The Left-Handed Designer* (New York: Abrams, 1985).

15 Ibid.

16 "Senator Nixon's Checkers Speech," September 23, 1952, http://www.watergate.info/nixon/checkers-speech.shtml.

17 Quoted in Christopher Buckley and Paul Slansky, "Nixon's Rap," *New York Times*, July 23, 1990.

18 Kurt Vonnegut, "Avoiding the Big Bang," *New York Times*, June 13, 1982.

19 Quoted in Joel Smith, *Steinberg at The New Yorker* (New York: Abrams, 2005).

20 David Owen, "1 in 4. Always. Bet on It," *New York Times*, February 29, 1980.

21 Byron Dobell, "Coffee," *New York Times*, March 9, 1980.

22 Joseph A. Johnson Jr., unpublished letter to the *New York Times*, May 5, 1983.

23 Susan Day, "My Husband Has AIDS," *New York Times*, March 29, 1987.

24 Neal Gabler, "For 25 Cents, Every Moviegoer Was Royalty," *New York Times*, January 24, 1989.

25 John Ullman, "Mum's Not the Word," *New York Times*, December 2, 1981.

26 Chwast, *Left-Handed Designer*.

27 Ewa Zadrzynska, "A Bracelet, an Odd Earring, Cracked Teacups," *New York Times*, June 8, 1988.

28 Czesław Miłosz, "To Lech Wałesa," *New York Times*, October 14, 1982.

29 Rafal Olbinski, *Rafal Olbinski Women: Motifs and Variations* (New York: Hudson Hills, 2005).

30 Ibid.

31 Gay Talese, *New York Observer*, April 24, 2006.

32 Frankel, *Times of My Life*.

33 Harold Evans, Comment, "Beyond the Scoop," *New Yorker*, July 8, 1996.

34 Susan E. Tifft and Alex S. Jones, *The Trust: The Private and Powerful Family Behind The New York Times* (Boston: Little, Brown, 1999).

35 Leslie H. Gelb, "Misreading the Pentagon Papers," *New York Times*, June 29, 2001.

36 Quoted in Ranan Lurie, *Chicago Sun Times*, October 18, 1976.

THE NINETIES

1 Josef Skvorecky, "After the Velvet Revolution," *New York Times*, July 22, 1992.

2 Quoted in Robert Plunket, "Would She Spank Me?" *New York Times*, May 15, 1992.

3 Quoted in Ulrich Ernst, "The Figures Poem: Towards a Definition of Genre," *Journal of Typographical Research: Visible Language* 20 (1986).

4 Art Spiegelman, Steven Barclay Agency online lectures and readings speaker information, September 23, 2001, http://www.barclayagency.com/spiegelman_wtc.html.

5 Karen Lehrman, "Beware the Cookie Monster," *New York Times*, July 18, 1992.

6 Susan E. Tifft and Alex S. Jones, *The Trust: The Private and Powerful Family Behind The New York Times* (New York: Little, Brown, 1999).

7 Quoted in ibid.

8 Quoted in George Stephanopoulos, *All Too Human: A Political Education* (New York: Little, Brown, 1999).

9 Quoted in Tifft and Jones, *Trust*.

10 John R. Kasich, "Get Rid of Corporate Welfare," *New York Times*, July 9, 1995.

11 Gay Talese, "Honor Thy Talese," *New York Observer*, April 23, 2006, http://www.observer.com/node/38740.

12 Milton Glaser, *Art Is Work* (New York: Overlook Press, 2000).

13 Ibid.

14 Quoted in Zina Saunders, online Art Talks profile, http://www.zinasaunders.com/index.html.

15 Andro Linklater, "565 Million Acres, Riv Vu," *New York Times*, April 28, 2003.

16 Quoted in Ellen Lupton, *D.I.Y: Design It Yourself* (New York: Princeton Architectural, 2006).

17 Nicholas Blechman, Christoph Niemann, and Paul Sahre, *Fresh Dialogue 1: New Voices in Graphic Design* (New York: Princeton Architectural Press, 2000).

18 John D. Barrow, "The Endless Unknown," *New York Times*, May 2, 1998.

19 Emma Gilbey, "Winnie Mandela's Rise and Fall," *New York Times*, April 14, 1992.

20 Anne Wu, "Whispers That May Wake the Dragons," *New York Times*, August 6, 2004.

21 Gustavo Gorriti, "Tough Journalism," *New York Times*, August 27, 1997.

22 S. Nomanul Haq, "Salman Rushdie, Blame Yourself," *New York Times*, February 23, 1989.

THE AUGHTS

1 Howell Raines, *The One That Got Away: A Memoir* (New York: Scribner, 2006).

2 Ibid.

3 Richard Pérez-Peña, "Former Times Editor in New Post at Magazine," *New York Times*, January 15, 2008.

4 Quoted in Jeff Coplon, "How Race Is Lived in America," *New York*, November 12, 2007, http://nymag.com/news/features/40647.

5 Ibid.

6 Ariana Huffington, "Howell Raines Redux," August 18, 2005, http://search.huffingtonpost.com/search/?sp_a=sp100395aa&sp_p=all&sp_.

7 Quoted in Philip Weiss, "Fishing with Howell," *New York*, May 1, 2006, http://nymag.com/news/media/16862/.

8 Coplon, "How Race Is Lived in America."

9 Pérez-Peña, "Former Times Editor in New Post at Magazine."

10 Quoted in Jesse Sunenblick, "Little Murders: The Death of Dangerous Art," *Columbia Journalism Review*, January–February 2004.

11 Alan Ehrenhalt, "Another Chance to Make the Sale," *New York Times*, June 6, 2001.

12 Walker Art Center, Paula Scher, Pentagram, New York, http://design.walkerart.org/detail.wac?id=1167&title=Past%20Programs.

13 Nicholas Blechman, Christoph Niemann, and Paul Sahre, *Fresh Dialogue 1: New Voices in Graphic Design* (New York: Princeton Architectural Press, 2000).

14 Bill Keller, "The Selective Conscience," *New York Times*, December 14, 2002.

15 T. Coraghessan Boyle, "Waiting for the Apocalypse," *New York Times*, October 29, 2003.

16 Frank Rich, "Springtime for Adolf and Tony," *New York Times*, May 12, 2001.

17 Olivier Roy, "Friend or Faux?" *New York Times*, May 15, 2007.

18 Milton Glaser, *Art Is Work* (New York: Overlook Press, 2000).

19 Harrison E. Salisbury, with David Schneiderman, eds., *The Indignant Years: Art and Articles from the Op-Ed Page of The New York Times* (New York: Crown/Arno Press, 1973).

20 David Shipley, "What We Talk About When We Talk About Editing," *New York Times*, July 31, 2005.

21 David Brooks and Ben Schott, "Candidates in a Box," *New York Times*, November 16, 2007.

22 Judith Pascoe, "Collect-Me-Nots," *New York Times*, March 17, 2007.

23 Dana Thomas, "Terror's Purse Strings," *New York Times*, August 30, 2007.

24 Quoted in Michel Melot, *The Art of Illustration*, trans. James Emmons (New York: Rizzoli, 1984).

25 Quoted in Eytan Avriel, "NY Times Publisher: Our Goal Is to Manage the Transition from Print to Internet," *Haaretz*, February 8, 2007, http://www.haaretz.com/hasen/spages/822775.html.

26 Mark C. Taylor, "What Derrida Really Meant," *New York Times*, October 14, 2004.

David Suter

Index